ETHIOPIA
Traditions
of Creativity

ETHIOPIA
Traditions of Creativity

edited by

Raymond A. Silverman

Michigan State University Museum, *East Lansing,*
in association *with the* University of Washington Press, *Seattle and London*

Library of Congress Cataloging-in-Publication Data

Ethiopia : traditions of creativity / edited by Raymond A. Silverman
 p. cm.
 Includes bibliographical references and index.
 ISBN 0-295-97740-X (pbk. : alk. paper)
 1. Art, Ethiopian—Themes, motives. I. Silverman, Raymond Aaron.
N7386.E82 1998
 709'.63—DC21 98-15691
 CIP

In memory of our colleagues

Fatuma Ibrahim Muhammed

Girma Kidane

Taye Tadesse

Seyoum Wolde

በጅ ያለ ወርቅ እንደ መዳብ ይቆጠራል ፨

Gold in one's hand is like copper.

Contents

FOREWORD

THE TWELFTH INTERNATIONAL CONFERENCE OF ETHIOPIAN
Studies, held in East Lansing, Michigan, in September 1994, was en-
livened by a skillfully designed exhibition, "Ethiopia: Traditions of Cre-
ativity," concurrently showing at Michigan State University Museum.
The exhibition celebrated the achievements of a number of Ethiopian
creative artists and artisans and revealed Ethiopia's rich and varied cul-
tural heritage. For the Institute of Ethiopian Studies (Addis Ababa), which
gave the logistical support for the collection of the objects and for the
supporting research, the exhibition represented a gratifying outcome
of its commitment to the promotion of the country's cultural heritage.
This book is a product of the research conducted for the exhibition and
further enhances our appreciation for these traditions.

In retrospect, the mid-1990s appear to have been significant years
for the growth of American awareness of Ethiopia's artistic traditions.
Two major exhibitions have brought home to the American public the
high achievements and the richness of Ethiopian art, classical as well as
modern. "African Zion," an exhibition organized by Intercultura and
the Walters Art Gallery (Baltimore), which toured the United States from
October 1993 to January 1996, introduced to the American audience
the icons, crosses, and manuscript illuminations that have traditionally
been regarded as the highest expressions of Ethiopian art. Viewed at a
number of venues on the East Coast and in the South and the Midwest,
it attracted record crowds.

"Ethiopia: Traditions of Creativity," which opened in the summer of
1994, has shown the other side of Ethiopian art, the one that has tra-
ditionally been less celebrated and yet has been equally demonstrative

of the Ethiopian creative genius. The two exhibitions should be viewed as complementary rather than antithetical, for they tell two sides of the same story. As Raymond Silverman has argued convincingly in the introduction to this volume, the exhibition and this book challenge the artificial dichotomy that is conventionally made between art and handicraft. By going behind the objects themselves and documenting the artist's creative experience, the contributors to this volume give substance to this assertion.

This volume and the exhibition of which it is a product are also welcome contributions to the rectification of the northern bias that has so often handicapped Ethiopian studies. For quite some time, historical and linguistic studies have concentrated on the classical Ethiopian polities of northern Ethiopia. It is only in recent decades that historians and linguists, assisted by anthropologists, have begun to uncover the cultural wealth of the southern polities. Through the critical use of oral evidence, students of history have succeeded in reconstructing the history of the southern peoples, in some instances managing to push back the frontiers of historical knowledge many centuries. Likewise, the linguistic kaleidoscope and ethnological wealth of southern Ethiopia have been engaging the attention of many renowned scholars in recent decades. *Ethiopia: Traditions of Creativity* marks a fitting artistic cap to these scholastic endeavors.

In essence, the spiritually oriented classical art of northern Ethiopia and the materially grounded "crafts" of southern Ethiopia are not without some points in common. An inherent functionality permeates both. The icons were painted and the crosses carved not merely to satisfy the artist's creative urge but to venerate saints. And they were in constant, often daily, use in the churches. The idea of displaying them in an exhibition as disembodied pieces of art would have been considered anathema until recently. Likewise, the pots and baskets that are among the objects highlighted in a number of the essays and in the Michigan State University exhibition serve a supremely functional purpose. Yet, in both instances, we speak of art because their creators have given the best of what they have to produce them. And just as there are crude baskets, there are also rough and unattractive crosses. The beauty of Dorze or Gurage houses is almost as spellbinding as that of the celebrated north-

ern edifices. This phenomenon of "art in craft" is not confined to Ethiopia. The creations of a Florentine glassblower would certainly vie in beauty and artistic excellence with many works of art.

Another common feature of both categories is the anonymity of their creators. Ethiopian icons have been distinguished by their anonymity. Of the exquisite paintings of the fifteenth and sixteenth centuries that have attracted the attention of art historians, only one is definitely known to have been executed by the great master Fre S'eyon. Many others have often been attributed to him, perhaps unjustly, merely by the similarity of style. For the equally great works of the Gonderine period (the seventeenth and eighteenth centuries), we do not have even one name. The same situation pertains to the crosses. The art objects portrayed in this volume generally are of an even more anonymous nature by virtue of their communal character. It is a tribute to this collection of essays that it has managed to go beyond this collective facade and uncover the individual artist at work.

This people-oriented (as opposed to object-oriented) casting of both the exhibition and this volume represents a healthy innovation. At the same time, one can hope that the kind of recognition thus afforded individual artists will help ease the stigma that has often been associated in Ethiopian society with quite a few of the craft traditions discussed in the essays that follow. And herein lies one of the crucial differences between classical Ethiopian art and the so-called crafts. Whereas painters of icons occupied an elevated position in Ethiopian society, craftsmen were generally looked down upon, some even being relegated to a kind of caste status. This was particularly true of tanners and potters. Biasio's essay on the artist Zerihun Yetmgeta, who enjoys considerable prestige as one of Ethiopia's leading contemporary artists, and the inclusion of his work in the Michigan State University exhibition are in this sense symbolically significant. His presence serves to smooth over the traditional distinction between "low art" and "high art."

The essays in this volume cover a lot of ground in terms of both regional representation and the selection of media of artistic expression. Nevertheless, they do not pretend to have covered all the ground. Nor do they claim to have told the full story of the evolution of these artistic traditions. That, as indicated in the introduction, remains a chal-

lenge for the future. It is a challenge that can best be met by historians, anthropologists, and art historians combining their resources and methods. It is a challenge that has been met admirably in the realm of political and economic history by *The Southern Marches of Ethiopia*, edited by Donald Donham and Wendy James. *Ethiopia: Traditions of Creativity* is an encouraging step in the direction of producing a companion to that volume in the realm of art and social history.

Bahru Zewde, Director
Institute of Ethiopian Studies
Addis Ababa University

Acknowledgments

This groundbreaking collection of essays is the culmination of a project begun in 1989 when Harold Marcus, professor of Ethiopian history at Michigan State University (MSU), learned that MSU would be hosting the Twelfth International Conference of Ethiopian Studies in the fall of 1994. He asked me to organize an art exhibition for the conference. Prior to this project, my research had focused on West African art and I knew little about Ethiopia. Overseeing the evolution of "Ethiopia: Traditions of Creativity" (both the exhibition and this book) was a tremendous learning experience. It took me on several trips to Ethiopia and through some of the world's great cultural-history museums. I had the opportunity to work with hundreds of people in Ethiopia, Europe, and the United States; I would like to take this opportunity to acknowledge their contributions and thank them for their assistance.

The project began as a collaboration between Michigan State University Museum and the Fowler Museum of Cultural History at the University of California, Los Angeles. The advice offered by my colleagues at the Fowler Museum, especially Doran Ross, Betsy Quick, and David Mayo, proved invaluable during the early stages of exhibition planning. We also involved a number of scholars as consultants during the planning process: Donald Levine, Stanislaw Chojnacki, Richard Pankhurst, Paul Henze, Grover Hudson, Marilyn Heldman, John Hinnant, Girma Kidane, Eike Haberland, Kay Shelemay, Achameleh Debela, Brigitta Benzing, Marsha MacDowell, Kurt Dewhurst, Diane N'Diaye, Chris Prouty Rosenfeld, and Neal Sobania. Later on, I also sought the advice of Jacques Mercier, Hermann Amborn, and Serge Tornay. I thank all of these scholars for their valuable insights into Ethiopian history, culture, and aes-

thetic tradition and for their assistance in helping us develop the conceptual framework for "Ethiopia: Traditions of Creativity."

A critical stage of the project included a survey of Ethiopian collections maintained in North American and European museums. Many thanks to the curators who assisted during my visits to these museums: Peabody Essex Museum (Salem, Massachusetts), Peabody Museum (Harvard University), American Museum of Natural History (New York), University Museum (Philadelphia), National Museum of Natural History (Washington), Oklahoma State University Natural History Museum (Stillwater), Mingei Museum of International Folk Art (San Diego), Fowler Museum of Cultural History (University of California, Los Angeles), University of Oregon Natural History Museum (Eugene), Portland Art Museum (Portland, Oregon), Field Museum of Natural History (Chicago), Frobenius Institute (Frankfurt), Museum für Völkerkunde (Frankfurt), Museum für Völkerkunde (Munich), Völkerkundemuseum der Universität Zürich, Museo Pigorini (Rome), Instituto Italo-Africano (Rome), Musée de l'Homme (Paris), University Museum (Manchester), Pitt Rivers Museum (Oxford), Museum of Mankind (London), Powell-Cotton Museum (Birchington, Kent).

Both the exhibition and the book have benefited greatly from a linkage established in 1991 between Michigan State University Museum and the Institute of Ethiopian Studies (IES) Museum at Addis Ababa University. Support from the International Partnership among Museums program of the American Association of Museums (AAM) allowed Girma Kidane, then Head of the IES Museum, and me to spend time at one another's institutions. This provided a firm foundation on which to pursue the research for the book and exhibition. I thank Marilu Wood and Helen Wechsler of the AAM for helping coordinate this important program. The IES played a vital role in the project, for it served as the base for our research in Ethiopia. I express my thanks to the Institute's directors, Bahru Zewde and Tadesse Beyene, for their support of the project. I appreciated working with the curatorial staff of the IES Museum, namely, Ahmed Zekaria and Taye Tadesse, as well as the museum conservator, Ketsela Markos. Also important was the support of Leule Selassie Temamo, Ethiopia's Minister of Culture and Sports Affairs, and Kassaye Begashaw, Head of the Center for Research and Conservation of Cultural Heritage.

The core of the project was research conducted in Ethiopia from April through June 1993. The fruits of this research are presented in this volume. Special thanks are extended to the scholars who led the research teams and authored these essays: Jon Abbink, Ahmed Zekaria, Marco Bassi, Elisabeth Biasio, Girma Fisseha, Alula Pankhurst, Worku Nida, Neal Sobania, Tsehai Berhane-Selassie, Mary Ann Zelinsky-Cartledge, and Daniel Cartledge. I also would like to thank Owen Moore of the Fowler Museum, who assisted us on a number of our research trips.

We obtained valuable assistance from residents of the communities in which we worked, in particular, Fatuma Ibrahim Muhammed, Werqnesh Weltamo, Father Emmanuel Fritsch, Gezahegn Alemayehu, Moges Lelissa, and Amatula Muhammed Ibrahim. A number of people in Addis Ababa also helped us at various stages of the project: Dell Hood, Isaac Russell, Marc Baas, Mathewos Tesfaye, Charles Schaefer, Margaret Chandler, Belainesh Haile, and Worku and Barbara Goshu. Special gratitude is extended to Berhanu Wolde-Amlak, who generously provided assistance on numerous occasions, and to Degefa Etana Rufo, who served as our primary research assistant and interpreter in Ethiopia.

It goes without saying that there would be no exhibition or book if it were not for the artists with whom we worked in Ethiopia. A special note of gratitude is reserved for them. I thank them for their time, patience, and the knowledge they generously shared with us (the names of the artists featured in this volume are highlighted in italics): *Amina Ismael Sherif,* Munira Ahmed Adish, Samiyya Ahmed Adish, Amatula Muhammed Ibrahim, *Elema Boru,* Jilo Hola, Jilo Dido, Dida Hukka, *Bogine Shala, Gelta Foroshowa, Ilto Indalay, Arba Desta,* Malako Arba, Kalkai Arba, *Tabita Hatuti,* Wagete Wodebo, Elizabeth Anjeyo, Kumpe Shubamo, Tumbe Gatore, *Menjiye Tabeta,* Gebre Wolde Tsadik, Nesqiye Andiye, Abebech Torcha, *Tolera Tafa,* Bekele Bedada, Sorri Tafa, *Gezahegn Gebre Yohannes, Abib Sa'id, Qengeta Jembere Hailu, Marcos Jembere, Zerihun Yetmgeta, Qes Adamu Tesfaw,* Qes Leggese Mengistu, Haile Alemseged, Brehane Mesqal Fisseha, Amha Gebre Medhin, and Belai Tedla.

Many people at MSU played key roles in the evolution of "Ethiopia: Traditions of Creativity." First, I would like to thank a number of graduate students who served as research and curatorial assistants at various stages of the project, namely, Andrea Bour, Teresa Goforth-Piselli,

Tibebe Eshete, Shiferaw Assefa, Chris Plescher, Earnestine Jenkins, Rae Welch, Heran Sereke Brhan, Sabine Barcatta, and Gerna Rubenstein. Two of my colleagues at Michigan State University Museum, Juan Alvarez and Kris Morrissey, were instrumental in planning the exhibition and its ancillary programs. Thanks also to Grover Hudson for accepting the challenge of editing the book's glossary. A special note of gratitude is reserved for Kurt Dewhurst, the Director of MSU Museum, who offered both administrative and intellectual support for the project. I am especially grateful for his assistance in publishing this volume.

Two other people deserve special thanks. John Eadie, Dean of the College of Arts and Letters at MSU, was keenly interested in this project from its inception and his support is greatly appreciated. My colleague and friend Neal Sobania, of Hope College, played a vital role in our project, serving as a consultant and assisting in the direction of the research teams in Ethiopia in 1993. I extend deep-felt thanks to him as well as the administrators at Hope College, who supported his participation in our project.

None of this would have been possible if not for the financial support of a number of individuals and institutions. I would like to thank them for their generous contributions: the National Endowment for the Humanities, the National Endowment for the Arts, and the Institute of Ethiopian Studies at Addis Ababa University; and at Michigan State University, the Office of the Provost, Office of the Vice President for Research and Graduate Studies, Office of the Dean of the College of Arts and Letters, Office of the Vice Provost for Computing and Technology, Consortium for Interinstitutional Collaboration in African and Latin American Studies (CICALS), Office of the Dean of International Studies, Office of the Dean of the College of Social Sciences, and the Center for Integrative Studies in Arts and Humanities.

The production of this book was no mean task. It took a considerable amount of specialized talent and effort. Grover Hudson, our local specialist in Ethiopian languages here at MSU, bravely took on the challenge of attempting to standardize the transliteration of the eight different languages spoken by the artists who are the subject of this volume. He did an excellent job of editing the book's glossary. Kim Kauffman produced the elegant studio photographs for the book. The folks

at the University of Washington Press played a key role in bringing this project to fruition. I especially wish to thank Naomi Pascal, Associate Director and Editor-in-Chief of the Press, who oversaw the production of the book, and Pamela Bruton, who did a superb job of copyediting the text.

Finally, I would like to acknowledge my appreciation for the experiences shared with four Ethiopian colleagues who sadly have passed away recently: Fatuma Ibrahim Muhammed, Girma Kidane, Taye Tadesse, and Seyoum Wolde. This volume is dedicated to their memories.

Raymond A. Silverman

A Note on Orthography

This collection of essays utilizes terms from at least eight languages spoken in Ethiopia. A number of transliteration systems have been used by various scholars who have written on the cultures of Ethiopia, and no single standard for transliterating these languages currently exists. For the sake of clarity and ease of reading we have chosen to render the names of people and places and other terms without the use of diacritical marks. The only exception is the apostrophe, which is used to represent a glottal stop. We have attempted to transliterate Ethiopian terms so that the reader may pronounce them as accurately as possible; however, one should keep in mind that there are sounds in all of these languages that do not occur in English and that are difficult to reproduce using Latin script. Readers interested in a more accurate rendering of these terms may refer to the glossary found at the end of the book, which offers transliterations using the International Phonetic Alphabet.

Personal names have presented the greatest challenge because many Ethiopians have chosen to spell their own names in print or in everyday use in Latin script in ways that do not conform to a single transliteration system—for example, Taddese, Tadesse, and Taddesse; or Marcos, Marqos, and Markos. Where an individual has already used a preferred spelling, we have continued its use. Similarly, place names present a challenge because they have not been transliterated with any consistency. In most cases we have employed the most widely accepted spelling of such names.

Among many of Ethiopia's peoples, individuals have two names. The first is the given name, and the second is the name of the person's father.

Throughout the book, when referring to specific Ethiopians, the first name is used, not out of familiarity but because this is how people are addressed in Ethiopia. Similarly, the bibliography is organized using this same convention; Ethiopian authors are listed alphabetically using their first names.

ETHIOPIA
Traditions
of Creativity

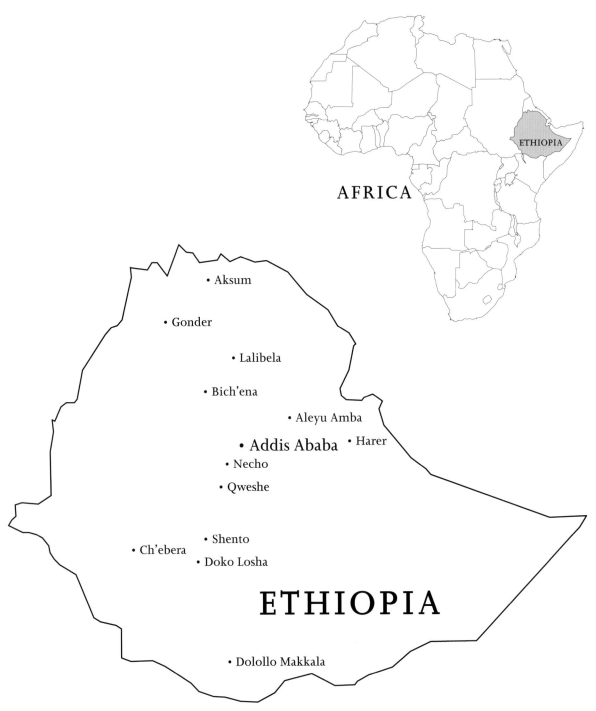

Ethiopia: Major sites mentioned in the text.

Introduction

Traditions of Creativity

Raymond A. Silverman

MOST PEOPLE TEND TO TAKE FOR GRANTED THOSE THINGS WITH which they are most familiar. The popular Ethiopian proverb "Gold in one's hand is like copper" admonishes us not to forget that there can be great beauty and value in the experiences of everyday life. Taking this aphorism to heart, this volume offers a celebration of traditions of creativity found in various parts of Ethiopia. They are traditions that in the eyes of Ethiopians are generally taken for granted and in the eyes of the rest of the world are generally ignored as too mundane to warrant much attention. *Ethiopia: Traditions of Creativity* focuses on the work and lives of a number of individuals who create objects—pottery, jewelry, paintings, basketry, woodwork, gourd containers, sorghum-stalk models, and textiles—that are central to the physical and spiritual well-being of the communities in which they live.

Ethiopia is one of the world's great crossroads where the peoples and cultures of Africa, the Middle East, and the Mediterranean have been meeting for thousands of years. One encounters a magnificent mosaic of culture, an ethnic and cultural diversity that has given rise to many unique and dynamic visual traditions. Yet, most books that have been written about Ethiopian art and material culture deal only with the paintings associated with the Ethiopian Orthodox Church.[1] It is a magnificent tradition stretching back to the advent of Christianity in Ethiopia in the fourth century—a tradition that still requires much more attention than it has received. But this is just one of countless creative traditions that one encounters in Ethiopia—traditions that are virtually unknown to the rest of the world. One of the principal goals of this volume is to introduce some of these traditions and perhaps contribute to a better

understanding and appreciation of their cultural significance. In a country with a population of sixty million people who are associated with thirty different ethnic groups and speak seventy different languages, there are virtually thousands of material traditions. Here we offer a glimpse of the richness and diversity of a few of them.

Another goal concerns developing a sense of who makes the wonderful objects that we associate with Ethiopia's material cultures. All too often the people who make the objects that are displayed in our museums are ignored and usually forgotten. Thousands of beautiful objects made by Ethiopians are found in museum and private collections around the world. Yet, with few exceptions, the identity of their creators is unknown. These objects are not signed, but this does not mean they must be anonymous.[2] The makers are unknown because the people who originally collected the objects were uninterested in recording the names of the people who made them.[3] Regrettably, the anonymity associated with the creative process now is erroneously perceived as a characteristic of most Ethiopian, as well as other African, societies.

The essays in this volume confront this issue. Each author has approached his or her analysis from a perspective that has been little used in studies of Ethiopian material culture and art: living artists are at the center of each essay. The authors attempt to offset the anonymity stereotype by focusing on the creator of objects as an individual. This is achieved primarily through biography and placing the individual in the context of the community in which she or he lives and works.

This book is the product of research undertaken in Ethiopia during the spring of 1993 for an exhibition organized by Michigan State University Museum. A number of small research teams, led by experts in various aspects of Ethiopian culture, documented the life and work of artists and artisans from different parts of Ethiopia who work in a range of media. The researchers are affiliated with different academic disciplines, including history, anthropology, sociology, and art history. One is an artist—a weaver. And they come from different countries—Ethiopia, Germany, Italy, Switzerland, the Netherlands, Great Britain, and the United States. In addition, each researcher was interested in learning specific things about the individuals with whom he or she worked; each asked different kinds of questions. As a result, the essays included

in this volume offer a fascinating mix of insights gleaned from engaging both object makers and the communities in which they live from a variety of perspectives.

Though the essays deal with individuals from different parts of Ethiopia, representing a number of cultures and working in a range of media, they share a number of common themes. These include (1) the challenge of interpreting other cultures, (2) occupational specialization, (3) the social status of artists and artisans, (4) how people acquire their special knowledge and skills, (5) creativity in Ethiopian culture, (6) the sharing or borrowing of material traditions, and finally (7) the problem of dealing with the ideas of tradition and change.

The Challenge of Understanding Other Cultures

One of the major issues that emerges from these essays concerns the preconceptions that we bring to our interpretations of other cultures. Here we are especially interested in how we deal with material culture, in particular, the values and attitudes that influence the ways in which we isolate art from artifact and differentiate artists from artisans.

A distinction is often made between the work of artists and artisans. Indeed, we received a good deal of criticism for not differentiating between the two and presenting the products of both artists and artisans in the same context in our exhibition. The three painters featured in the exhibition were viewed by these critics as artists, but the others—basket makers, silversmiths, potter, model maker, and woodcarvers—as artisans. We often heard questions like "How can you call this guy [Tolera] who makes the sorghum-stalk models and the lady [Tabita] who makes these pots 'artists'?" Some interesting value judgments were being expressed.

The concept of "art" is a recent introduction to Ethiopia even though objects of exceptional aesthetic quality have been produced in all Ethiopian societies for a long time. The reason that "art" has appeared in Ethiopia only recently is because prior to the present century there were no traditions that isolated specific things to serve *primarily* as objects of aesthetic contemplation.[4] This is a concept tied to a Western set of ideas and values. In this system art is associated with notions of creativity, uniqueness, and intellect. It is an *exclusive* category—only certain

objects are worthy of being deemed art. For instance, there are specific accepted media or idioms for *artistic* expression, in particular, painting and sculpture. Exceptions certainly exist, but, by and large, if the object is not a painting or a piece of sculpture, then it cannot be art. Other labels are used for aesthetic objects that do not meet these basic criteria: "craft," "handicraft," "artifact," and so on. These terms, in fact, are used by some of the contributors to this volume.

This is admittedly a simplification of a complex set of ideas, but it does underscore that we are grappling with a value system that is heavily grounded in a specifically Western cultural setting.[5] What happens when one is considering societies that do not produce paintings or sculpture? Do we assume they have no art? Do we assume that aesthetic expression and creativity do not exist in these societies? This is generally how the West has viewed much of Africa. Entire regions of Africa (specifically, the southern and eastern parts of the continent) are seen as having little, if any, art and, until recently, have been virtually ignored in books and exhibitions dealing with African art. The same holds true for Ethiopia. With the exception of contemporary academic art and a figurative-sculpture tradition associated with the Konso people of southern Ethiopia, the only formally recognized art that exists in the country are the paintings associated with the Ethiopian Orthodox Church. All other modes of aesthetic expression are regarded as handicraft.[6]

There is nothing wrong with categorizing objects. The problem concerns the values associated with the categories. Limiting our definition of art and being interested only in people who have art (according to this definition) prevent us from appreciating and understanding modes of creativity that fall outside these narrowly defined parameters. This is not a new problem; scholars of African art have been grappling with this for some time.[7] In Ethiopia the wealth of beautiful objects used in daily life requires confronting this problem. The need for a more comprehensive, a more inclusive category of art provided a major impetus for developing the specific framework for this book and the exhibition.

All of the essays in this volume deal with producing works of art of one sort or another—that is, production that involves aesthetic decisions being made by both the maker and the consumer of the object. But many of the traditions would not be classified as art by most modern-

day observers, nor would the people who participate in these traditions be considered artists. Abbink's work with Bogine and Gelta offers the most obvious example. Abbink observes that among the Me'en there are no artists; in fact, with the exception of blacksmiths, there are no individuals specializing in the production of specific types of objects. All men, as part of growing up in Me'en society, learn to work with various natural resources, like wood and gourds, to fabricate the things that they and their families need to survive. Abbink also notes that there are a number of criteria used in evaluating an object, such as its functionality (i.e., its ability to fulfill the utilitarian purpose for which it was created) and its history. This, however, does not mean that Bogine and Gelta do not make aesthetic choices while fabricating their wood and gourd containers, nor does it mean that the people who make and use such containers do not appreciate their aesthetic qualities. Though all men make wood and gourd containers, Abbink points out that some may be perceived as being particularly good at doing so. This type of community assessment can be associated with almost all the object makers appearing in this volume. Indeed, selecting artists based upon community consensus served as a basic strategy supporting our research for the exhibition and this book. Though the researchers were familiar with the communities in which they worked, in most cases they did not know a specific artist with whom they wanted to work. The first stage of research involved going into a community and talking to people about who they felt was the best potter, basket maker, jeweler, etc.

Though aesthetic decision making is not always a conscious act, it is something that all people do. Most people, however, have difficulty talking about the aesthetic choices that they make. How many times have we heard the expression "I can't tell you why I like it, I just *know* what I like." Whether performed consciously or intuitively, we all engage in a selective process involving attending to the nonutilitarian, formal qualities of an object.

One of the arenas in which these processes can be easily observed is a marketplace. Anyone sitting in a market anywhere in Ethiopia can observe women selling and buying pottery. Most customers pick up a pottery container, turn it over and over in their hands, tap it with their knuckles, look at it, and then set it down, only to pick up another and

repeat the process until they find a pot they wish to purchase. The rapping determines whether the pot is cracked, but the buyer also looks closely at each pot's proportions, surface decoration, and finish—aesthetic decisions are being made.

Another challenge confronting anyone who attempts to understand another culture concerns seeking an emic, or inside, perspective—attempting to understand a tradition on its own terms. A shortcoming of much of the scholarship that deals with Ethiopian material tradition is that it does not employ this critical approach.[8] Most scholars have chosen not to engage the people who produce and use the objects they study. Earlier, the observation was made that there are thousands of Ethiopian artifacts sitting in museums and private collections around the world. With few exceptions, these objects are mute; we know almost nothing about them because they were collected with little, if any, documentation. The only way one can even begin to grasp the functional and symbolic significance of an object is by experiencing the culture from which it emerged and by talking to the people who made and used it. Once again, the need for this kind of approach provided the impetus to develop an exhibition and book devoted to investigating both the artist and the products of his or her creativity.

I had many experiences while conducting research in Ethiopia that attest to the value of this approach. Here is a single example. Prior to working with artists and artisans in Ethiopia, I spent a good deal of time studying Ethiopian artifacts maintained in museums in Europe and the United States. I became quite familiar with the woodwork produced in the Gurage region of west-central Ethiopia. The wood objects I examined in museums included headrests and a variety of domestic utensils, and all had a deep brown patina. Those that carried an ethnic attribution were labeled "Gurage." I found them quite beautiful. When I began working in Ethiopia I saw similar objects in the souvenir shops of Addis Ababa. I also saw, in walking around the capital, especially in the Mercato (the large city market), similar objects that were crisply carved using a light-colored wood and painted with bright colors, usually pink and magenta. I *assumed* they were objects made for the tourist market. I found them a bit garish, not as refined as the *authentic* "Gurage" wood objects I had seen in the museums. In May 1993, I accompanied

Pankhurst and Worku to the Gurage region, where they were working with Menjiye, a woodcarver and member of a special (caste) group known as the Fuga, and we visited the market at Aftir. There in the market were hundreds of wood objects carved by the Fuga that were painted the same colors as the "tourist" pieces I had seen in Addis Ababa. I thought, "How strange—this market is far off the tourist circuit. Why would all these tourist pieces be for sale in a rural Gurage market?" Then the obvious occurred to me: these were not tourist pieces at all. This is what Gurage woodwork looks like when it is new.

Over the next few days, I visited a number of Gurage homes and observed Menjiye carving and painting combs and pottery stands, and my "revelation" was confirmed. I learned that the brown patina comes from use. Indeed, when we showed Menjiye some of the darkly patinated woodwork that we had been collecting, he remarked, "The black ones are old, while mine are not. It is not because of the nature of the wood but a question of age." All woodwork is hung on the interior walls of the Gurage house, cooking is done inside the house, and the house fills with smoke at least twice a day. Over a short period of time the porous wood absorbs the soot and oils from the cooking fire and develops a brown patina. My preconception, reinforced by my own aesthetic preferences, was thus overturned. I also learned that most of the wood objects used in Gurage homes are in fact made by the Fuga, and therefore the "Gurage" attribution that is usually given to the woodwork of this area needs to be modified to recognize the ethnic identity of the objects' creators, the Fuga. This information simply could not have been acquired without engaging the culture and people that produce the object. Why the woodwork looks the way it does and who actually makes these objects represent just two dimensions of a larger phenomenon, which we may refer to as "the life of the object."

We are used to looking at objects that are maintained in museums and that have been preserved in a particular state; their forms remain static, unchanging. The objects that most of the artists featured in this book produce are things that are meant to be used. In the process of being used, an object's form or appearance changes. These wood utensils are just a single example. A number of the essays in this book include references to other traditions where this occurs. The fine baskets that

Amina weaves are destined for display on the walls of Harari homes. When new, a basket's colors are bright and vibrant, but over time the colors fade and become muted. The surfaces of the gourd containers that Gelta produces darken over time and acquire a deep orange-brown patina. Elema's woven milk containers develop a smooth, dark surface on the inside, as well as a distinctive odor (the combination of smoke and milk), as a result of use. The appearance of Tabita's pots continues to change after they leave her hands. She pointed out that the specific seasoning technique used by the owner of a pot changes the color and often the pattern on a pot's surface. So it is with virtually all objects. But it is not only the physical form of an object that changes as a result of use; its symbolic value can also change over time. Often there is nothing inherent in the object that reveals its symbolic import. Abbink points out that the only way this information is acquired is by talking to the people who own and use the object. He refers to a stool that he collected that was regarded as a particularly "good" piece because it had been owned by Banja, the "rain-chief" of the southern Me'en, a very important figure in the area.[9]

An interesting variation on this theme involves the production of traditional painting. Some artists, like Adamu and Jembere, who learned to paint within the setting of the Ethiopian Orthodox Church, produce paintings for both churches and secular markets (e.g., museums and tourists), but there is nothing inherently different in the paintings destined for these two markets. Yet some would argue that the paintings destined for churches are more *authentic* than those destined for tourist shops. The notion of "authenticity" is another preconception that has impeded attempts to understand Ethiopian material culture.[10] Often things that are not regarded as authentic are ignored by those who seek an understanding of Ethiopian culture. The fact is, anything and everything that is made and/or used by a people is part of their culture and is therefore *authentic*. The essays that deal with the artists whose products are sought by foreigners touch upon this problem, which stems from attitudes about culture change, especially change associated with the assimilation and transformation of Western ideas and objects—an important subject that I will address a bit later.

Specialization: Who Makes These Things?

Throughout Ethiopia the creative process is limited to specific groups; few traditions are practiced by everyone. The two most significant factors relating to specialization are gender and ethnicity. In most societies a clear distinction exists between the activities of women and men. In fact, one's social identity is often based, in part, on the things that one produces. For instance, weaving baskets is a critical part of being a woman in Borana and Harari society. The importance of basket making in the life of a woman in Harer may perhaps best be characterized in Amina's own words. When asked if there was some point in a woman's life when she would stop making baskets, she replied: "Unless her eyes weaken she does not stop making baskets until she dies."

In Ethiopian communities, with the exception of those in the eastern part of the country, women make clay pots. They also spin cotton to produce thread and are often, but not always, responsible for making baskets. Men usually weave textiles, work metals, carve wood, and engage in leatherworking. Men paint murals and book illustrations. Among the farmers of the highlands, men are the architects and builders, but among the herding peoples of the south, like the Borana, women own and are responsible for building homes. There are of course exceptions to all of the "rules" of gender specialization, but for the most part they are maintained throughout much of Ethiopia.

Specialization is not so much related to the production of specific types of objects as it is to employing specific technologies. In fact, one of the themes that emerges from a number of the essays is that many objects require the involvement of both men and women. Such complementary roles reflect the interdependence of man and woman and the importance of the most basic social unit, husband and wife. For instance, in Doko Losha men weave, but it is the women, usually the wives and daughters of the weaver, who procure the raw cotton and spin the weft threads. If not for women, there would be no cloth.

The Borana use basically two types of containers: those woven from fiber, which are made by women, and those either carved from wood or formed from animal skin, which are made by men. There are, however, specific types of wood containers, like the *buttee* and *soroora*, that are

carved by men but have a woven fiber lip made by a woman, often the wife of the carver. Bassi points out that these composite containers echo a recurrent theme in Borana society: the differentiated but complementary roles of man and woman.

In Wolayta potter communities, women collect the clay and model the pots, but husbands and sons play an important role in the firing and marketing of pottery. Tsehai notes that all children, whether male or female, learn to make pots. Tabita has given birth to six boys, and all know how to make pots. This makes sense when one understands that it is the mother who is primarily responsible for raising children and that, because pottery making is part of her daily routine, it is not surprising that all young children learn to make pots. When boys become old enough to join their fathers in farming and hunting activities, they cease "playing" with clay. However, husbands or sons will often assist in the firing of pots. Involved in removing the pots once the firing is finished, they often take the pottery to market, especially if the pots are large. For instance, Busho, Tabita's husband, carries the large *gan* (beer-brewing pots) that she makes to market.

Among the Fuga, men and women work with bamboo to produce a variety of baskets and large mats. Men cut wood from trees and carve various domestic utensils and furniture, but women often become involved in finishing the objects. While we were working with Menjiye, his wife, Anchewat, helped him prepare the pigments he used to paint the combs and pottery stands he was making. It is common in the markets of the Gurage to see Fuga women applying fine incised designs to wood objects.

Specialization along ethnic lines is another issue some of the essays touch upon. With the exception of painting, and perhaps sorghum-stalk model making, all of the material traditions appearing in this volume are found throughout Ethiopia. Nevertheless, since the turn of the century, various ethnic groups have become associated with specific material traditions. The last quarter of the nineteenth century saw the expansion of the Amhara-ruled empire of Abyssinia. By the end of the century much of the territory that today is included within the borders of Ethiopia was conquered and brought under the control of Emperor Menilek II. He was aware of the special skills possessed by many of the

peoples he conquered, and he ordered large numbers of these specialists to the empire's newly created capital, Addis Ababa, where they played a critical role in producing the clothes, domestic utensils, furniture, tools, and weapons for the city. Today, "Dorze" is a term synonymous with weaving throughout much of Ethiopia, especially in Addis Ababa. Though it is the name of a single group of people belonging to a larger culture cluster known as Gamo, their name is used as a general label for any weaver coming from the Gamo highlands. The Gamo highlands of southern Ethiopia were conquered by Menilek II in 1898, and a large number of Gamo weavers were subsequently brought to Addis Ababa to produce textiles for the capital's growing population. Many Gamo weavers continue to migrate to Addis Ababa, where they become full-time weavers. Arba, for instance, spent a good deal of his life in Addis Ababa before returning to Doko Losha, and four of his sons still live in Addis Ababa, where two are professional weavers. A similar situation exists for the potters of Wolayta. Though pottery is produced virtually everywhere in Ethiopia, the potters of Wolayta are known for their well-made pots. Menilek II conquered Wolayta at the end of the nineteenth century and relocated several villages of potters from Wolayta to an area close to his capital. This community of Wolayta potters still exists and continues to produce pots for the markets of Addis Ababa. It is interesting that both the weavers and the potters, in addition to producing the wares popular in their homelands, learned to make the textiles and pottery preferred by the Amhara ruling elite.

The Social Status of Artists and Artisans

The social status of the object maker is an issue touched upon in most of the essays. With the exception of blacksmiths, and perhaps tanners, the status of the people who produce the material objects that a society uses varies from culture to culture. Tabita and Menjiye belong to special groups and maintain a special status within the societies in which they live. The term most often used to describe these groups is "caste." Among the Wolayta, potters like Tabita belong to a group commonly referred to as *chinasha*, a pejorative term used by the dominant group, who are farmers. Tabita indicated that she and other members of this special group prefer to call themselves *hilansha*—simply "people who

make things." In the Gurage area people like Menjiye belong to a group known as the Fuga.

Caste groups are found throughout Ethiopia and are associated with the production of certain types of objects. There is no single social profile that describes all caste groups, but among most of Ethiopia's peoples, potters, leatherworkers, and especially blacksmiths usually belong to a social group (sometimes a distinct ethnic group) that lives apart from the rest of society.

One of the common characteristics of caste groups is that they are perceived by the rest of society as wielding special supernatural powers and esoteric knowledge. This power and knowledge allow them to "create" useful things, for instance, to transform earth (clay) into pots, or rocks (iron ore) into tools and weapons. These powers are perceived as dangerous, potential sources of illness and even death. As a result, the creators of objects, especially those who manipulate the primeval elements of earth and fire, are isolated from the rest of society. They hold an ambivalent status with the peoples among whom they live: they are respected for their knowledge and the important contributions they make to society, but they are also feared and despised. They often live in separate communities and are not allowed to marry with the dominant group, who are usually farmers.

At times members of specific castes will perform other specialized tasks. They are often ritual experts who play critical roles in circumcision and funeral rites. Among the Wolayta, *hilansha* men perform as singers at weddings and funerals. Butcher-tanners in Doko society produce a special type of animal-skin cape, the insignia of leadership for a *halaka* (an elected leader in Doko society); they are also musical performers at important social events, such as the installation of a *halaka*. In the Gurage area, the Fuga are ritual specialists who play a vital role in what Pankhurst and Worku refer to as "social reproduction"—the transformation of children, both boys and girls, into adults.

Because of their lowly status they have traditionally been denied many of the privileges afforded the majority, "commoner" population. For instance, formerly they were not allowed to own land and had to either rent the land on which they lived and farmed or rely heavily on patronage from the landowning farmers. However, after the 1974 Revolution,

land reforms were imposed by the Marxist regime known as the Derg that redistributed property taken from the ruling elite. People affiliated with caste groups were given their own land and thus were among the few to benefit from the otherwise oppressive and destructive strategies of the Derg. In 1993 both Tabita and Menjiye expressed concern that policies introduced by the government that had recently overthrown the Derg might result in the loss of their land: property was supposed to be given back to those from whom it had been taken by the Derg. It is not surprising that those who belong to caste groups are often among the poorest residents of a community.

Once again, this brief consideration of caste is a simplification of a complex social phenomenon found not only in Ethiopia but throughout much of Africa and in many other parts of the world. In fact, one could argue that it is a universal social phenomenon, and it raises some interesting questions concerning how humankind, in general, responds to creativity and those who create.

Among the Amhara of central Ethiopia, virtually all manual labor not associated with tilling the soil (farming) is looked down upon. But this stigma does not exist in all societies. We learn from Zelinsky-Cartledge and Cartledge that among the Doko, weaving is not a caste-related occupation. Here we find many farmers who weave in their spare time as a means of generating extra income for the family. There is no stigma attached to weaving in the Doko-Gamo highlands; however, a weaver's status changes when he moves to Addis Ababa. Upon arriving in the capital and becoming a full-time specialist, the Doko weaver assumes the lower status generally reserved for artisans—a reflection of the cultural values of the ruling group, the Amhara, who, as mentioned earlier, founded the city in the late nineteenth century.

The historical evidence is inconclusive but suggests that there might be a differential status afforded various types of metal specialists in highland Ethiopia. Blacksmiths (those who work iron) represent the quintessential caste group throughout the highlands. But precious-metal specialists (those who work gold and silver), like Gezahegn and Abib, seem to be financially better-off. This may be due to the intrinsic economic value of the metals they use and the development of various means for (literally) extracting their fees from their commissions and the fact

that many of their clients come from the upper echelons of society.

Except in cases where it is practiced by a caste group like the Fuga, basket making seldom seems to have a stigma attached to it. In cultures like that of the Harari and Borana, learning to weave baskets is a requisite for all girls. Baskets serve vital utilitarian and symbolic functions in their cultures and it is therefore important that all women know how to make these woven containers. Abbink informs us that among the Me'en, perhaps the most egalitarian society discussed in this volume, all men, as part of growing up, acquire the knowledge to work in virtually all media, including wood, gourd, leather, animal horn, metal, and vegetal fiber (i.e., basketry). Clay pots are the only objects made by women. There are no real craftsmen, no "caste" of artisans, and the only artifact specialists are blacksmiths. Abbink asserts that Me'en material culture is a "democratic art," known by all.

Woodworking is a specialty that may or may not be associated with lower social status. The Fuga are often associated with woodworking, but Pankhurst and Worku point out that this occupation does not define their social status, for there are Gurage, among whom they live, who also carve wood objects. Indeed, all of the material technologies employed by the Fuga may be performed without stigma by Gurage. Pankhurst and Worku note that other factors, such as a special argot and religious beliefs, define the Fuga as a special (caste) group, and they tentatively conclude that the Fuga may in fact form a distinct ethnic group.

Compared to the other artists featured in this volume, Zerihun Yetmgeta is exceptional because he occupies a high status in the community in which he lives. He is a product of a new twentieth-century tradition, an academy-trained artist who maintains strong ties with his past while functioning in a global arena. He has an international reputation, his paintings sell for thousands of dollars, and he is regarded as one of Ethiopia's most distinguished citizens.

Learning to Make Things

With the exception of Zerihun, all of the artists featured in this book acquired their specialized knowledge either through formal apprenticeships or by observing and imitating the actions of family members and friends. In many cases the specialized knowledge needed to make

certain types of objects was acquired simply as part of growing up in a specific community and culture. Abbink, Ahmed, Bassi, and Tsehai inform us that the artists they worked with all began learning the technical processes associated with their métiers while very young, for in their communities all children were expected to learn to produce specific types of objects. Bogine and Gelta, like all men in Me'en society, learned to carve wood and gourds, weave baskets, and work with leather. Amina, like all women in Harari society, learned as a young girl to weave an array of baskets. The same is true of Elema. And Tabita, growing up in a potters' community, learned to make a variety of pots. In these contexts, learning to make these things is a cultural "given," part of what one needs to know to be a productive member of the community. The seamless relationship between the acquisition of specialized knowledge and the role it plays in everyday life is poignantly summarized in Tabita's terse reply to a question Tsehai asked her about productivity: "Work *is* knowledge, is it not?"

The informality and ubiquity of this process were demonstrated while working with a family of potters in the Wolayta community of Gurumu Wayde. One day, while observing Kumpe Shubamo and her eldest daughter modeling pots in front of their house, we heard a young child crying inside the house. Kumpe stopped working and brought the child, her three-year-old son Kule, outside and put a small mound of clay in front of him. Kule proceeded to begin pulling up the walls of a pot. His mother occasionally left her work and turned her attention to his little pot, making "corrections" and helping him as he played with the clay. This is how potters learn to make pots in Wolayta. Simple observation, coupled with imitation and practice, is a common process for learning to make certain types of objects. Abbink points out that among the Me'en, a similar learning environment exists, in which children learn to fabricate all that is necessary for living by imitation and trial and error. Indeed, the same sort of process is echoed in the biographies of several of the other artists we worked with in 1993.

In many cases, the specialized knowledge associated with creating objects is passed from generation to generation, from mother to daughter, from father to son, and occasionally from mother to son. Amina learned from her mother, as did Elema. When Bassi asked Elema how

she learned to make the beautiful basketry containers used for storing milk in Borana communities, she answered, "I learned to make milk containers from my mother and friends and I'm teaching my daughters—it's the same thing as going to school." Menjiye learned to carve from his father, and at least one of his sons, Yerochi, is carving. Abib learned to produce silver jewelry from his father, and he has begun to teach his young son. Tabita learned from her mother, and she has taught her six sons (she has no daughters) to make pots (as mentioned in the discussion of gender specialization, this is not uncommon in Wolayta potters' communities). Ilto learned to weave from his father, but Arba did not. It was not until later in life, when he was in his early forties, that Arba learned to weave from a neighbor, but Arba has taught four of his five sons to weave.

A few other artists did not acquire their knowledge from relatives but served apprenticeships with a "master" artist or artisan. Both the traditional painters, Adamu and Jembere, as part of their church education worked with mentors who were accomplished painters. They began by assisting their teachers in the most basic tasks, and then, as they learned the formal and iconographic canons of Orthodox Church painting, they were given more and more responsibility and finally began receiving their own commissions. Gezahegn acquired his knowledge of the various technologies used in fabricating gold and silver objects in the workshop of Haile Abraham in Addis Ababa, where he spent nine years as first an apprentice and then a wage-earning jeweler. He recalled that at the beginning of his apprenticeship he carried out the most mundane tasks, such as fetching tea for the workers and customers and sweeping the shop, but then Haile set him on a graduated course of learning how to produce a wide variety of jewelry.

Zerihun received much of his formal education as an artist at the School of Fine Arts in Addis Ababa, which is modeled after a European school of art. It is a modern, twentieth-century institution that offers a specific curriculum to train "artists," that is, individuals who produce works that are first and foremost objects of aesthetic contemplation. Zerihun, in addition to being one of Ethiopia's leading contemporary artists, also teaches at the School of Fine Arts.

The Creative Process and the Creative Person

Ethiopian material culture and the processes used in creating it are often characterized as being very conservative, slow to change. The reason frequently given for this is that social and cultural norms often leave little room for creativity and innovation in Ethiopian cultures. Relative to modern Western society, this is true. But this is an overstated and overemphasized observation that can lead one to fail to seek and recognize creative genius in Ethiopian material traditions. It is commonly assumed that the pots, baskets, and wood objects made today are like those made fifty or a hundred years ago. Again, this may be a valid assumption, but changes have occurred in these traditions that have been the result of an exceptional person introducing a new idea or treatment of a particular type of object. There are individuals who are born with or develop an exceptional drive to make things, to create, and perhaps to think about what they are creating in ways that lead to innovation.

As mentioned earlier, the model used for identifying the artists featured in this volume is based on the premise that there are in all communities object makers who excel at what they do, and may even be perceived as exceptional. In almost every case, the artists that we chose to work with possessed a special interest, at times even a passion, for their respective métier. Adamu offered the strongest evidence of such an outlook. After having invested over twenty years in study to become a priest in the Ethiopian Orthodox Church, he chose to leave the clergy and devote all of his time to painting. His rationale for doing so was crystal clear: "I have an interest and love for painting. I, in fact, dream about it most of the time."

A number of the individuals with whom we worked were quite self-conscious about their interest in their métier and their ability to be creative. In talking about how he develops his compositions, Jembere indicated, "I know about historical events and paint them using my imagination." The first time I visited Zerihun's studio I noticed a Miles Davis record album sitting among his paints and brushes. I soon learned that Zerihun loves listening to jazz music. Biasio points out in her essay that one of the key characteristics of Zerihun's paintings reveals an affinity with this music. Like a jazz musician, he often improvises around a cen-

tral theme, such as history, the strength of the church, and the unity of Africa. Zerihun expresses his thoughts about his experiences in his work, but as he freely confessed, "I always transform things, things I see, things I hear, and things I feel." Though Tolera probably does not think of himself as creative, his sorghum-stalk models reveal considerable ingenuity. The deftness with which he interprets photographic images of buildings like the Leaning Tower of Pisa to construct marvelous three-dimensional sorghum-stalk models is quite remarkable. Two traditional painters, Marcos and Adamu, when asked about painting the same theme over and over again, emphasized that they treat each composition as a new problem. They do not copy previous paintings but call upon their knowledge of the subject matter (iconography) and the medium (oil pigments) when interpreting a given theme. This is easily seen in the comparisons of Adamu's renderings of *Saint George Slaying the Dragon* (figs. 7.3 and 7.5, pl. 12) and Marcos's depictions of *The Battle of Adwa* (figs. 8.8 and 8.9).

Needless to say, the attitudes of these contemporary object makers about creativity, about being able to use one's imagination, may be a product, at least in part, of having been exposed to Western ideas about art and artists. But there is no doubt that there have always been exceptional individuals living in communities at particular times who have been able to exercise creative genius and give new expression to their own ideas as well as those of the societies in which they live.

Sharing Traditions

A few of the essays consider the external sources for the ideas that have driven the evolution of certain material traditions. Those dealing with the traditional painters (Adamu, Jembere, and Marcos) and the contemporary academic artist (Zerihun) deal with this issue at some length. This is because the subject has received much attention in previous scholarship, in which one of the dominant themes has been the introduction and subsequent assimilation of foreign models. These studies offer a historical scheme divided into two periods. The first begins with the advent of Christianity in Ethiopia in the fourth century and lasts to the end of the fifteenth century. During this thousand-year period, the primary source of artistic inspiration for the painters of the Ethiopian

Orthodox Church came from the Byzantine world. The inspiration for paintings of the second period, which dates from the sixteenth century to the present, is Western Europe. Many important ideas did come from outside Ethiopia, but this point perhaps has been overstated and overemphasized. Though a dynamic process of integration and transformation is acknowledged as having played an important role in the evolution of Ethiopian painting, it has not received much attention.

There is a great deal of evidence in other media that Ethiopia has been and continues to be a great crossroads of cultural tradition. The essay dealing with Gezahegn and Abib refers to the presence of Greek and Armenian silver- and goldsmiths in Ethiopia in the eighteenth and nineteenth centuries, who were probably responsible for introducing gilt filigree-work. And the silver jewelry of Abib and the Muslim jewelers of eastern Ethiopia reveals close affinities with the work of their counterparts on the Arabian Peninsula. Menjiye, in his discussions with Pankhurst and Worku, mentioned the introduction of certain types of objects, such as beds, large chairs, and cupboards, by the Italians. And Tolera, in response to recent commissions from European and American visitors to Addis Ababa, is now making sorghum-stalk models of Western monuments, such as the Leaning Tower of Pisa, the Palazzo Vecchio, the White House, and the Jefferson Memorial. The essays that deal with these trends, though only scratching the surface, begin to explore the reasons why and the dynamics of how these foreign ideas were integrated and transformed into Ethiopian tradition.

Very little attention has been given to the sharing of ideas on the local level. This is a subject that is more difficult to deal with, for it demands an even greater understanding of society and culture. Abbink is the only author to refer to this area of inquiry. In his comments about whether one can delineate a Me'en "style" he observes that "there are individuals from all ethnic groups who 'cross the boundary' and learn from neighbors and assimilate techniques, decorative patterns, or object types." He notes that this phenomenon would be a fascinating arena for study and he asks the familiar question "How, why, and by whom are specific artifacts 'borrowed' from other people?"

We seldom learn about traditions that have been introduced but have failed to take root. If we seek a better understanding of the process of

assimilation, then it is important to study these "failures." A very good example is offered in Tabita's recollections of the introduction of the potter's wheel to Shento in 1976. One would assume that this technology would have been quickly accepted, because it offers a more efficient means of producing pots. But today, no one in Shento is using the potter's wheel; women are still creating their pots solely by hand. Tsehai offers a fascinating recounting of this episode. The reason for the failure had nothing to do with the technology but pertained to the specific social and political context in which the potter's wheel was introduced.

Though we cannot at this point offer much in the way of insight into the nature of the process, we can suggest that the marketplace is perhaps the single most important setting for the exchange of information, the sharing of ideas and tradition. Many of the essays include descriptions of the markets and references to the importance that they have for the artist. The market at Aleyu Amba brings together the peoples of highland and lowland, the market in Harer is a meeting place for rural and urban peoples, and the markets of the Borana region bring together farmers and herders. It is in markets like these that the object maker becomes aware of the tastes and the demands of his or her customers. It also is where new inspiration is found in the ideas and things of other peoples and places.

Tradition, Innovation, and Change

A final theme, which takes us back to some of the issues considered at the outset, is the notion of change. There is always tension between things of the past and that which is new. The essay that considers the life and work of Jembere and Marcos includes a brief discussion of the problems this has caused for the interpretation of traditional painting in Ethiopia. Scholarship dealing with the topic has divided traditional painting into two distinct units, one historical, the other modern, and as a result they are often dealt with as separate phenomena. In fact they are not, at least not from an Ethiopian perspective. We are again faced with a distortion originating from the use of a Western idea, in this case the notion of tradition, to interpret Ethiopian expressive culture. A solution to the problem is to accept the fact that "traditional" is an ambiguous label, because traditions are fluid; they are constantly changing.

The two previous sections dealt with various sources for change. The changes that drive tradition can come from the creative spirit of individuals or from ideas borrowed from other people. But it is important to emphasize that all of the artists we worked with are well aware that what they are doing today is firmly grounded in the traditions of their ancestors—and they all have a great respect for the past. This reverence is very nicely articulated in a comment made by Bogine: "The things I make are like those that were made in the past. Everybody does it like this. This is Me'en work, Me'en style." This same view is echoed in Bassi's essay, in which he explains that the Borana have a term, *aadaa*, that has to do with the notion of a norm, a custom, or traditions—a sort of "cultural heritage." It can be used in many contexts; in all of them it alludes to something that is part of the heritage of a community, something that is transmitted from generation to generation. It is significant that the concept of *aadaa* does not exclude change. The Borana, in fact, distinguish it from the concept of *seera*, a term having a meaning associated with the idea of strictly maintained rules or "laws." Biasio points out in her analysis of Zerihun's work that despite the artist's "modern" outlook, much of what Zerihun does is grounded in Ethiopian tradition. The studio he recently built for himself is modeled after the circular Ethiopian Orthodox church. Indeed, Zerihun strongly believes that "Ethiopian and other African traditions should not be forgotten," and his paintings offer testimony to his convictions. One of the central themes in Zerihun's paintings is *tradition*, and we see, for example, not only *traditional* motifs but entire traditional idioms, like the magic scroll, fully integrated into his "bamboo-strip" paintings.[11]

Existing side by side with revered traditions of the past are new traditions. Most of the essays offer evidence of changes that have occurred in existing traditions and in a few cases describe the invention of new traditions. The checkerboard red and blue cloth called *fota* that Arba and his son Malako weave apparently is a relatively recent innovation said to have originated in the Gamo highlands roughly twenty years ago. It is woven on the same loom used to produce "more traditional" cloths like the *net'ala* and *gabi*, but the pattern, colors, and source of thread (factory-made) are all new. Mention has already been made of the introduction of new furniture designs in the Gurage area by Italian carpenters

during the Italian Occupation. More recently, Fuga carvers have been making a new type of coffeepot stand (they "traditionally" are made from *enset* fiber), and a Fuga carver named Gebre proudly showed Pankhurst and Worku a new type of oil lamp stand that he had created. Yet, no matter what the new creation, Menjiye and Gebre continue to use the tools and techniques for working wood, as well as the decorative design vocabulary, that they learned from their fathers.

The advent of academic painting in Ethiopia in the twentieth century has given rise to a major change in an ancient tradition. Painting used to be exclusively the domain of men, but there is now a female presence in the artistic community of Addis Ababa. Biasio mentions in her essay that a number of women artists, such as Desta Hagos, have attended the School of Fine Arts in Addis Ababa and are now actively pursuing careers as exhibiting artists. We also learned while talking to Adamu that he has been working with one of his daughters, Weyineshet, and that she is very keen on becoming a painter like her father.

The sorghum-stalk model tradition that Tolera is associated with is an excellent example of a totally new and unique tradition. Sobania's research revealed that it originated in the late 1950s or early 1960s with a couple of boys who were playing with discarded sorghum stalks. The boys began making toy waterwheels and soon were modeling toy trucks, cars, and airplanes. These ingenious models soon captured the interest of visitors to Ethiopia, and a market was created for not only sorghum-stalk models of toy vehicles but churches and, recently, famous European and American buildings.

Conclusion

This brief introduction cannot do justice to the variety and depth of ideas that are considered in the essays presented in this volume. It is important to reiterate that this collection of essays is offered as an initial foray into an exciting and extremely important dimension of Ethiopian cultural studies. Some essays are the first scholarly interpretation of a previously undocumented tradition, and it is hoped that future studies will build on these contributions. Though attempting to understand contemporary tradition is no mean task, and is a justifiable end in itself, this line of inquiry should be seen as the first stage of the much

more challenging task of reconstructing material-culture history. Pursuing such a course of inquiry would certainly yield important insights into the social and cultural history of Ethiopia's peoples.

Perhaps the most important message that this book carries concerns the importance of broadening one's gaze when considering the material or aesthetic traditions of other people. If nothing else, we hope that these essays engender an appreciation for even the most common of objects, for there is beauty and value in all things that people create. If this is accomplished, then perhaps the gold in one's hand will never turn to copper.

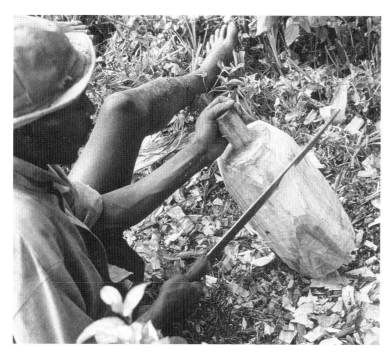

Fig. 2.1 Bogine Shala using a machete to rough out a *gongul*.

Fig. 2.2 Gelta Foroshowa selecting a gourd for carving.

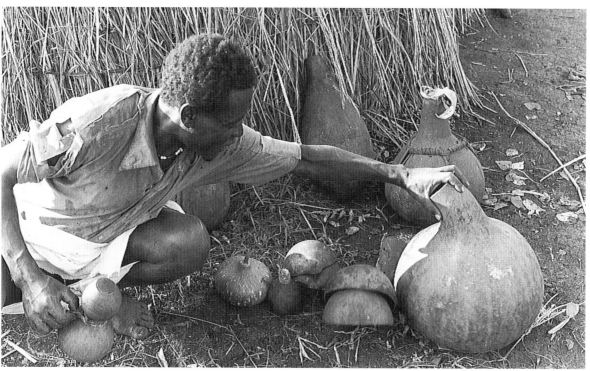

Artifacts as "Daily Art" in Me'en Culture

The Life and Work of Bogine Shala and Gelta Foroshowa

Jon Abbink

Introduction

Does every human society have "art," artistry, or at least artisans? In this essay about the Me'en people of southwestern Ethiopia, I will challenge some received ideas about "tribal" arts and crafts and thus provide a kind of counterpoint to many of the other traditions described in this volume.

When I was working with Bogine Shala and Gelta Foroshowa (figs. 2.1–2.2), two Me'en artifact producers, several questions presented themselves in view of the comparatively simple material culture which they, as average Me'en persons, produced and used: (1) Do the Me'en have an "art" tradition? (2) Do they apply ideals and conceptions of "beauty" to the material objects they possess and use? (3) Are those material objects in themselves—be they household utensils, tools, or personal decorative items—carriers of "meaning"? In other words, is their world of artifacts a domain of symbolic culture, of the cultural ascription of value? I pondered these questions while I was in the field conducting research on the artifacts and their wider significance in Me'en culture. It seemed

I wish to acknowledge with deep gratitude the help and openness of Bogine Shala and Gelta Foroshowa, the main subjects of research, as well as the invaluable practical assistance and friendship of Woliyyu Adem and Gontio Worku in Ch'ebera village. I also thank my friends Berhanu Worku, Arguatchew Teferra, Taddese Yayye, and Basagala Galtach. I dedicate this essay to the memory of Mengesha Kabtimer, a man who is sorely missed: *men-de-buyto, men-de-barit, Tuma kayn.*

to me that the Me'en, a group of predominantly shifting cultivators living in a remote, hilly bushland area, did not appear to have an elaborate material culture or any acknowledged experts or artisans known all across their land. Neither did they have spectacular pieces of figurative or decorative art (masks, carved images) like we find in West or Central Africa.

We know that people in Africa or elsewhere may not adhere to the same definitions of "art" and "beauty": as a matter of fact, these notions are tied up first and foremost with our own cultural history and our "high" literate arts, which are often detached from everyday life (see Gell 1992: 40–41). The concept of "the arts"—as denoting a class of objects or activities which invite "contemplation" from the viewer—is itself a cultural category (cf. Maquet 1979:14). Ethnologists and specialists in "tribal" and traditional arts have long emphasized that we should look at the entire sociocultural and historical context of material culture traditions. The production, distribution, and use of artifacts have various functional and social aspects and often cannot be considered in isolation, nor should they be measured with our, external, criteria of artistic or aesthetic quality.

But what about things like aesthetic feeling, affect, or artistry? For example, don't objects in societies which are "poor in art forms" have any minimal underlying notions of good form, extraordinary skill, or pleasant visual/aesthetic effect? And aren't some persons recognized as being more capable or skillful than others in producing "good objects" (see DeCarbo 1977: 28–29, 169–70)? Or is an artifact perhaps invested with meaning mainly because of its character acquired over time, its background, the history of its production and circulation (however mundane and common this object may be)?

During research on the relatively simple and nonelaborate material culture of the Me'en, I tried to answer these questions through observation and via interviews with several artifact producers, among them Bogine Shala and Gelta Foroshowa. What they told me and showed me has provided many of the answers presented here. Bogine and Gelta are two typical Me'en men in their forties, married and with children in their teens. Bogine is a member of the Koya lineage of the Gelit clan. Gelta is a member of the Afala clan and a son of a famous (now deceased)

spirit medium. They live in separate homesteads, some two hours' walk from the small, mixed Amhara-Me'en market village of Ch'ebera in the Me'en highlands. Their houses are modest, one-room dwellings made of wood and straw. Some of their fields and gardens (for maize and cabbage) are around their houses and are tended by their wives. Their other cultivation sites (for sorghum and t'ef) lie at some distance, in lower areas. Gelta recently moved his home from the lowland area to his present location because he missed his relatives and "could not stand the heat."

Both men are capable of producing various objects such as gourd containers and decorative items and can work in wood and do basketry. They are "average" men: I could have selected many other Me'en men in their stead. Significantly, Bogine and Gelta describe themselves, *not* as "craftsmen" or "artists," but simply as "cultivators," like virtually all Me'en do. They make hardly any extra income from their craftwork.

Partly on the basis of my experience with these two artifact producers (and, over the past few years, with many others as well), I will develop my discussion of their work and of Me'en artifacts in general from the following assumptions: (1) The term "art" is difficult to handle when considering the artifact traditions of non-Western, preliterate subsistence societies like that of the Me'en. "Art" is often encompassed by "material culture" and should first be considered as technical "artifact production and use," not as an ideal of detached beauty in and for itself. (2) Artifact production and use is a *social process* embedded in the exigencies of daily life and interpersonal relations. (3) Artifacts—even if appearing prosaic or mundane or "only functional-utilitarian"—always have a tacit dimension of visual aesthetic, or of what I would call aptness of form, which emerges out of their grounding in a sociocultural context.

Thus, an ethnological point of view on the matter of the "value" of Me'en artifacts would emphasize that they should be judged on the basis of (1) their sociocultural role in a society in which they gain their meaning and aesthetic value for the *users* and (2) the context of the *relation between available technical means and materials and personal effort and intention*. The simplicity of technical means in working the basic material does not imply that the crafting of artifacts is easy. I am always reminded of Amborn's remark (1990: 53) about his experiences among the Konso

and Burji blacksmith craftsmen. He admits that although he was educated as an engineer, he did not succeed in producing even one acceptable iron object with the "simple" local means available to him!

Viewed in this light, even objects like a wood stool, a knife, a gourd container, or a personal drinking cup can not only appear functionally efficient and aptly formed but also attain a dimension of beauty if we think of "beauty" as the radiance of something *authentic*, true or real, or if we speak "from the inside" of the culture from which the objects emerge, that is, if we know and feel something of the rich context of use of the objects and their sometimes quite individual histories. The primary point I wish to make is that the category of "art" should be broadened into one of technical "artifact production": the making of any object by humans for "aesthetic" and/or "utilitarian" purposes (see Gell 1992: 43). "Art" traditions are only one possible elaboration of this general process of applying mind to matter, or, in other words, of transforming nature into culture.

The Me'en People

To appreciate and understand Me'en material culture in general, and Bogine's and Gelta's work in particular, some background knowledge about the people is helpful. The Me'en are a rural population of about 50,000 people, divided into two branches: the Bodi (ca. 3,500) are agro-pastoralists living with their cattle herds in the savanna plains east of the Omo River, and the Tishana (ca. 46,000) are mostly shifting cultivators in highland areas (fig. 2.3). Both groups descend from a common stock, but the Tishana have incorporated a large number of people from neighboring ethnic groups (Dizi, Bench) (see Abbink 1992a). They also keep cattle, but in much smaller numbers than the Bodi. The Tishana and the Bodi have a fairly dispersed and mobile lifestyle, living in family compounds rather than in villages. Every two to three years at least, they rotate fields and places of residence. Politically, they are partly integrated into Ethiopian political structures like the *qebele* peasant associations, and in early 1993 they formed the ethnically based Me'en Organization. But they also maintain their own traditional leaders (elders, spirit mediums, and ritual leaders called *komorut*). They have a rather egalitarian social structure, with few differences in power or in

Fig. 2.3 View of Tishana Me'en countryside.

wealth between adults. Elders and *komoruts* enjoy respect and normative authority, but they have no executive power: they are not chiefs. It is important to keep in mind that the Me'en ancestors were a typical East African pastoral (herding) population, among whom independence and equality were always highly valued (see Abbink 1990). In addition, we know that such pastoral peoples always have a relatively simple material culture, with a limited range of artifacts (see Von Gagern et al. 1974: 38–39), compared to sedentary societies. Indeed, my guess is that the total number of objects used by the Me'en is only about 130, that is, the objects they themselves produce locally. When we count the imported items, like razor blades, cotton cloth, soap, shoes, rifles, etc., the number is higher (see Abbink 1992b).

Today, the Tishana Me'en—to whom both Bogine and Gelta belong—are subsistence cultivators, no longer real pastoralists. They keep some livestock (cattle, goats, sheep, chickens), but most of their labor time is spent in growing crops such as sorghum, corn, beans, and some wheat, barley, and t'ef. There are markets, but most "trade" takes the form of

barter. Men have favorite exchange partners with whom they often have established a ritual friendship bond called *lange*. Women do most of the daily work (food and beer production, planting and weeding the fields, tending the gardens, and petty marketing of foodstuffs they have produced). Significantly, women (including the wives of Bogine and Gelta) do *not* engage in any production of material objects, except pottery; they make the earthenware cooking plates, called *retech*, and the three kinds of pots (*dole, diski,* and *ju*) which the Me'en use. As in many other south Ethiopian cultures, it is believed that when men observe the production process of these wares, the end product will be brittle and useless. These pottery items are also the only artifacts which women sell in the market. The reason women do not make more objects is not clear, although observation of Me'en daily activities over a long period suggests to me that women have much less leisure than men in which to sit down and work on an object. They also do not readily use iron tools. Thus, only the vital cooking pots, used daily, are fashioned by them—with their hands, without tools.

The Nature of Me'en Material Culture and Its Valuation

The artifacts that we find in Bogine's and Gelta's homesteads are virtually the same as those found in any Me'en household. There are no great differences in the nature and number of their material possessions. For example, when visiting the houses of Gelta and Bogine, one would not conclude that they are "craftsmen," although Gelta had a larger than usual number of gourd plants growing in his garden, the fruits of which he would make into containers. Also, Me'en do not really differentiate between, for instance, utensils used for food preparation and decorative (or what we would probably identify as more "artful") items like their intricate beaded belts, leather bands, or earrings: all these things are called *a'a*, "goods" or "stuff," things needed in life. The ritual firesticks needed for harvest rituals are as much part of the system as cups and gourd containers used in daily food preparation. There is, however, a differentiation of artifacts according to age and gender. Among the Me'en, the desire to possess or use certain objects depends on one's stage in the life cycle (youngster or elder) and whether one is a wife or husband. For instance, young men absolutely want decorative items like

Fig. 2.4 The *daafa* (beaded belt) worn by women.

bead or leather chains, bracelets, metal earrings, and knives with an ivory and buffalo-horn handle. Girls want their own wood cups or bowls, brass bracelets, and colorful bead chains for the neck, arms, and ankles. Wives want all the household utensils, the full range of gourd containers (the Me'en distinguish at least ten types of gourd container), wooden spoons, strong clay pots and baskets, and also good clothes (which, today, means imported garments), bracelets, chains, and possibly a wide, multicolored beaded belt (called *daafa*), perhaps the most expensive and flamboyant Me'en material object (fig. 2.4). Elders want a *chakam* (a small wood stool carved from hardwood), a tobacco container, or a ceremonial spear.

It is through these varying preferences according to age-group and status that we not only see the communicative function of artifacts but

Artifacts as "Daily Art" in Me'en Culture

also discern the basis for the Me'en valuation of objects and the framework for a visual aesthetic. What makes young people want to have these things? Because they want to catch the eye of their age mates of the opposite sex, they want to appear attractive. And why these particular objects rather than others? Because they made them themselves, or because the objects were made of prized material. So there *are* concepts of beauty or "aptness" of material items. In Me'en, these items are related to personal appearance as a whole and not valued primarily in themselves. The "aesthetic of adornment" consists of the complex of coiffure, scarification patterns and skin color ("red" versus "black"), stature, song and dance skills, and also facial and physical traits. Once young people get married and start a family, this aesthetic and its underlying concept lose some of their significance as the demands of functional efficiency of other goods like tools, bowls, baskets, etc.—necessary for sustaining the household—slowly take over. Indeed, one does not see adult married men wear the kind of personal adornments the young men have. But they occasionally carry trophy-like items, like bands made of skin or small bones of animals such as monkey, wild hog, or leopard. Gelta wore a leopard bone on his left upper arm, a reminder of his successful kill some years ago.

In most other categories of artifacts, like tools, weapons, and household items, the functional element predominates, not the "aesthetic." Here the object is valued for its durability, ease of use, size, strength, and shape, apart from its color or aptness of form. Like Bogine said while working on a wooden bowl: "A good one is one which stays, which is strong and can be used for a long time. If you have the right kind of wood, it's possible. The form should be straight, equal." However, like decorative items, these "utilitarian" objects can also acquire a special meaning or importance in the course of time. A nice dark red patina suggests age and durable value. The Me'en attach importance to how an object was acquired, who owned it previously, where it came from, and what was done with it. An object has a life history that is never immediately visible (see Ravenhill 1991: 6). This is a dimension of the object that we as outsiders often do not see but that has significance for the Me'en.

Both decorative items and utensils, tools, and ceremonial items possess a recognizable "Me'en style." This was always pointed out to me

by both the Me'en and their neighbors (Amhara, Bench, and Dizi people) and illustrates the fact that their tradition is indeed a culturally specific one. For example, no Dizi or Bench will carry a *chakam*, nor will one ever wear Me'en buffalo-skin sandals (*chaych*) or leather bracelets (*laka*) on the upper arm. It is also asserted (although incorrectly) that the Dizi and the Bench "cannot make" good gourd containers, woodwork, knives, etc. and have to buy them all from the Me'en. Despite this Me'en style, there are individuals from all ethnic groups who "cross the boundary" and learn from neighbors and assimilate techniques, decorative patterns, or object types. This is an interesting topic for further study: how, why, and by whom are specific artifacts "borrowed" from other people?

Me'en Artifact Production as a Technical Process

The limited range of Me'en objects is in accordance with the relatively low level of material development and environmental control found in Me'en society. We can formally distinguish several classes of objects: household utensils, tools, weapons, decorative items, items of personal status, and ceremonial items. It is very important to realize that the Me'en are self-sufficient in the production of almost all of these material objects. There are no real artisans, and consequently, there is no "caste" of artisans or craft specialists such as, for instance, the Fuga among the Gurage or, formerly, the Felasha among the Amhara of Gonder. In their work of producing "daily art," Bogine and Gelta are matched by virtually all adult Me'en men (although their personal touch, especially Bogine's, in certain things is recognized by relatives and neighbors in their immediate area). Hence, among the Me'en, there is no dependency on other people for material goods. For us, members of an industrial-technological society completely dependent on highly educated technical specialists for all our daily goods, it is hard to imagine what this means. The Me'en still have to deal, almost on a daily basis, with the challenge of transforming nature's raw materials into tools, utensils, and other objects that have to work and are used to solve the problems of making a living—and almost all the Me'en can do it.

The materials used are wood, tree bark, grasses, reeds, clay, gourds, iron, the skins of cattle, sheep, goats, and game animals, and pieces of discarded objects like aluminum tins and empty cartridge shells. The

adoption of "modern," imported goods has been very limited in the Me'en area; for example, they do not use furniture, radios, flashlights, or bicycles. This means that for their basic means of production, household goods, and decorative and ceremonial items they are dependent on no one. Within their own society, the only "specialists" are the iron-workers/blacksmiths (urit), who do not, however, form a special, separate group, let alone a "caste" (as they do among the neighboring Dizi). They fashion knife and spear blades, hoes, and picks and hammer out bracelets from old cartridge shells or metal debris and decorate them with the standard figurative patterns. Bogine and Gelta do not know this work. Apart from this ironwork craft, Me'en material culture is a "democratic art," known by all and observed by children from an early age. The techniques of production are familiar and acquired through imitation and trial and error.

The Artifact Producer and His Work

Bogine Shala is a quiet, unassuming Tishana-Me'en man, about forty-five years old. He is married and has four children. His wife does not engage in craftwork, although, like most Me'en women, she can make clay pots and cooking plates. Bogine describes himself not as a "craftsman" but as a farmer. I came to him because several people told me that he had been producing a fair amount of woodwork, basketry, and gourd containers lately. However, when I asked, he denied that he was making a living with such work: he had sold only a few things. Originally, he did not make objects for sale. Once, when he had made a big wooden beer tray, some people in his area asked him if they could have it. They agreed on a price and after that he made another. From talks with other artifact makers, I have the impression that lack of money as well as problems with crops (i.e., bad harvests) prompt them to take up some handicraft work. Nevertheless, they can never make a living from such work. Even the one Me'en blacksmith I met said he also cultivated his fields and gardens "just like anybody else."

Bogine lives in a small compound in the clan area where his father and some of his paternal uncles used to live. When they used to work on artifacts, he always had plenty of opportunity to observe them. The production of artifacts was a matter-of-fact thing, like building a house

or going to clear or weed the fields. It was not an activity steeped in supernatural or ritual awe. Knowledge to produce an object did not demand any link with gods or spirits or even ancestors: the *technical* aspects always dominated, like it does now. In the limited period during which I was able to observe Bogine work, I had the opportunity to see some of his woodwork and basketry. He is able to make most Me'en wood products, like bowls, cups, spoons, and stools. I will first describe his work on a food bowl: the rough one seen in plate 1.

Wooden Bowls

When I asked Bogine to make a wooden bowl (*gongul*) for me, he told me to come back the next day. In the meantime, he searched for the wood and notified me when he had found it. When I arrived around midday the next day, he was already busy cutting a large branch from a Sudan teak tree (*Cordia africana* Lam.) with an ax (called *bhech*). The other tool he used to fashion the bowl was a machete (*banga*). For a smaller, square type of bowl, he uses a knife also, for the finer work on the rims and the handle. Lowland Me'en use the leaf of a tree called *qaraych* for polishing the wood so that its surface becomes very smooth. But this leaf is not available in the area where Bogine lives. When highland Me'en compare their products with those of the (more isolated) lowlanders, they point to things like the availability of certain natural materials as the reason for the difference in quality and not to differences in skill. Whether their claim that they are "as good as the lowlanders" is true is doubtful: my impression is that apart from using different materials, the lowlanders do produce more attractive objects; that is, they give more time and thought to producing them and are more creative. For instance, the light-colored wooden cup with black lines in plate 1 is an object not often found in the highlands. Instead, one finds dark-colored, undecorated cups (pl. 1). The same holds true for grass baskets: the lowland ones are more popular, for reasons of both durability and form (fig. 2.6). Bogine claimed that he could make any object that the lowlanders make, including the stools (*chakam*), if only he had the right kind of hardwood and the polishing leaves.

After he had cut off the branch (fig. 2.5), Bogine began roughing out the form of the bowl, which this time was to be square. He did this

Fig. 2.5 Bogine Shala cutting a tree branch.

with a machete (fig. 2.1). In less than two hours I could see the form of the bowl and handle. The outer bark was removed and then the small trunk was hollowed out, with both the machete and the ax (Bogine had removed the ax's wooden handle). While carving, Bogine chatted and joked with people who happened to be around, exchanging news and gossip and replying to questions. A few hours later, he took the almost finished product to his house and sat down on the grass to give it the finishing touches and to do some polishing, all the time observed by his children. His wife was present only part of the time and did not seem to be very interested in the work. After being carved, the *gongul* dried for a week or two and was then polished again, especially its interior. The exterior can be rubbed with castor oil. No decorations were made on the wood surface—this may be a personal preference.

When I showed Bogine a wooden bowl (pl. 1, back row, right) with a kind of wave pattern, seemingly simple but difficult to carve, he recognized it as "typical lowland style," which was true (it does not yet have the patina of use). It is indeed a type not readily found among the highland Me'en, but he said he could make one like it. Nevertheless, demand for such specific forms is low, which seems to point to a certain "erosion" of notions of aesthetic form among highlanders, who tend to be more "functionalist" in their production and use of objects.

Baskets

The Me'en have a very limited number of basket products: a beer sieve (*zarzarach*), a plate (*woshi*), and two kinds of food baskets (*garju*). All are simple in design and execution; unlike Oromo and Harari baskets, there is neither decoration to speak of nor coloring. The bowl-shaped basket called *garju* is a product of the lowland Me'en, because, again, it uses materials only found in the lowlands, such as leaves from the *Hyphaene thebaica* palm. For this reason, Bogine, though he is an all-around artifact maker, only produces the basket plate and the beer sieve, not the *garju*. The example illustrated here (fig. 2.6, left) is a variation on the common basketry plate (*woshi*). Although most highland basketry plates are made using the checker-weave technique, Bogine used the coil technique to produce his plate—the technique used by the lowlanders for their *garjus*. This example is smaller than normal and is made of mate-

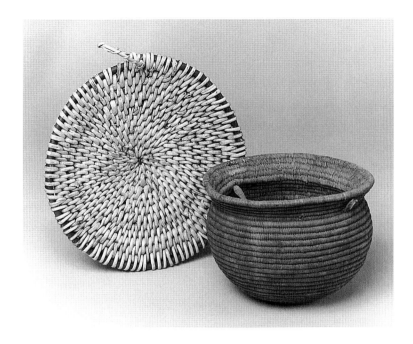

Fig. 2.6 Baskets: (left) a *woshi* made by Bogine Shala, (right) a *garju* made by Goluga.

rials not often used for this object. Bogine produced it in one day, from the flexible branches of the *ket-te-koroy* bush and from the tough, moist bark of the *bans'alach* plant. First, a few suitable branches were cut from the *ket-te-koroy* bush. Second, the coiling of the *bans'alach* bark around the branches was started. Bogine began from the inside, wrapping the bark-strips around the branch toward the outer rim. Care was taken so that the shape would be perfectly round and slightly convex—the shape of a plate. This simple-looking piece is made with resistant, difficult material and is much more complicated than it looks. Other Me'en (as well as some Amhara and Dizi people) admitted that they certainly could not have made such a piece as skillfully as Bogine.

Gourd Containers

In daily life, the Me'en use various types of gourd containers made from the fruit of the gourd plant (*Lagenaria siceraria* or L. *vulgaris*). Indeed, this item seems to be the most widespread material object. There are many types of gourd containers. They are one of the few categories of Me'en artifacts that are decorated (combs, bracelets, knife sheaths, and occa-

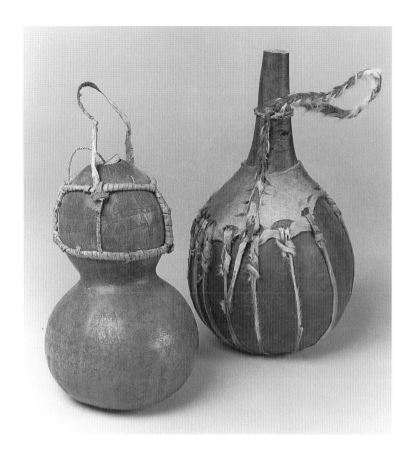

Fig. 2.7 Gourd containers: (left) a *bhogol*, (right) a *qada* made by Worqu Kabtimer.

sionally stools are also decorated). When the freshly cut gourd has dried enough, the maker (invariably a man) incises geometric patterns on the exterior with a small iron pick (*muda*). Then charcoal is rubbed into the incised design to give it its black color. The designs consist of a variety of nonfigurative triangles, lines, and circles. Although the patterns suggest representations of roads, snakes, rows of houses, or granaries, direct and indirect questioning of producers of these containers, including Gelta Foroshowa (whom I interviewed several times), did not reveal any deeper "meaning." These patterns (which are also found on the *daafa*, the colorful beaded belts worn by women) do not represent houses, roads, or any other concepts or objects. They apparently have no culturally standardized meaning. The origin of these motifs, which could perhaps tell us more about their significance, is no longer known to the

Me'en producers. Interestingly, they also occur among the Surma, a neighboring agropastoral group, historically related to the Me'en.

Making a gourd container may seem even easier than making a basket or a wooden bowl. Doesn't it involve simply cutting open the full-grown, already shaped gourd and then just carving the decorations on its surface? I put these and other questions on gourd container making to Gelta (fig. 2.2). He is an active, talkative man, about forty years old, who belongs to the old Afala clan. After spending several years in the lowlands, he now lives in a highland zone of the Tishana-Me'en. In his small house, he has a larger than average collection of gourd containers, from small drinking cups to big honey containers, all made by himself. Like Bogine Shala, who sells wooden bowls and baskets, Gelta has started trading and selling some of his products, but he cannot make a living from the proceeds.

Every year, Gelta plants gourds. During the growing period, the gourd fruit can be tied with rope to influence its shape. A type of container called *bhogol*, for instance, usually has a slender waist (fig. 2.7, left). A *qada* is bottle-shaped and made from an untied fruit (fig. 2.7, right). Twice a year, in July and especially in September, Gelta harvests the gourd fruits. Although well-made gourd containers last much longer than one year, with every harvest new gourd containers are produced in every household, especially when the fruits are of good quality.

After having been cut from the plant, the fresh fruit (called *qajach*) has to dry for at least a week. Then the fruit is carefully cut open. Gelta showed me how he can make two coffee bowls by splitting open a small gourd. He drew a line across the fruit, measured it, and started making small holes along it. Then with a machete he slowly split the fruit into two halves. If this is not done carefully, the halves will be damaged and rendered useless. Inside, one finds the whitish, inedible flesh of the fruit, often too fresh and tough to be removed immediately. Gelta loosened it with a pick, then (a week or so later) took it out with a knife (at times he uses a small spear). The seeds are stored and dried, to be planted later in the season. Gelta then cut the edges of the two cups with a knife and put them away to dry, often in a pile of grass or refuse to ensure that the containers dry slowly and evenly so that they don't crack. A few weeks later, he took them out to be polished and finished. The remnants

of the thin outer skin were removed with a knife, and the exterior was rubbed clean with sand and leaves. The edges were again cut straight. Once again, Gelta put the gourd aside for a few days. Finally, the exterior was decorated with the familiar Me'en line patterns. If Gelta produces the container for someone else, he does not incise its surface with designs; the new owner will do that for himself or herself. In the course of time the gourd container acquires a distinctive patina, changing color from brownish green to an attractive deep yellow or dark red. They are not easily thrown away when damaged. Several of the gourd containers used in Gelta's household were cracked but had been delicately repaired with plant-fiber threads.

Function and Form in Me'en Artifacts

The three types of objects that we have just considered are utensils used in everyday life. They are not ascribed any ritual or ceremonial value, nor are they highly prized by the Me'en themselves as "beautiful objects" (in Me'en, *an-de-she'i*). So, if we wish to use the Me'en concept of *shek-tin* ("beauty" or "goodness" or "aptness"), how do we assess the quality of these objects? For these objects it must simply lie in the equal presence or overlap of functional efficiency and aptness of form. Bogine, Gelta, and other Me'en told me about "good" material objects: an object is good or beautiful when it does what it is made for and it does it well. This implies that it must be made of good and strong material and must be adequately shaped and prepared. For us this is a simple, straightforward answer, but we must realize that applying the seemingly simple techniques to natural materials with simple tools requires an original, careful sequence of decisions to achieve an acceptable result in terms of the function(s) an object is destined to serve.

Many other objects of the Me'en show a beauty or aptness of form that goes beyond "mere" functional efficiency, or, to put it properly, they enhance their efficiency by their outstanding aptness of form. Such objects are the small lowland tobacco containers of horn and leather and the small stools, for which the Me'en justly have a local reputation (fig. 2.8). When asked about the beauty of these kinds of objects, the Me'en often say that they should not only be well formed and adequate but also be handled with care and respect "by the right people." These

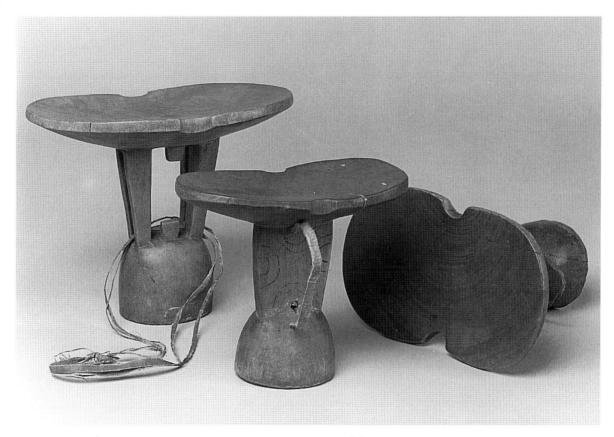

Fig. 2.8 From left to right: a *chakam* made by an anonymous carver, a *chakam* made by Ondai, and a *chakam* formerly owned by Beyene Banja.

very personal objects cannot really be bought with money: they are exchanged with a person who has established a "noncommercial" relationship with the producer or owner. We see here that "value" accrues to an object chiefly because of its life history. For example, the *chakam* (stool) illustrated in figure 2.8 on the far right was formerly owned by the Banja, the foremost *komorut* (hereditary "rain-chief") of the Tishana-Me'en, and was made by his father's brother quite a number of years ago. It is also important to know that the wood used was *jakach*, a lowland tree said to have "power" and reserved for such important persons. Another example that should be mentioned in this context is the wooden cup made of lowland wood and with line decorations that is shown in

plate 1. It was carved by a lowland man, Woyday Dorichali, who always carried it when visiting relatives or friends in remote places. I met him when he was visiting a Me'en highland family. Such a cup, a very fine individual product, is not often seen and was much admired by other Me'en.

Significantly, these latter artifacts are also the type of Me'en objects that most directly appeal to outsiders such as ourselves. Possibly this is because they reveal a certain "panhuman" aesthetic preference for symmetry, clarity, recognizable space, and self-containedness that conveys a sense of visual harmony and balance. In this respect, a simple, non-technological and nonspecialized culture like that of the Me'en may be seen as possessing the same basic aesthetic sensibility that exists in Western cultures.

Conclusion: The Equality of Affect Engendered by Me'en Material Culture

Me'en material culture is the product of a nonhierarchical, mobile, and relatively self-contained society. The absence of "chiefs," of institutionalized groups of craftsmen, and of an autonomous domain recognized as "art" has stimulated an "equality of affect" in the production and social use of artifacts within this culture. By this I mean that the "force" of artifacts, their mobilization of sensibility or of affect among persons in Me'en society, is fairly uniform, and that evoking that affect by making these artifacts is within the scope of almost everyone. From the life history of a Me'en person (male or female) within his or her culture, it is possible to anticipate the material objects he or she will need and try to acquire in the course of life. Without denying change from within and from without the society (especially in a political and economic sense), the material culture of the Me'en is still largely dominated by "tradition." Challenges and problems of Me'en daily life could, until recently, largely be met on the basis of their present level of technology and craftwork, the norms and forms of which have been handed down by preceding generations. What we see in the "careers" of Bogine and Gelta as artifact makers does not (yet) single them out from the mainstream. However, if they would fully devote their time to making objects and would learn more of the methods and use of materials of lowlanders,

they could quickly become "specialists" and develop a personal style. As I have made clear, current Me'en daily aesthetic and social organization mitigate against this. Although the Me'en material traditions have remained fairly constant, it can be concluded—not only from what artifact producers like Bogine, Gelta, Woyday, and many others said but also from observing the Me'en objects in their proper context—that there is always an underlying sense of aptness and goodness in the artifacts, a visual aesthetic that unites form and function and that makes the objects satisfactory and pleasing in their simplicity and authenticity.

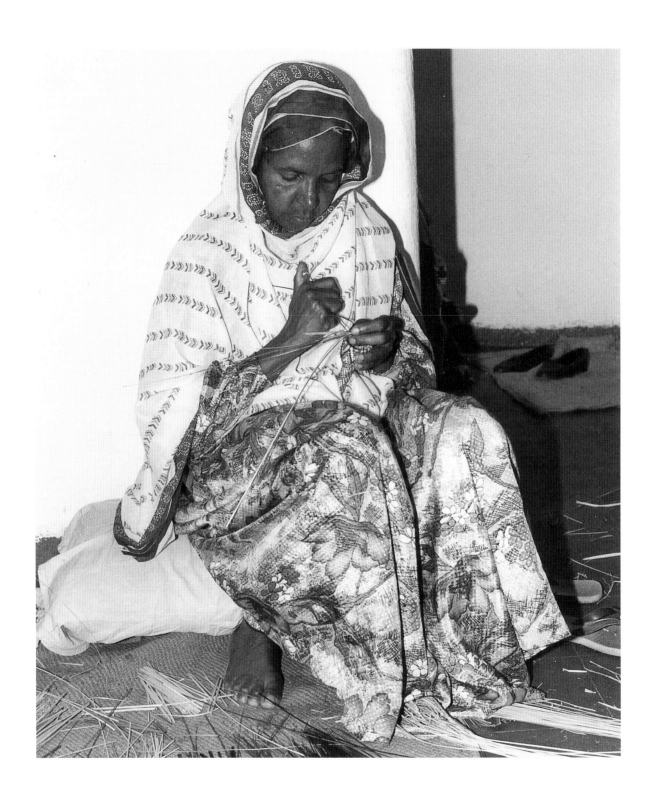

Harari Basketry through the Eyes of Amina Ismael Sherif

<div style="text-align:right">3</div>

Ahmed Zekaria

HARER IS LOCATED IN EAST-CENTRAL ETHIOPIA. THE OLD walled city, known as Jugal, has a population of over 30,000. Jugal is pear-shaped and covers an area of 48 hectares. It is the home of the indigenous Harari as well as other peoples—Oromo, Somali, and Argobba. Indeed, people from virtually all parts of Ethiopia may be found in this great walled city.

Fig. 3.1 Amina Ismael Sherif weaving a basket.

Much has been written about the natural beauty of Harer. More than forty years ago John Buchholzer commented: "It doesn't matter whether you go there when the coffee bushes are in flower and the air is heavy with their strong, bitter scent, or when the ripe fruit of the orange trees glow in the sunlight, it is always lovely in Harer; there is always something blooming, always something being harvested" (1955: 101). A mountaintop view of Harer reveals a mosaic of diverse scenery (fig. 3.2). One sees great natural beauty complemented by the beauty of the human-built environment. The colors are remarkable. Outside the city walls the lush green foliage and meandering streams remind one of Persian carpets. In contrast, inside the old walls the colors and shapes change; one

At the top of my acknowledgment list I must mention Amina Ismael Sherif, who willingly provided much information about Harari basketry. Next on the list comes Fatuma Ibrahim Getu, who filled in the gaps. Amatulah Ibrahim (Fatuma's mother) and Munira Ahmed (Amina's youngest daughter) also contributed by providing their knowledge of basketry from two perspectives, that of an old woman and that of a young girl. And finally, I thank the Harari historian Abdulmuhaimin Abdunasir for sharing with me his unpublished manuscript, an important document that sheds light on the historical songs and sayings concerning baskets.

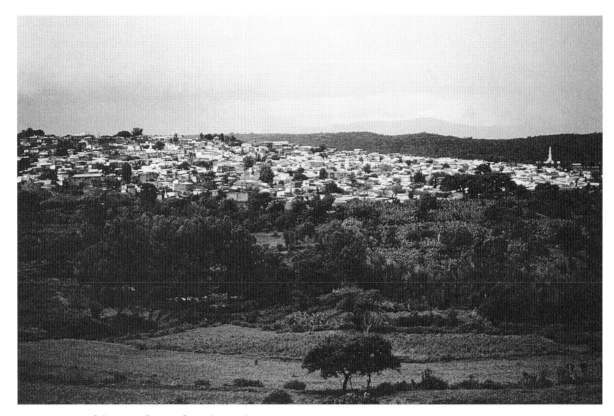

Fig. 3.2 View of the city of Harer from the south.

sees primarily whites and grays and a diverse range of geometric shapes of varying size (figs. 3.3–3.4). The hill on which the old city rests is a constantly changing organic form, shaped and reshaped by the hands of masons for over a millennium. The houses, mosques, churches, marketplaces, and narrow streets form this magnificent work of art.

Moving from a macro- to a microview of the city reveals an abundance of aesthetic traditions that echo this beauty. The Harari house is warm and inviting and displays a sense of proportion and a mastery of a building technology perfected over the centuries. Inside the house, one is overwhelmed with the balance and color composition of the traditional display of baskets on the walls of the living room (fig. 3.5). The colorful dress of Harari women is another dimension of the beautiful aesthetic that permeates Harari life.

Fig. 3.3 One of the five gates to the old walled city of Jugal, commonly known as Harer.

Fig. 3.4 Typical street inside the walls of the old city.

Fig. 3.5 The *gidiir gaar*, or living room, of a well-to-do Harari family.

Harari Basketry through the Eyes of Amina Ismael Sherif

49

The primary driving force behind the development of Harari art has been the convergence of a number of major cultural traditions within the city. It is a veritable melting pot. Harer has been the center of trade and learning for a vast region of the Horn of Africa for at least one thousand years. Various crafts and art were introduced by people who came from near and far, from all directions of the compass, and who contributed their knowledge and expertise to the collective culture of Harer. This interaction and exchange has fostered the development of Harari art. Jewelry, calligraphy, bookbinding, embroidery, architecture, and basketwork are just a few traditions that enrich the aesthetic environment of Harer.

The dominant artistic influences have been associated with Islamic culture. Geometric patterns and designs are favored over figurative representation. Two traditions in which this influence is seen are calligraphy, produced by men, and basket making, which is the domain of women. Let us visit the house of Amina Ismael Sherif and consider one of these traditions in greater detail.

In Harer there is a saying, *Sheisti geusu gutibe meheama yiet farakumel*, roughly translated, "Among three Hararis, you cannot speak ill of anyone." It implies that in Harer each person is in some way related to everyone in town. Indeed, Amina is my aunt. Amina Ismael Sherif, often called Amina Sitti ("Sitti" is an honorific title for a member of the Sherif family), is a daughter of Harer, born around 1940 (fig. 3.1). Her father (and my maternal grandfather) was Ismael Sherif, and her mother was Khadija Muhammed Wubir. Amina was raised alone, her mother's only daughter. Unfortunately, Khadija lost her eyesight, and Amina, while still a young woman, shouldered the responsibility of caring for her. This contributed both directly and indirectly toward her becoming a professional basket maker, for she was forced to stay in the house to care for her mother and therefore had more time to devote to weaving baskets. Amina lost her husband in 1990. Fortunately, two of her five daughters are married. One of the married daughters and an unmarried daughter are living abroad. In 1993, two daughters, Munira and Maria, were still residing with Amina.

Amina is not an unusual Harari woman. She is a member of an *afoocha* (a community association), has no special role in the community, tends

her house, and supports herself and her daughters by producing baskets for sale. Her daughters who live abroad occasionally send gifts to help support the household. Amina and her daughters are playing an important role in sustaining the art of basket making in Harer. Even her daughter living in Australia has not abandoned basket making—Amina sends her the necessary raw materials from Harer.

Basket making is an ancient art found in many societies throughout the world. Nevertheless, every basket tradition has its unique dimensions and not all traditions share equal weight in the realm of art appreciation. Many who have visited Harer have appreciated the beautiful baskets that the city's women have produced for centuries (see, e.g., Hecht 1992). Today, the famous baskets of Harer are one of the old walled city's major tourist attractions. Whether the baskets of Harer should be regarded as art or not is difficult to say. After all, "beauty is in the eye of the beholder," and it is up to the individual to define what is art and what is handicraft. This is not the place to deal with this complex issue, nor to criticize the West's use of a classification system that labels aesthetic objects as primitive, low and high art, or handicraft. Suffice it to say that there is great beauty in Harari baskets and they are aesthetic objects that deserve careful study.

The Harari basket, however, is far more than a beautiful object to be purchased by tourists and studied by art historians. It is a sign of identity loaded with social and cultural meaning. The Harari basket may be studied in both a physical and a symbolic context. In her analysis of Harari basketry Hecht (1992: 11–12) offers a hierarchical list of the significance baskets hold in Harari society. Here I paraphrase the various functions she enumerates:

1. Baskets are a symbol of identity for women.
2. They are a symbol of Harari women's sphere of life. Men have nothing to do with baskets or basketwork,[1] and although baskets may be handed from mother to daughter, they are not referred to in a will.
3. They demonstrate that luxury is affordable (without being ostentatious); they reveal a refined aesthetic sensibility on the part of the owners, as evidenced by owning many delicate

baskets of the same type and same decoration.

4. They have decorative value and demonstrate that the housewife knows how to properly configure baskets following Harari conventions for basket display.

5. They serve distinctive functions in social activities, in particular, in the ceremonial exchange of gifts, especially food, during life cycle festivities.

6. They are objects of daily use.

Amina was kind enough to sit down with us for several hours in May 1993 to explain the basics of basket making: how one acquires the materials that are used in fabricating baskets, the technique of dyeing the fiber, the different types of baskets, and the functional, decorative, and symbolic meaning of baskets in Harari society. She also provided some interesting insights into new trends in the local and the international basket market.

The learning process for basket making is part of the female's world. It is a female-specific tradition in Harari society. This, of course, does not exclude men from using baskets. Indeed, there used to be a special basket called *aw moot*, "father's basket," produced for a bridegroom to be carried around with him when visiting his relatives.[2]

I find Hecht's view that baskets are exclusively the domain of women too narrow. Amina told us about an incident that occurred at a wedding she attended in Dire Dawa that demonstrates this point.[3] The wedding ceremony went well, without any hindrance. Afterward, the bridegroom, following tradition, escorted his bride from her family's home. All was fine until he learned that some important objects were missing: when they reached their new home, he discovered that his bride had not brought any basketwork with her. This omission was taken as an unforgivable offense and eventually led to the dissolution of their marriage. I have observed similar incidents in the Harari community in Addis Ababa.

It is true that men do not interfere with the process of making baskets, but it seems that the symbolic value of baskets is an important element of male identity within the context of marriage. This is a deeply ingrained tradition in Harari society that may be difficult for an out-

sider to appreciate. Basketry is important for both men and women. The main differences pertain to the process of production and the frequency of symbolic usage. The basket's decorative and utilitarian functions are more or less the same for both husband and wife, but it has greater significance for women within the realm of rites of passage.

Formerly, daughters, at an early age, were encouraged by their mothers to train their hands how to weave baskets. Basket making used to be a lifelong skill learned in early childhood and practiced until old age by almost all Harari women, rich or poor. Traditionally, a girl's first basket was burned to ashes, and the ashes were rubbed on the girl's hands. This custom signified a transition to a more skilled level of basket making. Even today, daughters master the basic concepts of basket making before they join the *gelach*, a society of young women of similar age who live in the same neighborhood. This occurs at around the age of nine. The *gelach* meets at the home of one of its members, which is then known as a *mooy gaar*, or "house of work."

For every girl, Amina recalls, the daily routine started early in the morning when the cock crowed. First, she made breakfast for the family. After breakfast, she swept the whole compound, including the street in front of the house (Harer used to be very clean and one could always smell the fragrance of incense coming from every house). Then it was time to go to the farm. It was common for a Harari girl to be praised by the young men she encountered on her way to the farm. Their admiration was voiced at a distance and in song. Here are examples of a few verses recorded by Duri Mohammed (1955: 17):

> *Tadarat wa, harir tafatlat wa marign malasayuw talabsat wa.*
> *Haramaya hemini dakiya kor mawardi malasayey.*
> *Dad has yasyheranal wa; aw saba gadamu kut yetfikranal wa.*

> At her loom she weaves silk, a coat for her lover.
> Her beauty is [like] one of the waterfowl on the
> lake of Haramaya.
> She is a rose.
> I am drunk on her love; I leap like the deer on the
> hills of Aw Shab.

She responded, either with friends or alone, to the love song with a gentle sweet voice, competing in the early morning with the songs of the birds.

Formerly, Harari women were economically independent. The urban-based farming community of Harer devised a system of liberating women from economic dominance by their husbands. Women acquired plots of farmland as part of their bride-price from the groom's family. This plot could be as small as one or two rows of ch'at trees. This arrangement gave Harari women a good deal of economic freedom and thus provided a stable economic foundation for the marriage. Every wife and her grown daughters had to visit the farm each day.[4] It was regarded as a bank from which a woman could withdraw some bundles of ch'at for the expenses of the day. On her way home from the farm she sold the ch'at for cash. She was back home by nine o'clock in the morning.

After taking a short rest, she joined her friends at the *mooy gaar* for most of the day. The members of the *gelach* spent their early years at the *mooy gaar*, which served as a training ground for Harari girls where they learned not only basketwork but also *hala mehal*, the important lessons associated with social etiquette. Many of the lessons have been encapsulated in proverbs. For instance, here is one that admonishes latecomers: *Zikedema zibedera zetehara zibereda*, meaning "One who comes on time succeeds while one who comes late freezes."

The value placed on friendships forged in the *mooy gaar* is expressed in different couplets. Amina sung a few of them as she nostalgically recalled her youth.

> *Geley ded lekehey.*
> *Sinet tetlimjinash wa.*
> *Moy garbe beley.*
> *Gar gebekhu girmakh hina geley.*
>
> My friend, you are my debt of love,
> You are my expert in art.
> In *mooy gaar* you are my friend.
> In wedding you are my best maid.

The atmosphere of the *mooy gaar* was warm and secure. Each member shared her knowledge to build up a strong collective experience. The young women often sat as a group working on baskets. Each brought her *agergera* (a type of straw used like thread for weaving), *migir* (a type of sturdy grass used for the core of the coil), and *qerma* (barley stalks used for wrapping the coil) (fig. 3.6). Every girl had to have her own

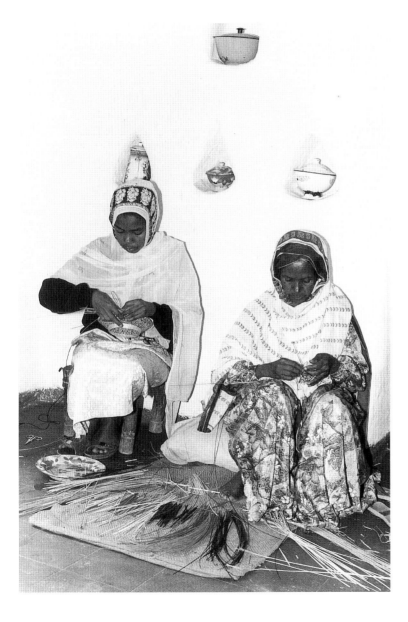

Fig. 3.6 Amina and her youngest daughter, Munira Ahmed, weaving baskets. Note the various types of grasses on the floor in front of the women.

Harari Basketry through the Eyes of Amina Ismael Sherif

55

wasfi, or awl. In the center of the group they placed a small wooden bowl (today a small enamelware bowl is used) with water in it to soften the *qerma* and *agergera*. The bowl also served as a receptacle for receiving coins, a tradition known as *metarika mahallaq*. The coins were primarily collected from visitors, both male and female. Male visitors occasionally visited the *mooy gaar* to observe and admire the basket making and for courting. During their visits they often commented on the quality of the baskets. The members of the *gelach* and their female visitors exchanged ideas for new techniques and designs, as well as more general news and views about their families and life in Harer.

Amina became lost in memories of her youth when we asked her about the availability of raw materials. She recalled that all her supplies were readily available in and around Harer except for the powder used in dyeing the fiber. The farmers used to grow *agergera* to serve as a dividing line between plots of land and to impede soil erosion. The *migir* grew wild outside the farming zone, and the *qerma* was collected after the barley harvest. Today, all are imported from different places. The *qerma* comes from the nearby Hakim Mountains, the *agergera* is transported from Jijiga, 120 kilometers to the east, and the *migir* comes from Addis Ababa. There are merchants in Harer who supply these raw materials. Population pressures and ecological changes have contributed to the scarcity of raw materials. And the scarcity of raw materials has been one of the factors contributing to the atrophy of the basketmaking tradition. In the past, everyone could collect their own grass for free from the farm, but now the cost of a small bundle varies from season to season, ranging from 2 to 5 birr,[5] and is affected by fluctuations in the cost of transportation. The awls, which are used to pierce holes between the coils while weaving the basket, are produced locally by a blacksmith.

The work space should be blessed with prayers praising Allah and his Prophet, Muhammed—prayers learned at Qur'anic school while growing up.[6] Every girl had to repeat a specific prayer before starting to weave. Then the young women in the *mooy gaar* could commence work on their baskets, meanwhile discussing current events and news of marriage engagements. When the group had had enough of current affairs, singing took its place. The group often sung together; sometimes two particularly good singers would exchange couplets praising Allah, his

Prophet, and the *mooy gaar*. They also praised their friends in song, singing about their good qualities.

The work environment was lively, full of activities and enjoyment. Once a week, on Friday, the group bought grain with the coins they had collected in the water bowl and prepared *shuhum*, boiled grain. A straw was stuck at the center of the *shuhum*, so that everyone would learn table manners. Whoever made the straw fall over was obliged to contribute a certain amount of money to the water bowl.

The weaving of *bitt'i bitt'i*, a small flat basket, is the beginning of a long journey to acquire expertise in basket making. The first stage involves only natural, undyed grass. After mastering the weaving process, one gradually learns to manipulate *qeeha t'ey*, "red and black," a term used for dyed grass, to produce a wide range of complex patterns and designs.

Initially, everyone had to buy from individuals who prepared dyed *agergera* and *qerma*. Amina remembered "the good old days" when mothers used to share their dyed grass with their daughters in exchange for the service of splitting *agergera*. Both natural and artificial powdered colors are still essential components for the making of dyes. The most commonly used colors include *qeeh* (red), *wariiq* (green), *hurdi* (yellow), and *t'ey* (black). These are called *gerengi*, Harari colors, whereas pink and orange are considered tourist colors. The essential ingredients are plants, such as *hurdi inchi* (yellow spice); imported powdered dyes; water; and lemon juice. The dyeing process involves dissolving the natural plant material or the powder in boiling water and then soaking the *agergera* and *qerma* in the solution. Lemon juice is added to set the color.

Color dyeing requires special skill. It is not something any basket maker can do. Although the technique of dyeing may seem easy, it is an intricate process requiring careful timing and measurement of ingredients. Every dyer has her own way of producing dyed grass. Most of the time the techniques are kept secret by the specialists so that they can maintain an influence on the market. Today only one house in Harer specializes in dyeing basket fiber for market. However, there still are professional basket makers, like Amina, who prefer to do their own dyeing.

Different colors are combined to form patterns and designs of varying complexity. One starts with simple designs like the *uuf harda*, the "foot-

print of a bird." More complex arrangements include *qut'ur fetah* (tie and release), *finch'iq* (splash), *fershi mahallaq* (coin), *gebre merfi* (slave needle), *meqnati* (belt), *bisaat'* (rug), and *mesob* (bread table).[7] Today there are more than twenty-five designs and patterns. Some of the designs are named after building and place names, such as *Muhammed Ali gar*, a building built inside the city walls by a wealthy Indian merchant (ca. 1910), and "Bombay," named for the textile of similar design that is imported from Bombay. Many of the design names refer to animals, like the previously mentioned *uuf harda* and also *adurru iin* (the eye of a cat) and *dokhon lanka* (the trunk of an elephant), etc.

To produce these designs Amina demonstrated the painstaking steps of counting coils and interweaving *agergera* and *qerma*. She adorns the *oor*, the "good" side of the basket, with *t'ihin*, refined weaving. *T'ihin* weaving is used to produce high-quality Harari baskets. The other type of weaving, called *toh toh*, or unrefined, is mainly used for tourist baskets. The *ari*, the "bad" side (inside), is the functional side of a Harari basket; the *oor*, with its iridescent *qerma*, is decorative.

Harari basket designs usually integrate geometric patterns of triangular, rectangular, and lozenge shapes. There are also zigzag patterns that imitate wavelike movement. Some of the basket makers have integrated calligraphy in their basket designs. Amina, for instance, has used both Arabic and Amharic letters in her baskets. Most of the inscriptions are either the personal names of owners or specific Qur'anic quotations.[8] Amina told us that there is room for creativity, for introducing new designs and patterns, but that the conservative demands of the market for traditional dowry baskets do not favor innovation. Thus the collective aesthetic values of the community in Harer have discouraged individual expression and creativity.

The six basic basket shapes may be classified as follows: flat circular, flat at the center and flaring out at the edge, triangular, rectangular, conical, and hemispherical. Before her wedding, every Harari girl must prepare the following baskets: one *gufta mudaay* (hairnet container), two *it'aan mudaay* (incense container), two *bissha mudaay* (chewing gum container), four *aflala uffa* (a conical lid), four *finjaan gaar* (a small lidded container), and six *sehna segaari* (a small plate) (pl. 2). Today some of the larger sets of baskets have been reduced to sets of two because of the high cost of

baskets. Amina commented that the introduction of the modern school system, which requires a major time commitment, does not allow girls enough time to prepare the necessary items for their dowries. It used to take about a year to complete a set of dowry baskets. This situation has brought about the establishment of a new occupation: professional basket making. Today, in the city of Harer there are fewer than ten professional basket makers, who are responsible for producing almost all the dowry baskets. Each professional has her own specialty. Amina's specialty is the *aflala uffa*. Now, a girl's family must spend a substantial sum to acquire the baskets needed for marriage. In May 1993, Amina quoted us these prices:

gufta mudaay	1,000 birr
bissha mudaay	125 birr
it'aan mudaay	125 birr
aflala uffa	250 birr
finjaan gaar	225 birr
sehna segaari	250 birr

This new trend has affected both the social and the symbolic significance of baskets, as well as the market for Harari baskets. Although it remains an important symbol of identity, the basket does not play the central role it used to. Nevertheless, a minimum standard is still maintained. Every bride must bring a minimal set of baskets to her marriage. The continued social import of baskets in Harer is manifest in a number of traditions. At the end of the honeymoon both the bridegroom's and the bride's relatives come together and compete in song. The bride's side mentions the quality of the baskets that the bride has made. It is therefore critical for pride's sake that every bride have some baskets.

Amina is known for the quality of her work. With an expert eye one can distinguish her work from that of other basket makers. Her skill may be appreciated by examining the *aflala uffa* that she makes—veritable works of art (fig. 3.7, pl. 2d). Those familiar with the art of basket making will know how difficult it is to coil a conical form and will appreciate the exquisite proportions and the perfect execution of the design patterns.

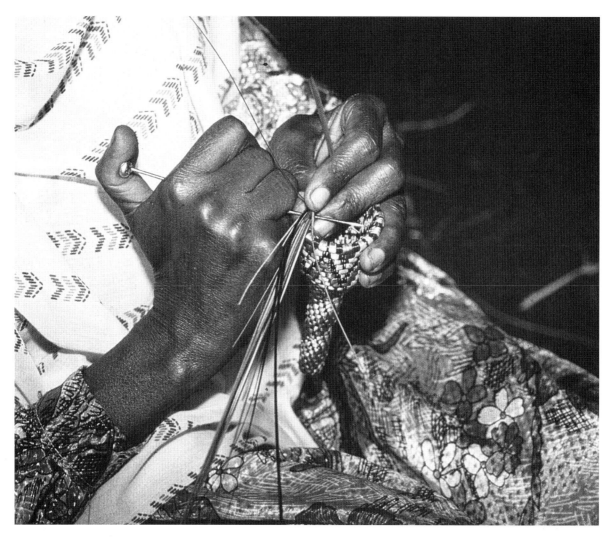

Fig. 3.7 Close-up of Amina beginning to weave an *aflala uffa*.

The income derived from basket making is not enough to live on but it is better than it used to be. The aphorism *Merfi niki weldim alaleka*, meaning "A piece of an awl does not raise a child," instructs one not to indulge in basket making as the sole means of making a living. Producing baskets should supplement one's primary mode of subsistence; one should never rely on it as a primary source of income. Amina was forced to stay at home when she became responsible for caring for her

blind mother. Her limited mobility influenced her decision to become a professional basket maker. Amina spends roughly five hours a day working on baskets. She told us that her income is barely enough to survive. It takes a lot of time to produce a t'ihin basket. The traditions of production have changed over the last twenty years. The impact of the last regime (i.e., the Derg) on social organization was devastating. One casualty was the mooy gaar. The group effort has been replaced by the individual effort.

Most of Amina's baskets are used within Harari society. She does not involve herself with tourist-oriented basketwork. The main reason she has avoided the tourist market is because there is better remuneration for commissioned dowry baskets. Only the best basket makers, like Amina, receive these commissions. The less-skilled basket makers focus most of their production on less-demanding tourist baskets. The demand for Amina's baskets is both local and international. These days, many Hararis living abroad in Europe, North America, and Australia commission their dowries. The introduction of international currencies has substantially inflated the cost of baskets.

A standard Harari house has one living room, called a gidiir gaar, with five raised seats (pl. 3).[9] These seats signify social hierarchy. The seat immediately to the right of the entrance is called amir nedeba; it is the place reserved for the owner of the house or for an alim (a learned person). The second seat is gidiir nedeba; it is for the elderly. The third is sutri nedeba, which functions as a bed for the owner of the house. The t'it nedeba and the gebtiher nedeba are seats for ordinary people. Traditionally, almost the entire wall surface was covered with basketwork and wooden bowls. Today most gidiir gaar also contain enamelware hanging on the same walls, often interspersed with the more traditional baskets and wooden bowls. The different niches serve as bookshelves and cupboards.

Formerly, every Harari woman was supposed to know basket arrangement—if she did not, she could be bitterly criticized. A wife who did not possess this knowledge was considered a busetti, "a careless or lazy woman." Every basket has a specific place on the wall. If it is hung in the wrong spot, its symbolic meaning might be confused. One never sees a lemat (a large flat basket) hung from a pillar, or a hamaat moot (mother-in-law's basket) in the place reserved for the ukhaat moot (a bread

basket). The presence of a *hamaat moot* in a house indicates that a son has been married, and it must be hung in a specific location to signify this important event.

The role of basketry in Harari society is threefold: utilitarian, decorative, and symbolic. Utilitarian baskets like *ukhaat moot*, *afutu*, and *sugud* are made in Oromo communities near Harer and bought in the Harer market. They are made using simple coiling techniques and are devoid of any decorative pattern. The *ukhaat moot*, the bread basket, has been replaced by inexpensive Chinese enamelware. But some women still prefer to use the basket, especially when they take bread to a house that is in mourning. The *afutu*, or sieve, is also being replaced by plastic or metal sieves. The *sugud*, a special container for grain measurement, might remain as a utilitarian basket for some time because it represents a specific unit of measure.

Harari basketry also serves a decorative role in the Harari house. This function has been affected by the recent introduction of factory-made cement. Many Harari house walls are now plastered with cement, which makes them difficult to pierce for basket hanging. Nevertheless, some of the essential dowry baskets have not lost their decorative function; they are displayed in other contexts, for instance, on tables.

The third role of Harari baskets involves their symbolic significance in rites of passage. Here also the new wave of cultural change has affected the importance of these baskets. Each decorated Harari basket used to play a pivotal role in important social events like the birth of a child or a marriage, but now traditional rituals associated with these events are giving way to modern ones and this has had an impact on the production of most types of baskets. The only basket that continues to maintain a special social significance is the *hamaat moot*, or mother-in-law basket. Every mother-in-law still expects this basket from her daughter-in-law. In the past, the daughter-in-law would make this piece during the first year of marriage, but now professional basket makers have started producing this beautiful basket. Mothers-in-law still carry bread for social events in the *hamaat moot*, denoting that they are on good terms with their daughters-in-law.

The future of Harari baskets is uncertain. Amina is now primarily producing the baskets required for the dowry, and some of her friends

specialize in *hamaat moot*, but no one has taken responsibility for the larger baskets such as the *lemat* (a flat basket), *waskembaay* (a conical basketry lid), and *le'ay mooreja* (a basketry plate used as a cover for another basket). They certainly will soon disappear. Nevertheless, there is reason to hope that the tradition of Harari basket making will be sustained by the next generation. Amina's daughter Munira Ahmed is an excellent example of this hope (fig. 3.6). When we worked with Amina in 1993, Munira was seventeen, and already she was a skilled basket maker and adept at making all of the baskets that form a bride's dowry. Perhaps young women like Munira will sustain this magnificent tradition.

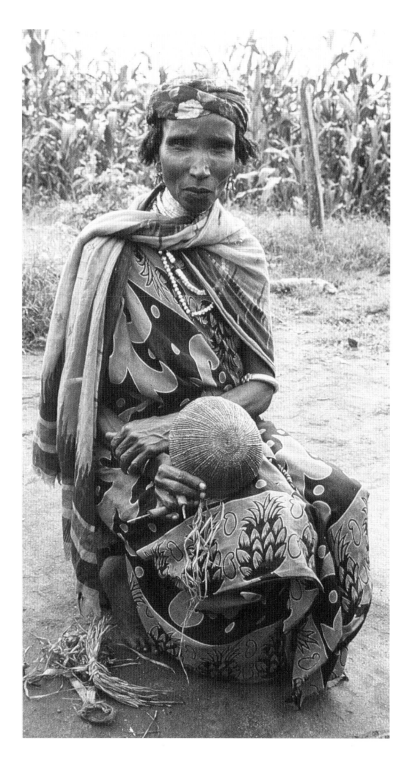

Fig. 4.1 Elema Boru holding the base of
a *ciicoo* she is weaving.

Every Woman an Artist

The Milk Containers of Elema Boru

Marco Bassi

The Oromo-Borana

The Borana live in southern Ethiopia and northern Kenya. They are a pastoral group speaking a southern dialect of the Oromo language (fig. 4.2). According to the "History of the Galla," written at the beginning of the seventeenth century by a Christian monk (Bahrey 1954), they are one of the two major Oromo groups who have expanded from the southern part of present-day Ethiopia into the Ethiopian highlands, beginning in the sixteenth century. In the nineteenth century the Oromo controlled most of southern, central, eastern, and western Ethiopia, but they did not build a centralized empire. Rather, during the process of expansion they reproduced their own egalitarian society with only limited structural and cultural changes—the result of integrating autochthonous people into their society and adapting to new geographical environments. Thus the Borana, despite their strong cultural homogeneity with other Oromo groups and their incorporation into the Ethiopian Empire at the end of the nineteenth century, still regard themselves as a unique people. Their autonomous ethnic identity is expressed in various ways and contexts, including the distinct style of their milk containers (fig. 4.3).

The Artist

During our study of Borana milk containers our research team established a privileged relationship with Elema Boru (fig. 4.1). She was intro-

I would like to thank Neal Sobania for his comments on an earlier version of this essay, and Boku Tache Dida for checking the Oromo words to ensure that the spellings conform to the Qube transliteration system.

65

Fig. 4.2 Borana cattle grazing near the village of Olla Mamu.

duced to us by the people of Dolollo Makkala, located about twenty kilometers south of Mega, when we asked for a skilled milk container maker. We found her busy weaving a container, sitting on a stool outside her house. She immediately impressed me because, unlike other women, she did not pay much attention to us; she simply went about her work while replying to our inquiries with short answers. She was dressed in typical Borana fashion, in a colored cotton cloth imported from Kenya. Despite her age and the hardship she had experienced, which could be seen in her eyes, her thin but clearly strong body revealed an extraordinary energy.

Elema was born in Romso (located southwest of Mega) during the *gadaa* of Guyyo Boru, which, according to Asmarom Legesse's (1973: 190–91) *gadaa* chronology, corresponds to the period 1944–52.[1] After

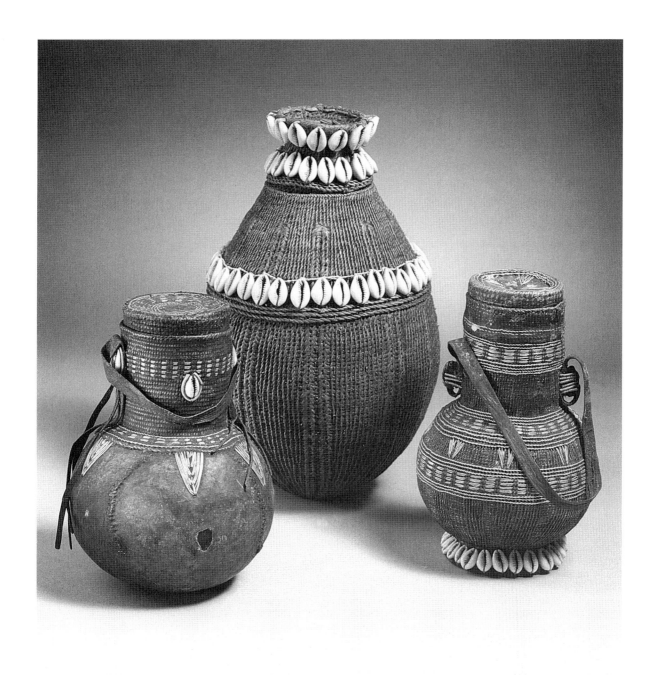

Fig. 4.3 Borana milk containers: the two flanking containers were produced by a neighboring Oromo people, the Guji; the container in the center is a *gorfa* made by Jilo Dido.

her marriage to her husband, Boru, at the age of fourteen, she led a conventional pastoral life, never moving very far from her birthplace. Elema bore three daughters. The lack of a son was probably the reason her husband married a second woman.[2] Eventually, Elema did give birth to the desired son and a fourth daughter. The relationship between Elema and Boru deteriorated and finally collapsed from the strain brought on by the 1983–84 drought. Boru stayed in a pastoral village with his second wife, looking after the few cattle he had left. Elema was forced to find refuge in the Dolollo Makkala camp for destitute pastoralists, where they are assisted by national and international organizations. She has been living without any cattle, surviving on food brought by relief agencies, on agricultural activity performed with the help of her son and unmarried daughter, and on other occasional sources of income. In Dolollo Makkala she built, like most other inhabitants, a house different from the traditional Borana dwelling and more suitable to permanent settlement. It is round with a central pole supporting the sloping roof, and the solid wall was made by plastering a mixture of mud and cattle dung over a wooden inner structure, instead of by covering intertwined twigs with grass, as in the traditional house.

The Limits of Creativity

The main characteristics of Borana milk, butter, and water containers are described in the table (also see pl. 4). A precise classification with given standards clearly exists. When a person decides to make a new container, she or he thinks about one of the prescribed categories and the specific characteristics associated with that category (e.g., material, shape, size). The person also must consider the gender distinctions associated with container making (this topic will be discussed at greater length later in the essay).

Several times I have asked Borana women and men why a given milk container must have a certain shape; the most common reply was simply, "*aadaa.*" *Aadaa* may be translated in many ways, depending on context; basically it has to do with the notion of a norm, a custom, or tradition. A more general translation might be "cultural heritage," because in all contexts the word describes something that is part of the common legacy of the community and that is transmitted from generation

Milk, Butter, and Water Containers of the Borana

Type	Use	Gender distinctions	Material and workmanship	Shape	Capacity (liters)
gorfa[a]	Storing fresh milk or curdled milk; ritual; making butter[b]	Made and used by women	Woven natural fiber, decorated mainly with cowries	Upper part: truncated cone; lower part: an oval truncated above the midline	2–5
ciicoo[a]	Storing fresh milk or curdled milk; ritual[b]	Made and used by women	Woven natural fiber	Round horizontal sections, oval vertical section	1–2
golondii	Carrying milk or water on journeys[b]	Made and used by men	Carved wood covered with cow leather, leather-strap holder	Like a sphere compressed on top and bottom	0.8–2
soroora[a]	Storing and carrying fresh milk, curdled milk, or water; making butter[b]	Made by men,[c] used by women	Carved wood, decorated with incised work; sometimes with woven natural-fiber neck	Sphere lengthened on top	1.5–3
buqqee	Simple milk container; also used as feeding bottle	Made and used by women	Gourd, simply dried; sometimes encased in leather	Gourd shape	0.4–2
okolee	Open milk and water container used for milking and drawing water from wells	Made by men, used by men and women	Two pieces of giraffe skin sewn together with skin and slowly dried by smoking[d]	Cylindrical with round lower corner, able to stand	3–7
okolee qadaadaa	Holding and carrying milk	Made by men, used by men and women	Same as okolee but with wooden lid and leather-strap holder	Cylindrical with round lower corner	ca. 1
dibbee[e]	Storing butter in the house[f]	Made by men used by women	Carved wood, with incised decoration	Open spaces between an ovoid main body and a base	0.5–2
doola[g]	Storing butter in the house for long periods	Made by men,[c] used by women	A single piece of oryx skin;[d] sometimes having a woven natural-fiber neck	Corrugated sphere with cylindrical neck	3–8
budunuu dhadhaa or mooyyee qayyaa[e]	Storing butter; pulverizing and mixing scents with butter (cosmetic)	Made by men, used by women	Carved wood, with incised decoration	Same as dibbee	0.2–0.5
buuda	Storing aromatic butter used to smear the hair of women	Made and used by women	Section of cattle horn closed at on bottom and top with leather	Cylindrical	0.2–0.5
buttee okollee[g]	Fetching and storing water	Made and used by women	Woven natural fiber	Same as ciicoo	8–25
buttee[g]	Fetching and storing water	Made by men,[c] used by women	Carved wood, with a woven natural-fiber neck	Same as soroora	8–25

[a]The container is encased in the *seephani* holder, consisting of leather straps, sometimes adorned with cowries. Straps are used to secure the lid and to suspend the container. [b]Also used to carry milk to market for sale. [c]The natural-fiber neck is made by women. [d]Sometimes the thickest part of ox or bull skin or the skin of another wild animal is used. [e]Leather straps are used to secure the lid, passing between the base and the main body and through openings on the wooden lid. [f]Also used to carry butter to market. [g]The *cancala* semispherical frame is used for holding the container; the *cancala* is made with wood twigs and leather straps. The container and the lid are tied with straps to the frame.

to generation. Very often the term *aadaa* is uttered in association with *Booranaa*—*aadaa Booranaa*—thus underscoring something that distinguishes the Borana cultural heritage from other people's.

Within the broad categories described in the table, the maker has room for personal choice. For example, we spent a lot of time observing the work of Didi Hukka, a very well known carver living in Dolollo Makkala (fig. 4.4). Didi explained that he learned the patterns of incised decorations on wooden containers from his teacher but later modified them according to his own wishes and to the demands of the market. Regarding woven milk containers, Elema Boru told us that she can freely combine a number of weaving styles to give to each container a unique surface design. She showed us a number of containers she had made, all different from each other.

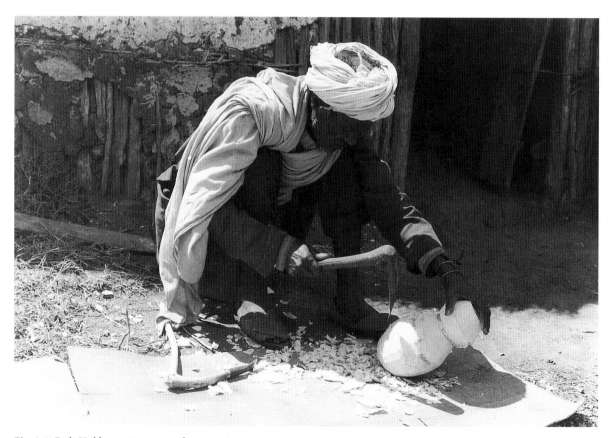

Fig. 4.4 Didi Hukka carving a wooden container.

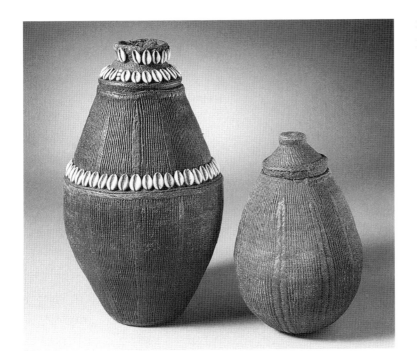

Fig. 4.5 A *gorfa* and a *ciicoo* made by Elema Boru.

An individual can also decide to make a container that dramatically varies from the norm. One day Elema Mamu showed our research team a *gorfa* that was spherical and much smaller than usual (pl. 5, left). She justified this "deviation" by saying that she made it as a toy for her small daughter. However, when asked why she did not maintain the typical proportion between the upper and lower parts, she admitted that she had seen her mother make a similar *gorfa* and simply liked the shape.

Let us assume that many people admire the "nontraditional" *gorfa*, as our research team did. In this case there is no reason why other women should not reproduce the spherical *gorfa* in response to the new demand. The *gorfa* type of milk container may, in this way, evolve into a wider range of possible shapes, and eventually a new type of milk container, with its own name, may result. It is perhaps through just such a process that the *gorfa* and *ciicoo*, which are rather similar in shape, material, work-manship, and size, became differentiated, especially when cowrie shells became more accessible in the area (fig. 4.5). A creative act by an individual may thus become part of the cultural legacy of the community, its *aadaa*. The concept of *aadaa* does not exclude change.

Every Woman an Artist

Gender and Container Making

Among the Borana there is a strict sex distinction in container making. Wood carving is restricted to men. Consequently, all carved containers (*soroora, golondii, dibbee, buudunuu dhadhaa, buttee*) are produced by men (fig. 4.6). Similarly, weaving is restricted to women. All woven containers (*gorfa, ciicoo, buttee okollee*) are therefore made by women (fig. 4.7). During my long stay among the Borana I did not record a single exception to this rule.

Working with skin, especially that of hunted wild animals, is also a male prerogative. Containers like *okolee, okolee gadaadaa,* and *doola* are therefore made by men, but I have sometimes seen women smoke-drying

Fig. 4.6 Borana wood containers (left to right): *dibbee, soroora, buudunuu, soroora.*

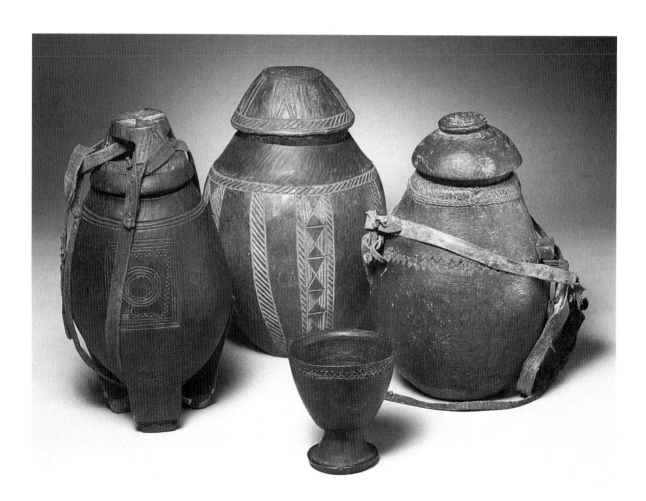

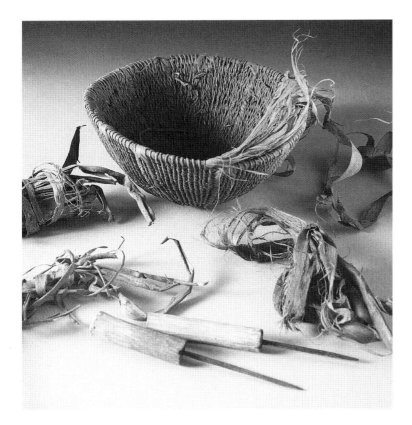

Fig. 4.7 Beginning of a *ciicoo* by Elema Boru and a selection of fibers and awls used by Borana women for weaving milk, butter, and water containers.

animal skins. Lastly, small containers like *buuda*, made with a section of cattle horn closed at the top and bottom with cowhide, and *buqqee*, made from a dried gourd, are produced by women.

Some containers (*buttee, soroora, doola*) involve both carving and weaving or working with skin. They therefore require the work of both a man and a woman, usually husband and wife, or at least family members living in the same household. Such containers reflect a recurrent feature of Borana society: the differentiated but complementary roles of man and woman, whose effect is that a man cannot live without a woman and, conversely, a woman cannot live without a man. Men are associated with all activities involving relations with human groups outside the family, whereas women have full responsibility for all domestic activities. Cattle, central to Borana culture, exemplify this set of relations. Cattle belong to men. They can be exchanged or given as gifts

or loans beyond the family boundary and yet have to be protected from outsiders. The milk produced by cows, which provides for the family's subsistence, falls within the domestic sphere, and consequently, women both milk cows and are considered the absolute owners of milk.

Milk containers, particularly woven milk containers that are used for storing milk inside the house and are therefore part of the domestic sphere, fall within the female domain (see Dahl 1990; Prussin 1987). We find, in fact, another very important gender difference in container making: although the male container maker is a specialist, in that only a few men are able to carve, all Borana women are expected to know how to make woven milk containers. The superior cultural value attributed to containers made by women becomes evident when the ritual meaning of woven milk containers is considered.

Milk Containers and Ritual

Most Borana ceremonies include ritual practices that involve the use of woven milk containers. To my knowledge carved containers serve no ritual role. During the name-giving ceremony for a firstborn male, called *gubbisa*, every participating married woman brings a *gorfa* full of milk or *itittuu* (curdled milk) and hangs it on a section of the *galma* (the large ceremonial house) roof. During such ceremonies one often sees more than a hundred *gorfa* hanging together. One after the other, the *gorfa* are taken to feed the guests, who continue singing through the night. Just before sunrise a bull is slaughtered. Part of the meat is cooked and eaten by the guests. Some is put on top of the *galma* and later taken away by a *waata* (ritual assistant belonging to the hunter-gatherer caste) and by a *tumtuu* (blacksmith). A third portion is divided into small pieces which are tied to each of the *gorfa* once they have been emptied. Every woman returns home with her *gorfa* and a share of the meat. Similarly, before every sacrifice, which occur at all important ceremonies, a small amount of fresh milk is poured on the lid of a *ciicoo* and offered to the sacrificial animal.

As mentioned by Father Leus (1988) in his dictionary, on the occasion of the *gadaammoojjii* ceremony (a rite related to the complex *gadaa* generation-class system of the Borana), the *gadaammoojjii* elder will receive from a sister a *ciicoo* containing fresh milk. In return she receives

a cow, which is called *dhibaayyuu*. A small amount of fresh milk is poured from a *ciicoo* on the ground on several other occasions, including during the *dhibaayyuu* rite, which occurs at a well before the beginning of its seasonal utilization, and during the *soodduu* ritual, which commemorates a death.

When used in ritual, *ciicoo* and *gorfa* are called respectively *miyyu* and *madaala*. These two terms indicate both the container itself and the milk or curdled milk that must be inside. For the Borana, milk and butter serve as metonymic symbols of abundance. The containers themselves also have symbolic meaning. They are woven. When a girl marries, she makes two plaits in her hair. When she becomes pregnant, all of her hair is plaited. Only women can do the job of weaving. All this seems to indicate that weaving in Borana is associated with fertility. Thus, the container and the milk inside it symbolize the ideal combination of fertility and abundance, two fundamental prerequisites for the reproduction and prosperity of the group.

Woven milk containers, however, are not merely objects necessary for the performance of some rituals. When a bride is taken to the groom's village (*intala fuudhuu*, "marriage," literally "to take the girl away"), she must bring a *miyyu* (a *ciicoo* containing milk) with her. This container was made by the girl's mother when the latter decided it was time for her daughter to marry. The making of such a container provides a very clear message to the community and signals that the engagement process can start. On one occasion, many years ago, my closest friend's daughter called me to her house. She showed me the *ciicoo* that her mother was weaving and explained that it was for her marriage. This was a very direct courting gesture—a message that I should contact her father and ask to marry her before someone else (someone she didn't like) did!

The association between *ciicoo* and marriage is so strong that it is believed that giving away a *ciicoo* made for marriage will bring great misfortune on the daughter's marriage. Any action involving the *ciicoo* represents an action in the marriage, as is evident in the funerary ritual of a married man. At death, the corpse is buried very deeply, with many stones piled in a cylindrical configuration atop the grave. Some of the dead individual's most significant personal objects are broken and put on top of the stones, including the *ciicoo* of his first wife, which is cut

in two. At death, the man's reproductive capacity ceases; his wife's *ciicoo*, which both stands for and promotes reproductive capacity, no longer has any reason to exist. But why is the *ciicoo* of the first wife chosen? In Borana the firstborn male of the first wife, *angafa*, inherits all the special rights and prerogatives of his father. In all respects the *angafa* takes over the social position of the dead man, thus representing his social continuity in the group.

When a married woman dies, her *gorfa* is cut and put on top of the stone burial mound. At marriage, the family of the groom has to present at least one *gorfa* to the newly established family.

Woven milk containers, therefore, metaphorically represent the reproductive capacity of the family. No wonder Elema Boru refused to sell the *ciicoo* from her own marriage and was reluctant to sell the *ciicoo* she had already completed for her last daughter's marriage (fig. 4.5, right).[3]

The physical reproduction of a man, hence the reproduction of the society, depends on his wife's fertility;[4] similarly, a man's marriage, the social setting for reproduction, depends on women-made objects. Simply put, there cannot be any marriage without a *ciicoo* and there cannot be any reproduction without woven milk containers. That is why every woman must be able to make milk containers. Woven milk containers represent her own fertility. They are round, full of milk and nourishment, just like a pregnant woman—inside the woman's womb is a life that will sustain the social continuity of her husband and family. The identification of the woven container with the female body is again stressed, in my opinion, by the cowrie shells attached to the *gorfa* container, symbolizing, by formal analogy, the vagina.

Woven Milk Containers: The Learning Process

Elema Boru explained that she started to learn the art of weaving at the age of ten. She watched her mother, and when she felt like it, she asked her mother to allow her to weave. Her mother first guided her in the basic work of weaving, allowing her to make only a few stitches. With increased practice she was allowed to assume a greater share of the work, and at the same time her mother taught her the other lessons associated with container making, including the identification and collection

of materials, the techniques for maintaining the almost perfect symmetry of the container, and the methods for proper decoration. When she married and left her mother's house, she was not yet an accomplished container maker. Only with further practice did her skills improve. In time she began to supplement the basics learned from her mother with ideas of her own.

Each woman we asked confirmed that she had learned the art of container making from her mother or from a woman she had lived with prior to marriage. Jilo Hola, a woman who was making a *gorfa* during our last visit to the Borana, showed us how she was teaching Elema, her twelve-year-old daughter. Although Elema was quite adept at working on her mother's *gorfa*, she had not yet completed anything by herself. Maintaining the proper shape and proportions can be achieved only when someone is extremely skilled and knowledgeable.

Making woven milk containers is, therefore, part of the daily educational process, learned by every woman before marriage, in the same way milking, collecting firewood, and making butter are learned.

Milk Containers as an Exchange Commodity

Most often women make milk containers for their own families, either for daily use or for the marriage of their daughters or sons. It is, however, not only recognized but also ritually prescribed that they may also make them for relatives outside their own nuclear family, as in the already mentioned case of the *gadaammoojjii* ceremony.

To give an example, during her lifetime Elema Boru has produced two *gorfa* for her own use, three *ciicoo* for the marriage of her three daughters, and several other milk containers for her male and female relatives. She explained that she never sold milk containers for cash. Instead, she acquired *galata*, a sign of gratitude, consisting of either women's clothing or a cow. The same pattern of exchange was confirmed by the other women interviewed. Again, in this respect woven milk containers differ sharply from the containers carved by men, which are regularly sold in the market.

Jilo Dido, who claims to have made about thirty milk containers in her life, explained that she sold for cash five woven containers to CARE International, a development and relief organization. This new practice

was introduced recently by CARE International as a means of alleviating poverty. Jilo explained that all commissioned milk containers have been resold outside the Borana region.

It is very interesting to analyze the goods given as *galata*. If a relative needs a milk container, it means that he has enough cows and therefore can afford to give either a cow or clothes. On the other hand, a woman will agree to make a milk container if she is in need, particularly if she needs cows to reconstitute a lost herd. Thus, the practice of giving milk containers outside the nuclear family is one of many mechanisms for redistributing wealth among the Borana. A man whose wife is a skilled milk container maker has an additional resource for reconstituting his herd in time of need. The husband, who possesses property rights to the incoming cattle, will derive most of the benefits from his wife's work, but the wife also will acquire prestige and power in her relationship with her husband.

From this perspective, CARE's activity is a logical extension outside Borana society of a traditional internal mechanism for reconstituting herds. It has proven effective during the present difficult situation of generalized destitution, when no Borana family needs extra milk containers and no family is in a position to give cows away.

Making Woven Milk Containers

As previously noted, there are two types of woven milk containers, *gorfa* and *ciicoo*. They are both made with the same materials and the same weaving techniques. But they differ in shape, size, and decoration.

Three types of natural fiber serve as the basic material for weaving (fig. 4.7). *Suxaa* (pronounced "suta") provides the core material for all the milk containers. It is derived from the bark of small branches of the *qararrii* tree (*Sterculia africana*).[5] The *suxaa* fiber is woven with either *ergamsa* or *holotaa*. The word *ergamsa* signifies both the small plant and the fiber made from its root. *Holotaa* is the name of both the thorny small tree itself and the fiber derived from its root. A fourth type of fiber, *okollee*, is obtained from the root of another small tree, but it is only used for the *buttee okollee*, a big water container.

These plants are all found in the Borana lowlands (the southeastern and southwestern fringes of Ethiopian Boranaland and in adjacent regions

of Kenya). The women living in the higher territories, especially in the area between Yavello, Arero, and Mega, have to either spend several days traveling to find the plants or buy the fibers in the markets, where they are rather expensive.

Elema Boru showed us the weaving technique. A number of *suxaa* fibers are bunched together to form the horizontal coil that moves in an upward spiral from the base, where all woven containers begin. Small pieces of *holotaa* or *ergamsa* fiber are wrapped around the *suxaa* at regular intervals on each horizontal row so that they form decorative vertical lines on the container surface. The diameter of the container increases as the weaving progresses from the base to the middle and then decreases from the middle to the top. To maintain parallel vertical lines it is necessary to occasionally add or drop a *holotaa* or *ergamsa* stitch. Working from the base, as the diameter increases the weaver, at a certain point, will have to add a new *holotaa* or *ergamsa* stitch and thus begin a new vertical line. Conversely, as the diameter decreases toward the top of the container, she will have to drop a stitch at some point. This technique results in unique raised surface patterns on every container.

The work is done with two different kinds of awls (fig. 4.7). Once the *ergamsa* or *holotaa* tuft is passed over the *suxaa*, it must be turned down inside the container and passed through the already woven surface from inside out. A hole is made with a sharp awl, called *mutaa waraansaa* (the awl of the hole). The second awl, *mutaa midaa* (the awl to make), has a notch cut into its point. It is passed through the hole from the outside and is used to catch the fiber and pull it through the hole. Both awls are made by local blacksmiths, the *tumtuu*, and are easily and inexpensively obtained in the market.

There are two primary weaving techniques: *baballoo* and *micciirroo* (from *micciirru*, "to twist"). The *baballoo* style involves simply passing the fiber around the *suxaa*. The second style requires twisting the fiber before passing it around. The second style results in a tighter weave, and the decorative vertical lines are thinner. Of course, the *micciirroo* technique is more time-consuming.

Usually *ergamsa* fiber is used with the *micciirroo* style of weaving. The *baballoo* style is usually adopted when *holotaa* fiber is used. The reason is quite simple: the *holotaa* fiber is much stiffer, and if it is to be twisted,

it must be soaked in water for a few hours to soften it. The combination of the *micciirroo* style and *holotaa* fiber, however, is considered the best work, but our research team saw only a single example of such a container, a *gorfa* made by Elema Mamu (fig. 4.8).

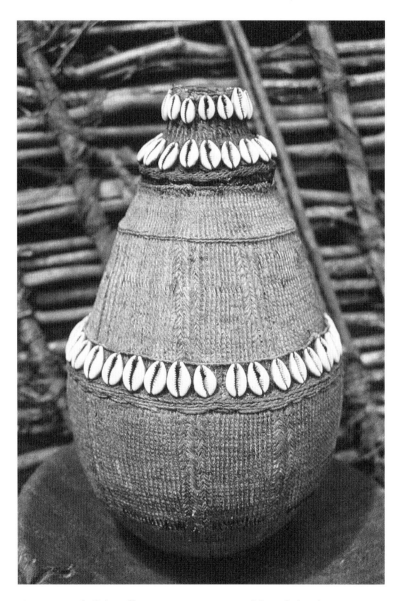

Fig. 4.8 A *gorfa* (*holotaa* fiber woven in *micciirroo* style) made by Elema Mamu.

To supplement the aesthetic impact of these basic weaving techniques, the surface of both *gorfa* and *ciicoo* may be enriched with the *oobrisa* decoration. This consists of a number of thicker vertical lines made by means of cross-stitches. Although most women are able to make only one type of *oobrisa*, Elema Boru showed us two different containers having different types of designs (fig. 4.5, right and left). The first design, very common, is called *oobrisa looni* (*oobrisa* of the cattle). The second one is *oobrisa qeenc'a tarri*, meaning the *oobrisa* of the dik-dik hoof, because it resembles a dik-dik hoofprint. Elema mentioned that she knows at least five different *oobrisa* motifs. The *oobrisa* decoration is associated with the *micci-irroo*, or "twisted," style. Although Elema Mamu claims that it is in theory possible to integrate *oobrisa* on a *baballoo* background, our research team never saw such a combination. It is very likely that the *oobrisa* would lose its decorative effect on the *baballoo* background because of the latter's characteristic thicker vertical lines. Because *holotaa* fiber is usually worked in *baballoo* style, it is also very unusual to see *oobrisa* on a *gorfa* made from *holotaa*. The only exception we observed was the *gorfa* mentioned earlier made by Elema Mamu.

When available, women like to weave giraffe tail hair, *marxa* (pronounced "marta"), into the *gorfa* surface to add a black decoration. This is especially common on *baballoo gorfa*, to enrich their otherwise subtle surface. Recently, colored plastic cord has begun to replace the *marxa*, because plastic is more readily available and because it is perceived as having a greater visual impact. For instance, one can see blue plastic thread used in the unusual spherical *gorfa* made by Elema Mamu (pl. 5, left).

Beyond the basic differences in weaving technique, *ciicoo* and *gorfa* milk containers also differ in other respects. For example, the *ciicoo* is smaller than the *gorfa*. Its beauty lies in its symmetry, its simple but elegant elliptical profile. The lid, called *gadaada ciicoo*, does not break the continuity of the profile. Cowries are used to decorate *gorfa* but are never attached to *ciicoo*. This is probably due to the fact that the profile itself is regarded as having significant aesthetic impact—it would be spoiled by high-relief decoration. Elema Mamu showed us the *ciicoo* made for her marriage. Its *baballoo* pattern displayed diagonal, rather than the more common vertical, lines. She explained that this *ciicoo* was started as a *gorfa* and at some point her mother turned it into a *ciicoo* for Elema's marriage (perhaps,

while her mother was working on the container, someone asked to marry Elema). The parallel diagonal lines are, according to Elema, old-fashioned. The effect, to our eyes, was very pleasing, because it gives more movement to the plain surface. But the Borana seem to be of the opinion that such extra effects on a small container's surface are visually too busy. On the other hand, diagonal lines are the norm in the large *buttee okollee* water containers, which otherwise have exactly the same shape as *ciicoo* and are devoid of any relief decorations.

Whereas the *ciicoo* may be characterized as a single-volume shape (i.e., there is a continuity of line in all directions), the *gorfa* is composed of two volumes. This is probably due to a perceived aesthetic necessity to visually break the larger form at some point. The lower portion is similar to the *ciicoo*. The elliptical form, however, ends slightly above its midpoint. The lower part is called the *labagaadi* (down from *laba*); the *laba* is a horizontal band of *ergamsa* or *holotaa* stitches. *Laba* is, according to everyone we spoke to, a required element of all *gorfa*. The upper section, called *morma* (neck), is a truncated cone surmounted by a lid. There is a standard proportion between the lengths of the lower and upper parts, which the Borana measure using reference points on the palm of the hand to particular finger joints. Elema demonstrated this and noted that there can be two different sizes, with different points on the palm used as reference. To ensure that the proper proportions are maintained, Borana women can either measure or estimate, depending on their skill and experience at weaving. About one or two centimeters above the *laba* another horizontal band should be woven using either *ergamsa* or *holotaa*. Slightly smaller than the *laba* itself, this woven band is called *riftoo* and is considered another constitutive element of a *gorfa*.

The function of both *laba* and *riftoo* became clear when we observed Jilo Dido fixing the cowrie shells, *elellaani*, to the surface of a *gorfa* (fig. 4.9). The cowries are sewn with giraffe tail hair, *marxa*, to the *riftoo* and *laba*, which serve as structural supports for attaching the shells. Jilo selected each cowrie very carefully, so that each was the same size. Before affixing them side-by-side, she punched a hole through the round part of the shell using one of the awls. The circle of cowries on the *laba* sharply demarcates the lower from the upper part of the *gorfa*, a division that is the primary characteristic of the *gorfa* design. Cowries also have a spe-

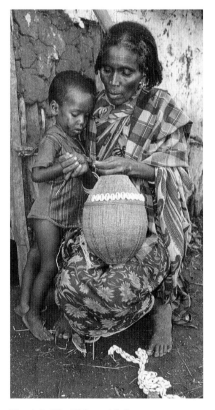

Fig. 4.9 Jilo Dido, with her young son looking on, attaches cowries to a *gorfa*.

cial place on the *gorfa* lid (*gadaada gorfa*.) The lid has a horizontal line of either *holotaa* or *ergamsa* stitches, called *laba qadaadaa*, on which cowries can be sewn.

Many *gorfa* have no cowries, usually because the maker had problems obtaining the shells. Cowries are expensive (they are bought in the shops or markets of the large towns), and they are not necessary for the utilitarian function of the container. A woman often starts using a container before she has added the shells. Whenever we asked a woman why she had not added cowries, she always replied that she was going to do it soon.

Because they have round bottoms, *gorfa* and *ciicoo* cannot stand on their own, with a few exceptions.[6] Each must have a holder, *seephani*, made out of several leather straps. The straps are used both for tying the lid down and for hanging the container on the house wall. The holder, which is made by the woman owning the container, may or may not have cowries (fig. 4.10). The *cancala*, a semispherical frame, is used to hold the *buttee okollee*, a large water container.

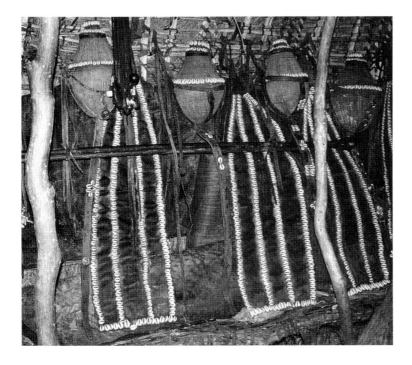

Fig. 4.10 Four *gorfa* hanging in the house of Elema Mamu.

Making a woven milk container takes a long time. It is usually done when there is free time. Elema told us that it takes her about one or two years to finish one. Of course, it could be completed more quickly if she dedicated more time to it, but even if she worked on it every day, it would probably take three or more months to finish one.

Daily Use

Despite their ritual functions, *gorfa* and *ciicoo* are basically objects of daily use, just like carved-wood milk containers. Milk is taken from the cow using an *okollee* container set on the ground. The milk is then poured into a closed container (*koddaa* is the general term for all small storage containers with lids). Since new milk is never added to old milk, an empty container must be found. However, before use, all empty containers have to be cleaned and purified.

The cleaning operation, called *qoraasuu*, is performed shortly before milking. The container's owner (a woman) puts pieces of aromatic wood or of charcoal made from this wood on the fire until they become hot (*qoraasuma*).[7] Meanwhile she pours a little water inside the container. Using a stick with a cut at one end, she picks up a *qoraasuma* and drops it into the container. The contact with the water immediately produces a lot of steam. The woman closes the lid and turns the container end to end with rhythmic movements so that the charcoal comes in contact with all the interior surfaces. When the charcoal is completely extinguished, she puts it back in the fire. She again adds a little water and takes another piece of hot charcoal. The operation is repeated at least six times for each container.

The *qoraasuu* operation burns the inner surface, which becomes black, dense, smooth, and aromatic. The operation completely purifies the container and gives the milk a wonderful fragrance. It may also aid in its preservation and its transformation into curdled milk.

Once the milk is put into the purified container, it is stored by hanging the container on the back wall of the house (fig. 4.10). Some milk is drunk fresh within a couple of days; some is stored. Slowly, it turns into itittuu, curdled milk. *Itittuu* lasts for several weeks. Before the *itittuu* is consumed, it is mixed with a special stick, called *irbaa*.

Borana milk containers provide a wonderful environment for pre-

serving milk. Woven natural fibers allow both transpiration and evaporation, which lower the temperature of the liquid. Wooden containers allow some transpiration and thermal isolation.

If there is enough milk, some of it is used for making butter. Both *gorfa* and *soroora* can be used, but the latter is considered the more appropriate container. Some *soroora* have a lid with a small hole, kept closed with a piece of resin. The container is filled to three quarters of its capacity with milk. The woman, sitting on a stool, holds the container on her lap and rhythmically shakes it back and forth. She regularly stops to open the hole on the *soroora* or to partially open the lid when using a *gorfa*, to allow air to escape. The butter is collected from the surface of the liquid and stored in special butter containers (see table) and later used either as food, to fry coffee beans, or as a cosmetic.

All the small containers categorized as *koddaa* are also used for carrying milk to market for sale. The *golondii* is made and used only by men. It is not used for storing milk but is ideal for carrying milk or water on long journeys. It is used, for example, in the mobile cattle camps (*foora*), when young boys take the livestock from place to place, traveling without shelter for several months, or on raids, when warriors may have to walk several days with little time to rest and eat.

Evaluation Criteria

Since all milk containers are different, they are subject to evaluation by the community. This process, as already discussed, will influence the evolution of the object type. The Borana distinguish between functional and aesthetic evaluation criteria. For example, when Elema Boru showed us her *gorfa* made with *holotaa* fiber (fig. 4.5, left), she explained that *holotaa* is better than *ergamsa* both because it lasts longer (functional criterion) and because of its reddish color (aesthetic criterion).

Most of the newly made containers conform to certain canons pertaining to shape and media. The artist, however, must always make aesthetic choices, such as those regarding incised decoration (wooden containers) and raised design (woven containers). The implication is that whereas all containers are subjected to aesthetic evaluation, functional evaluation applies only to those containers that sharply deviate from shape, size, or material standards. The case of the introduction of

plastic cord is an interesting one. At one level, the cord is an aesthetic innovation, and yet on another level, plastic is functionally incompatible with the practice of burning the internal surface of the woven milk container. Which evaluation criterion will prevail? Will the new practice survive or will it be abandoned?

In order to better understand the aesthetic criteria, our research team presented three different woven milk containers for evaluation to a group of women in the village of Sallo, a traditional Borana village located south of Mega, less than sixty kilometers north of the Kenya-Ethiopia border. All three containers were, to our untrained eyes, equally good. To be honest, until that day we had no idea how to judge a container.

Each woman took the first *gorfa* and checked the proportion between the upper and the lower part using the palm-of-the-hand-to-finger measurement. After a more detailed examination, they all agreed that it was a decent *gorfa*. When asked why, they replied that everything was there: good shape, *marxa* (black decoration), *elellaani* (cowries). They also admired the long neck, which was evidently longer than the standard measurement. In short, they said, nothing was wrong with it, which, in Borana society, is a diplomatic way to say that it was nothing extraordinary.

They observed that the second *gorfa* was made by an expert, someone with a good hand and a lot of practice. However, they did note that it lacked cowrie shells. The women all agreed that the third container, a *ciicoo*, was the best. I actually could not see any difference from the other containers and, therefore, I again asked why. They explained that its lines were straight and evenly spaced. In conclusion, they said, all three were nice—but, they added, even in their village there were containers better than the three we had asked them to look at.

In order to gain a better understanding of what is unacceptable, we asked to see a poorly made container. After a short discussion, the women sent a girl to get a *gorfa* (fig. 4.11). When it was presented to the group, everyone started laughing—even I could see that it was not a good container. The surface was uneven, the decorative *ergamsa* lines were irregular, and the general shape was awkward. After this encounter with a poorly made *gorfa*, Qabballe Elema, our host, showed us her own *gorfa* as an example of excellent work (fig. 4.12). The contrast was very apparent: it had an elegant profile and straight, thin, and tightly rolled lines

that were regularly spaced, and the surface was very smooth. Each line was a perfect arc.

Clearly, different people tend to agree on the aesthetic evaluation of milk containers. A technically perfect execution is the most appreciated quality, even more than the richness of decorative motifs. But technique and functionality are closely tied to the overall aesthetic. In their judgment, Borana women are guided by models, by the ideal of what a certain container should be. There are, however, an infinite number of possible aesthetic choices within a technically perfect execution. The model is itself flexible.

To summarize, milk containers are basically objects of daily use that are the result of a dynamic interaction between the group's cultural heritage and the individual's creativity. They reflect a continuous process of both aesthetic and functional innovation (mainly by individuals) and evaluation (mainly by the group). Within this framework, woven milk containers have assumed a special symbolic and ritual role among the Borana.

Fig. 4.11 Example of a poorly made *gorfa*.

Fig. 4.12 Example of a well-made *gorfa* woven by Qabballe Elema.

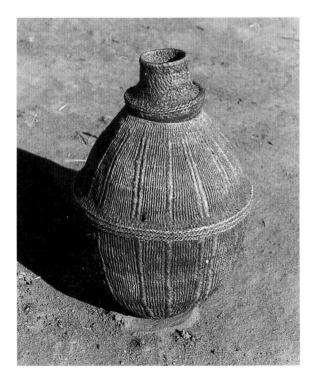

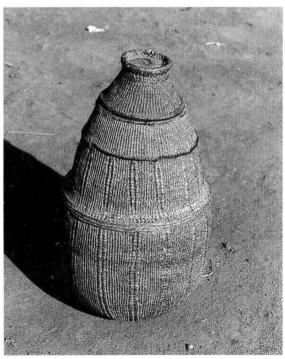

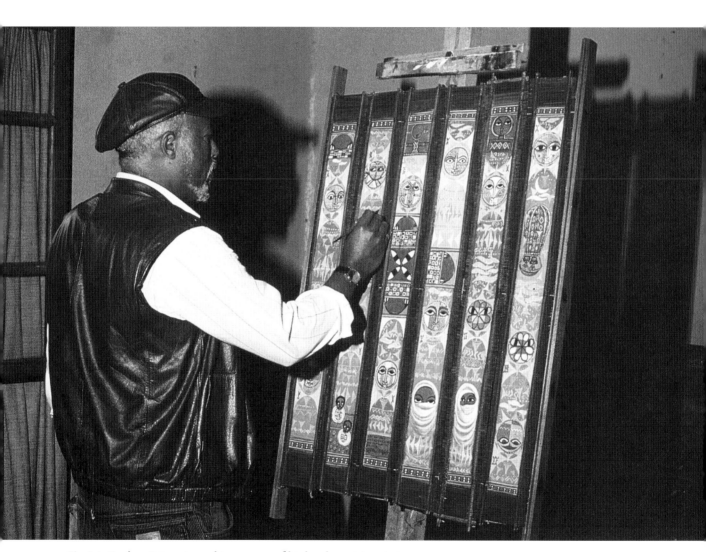

Fig. 5.1 Zerihun Yetmgeta working on one of his bamboo-strip paintings.

Zerihun Yetmgeta and Ethiopian World Art 5

Elisabeth Biasio

Back to the Roots!

I met Zerihun Yetmgeta for the first time in 1986, almost accidentally. I was engaged in research on contemporary traditional painters in Addis Ababa, and I had been asked to bring Zerihun a videocassette by one of his friends living in Zurich. When I first saw Zerihun's work, I was struck by the way he transformed traditional motifs into a modern idiom. When I prepared the 1989 exhibition "The Hidden Reality," which featured three Ethiopian artists, for the Völkerkundemuseum der Universität Zürich, there was no question that Zerihun should be represented.[1] Back in Addis Ababa in spring 1989, I became better acquainted with him, and since then I have on many occasions enjoyed his hospitality (fig. 5.1). Zerihun is a warm, open, and strong personality. His Western-style clothes, including a leather vest and a leather cap, express his free behavior as an artist. He does not care about suits and ties and he

An important basis for this essay were the interviews with artists and talks with directors of cultural institutes in the spring of 1993 in Addis Ababa. I would like to thank all those who helped me with my project, especially the following artists: Abebe Zelelew, Abdelrahman M. Sherif, Besrat Bekele, Daniel Touafe, Getachew Yossef, Leul S. Mariam, Lulseged Retta, Mezgebu Tessema, Samuel Sharew, Tadesse Mesfin, Taye Tadesse, Teshome Bekele, Tibebe Terffa, Worku and Barbara Goshu, and Zerihun Yetmgeta. Furthermore, I would like to thank Tadesse Belayneh (director of the School of Fine Arts), Jean-Michel Champault (Alliance Ethio-Française), Ms. Gugenberger (Goethe Institut), Giovanna Jatropelli (Istituto Italiano di Cultura), and Jacques Dubois (Ethiopian Tourist Trading Enterprise). Special thanks go to Dr. Peter R. Gerber, who accompanied me and took photographs for me. Many of his ideas have been incorporated in this essay. Thanks are also due to Sabine Barcatta, who translated this essay from the original German.

does not conform to the rigid social conventions of modern Addis Ababa. More than twenty years ago, Chojnacki characterized him as follows: "Above all, he wishes to be independent, free from complexes, free from the rigidity of positions and grades so rooted in Ethiopian society" (1973c: 89).

In 1989 Zerihun lived with his extended family in a small Western-style house surrounded by an uncultivated garden in Gullele, a section of northwest Addis Ababa. At that time he and his wife, Etagennyehu Welde, an Amhara from the region of Menz (Shewa Province), had three daughters: Eti (b. 1975), Leyu (b. 1978), and Ch'ora (b. 1985). In 1989 and 1990 Zerihun and Etagennyehu's two sons, S'egga and T'enya, were born. In 1990 the family moved to the bigger villa formerly owned by Etagennyehu's deceased mother. Etagennyehu's divorced sister, Eteme'alisha Welde, and her son have lived with the family for many years. She is the owner of a bar, which was given to her by her mother. Since 1990, a widowed sister of Etagennyehu, Te'egest Welde, who runs a small taxi business, and her daughter have also lived with them.

The new house is also situated in Gullele but is nearer the center of the city. To be invited for lunch in Zerihun's house is unforgettable—the Ethiopian meal demonstrates how deeply Zerihun and his wife are still rooted in tradition. The guest can try all the specialties: *injera* (pancakes made from t'ef, a millet-like cereal grown in the highlands of Ethiopia), *doro wet'* (chicken and eggs with hot pepper sauce), and t'ibs (roasted meat). After lunch, Etagennyehu or one of her sisters, wearing traditional Ethiopian dress, celebrates the coffee ceremony, and soon the smell of roasted coffee and incense wafts through the house. The children are rarely seen; they prefer to eat separately. But Etagennyehu joins us for the meal, and I like to talk with her. She is the owner of a small taxi business, and in 1991 she began a business selling African clothes designed by one of her friends in Nigeria. On 10 December 1993 at the Alliance Ethio-Française, Etagennyehu held her first fashion show, and Zerihun exhibited some of his paintings at the same time. Zerihun told me that it was a big success, and Etagennyehu plans to open a boutique. As in all middle- and upper-class families, a *mammite* (housemaid) and a *zebennya* (guard) perform a lot of the work around the house, so that not all the household duties rest on the wife's shoulders.

After lunch, Zerihun takes his guests to the studio he has built in the compound: a marvelous traditional round structure whose outer walls are decorated with motifs from magic scrolls. A finial similar to those atop churches crowns the roof; its metal bells ring mysteriously even in the slightest breeze (figs. 5.2, 5.3). Zerihun refers to his studio as his "church." The walls are covered with his works, and paintings are piled up in a small adjoining room, bearing testimony to his enormous creative drive (fig. 5.4).

Fig. 5.2 Zerihun's studio, exterior.
Fig. 5.3 Zerihun at the entrance to his studio.
Fig. 5.4 Zerihun's studio, interior.

After his first one-artist show in Addis Ababa in 1970, Zerihun had numerous exhibitions in Ethiopia as well as abroad.[2] In late 1991, he represented Ethiopian art at the Cuarta Bienal de la Habana at the Centro Wifredo Lam in Cuba with twenty of his works (Esseye Gebre Medhin 1991: 184–85; González Mora 1992: 6–7), and in December 1992, he exhibited two of his works at the DAK'ART 92 (second Biennale Internationale des Arts de Dakar) in Senegal, where his exceptional talents as an artist were recognized—he and the Senegalese sculptor Moustapha Dîmé shared the Prix de la Biennale (*Beaux Arts* Magazine 1992: 18; Anselmi 1993; Chauvy 1993). Zerihun's participation at the Kenya Art Panorama at the French Cultural Center in Nairobi in November 1993 was also a success. Zerihun was one of 110 participating artists from eastern, central, and southern Africa as well as from some Indian Ocean islands, and he won the second prize for one of his compositions on bamboo strips (wa Gacheru 1993).

Today, in international circles, Zerihun is probably the best-known Ethiopian artist, and his pictures find many admirers and buyers at his numerous one-artist shows in Addis Ababa. Some of his patrons have become his personal friends, visiting him regularly at his studio. The biggest and most important collection—more than forty works—is owned by Helene Sokoloff, an artist and art historian from Vienna who is currently living in Addis Ababa.[3] Thanks to her continuous patronage, the collection is representative of the artist's work. Another extensive collection was acquired by the Swiss physician Dr. Herman H. Waldvogel, who worked at the Black Lion Hospital in Addis Ababa from 1973 to 1976.

Zerihun's success can be explained in part by the fact that his work has the touch of "authenticity" (is viewed as truly Ethiopian and African) and is favored by a Western audience. Works in a purely Western style are often dismissed as imitative or derivative.[4] His inspirations, the high technical level of his work, and the complexity of media, techniques, and stylistic devices also find praise: Zerihun is a talented wood engraver; he also works with oil, tempera, acrylic paints, pen and ink, and mixed media on hardboard, canvas, skin, and wood. The multitude of his media of expression captured the attention of Stanislaw Chojnacki many years ago: "He started with woodcuts, of which his series

of the Passion of Our Lord is the best known, then he moved to painting. At first strongly influenced by Skunder's modes and moods, he then tried other styles, one of them consisting of integrating into a composition brightly-painted gourds and pumpkins; this method seems to be close in concept to Gäbrä Krestos' use of vividly-coloured cans" (1973c: 89). Zerihun's works in mixed media were especially lauded by Edmund Murray after Zerihun's first one-artist show at Addis Ababa City Hall in 1970: "Perhaps the most interesting works . . . were the several box-like structures in which carved and painted wood functioned both as a frame for the set-back canvas and part of the painting itself. Mixed media to achieve effects not possible in one medium alone is a significant innovation among modern artists" (1970: 46).

Zerihun Yetmgeta was born in Addis Ababa in 1941, the son of Orthodox Christian parents of Amhara-Oromo descent. His father, Yetmgeta Beleta, owned a small transportation business, and his mother was a housewife. Zerihun spent his childhood in different parts of the capital, where he accomplished his primary and secondary education. Asked how he became a painter, Zerihun relates that in boarding school he acquired the nickname "Scientist" because he was often found busy with some type of handicraft. When, at the age of fifteen, he won first prize in a national art competition, he sensed his destiny as an artist. Thus inspired, after Zerihun finished high school, he enrolled in painting classes at the Empress Menen Handicrafts School for one year and then studied at the School of Fine Arts in Addis Ababa from 1963 to 1968. The first artist who made a lasting impression on him was the German wood engraver Hansen-Bahia (Karl Heinz Hansen), who had initially emigrated to South America in 1949 and later moved to Addis Ababa, where he taught graphic arts at the School of Fine Arts from 1963 until 1966. Zerihun was fascinated by his expressive, colored woodcuts, and the young artist was greatly saddened when Hansen left Ethiopia. Zerihun admired his second teacher, Gebre Kristos Desta, for his free use of colors. Zerihun believes that Gebre Kristos is Ethiopia's greatest artist. Zerihun teamed up with Skunder (Alexander Boghossian), whose work fascinated him, and they worked together in the same studio. Zerihun claims that the interaction with his teachers was more a mutual exchange of ideas than a one-sided influence: "One recognizes Hansen's technique

in my woodcuts; nevertheless, I attempt to find my own way. Skunder and I worked together in the same studio, where we used to share our ideas. The result was a mutual, creative process."

After his graduation, Zerihun chose to stay in Ethiopia and has been teaching graphic arts at the School of Fine Arts since the early 1970s. He deliberately did not attend a foreign art school to continue his studies, unlike many of his contemporaries. In an interview with Sebhat G. Egziabher, he explained: "Had I studied abroad, my studies, which know nothing of Ethiopian art, would have filled me with rules and beliefs which would prevent me from being fully Ethiopian and unabashedly African, which is to say I would not have been able to be fully myself as an artist" (1983: 20).

Although Zerihun never studied abroad, he does travel often. On the occasion of exhibitions in Africa, Europe, the United States, and Cuba, he has been invited for openings and workshops. Zerihun travels with an open mind and an open heart, and he likes to experience other realities and to converse with people of other countries: "Wherever I go, I always have an explosion of my mind." He liked Zurich "because all was so bright and clean" and he transformed his impressions of the city and the exhibition into the painting *For Memory*.[5] In the foreground, the canvas shows the three artists represented in the exhibition in a wooden boat on Lake Zurich: Zerihun in the middle, Worku Goshu on his right, and Girmay Hiwet on his left. In the background, the clean streets and houses of the city can be seen, rendered as paintings of the respective artists, and at the top of the composition is one of Zerihun's bright Ethiopian suns. Zerihun was also fascinated with the rich supplies in the shops, and he enjoyed buying pigments and other painting materials not available in Ethiopia. In Dakar Zerihun was impressed by the strong feelings of identity that Senegalese artists have as Africans, and he believes that some of these artists are freer than Ethiopians. In his opinion, the Ethiopian Orthodox Church is responsible for this: "Ethiopian religion always puts you down, calms you down. It is a big chain around your mind psychologically. So, one has to break out. That is the difference between Ethiopian and West African artists."

In spite of his traveling, Zerihun derives his cultural identity from his home country, Ethiopia, without losing sight of the connection with

Africa as a whole. His work is centered on these two thematic points of focus, and Zerihun, much like Cheikh Anta Diop, stresses the unity of Africa and links Ethiopia to the other African countries in his evolutionary theory: "African art, mostly Black art, is important in my work. Man and early civilization started in Ethiopia but they exploded in Egypt. And concerning national and international African art, one has to think of interior first and then exterior: first the inside world and then the outside world."

Among the themes of the "inside world" are motifs from the churches of Lalibela (ca. thirteenth and fourteenth centuries), Ethiopian cultural history, and especially magic scrolls. Magic scrolls are magico-religious devices made of strips of parchment containing prayers, magic formulas and images, and Christian images (eye motifs, eight-pointed stars, crosses, angels, and saints), which were used to heal sick people and to scare away demons.[6] Ethiopian cultural history is depicted in Zerihun's painting *History* (pl. 6). The first stage is represented by a 3.2-million-year-old hominid skeleton found in the Afar Valley in 1974,[7] and the last stage shows the influence of the Western world by depicting a modern-day fashion—a boot—along with a question mark, on one of the stelae of Aksum. The composition includes renderings of the statue of the sitting woman of Hawelti, which dates back to the Sabeo-Ethiopian period (ca. fifth century B.C. to first century A.D.); the stelae of Aksum, representing the Aksumite period (first to seventh centuries); and a coin picturing the Aksumite ruler Ezana, which recalls the period of Christianization in the fourth century. A scene from the legend of the Queen of Sheba—one of the queen's messengers on his way to Jerusalem—refers to the etiological myth of the Ethiopian ruling dynasty, and the lion symbolizes the ruler and the nation. The cruciform church of Qiddus Giyorgis (Saint George) represents the churches of Lalibela, and, together with the procession of priests at the festival of t'imqet (19 January), the Christian era of the country. One sees eye motifs, the guardian angel, and Solomon, who represents Jesus Christ in the magico-religious traditions of highland Ethiopia.

Cultural history, especially magic traditions, has long been of interest to Zerihun. His works in mixed media on parchment recall the illuminations that priests and monks have for centuries produced for holy

books, but the techniques that Zerihun uses to develop his rich surface textures are modern.

In a series of bamboo-strip paintings, formally modeled on the magic scrolls, the painter tells stories in pictures (fig. 5.1). Often his images are captioned, a common feature in traditional painting, or Amharic characters or magic prayers are added. Sometimes these pictures depict magical themes, but often they tell the story of humanity, frequently combining the "inside world" with the "outside world." In *Yesterday and Today* (pl. 7), the first strip represents early or prehistoric times with motifs from petroglyphs found in Ethiopia.[8] The second strip shows the development of Egyptian culture, followed by the Disciples at the Last Supper in the third and seventh strips. Jesus Christ dominates the center in a magical representation: surrounded by rockets and satellites, he towers over computer chips, symbols of modern civilization. The Islamic East, symbolized by the full moon and the crescent moon, is incorporated in the last two strips. The first "bamboo-strip" compositions were created as early as 1968, although the strips were then painted on canvas. In 1987, when Zerihun discovered combs for looms made from wood and bamboo in his father's store, he had the idea of putting several combs side by side, gluing strips of parchment on top, and then painting on the parchment surface. Since the first showing of this series in 1988 at the Istituto Italiano di Cultura, these bamboo-strip compositions have been extremely successful.

His series of wood reliefs is dedicated to the "outside world," specifically to the masks of Africa (pl. 8). Zerihun explains: "I have been involved with African masks for quite a long time and suppose I will be my whole life. We have no masks in Ethiopia; so that's why as an artist I am trying to make them known, not as sculptures, but as flat reliefs, corresponding more to the Ethiopian tradition. I saw masks in Kenya and at the Alliance Ethio-Française and I have a book about the subject. However, I do not copy specific masks, but I create one according to my own ideas." Often he uses images derived from the *nimba* mask of the Baga (Guinea) or from the Asante *akua'ba* figure (Ghana), both of which are related to fertility traditions. These motifs are important to the artist because of the famines in Africa. However, he frequently creates his own masks, and sometimes he integrates a beautifully adorned

African woman and an Ethiopian sun into his compositions. It is his intention to revive the religious ideas formerly associated with these masks: "I perceive in particular the soul of the masks and the belief that links people to these masks. I am Black; I am African; and I feel indebted to African art in these compositions." The production of these wood reliefs is labor intensive, especially the carving and creating the elaborate texture.

Frequently the works in this series are entitled *African Mask Research*. Another series, in different media and using different techniques, is called *Research from the Art of Magic*. These titles indicate that Zerihun understands that his focus on certain themes in his work not only is an intuitive process but is an intellectual act as well, which is why he can articulate (in words) the ideas behind his compositions. Asked about his creative process, the artist comments: "I always transform things, things I see, things I hear, and things I fell. I listen to the international and national news and to music, mostly to jazz music. I put all this together with my own imagination and I put it on a canvas, on a board, or on anything. My works are like poems, like 'wax and gold.'" ("Wax and gold" is a form of Amharic poetry with both an obvious and a hidden meaning.)[9]

The strong influence of magic scrolls started after the revolution of 1974, says the artist. Since he felt less free, his works had become more figurative and decorative. In some of his pre-1974 works the figures emerge out of an animated background due to his elaborate mixed-media techniques.[10] Since the change of the political situation in 1991, he has returned to his earlier, more abstract style, as documented by some of his recent works on canvas or parchment. The painting *Perspective Patterns* (fig. 5.5) incorporates representations of many small ornaments like those found on traditional African clothes or on masks. The return to African ornaments is typical of many artists who consciously deal with African traditions. Viewed from a distance, one can see other motifs in the picture as well: priests and a mother with her child. The title, explains Zerihun, suggests that the work must be viewed from different perspectives in order to reveal itself to the viewer in all its aspects.

Many of Zerihun's works focus on a central theme of traditional values and their changes. They often transmit the message that Ethiopian and other African traditions should not be forgotten, that they are still

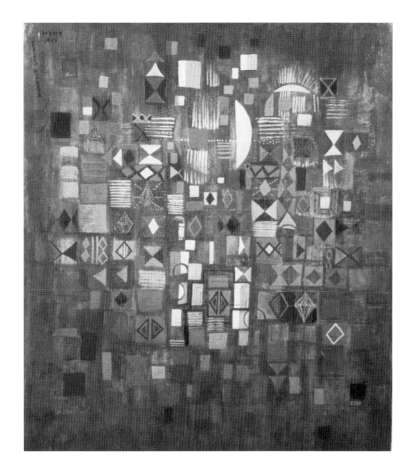

Fig. 5.5 *Perspective Patterns,* by Zerihun, 1993. Mixed media (acrylic, watercolor, ink) on parchment, 85 × 75 cm. Collection of the artist.

current and valid. As in a musical piece, Zerihun improvises around a central theme, which surfaces time and again in different variations. This is typical of many Ethiopian and other African artists. The Western conception that each piece of work has to be new and original has little bearing here, and African artists do not object to creating reproductions of earlier works that have been successful.[11]

The Development of "Academic" Painting

Zerihun Yetmgeta is a typical citizen of Addis Ababa, which is a cultural and multiethnic center and a locus for the introduction of Western traditions. Many of the city's inhabitants still live in traditional ch'iqa houses (houses built of mud and straw); the middle and upper classes live in their Western-style villas, which display all the achievements of West-

ern civilization. An important impetus for modernization was the modern school system, which is independent of the Orthodox Church and was established in 1925 by Ras Tefari Mekonnen, who was crowned Emperor Haile Selassie I in 1930. The Western-oriented school allowed Ethiopians to study abroad and painters were able to acquire their training at foreign art schools and as of 1957 at the Western-oriented School of Fine Arts of Addis Ababa.

Chojnacki (1973c) has divided the development of "academic" art into two phases: the first phase stretches from the 1920s to about 1960, and the second phase lasted until 1974. The period of the socialist regime can be identified as a third phase. Signs are present that the coup of 1991 may have signaled the beginning of another phase in the development of art.

In the first phase of painting, artists were educated at foreign art schools and they had to execute numerous commissioned works by the state upon their return. Besides wall murals for churches and public buildings, they had to make portraits of the emperor and designs for street signs, bank notes, and stamps, or they were employed as art teachers. Their private works dealt primarily with scenes of traditional everyday life, portraits, and landscapes. Their style was influenced by the academic traditions of the last century. Afewerk Tekle (b. 1932), the most prominent artist of the 1950s and early 1960s, who received his artistic training in London, holds a transitional position. The manner in which he idealizes the Ethiopian establishment and romanticizes Ethiopian life is partly responsible for Afewerk Tekle's fame. He has produced numerous commissioned works for the state, like the paintings in the church of Qiddus Giyorgis in Addis Ababa (fig. 5.6).

The School of Fine Arts of Addis Ababa, founded in 1957, offered painters an opportunity to obtain their training locally. In the beginning, the school offered only a few academic fields besides drawing and painting. Foreign instructors then inspired new possibilities of expression and expanded the school's curriculum. Since the early 1960s until 1974, more and more Ethiopian artists worked as instructors, and after 1974, the instructors were exclusively Ethiopian.

During the second phase, especially in the 1960s, a fundamental social and cultural change took place that fostered an acceptance of modern

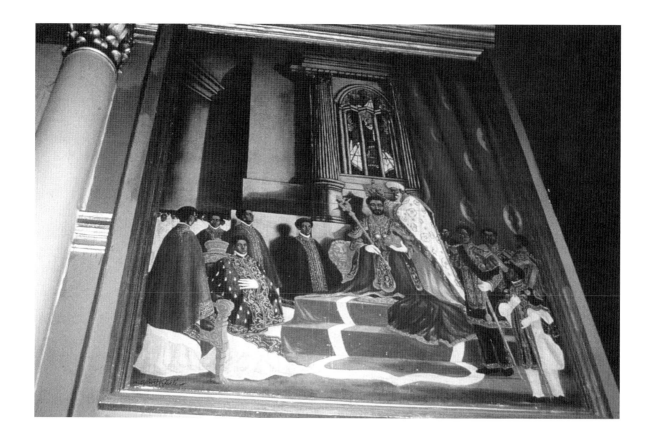

art. The establishment of a system of higher education and the founding in 1961 of Haile Selassie I University (since 1974 Addis Ababa University) brought an international as well as national academic elite to the city. This academic elite became the audience for, as well as the potential buyers of, art. The taste of this audience, who increasingly questioned the paternalism and the autocratic rule of Haile Selassie, differed greatly from the taste of the ecclesiastical and state elites.

Now there were numerous possibilities for artists to present their works. Exhibitions were organized: for instance, at the Creative Arts Center of the university (today called the Cultural Center), founded in 1963; at the gallery in City Hall, finished in 1964; and, since 1970, at the J. F. Kennedy Library at Addis Ababa University. Private galleries were operated as well, among which the Belvedere Art Gallery, founded in 1963 and closed after the 1974 Revolution, was the best known. In addition,

Fig. 5.6 *The Crowning of Emperor Haile Selassie,* by Afewerk Tekle, ca. 1955. Church of Qiddus Giyorgis, Addis Ababa.

100

the foreign cultural institutes, such as the Alliance Ethio-Française, the Goethe Institut (German Cultural Institute), and the Istituto Italiano di Cultura, started organizing exhibitions. Professional art criticism thrived in this environment and played a critical role in the establishment of modern, abstract art.

The "father" of abstract art in Ethiopia was Gebre Kristos Desta (1932–81). With his first exhibition in Addis Ababa in 1963, which did not win acclaim everywhere, Gebre Kristos became the ground-breaker for modernism. Among his most famous works are abstractions created with circles and lines as well as the paintings from his so-called Skeleton Series (fig. 5.7). This painter, influenced by German Expres-

Fig. 5.7 *Shoe Shine Boys,* by Gebre Kristos Desta, 1967. Oil on hardboard, 120 × 100 cm. Private collection, deposited in the Staatliches Museum für Völkerkunde, Munich.

Zerihun Yetmgeta and Ethiopian World Art

the foreign cultural institutes, such as the Alliance Ethio-Française, the Goethe Institut (German Cultural Institute), and the Istituto Italiano di Cultura, started organizing exhibitions. Professional art criticism thrived in this environment and played a critical role in the establishment of modern, abstract art.

The "father" of abstract art in Ethiopia was Gebre Kristos Desta (1932–81). With his first exhibition in Addis Ababa in 1963, which did not win acclaim everywhere, Gebre Kristos became the ground-breaker for modernism. Among his most famous works are abstractions created with circles and lines as well as the paintings from his so-called Skeleton Series (fig. 5.7). This painter, influenced by German Expres-

Fig. 5.7 *Shoe Shine Boys,* by Gebre Kristos Desta, 1967. Oil on hardboard, 120 × 100 cm. Private collection, deposited in the Staatliches Museum für Völkerkunde, Munich.

Zerihun Yetmgeta and Ethiopian World Art

101

sionism in Cologne, refused to present an idealized Ethiopia—many of his works deal with the lives of the underprivileged.

Unlike the first phase, during which traditional Ethiopian themes were predominantly depicted in European styles of the last century, the artists associated with the second phase drew upon twentieth-century art movements, like Cubism (e.g., Besrat Bekele), Expressionism and work in mixed media (e.g., Abdelrahman M. Sherif), or Surrealism (e.g., Daniel Touafe). There was practically no interest in dealing with contemporary Black African art until Alexander Boghossian (b. 1937), who calls himself Skunder (Eskender). Boghossian had his first exhibition in Addis Ababa in 1966. Although he was inspired by Surrealist artists and theorists during his years of training in Paris, more important influences were Léopold Sédar Senghor's cultural theory of *négritude*, especially as manifest in the writings and lectures of Cheikh Anta Diop, and contact with Black African artists and their works (see Diop 1974). In Ethiopia he took inspiration from old churches, illuminated manuscripts, magic scrolls, and depictions of legends; and he used goat skin or tree bark as a painting surface. Similar to the Sudanese artist Ibrahim El Salahi, he integrated the calligraphy of his language into his pictures. The critics were enthusiastic about his first exhibition—Skunder's paintings suited the taste of the academic elite (fig. 5.8).

Fig. 5.8 *The End of the Beginning*, by Skunder, 1972–73. Oil on canvas, 122 × 170 cm. National Museum of African Art, Smithsonian Institution.

Both Gebre Kristos Desta and Skunder taught at the School of Fine Arts: Gebre Kristos from 1963 to 1978; Skunder, who lives in Washington, D.C., today, from 1966 to 1969. Both of these leading avant-garde artists had an enormous impact on the thought and style of their students, an impact still seen today. When Skunder left for the United States, most of his disciples followed him.[12] Zerihun Yetmgeta is the only member of Skunder's former circle who lives in Addis Ababa; he still represents the genius of that time, when the rigid social conventions, also perceptible in art, started to ease and gave way to a more creative dealing with reality.

The overthrow of Haile Selassie and the social revolution (1974) were followed by a cultural revolution. In this third phase of painting, art was used as a weapon in the fight against suppression by feudalism and imperialism and as an instrument for political education of the masses in the spirit of socialism and for the development of social consciousness. Realistic art became popular again because it was commonly held that modern art is rarely understood by the people and because, true to Lenin's teachings, art was supposed to belong to the people.

Poster and slogan art was developed to reach the masses effectively. Graphics and slogans that praised the achievement of the revolution could be found on the walls of public buildings and on the arches built just for this purpose in the center of Addis Ababa and other towns. In order for the artists to fulfill these new tasks both formally and in terms of content, a vivid cultural exchange took place with the former GDR, the former USSR, and North Korea (Aleme Eshete 1982: 28; Sahlström 1990: 66–67).

The state organized big art exhibitions in conjunction with important public events. They were group exhibitions, which presented a selection of the artistic creativity across the country. The last of these national exhibitions, "Ethiopia in Fine Arts," was presented in the annex of the National Museum in the spring of 1991 (Ministry of Culture and Sports Affairs et al. 1991; Biasio 1991). Seventy-three pieces, partly senior thesis work of new graduates of the School of Fine Arts, were presented on the first floor. All the work was figurative painting and adhered to the tenets of Realism, the primary idiom of artistic expression taught at the School of Fine Arts since the social revolution of 1974. Ideas were

borrowed from academic Realism of the nineteenth century as well as from Impressionism—only a few works showed Expressionistic or abstract tendencies.

The second floor of the museum was dedicated to the "senior" artists and showed an overview of the development of art since the 1920s. Here it became clear that elements of avant-garde art (of the sixties and early seventies) had been sustained and were beginning to coalesce once again. Zerihun Yetmgeta's work, for example, was represented by the wood relief *African Mask Research* and the painting *13 Months of Sunshine* C (mixed media on bamboo strip).[13] Other manifestations of this "rebirth" are found in the very personal, expressive works of Tibebe Terffa (b. 1947) (fig. 5.9) and in the compositions of Teshome Bekele (b. 1950), which show affinity to Skunder's techniques (fig. 5.10). Both Tibebe and Teshome graduated from the School of Fine Arts shortly before the outbreak of the revolution in 1974 and did not study abroad. In addition, one should mention the semiabstract works of Lulseged Retta (b. 1952), as well as the dramatic, heavy oil paintings of Getachew Yossef (b. 1957), who draws from Rasta philosophy. Although both of these artists attended art schools in the former Eastern Bloc, they have freed themselves of the academic style (i.e., Social Realism) and are looking for a pictorial language of their own. Even though Getachew Yossef is a colleague of Zerihun Yetmgeta—he also teaches graphic arts at the School of Fine Arts—he does not try to imitate his friend's mode of expression. A certain affinity to Zerihun's wood reliefs can be seen, however, in some of the works of Abebe Zelelew (b. 1964).

The Situation of the Artists

Every year, some women graduate from the School of Fine Arts. Nevertheless, only one woman was represented in the whole group of forty senior artists in "Ethiopia in Fine Arts": Desta Hagos (b. 1953). Women worldwide have to deal not only with the problems they share with men but also with their gender-specific problems. If one compares the biographies of female and male artists, it is striking that with the exception of Desta Hagos no other woman was able to study abroad.[14] When women marry and have children, it is more difficult for them to

Fig. 5.9 *Harrar Impression III,* by Tibebe Terffa, 1992. Oil and acrylic on canvas, 45 × 35 cm. Völkerkundemuseum der Universität Zürich.

Fig. 5.10 *Puzzle of Life,* by Teshome Bekele, 1992. Gouache, mixed media on paper, 41 × 26 cm. Völkerkundemuseum der Universität Zürich.

reach artistic maturity or even to find the time for painting and having exhibitions.

Most artists have a job: they are teachers at the School of Fine Arts or at another school; they work as restorers in museums or as designers in one of the ministries. But wages are low and hardly pay for necessities, not to mention art supplies, which are very scarce and expensive in Ethiopia. Whenever possible, the artists try to get their supplies abroad,

usually through foreign acquaintances and friends. But the prices are high even abroad, and the state demands large customs duties.

Apart from the lack of arts supplies, since 1974 artists have had to fight other problems as well. For most artists, except for those few who were able to study in the former Eastern Bloc nations or for well-known artists like Zerihun Yetmgeta who were invited to the openings of their exhibitions abroad, trips and therefore visits to art museums were impossible due to a lack of hard currency. Artists could hardly keep up with new Western trends; even art books or prints were no longer available in the country.

The repressive atmosphere during the socialist regime did not encourage creative experiments, and censorship ensured that no criticism of the state would become public. However, the "abstract" painters seemed to have had less difficulty because their art was often incomprehensible to the censors, according to the statements of several artists. Some artists were not only afraid that one of their undesirable pictures might be removed from an exhibition but also that they would be punished by serving time in jail. Thus censorship created an atmosphere of fear and insecurity.

At the beginning of the 1974 Revolution all private artists associations, like the Association of Young Artists, whose president was Tibebe Terffa and whose vice president was Teshome Bekele, were prohibited. Consequently there was no debate about art except for the occasional discussions among artist friends. Artists, just like other professionals, had to organize themselves under the state's aegis. All established artists had to join the Ethiopian Artists Association, especially if they worked for a public institution. In response to the question whether this organization had supported artists, all artists answered reluctantly or cynically. The organization only helped the state, not the artists. The artists were controlled by the organization, and all the meetings were a waste of time.

The Arts Market

During the socialist regime, foreign cultural institutes, led by the Alliance Ethio-Française, liberally contributed to the support of artists. The Alliance offers an informative program that introduces less well

known artists to a wider audience. Members of the diplomatic community (i.e., employees of embassies and the Organization of African Unity) meet at opening nights. In June 1992, one year after the Ethiopian People's Democratic Front (EPRDF) came to power, another private gallery, the St. George Interior Decoration and Art Gallery, was opened and acquired pictures by Zerihun Yetmgeta, Tibebe Terffa, Teshome Bekele, and Lulseged Retta. Teshome Bekele had an opening at this gallery in May 1993. Here, too, the foreign community congregated, and by the end of the opening reception, most of the pictures had been sold. Many artists realize that their works, with few exceptions, are acquired by foreigners. Abebe Zelelew, whose compositions were presented at the Istituto Italiano di Cultura, accurately describes the situation: "Foreigners have a lot of birr [Ethiopian currency]; they can buy easily. But the artworks go to other countries. But we have no choice. We cannot live, and when you don't have money, you can't make pictures. That is the problem." The socialist state never officially supported the private art market, but it was tolerated because the sales of artworks secured the artists' existence.

New Trends with a New Regime

There are signs that another phase in the development of the arts has started with the takeover of the EPRDF in 1991. New galleries may follow the opening of the St. George Art Gallery, various plans are in place, and Richard Pankhurst has strongly argued for a museum of modern Ethiopian art, "so that Ethiopians and foreigners alike may witness modern Ethiopia's artistic achievements, creativity and progress" (1993: 15).

Like Zerihun, most artists feel that they have more freedom and that this is reflected in their work. In contrast to my earlier interviews, conducted in 1989, they speak more freely about their situation. In March 1993, Zerihun Yetmgeta, for instance, organized a workshop for painters at the Cultural Center at Addis Ababa University together with the European cultural institutes in order to provide a sense of "the freedom of art." New graduates of the School of Fine Arts have started to form associations again; the Point Group, founded in 1993, consists of nine artists who recently graduated from the school. Their first exhibition took place in May 1993 at the Alliance Ethio-Française. Their goal is to break with

the Academic style of painting they were taught at the School of Fine Arts. Mutual support and discussions about new strategies should help them find a new visual vocabulary and new concepts (see Alliance Ethio-Française 1993). The artists would also like to exhibit abroad and to have the opportunity to examine Western artistic trends, as underscored by Samuel Sharew and Leul S. Mariam, two members of this group.

What Is Ethiopian World Art?

Lastly, the title of my essay requires an explanation. None of the artists educated at the School of Fine Arts in Addis Ababa consider themselves ethnic artists, that is, as representatives of a specific ethnic group. All artists describe themselves as Ethiopian artists and, at the same time, point out that their art is international, universal, a part of world art. Worku Goshu (b. 1941), for instance, defines his artistic identity as follows: "I am an Ethiopian artist because I was born here, I was educated here, and my roots are here. But my way of expression is more or less European or international." Zerihun takes a similar position but he feels more engaged in Black African art: "I am based in my culture, but I paint more or less international styles and themes of Black art." This attitude is strongly connected to the typical artist's biography. Artists sometimes are affiliated, through their parents, with more than one ethnic group; they are Ethiopian Orthodox or Catholic Christians or Muslims, and the profession of a painter is not, as used to be the case with traditional painters, passed on within the family. Even if artists do not grow up in the capital city, they all receive a modern education and further training in the multicultural capital at the School of Fine Arts and sometimes at a foreign arts school. Visits to European art museums and studying the great masters are among the strongest formative experiences for these artists. Asked which European artist impressed them the most, many named Pablo Picasso and his work with the formal aspects of African masks. Sometimes, in the work of younger artists, one can detect hints of Picasso's Cubist paintings.

The common denominator of Ethiopian world art is Ethiopian culture, which has shaped the artists. That culture includes not only their physical environment but also religious painting and especially contemporary traditional painting (or popular painting). In the latter, major

themes are legends, historic events, and scenes of everyday life. The transformation of the real world into a picture often takes place under the influence of different European stylistic traditions. Chojnacki (1973c: 94) correctly points out that this happened in traditional painting as well and that Ethiopian painters translated those influences into their own idiom. Therefore, within Ethiopian world art, we find artists ranging from the most conventional to the most modern, the latter not always finding acceptance. However, Gebre Kristos, who was criticized in Ethiopia for not speaking the "language" of the people any longer, countered in an interview: "We create ultramodern houses in our developing countries. . . . We use all sorts of up-to-date international styles in technology, science, education, medicine. . . . Why in the world should art be any different?" (Head 1969: 22). Zerihun Yetmgeta, like other artists of the "Skunder school," went in another direction. He transforms Ethiopian and other African motifs into a modern idiom without adopting European styles. He does so by combining Ethiopian and European materials and techniques as well as by commenting on contemporary life. Zerihun is deeply rooted in Ethiopian culture, but his mind is open to the rest of Africa, to the rest of the world, and to modern life.

APPENDIX
Exhibitions of Zerihun Yetmgeta (as of 1993)

One-Artist Shows in Addis Ababa

1970	City Hall
1972, 1974, 1975	Belvedere Art Gallery
1976	German School
1977, 1978, 1979	Istituto Italiano di Cultura (Italian Cultural Institute)
1979	Alliance Ethio-Française (French Cultural Institute)
1980, 1981, 1983, 1984, 1985, 1986	Goethe Institut (German Cultural Institute)
1987	Alliance Ethio-Française
1988	Istituto Italiano di Cultura
1990, 1992	Alliance Ethio-Française

Group Shows

1966	"Graphic Art," traveling exhibition through Europe
1968	Creative Arts Center, Addis Ababa
1971	Leza Gallery, Addis Ababa
1972	"Africa Creates," Union Carbide Hall, New York
1973	Hilton Hotel, Addis Ababa
1975	German School, Addis Ababa (two-artist show)
1976	Centre Culturel Français, Nairobi, Kenya
1976	Goethe Institut, Nairobi, Kenya
1977–78	"African Contemporary Art," traveling exhibition through the United States
1977	"African Contemporary Art," Howard University, Washington, D.C.
1977	"Contemporary African Painting," New York
1979	School of Fine Arts, Addis Ababa
1982	City Hall, Addis Ababa
1988	"The Well-Known Ethiopian Artists," Cultural Center, Addis Ababa University
1989	"The Hidden Reality," Völkerkundemuseum der Universität Zürich (three-artist show)
1990	"Art Exhibition of 55 Contemporary Ethiopian Artists," National Museum, Addis Ababa

1991	"Ethiopia in Fine Arts," National Museum, Addis Ababa
1991	Cuarta Bienal de la Habana, Centro Wifredo Lam, Cuba
1992	DAK'ART 92, La Biennale Internationale des Arts de Dakar, Senegal
1993	Kenya Art Panorama, Centre Culturel Français, Nairobi, Kenya

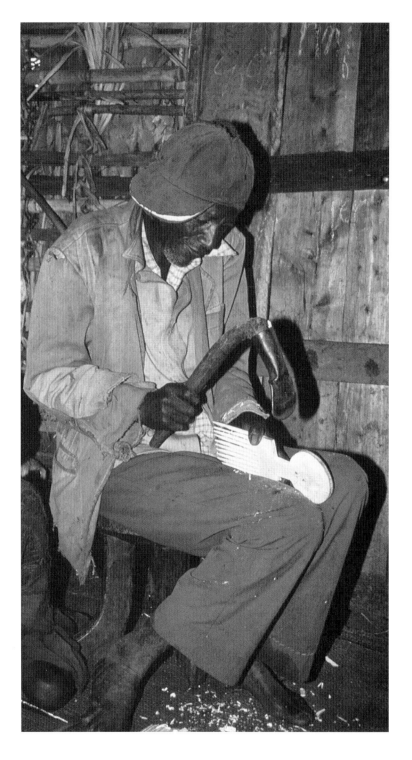

Fig. 6.1 Menjiye Tabeta carving a wood comb with an adz.

Menjiye Tabeta—Artist and Actor 6
The Life and Work of a Fuga Woodworker

Alula Pankhurst and Worku Nida

Portrait of an Artist

When we first met him, Menjiye Tabeta was sitting astride a piece of wood he was carving into the leg of a bed for a man in whose compound he was working. Peering out from under a cap rakishly tilted sideways, and with a quizzical, slightly roguish expression, Menjiye enthusiastically began to tell his story, continuing all the while to chip at the wood with a sure touch (fig. 6.1).

Menjiye was born in Dalocha, eastern Gurageland. While still a young boy he migrated with his father, Tabeta Tamiya, and mother, Sergut Lete, to Chaha in Sebat-bet Gurage, where they settled in the village of Yadaweqe on the land of General Welde Selassie Bereka, who became his father's patron. Menjiye later moved to Qweshe village, where he lived on Qenyazmach Amarga Oqubato's land until the 1974 Revolution (fig. 6.2).

Menjiye has two sisters and four brothers, all involved in woodworking. One brother, Bejedri, is a famous house builder renowned for his large "modern"-type houses with windows and porches. Another brother, Ishaq, who lives near Menjiye, taught him how to carve. He too has specialized in building houses together with his sons. Menjiye was already carving when the Italians occupied Ethiopia, which would put his age at about sixty-five. However, he does not look that old and has the sprightly manner and jocular behavior of a man half his age.

Menjiye is proud of his marital record: five wives in succession. His first wife, Denqut, came from Ezha. His latest, Anchewat, who sometimes helps him paint, comes from Geta. She has had ten children, three of whom died. Yerochi, one of his sons from an earlier wife, follows in

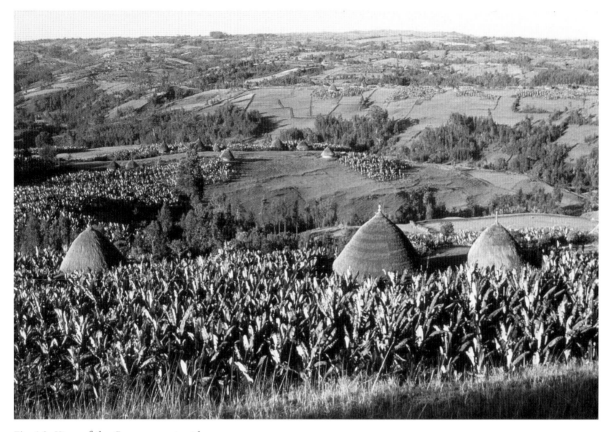

Fig. 6.2 View of the Gurage countryside.

his father's footsteps as a carver. Anchewat makes baskets and pots; she apparently learned the latter craft from one of Menjiye's former wives, Mehrut, whose mother was a potter.

Menjiye takes pride in his craft and was delighted that foreigners were interested in his work. He liked to boast that he was better than others and could show us everything, although when we asked who was the best woodworker, he had the humility to answer, "Ask the others."

We soon discovered that Menjiye was quite a character and an accomplished storyteller. He confidently informed us that he knew many of the foreigners who came to Gurageland and had taught them many things. He spoke of the *piscor* (Peace Corps) and William Shack (the anthropologist). There was an element of make-believe in his talk. List-

ing the objects he makes he mentioned in all seriousness a fabulous chair with a sunshade and footrest (which nobody else has ever heard of). He made the extraordinary claim that an American friend, whom he called Liben, had taken two hundred of his beds to the United States. Menjiye was clearly given to hyperbole. On another occasion he claimed that he had been to America and had been given a fifty-dollar bill by the president! When we inquired about his experiences in America he retorted: "How should I know? I was locked up like a dog!" As for American food, he asserted: "They eat chickens with the skins on!"

Another aspect of Menjiye's personality is an inability to take things seriously. He would respond to questions with other questions in a rhetorical style or sidetrack to some apparently irrelevant story. He joked about the microphone from our tape recorder, calling it the wire he was tied to.

This was a strange sort of master artisan; one who took himself lightly and acted the clown, sometimes standing to attention to salute for the camera or placing an object he had carved on his head. Yet Menjiye was a man with skills recognized far and wide in this part of Gurageland. He had been given the title Abba Zenab, or "Father of the Rain," apparently because of his generosity. His craft has not earned him a fortune and he leads a simple life. He wears tattered clothes and was too ashamed to show us his decaying house, preferring to meet us in the houses of richer clients. He also exhibited a tendency to self-denigration and an ambivalence toward himself, epitomized in a phrase he often interjected when there was a pause in the conversation: "Menjiye good, Menjiye *leba* [thief]." He called one of his sons *gojo meqera*, which means "the despair of the hut."

However, Menjiye is not overcome by bitterness with his lot, nor is he depressed by the way his skills are undervalued by his society, which despises woodworking Fuga and treats them as a low-caste group. He makes light of his plight, resorting to joking and the bottle. He hinted that a little liquor would loosen his tongue. He once commented, "If I get *areqe* I will become a radio!" He also possessed a bawdy sense of humor. When we asked whether he had children from his former wives, his current wife answered, "Yes," and Menjiye added: "Yes I have many. Otherwise what is the use of having [a penis]. When it becomes unpro-

ductive, it should be cut off and thrown away. Why should it be heavy?
Let Menjiye die [when he can no longer have children]."

Who Are the Fuga?

The Fuga have been described as "a low-caste occupational group of
hunters, artisans and ritual specialists" living among the Gurage (Shack
1966: 8). The term has been used to refer to artisans as a whole among
several ethnic groups in southern Ethiopia. Following this usage, Shack
(1964: 50; 1966: 8) treats the term as generic, referring to all occupa-
tional castes. However, as Shack is aware, among the Gurage, smiths and
tanners are not referred to as Fuga, a term reserved for a caste group
that specializes in working with bamboo and wood and that performs
certain ritual functions.[1]

The Hunting Background

The Fuga maintain strong hunting traditions. Although hunting is
becoming rarer because of the scarcity of game, Menjiye reenacted a
realistic hunting scene, and Shack's book has a photograph of "Fuga
hunters stalking game" (1966: 64, pl. Ia). Menjiye's father was a re-
nowned hunter who killed three leopards; his brother Ishaq also killed
one. Menjiye told us that Fuga hunt large game in groups of 75–100
as far as the Gibe Valley and in groups of 10–20 men for more local
hunting of small game.[2] In the past, when a Fuga and a Gurage met,
the latter's response to the former's respectful greeting *abiye*, meaning
"master," used to be "Kill the animal!" for a man and "May he kill the
animal for you and may you eat it!" for a woman (Leslau 1950: 62).
Thus the linguistic interaction in greetings refers directly to this hunt-
ing background. It seems likely that at least part of the ostracism of Fuga
can be explained in terms of this hunting past: they are accused of eat-
ing wild animals considered taboo and are said to eat animals that have
died without being ritually slaughtered. However, by removing dead
animals, which are considered polluting, the Fuga perform an impor-
tant function for their patrons. Like many caste groups, the Fuga are
believed to possess the "evil eye," and supposedly, they have the ability
to transform themselves into hyenas at night, attacking children and eat-
ing their entrails (Shack 1966: 10).

The Fuga hunting background lends a measure of credence to Shack's view that they were among the "so-called 'primitive hunters' of the Horn of Africa" (Shack 1964: 50).[3] Other evidence relates to alleged physical or linguistic differences. Shack claims that "Fuga mainly resemble the Bantu Negro, in color and physique," and that the Gurage "consider themselves to be 'racially' different from Fuga, because Gurage have strong Semitic features as a rule, with colors ranging from light to dark brown" (1964: 50). On the basis of observing only a few individuals it is difficult for us to conclude that such physical differences exist. Menjiye pointed to one of his daughters, who was indeed darker than the rest, and said in his characteristic style: "She is black, she is a slave, she is a thief!"—a clear instance of the social construction of color as much as observable reality.

The Fedwet "Ritual" Argot and the "Language" of the Games

The question of linguistic evidence for a separate identity is much more complex. Shack writes: "The Fuga have adopted the language of the dominant group, while retaining their own 'language' or 'jargon,' which in certain ritual observances is highly esoteric, being understood only by those belonging actually and symbolically to their caste" (1966: 9). The issue of a Fuga "language"[4] needs to be distinguished from the ritual "language" called *fedwet*, which is used in the initiation of Gurage girls into an age-group called *mweyet* (Shack 1966: 132–33).[5]

During our visit to Gurageland several Fuga told us that a Fuga "language" existed (they were not referring to the *fedwet*), a fact Menjiye was proud of. He called it the language of the Games, the name the Fuga use for themselves, adding: "Is there anyone without a language? Our education is our language; we created it and learned it by ourselves."

Other Fuga at first denied knowing this language. Some were unwilling to tell us much, and several younger Fuga only knew a handful of terms. Altogether we were told some fifty terms by four Fuga men. Most were names of wild and domestic animals, which is significant given the Fuga hunting background.[6] Other words were for wood, houses, domestic objects, food, and *enset*.[7] We were also told of terms relating to sexual intercourse and, interestingly, words for "circumcision," "evil eye," and "thief," and two violent expressions: "hit him" and "take his

money." It seems clear that this Fuga argot is partly used as a means of communicating in a way that Gurage do not understand. Menjiye made this point explicitly: "We speak it among ourselves when we want to hide things from the Weleba [the Gurage]." He added that the language was "dangerous" since "it sells you as you sit down not knowing that you are being sold!"

These few terms have not been studied and the subject requires further research. However, it is clear that special words and expressions are used by Fuga, and perhaps these constituted a dialect in the past. It is also clear that these are different from the *fedwet* ritual argot used in the *mweyet* rites.[8] Menjiye also claimed that the Fuga have their own songs and a rich repertoire of proverbs.

Fuga "Religion"?

Another factor that could lend credence to a separate Fuga identity would be the existence of distinct religious notions. Shack suggests that the Fuga religion "most probably has had some effect on the beliefs and practices of the Gurage since certain magical practices and sorcery are in the hands of Fuga" (1966: 9). However, he adds: "Fuga rituals and beliefs, apparently, have been completely merged with the religious organization of the Gurage. *If the Fuga have ritual observances of their own, I uncovered no evidence of this,* but the Gurage believe that Fuga ritual experts possess rich powers of magic and their sorcery and malediction are greatly feared" (1966: 9; our emphasis).

While it is true that Fuga take part in traditional Gurage cults, this does not mean that they do not have their own beliefs.[9] They have a shrine in a place called Gorara. Menjiye explained: "Like a mosque is for the Muslims and the *tabot* is for the Christians, our shrine is at Gorara." He added: "The shrine is in Waliso, and the head of the religion is a man known by the [traditional Gurage] title *damo*. The office is hereditary." Menjiye explained that some of the meat from animals sacrificed at the time of the Mesqel feast is set aside in honor of the shrine, and that Fuga from all over Gurageland go to the shrine bringing "everything we promised to bring: meat, money."

Menjiye goes regularly every year with his wife.[10] He assured us that Fuga take the matter seriously: "The *damo* is also our administrator. We

observe his ritual decrees. We follow the directives from the head. It is no joke; it is very strict. If one violates the decrees, he dies. Whenever and whatever injustice happens to a Fuga, he presents his problem before the head. Then the *damo* calls upon the accused person and gives him a trial."

This Fuga shrine under a Fuga leader is a pilgrimage center, to which Fuga take votive offerings. The shrine is also a judicial center where arbitration takes place.[11]

The Fuga Role in Gurage Ritual

Some Fuga are ritual experts in Gurage society. They circumcise boys and perform clitoridectomies on eight- to ten-year-old girls (Shack 1966: 131–32).[12] Furthermore, certain Fuga play a crucial role in the initiation of girls into the *mweyet*, an age-group associated with the cult of Demwamwit, the Gurage fertility goddess. The administration of the cult is divided between the leader and his assistants.

The initiation ceremony is carried out annually after the girls have been circumcised.[13] All the initiates are taken into the "bush" and secluded for about one month under the tutelage of the *mweyet* leader and his assistants, who teach them the "secrets" and *fedwet*, the ritual language used by women and girls in songs at religious festivals (Shack 1966: 133). The *mweyet* provides women with a sense of solidarity, and later in life at times of crisis they may enter trances and speak in *fedwet* and call upon the assistance of the *mweyet* leader.[14]

The intimate involvement of Fuga in the social reproduction of the Gurage poses some interesting problems about their status. They circumcise boys, marking their transformation into men. After a period of seclusion, the young men are publicly paraded through the marketplace (Shack 1966: 132). Fuga are also required to turn Gurage girls into women, whom they cannot marry. They are the only men, apart from the non-Fuga leaders of the cult, to be involved in the women's initiation ceremony and the only men to know the secret language, which they teach the girls. These Fuga are therefore an intimate and indispensable part of Gurage social life, entrusted with the very transformation of Gurage from children into adults. They also perform essential services at funerals. They construct the burial vaults and inner chambers

(Shack 1966: 128). Menjiye noted: "We carve the box for the corpse, chop wood, dig the grave, and we perform the traditional mourning." Fuga also act as bonesetters and as uvula and teeth extractors, though Gurage experts also perform these activities (Gebru 1973: 51).

Contrary to observations by Leslau and Shack, possibly arising from miscommunication between researcher and informants, the current leader of the Demwamwit cult in Chaha is not Fuga.[15] However, it is also clear that many of the ritual leaders of the *mweyet* are Fuga. According to Menjiye these Fuga are not allowed into the inner spaces of the sanctuary and are assistants of the cult leader.[16]

Making a distinction between craft and ritual Fuga is unsatisfactory since the Fuga involved in circumcision, burial, and medical practices are also the craft Fuga.[17] The cult Fuga are not exclusively ritual specialists, nor are the craft Fuga solely artisans. In fact, the difference is more one of degree. The male *mweyet* are primarily involved in rituals connected with the cult. Menjiye told us that the Fuga *mweyet* do not carve and are dependent on the people who buy them *areqe* liquor in exchange for their services initiating girls. However, apparently they also make baskets. The woodworkers are actively involved in circumcision, and some are bonesetters, dentists, and other medical specialists. We were told that the cult Fuga can marry craft Fuga.[18] The Fuga involved in the cult seem to have a higher status and ranking among the Fuga themselves, while the craft Fuga are undifferentiated. The Gurage consider both to be caste groups, like the tanners and smiths.

Caste and Craft in Gurage Society

In Gurage society, three groups are considered craft practitioners: Fuga engaged in woodwork, bamboo work, and pottery; Nefwre engaged in ironwork; and Gizhe in leatherwork. However, one must resist the assumption that they are castes *because* they are engaged in these occupations. Of the caste groups, only the Fuga have a ritual role. Moreover, many wooden items are made by the Zhera, the ordinary Gurage. Fuga women sometimes make pottery; but most potters are ordinary Gurage, not Fuga women. In Gurage society potters are not despised *unless* they are Fuga. Therefore, the occupation does not seem to be the *cause* of the caste status. Fuga women assist Fuga men in making bamboo baskets

and mats. But ordinary Gurage women often decorate these baskets with leather strips. This does not make them Fuga or Gizhe.[19]

The castes are apparently largely endogamous, with status ascribed by birth. But the idea that they marry close kin, "even brothers and sisters," as Shack was told, may be a Gurage perception.[20] Of the three artisan groups, the smiths have the highest status, as exemplified by occasional instances of Nefwre women marrying ordinary Gurage men, and one case mentioned by Menjiye in which a Nefwre man married an ordinary Gurage women. Both Fuga and Zhera consider the Fuga to be inferior. Gurage and Fuga respondents told Gebru that this was either because of tradition or God's will (1973: 40, 56). Asked what "Fuga" meant, Menjiye replied: "It means despised." He added that Fuga was their clan, which he contrasted with Gurage clans. For Menjiye the Fuga constitute a racial, not a social, entity. As he put it: "When a Fuga is born, he is born Fuga."

The Livelihood and Status of the Fuga

The Fuga were estimated by Shack to number some 5,000 people out of a total Gurage population of 500,000 (1964: 50). The proportion of 1 to a 100 may be fairly accurate. Considering the current Gurage population of over 2 million, this would suggest a figure of about 20,000 Fuga.

In terms of Fuga settlement Shack suggests two patterns: "either a small plot of common land is set aside on the edge of the village on which huts can be erected and crops grown; or a wealthy Gurage will permit a Fuga to erect a hut on his land at a 'safe' distance behind the homestead so that the landowner enjoys the right of priority over the service which the Fuga performs for the village" (1964: 50). In the first case the Fuga can live together, with their social distance reflected in their geographical isolation. In the second we see a patron-client relationship. A third possibility seems to be several Fuga living in the vicinity of shrines or as clients of cult leaders.

The Fuga could not own land prior to the 1974 Revolution.[21] However, Fuga could become clients to Gurage patrons, whose land they would work. Likewise, Fuga apparently did not own livestock. However, they could look after the livestock of Gurage patrons in exchange

for milk.[22] It seems that Fuga were rigidly excluded from property ownership and relied heavily on patronage. As Menjiye put it: "A Fuga had no property except his spear." The Fuga were, however, integrated within Gurage society. At festivals they were given "the Fuga's share."[23] According to Shack, the Fuga were feared as having special powers.[24]

Since the 1974 Revolution the Fuga have been able to own land. However, we did not come across any wealthy Fuga. Most Fuga we spoke to had very few belongings in their houses since they produce mainly for sale. The roof of Menjiye's house was collapsing. Apparently the previous landowner has recently been attempting to reclaim his land, and Menjiye is in danger of losing his plot.

It seems likely that in the past the Fuga performed a wider range of tasks as clients of Gurage and were not restricted to working in wood and bamboo.[25] Asked what a Fuga did for his master, Menjiye answered: "Chopping wood, digging out the *enset* plant for harvest, cutting grass. We did everything, for we depended on them." In exchange, patrons provided land, food (including meat for the Mesqel celebration), and cloth.[26]

Fuga Resistance

Although Menjiye may seem an eccentric joker, he is probably by no means unique. Indeed, such a personality is an excellent protective mechanism, allowing talented persons among the "despised castes" to excel. They can even joke about their former masters without offense. For a group of people who are ostracized by the people among whom they live, there are several ways for the brightest to retaliate. One way is by playing the jester. Menjiye typified this. For the benefit of the camera he adopted a slow-motion, jerky, parodic movement when working, which annoyed us until we began to see that it was part of his style.

Another form of resistance is having their own "language." Menjiye proudly told us of expressions used by the underdog Fuga to outwit the Gurage overlord. He also enjoyed telling us stories of Fuga burning the houses and belongings of their masters.[27] He told us of a Fuga who became a thief and stole cloth, sheep, and goats. Menjiye would often interrupt his speech to call himself or one of his family a thief.[28]

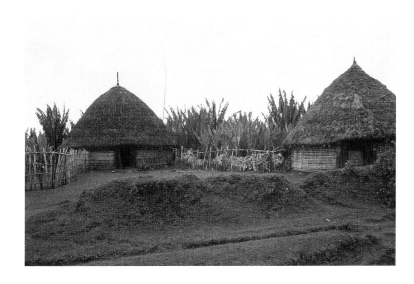

Fig. 6.3 Gurage houses.

Fuga Craft and Art

As Shack notes: "Gurage technology is based on the Fuga" (1966: 12). The respect for Fuga skills and know-how is summed up in the Gurage saying "A Fuga is one who knows" (Shack 1966: 12). The Fuga craftsmen are the only Gurage exclusively involved in bamboo work; other Fuga have specialized in woodwork. However, non-Fuga Gurage men also work with wood without being stigmatized.

The Fuga play a crucial role in the construction of houses (fig. 6.3). Some Fuga specialize in house construction and have a leading part in this activity, which requires the involvement of dozens of people. Such traditional builders are called *qana*. It is said that in the past they used to be exclusively Zhera Gurage and that Fuga have gained this status only in recent times, perhaps only during the present generation. Zeleqe and Bejedri, two of Menjiye's brothers, are said to be pioneer Fuga *qana* among the Sebat-bet Gurage. Bejedri is reputed to be the most famous *qana* in the area and is acknowledged to have skills surpassing those of Zhera Gurage. Fuga builders often make the *echba*, the house's central pole, which has important symbolic and ritual significance (fig. 6.4).[29] Fuga also carve and fit *weka*, the supporting beams that are peculiar to Gurage housing and that radiate off the central pole and hold up the roof. Fuga

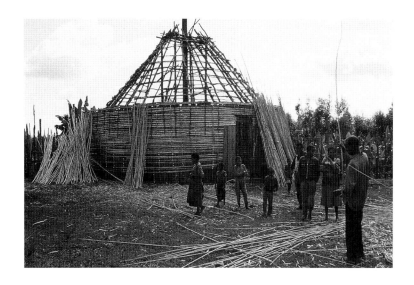

Fig. 6.4 A Gurage house under construction.

sometimes make walls and fit rafters and beams (Shack 1966: 11), as well as doors, door frames, and lintels (Shack 1974: 112).

In addition, Fuga make traditional two-pronged digging sticks (*wenet*) and single-pronged iron-tipped ones (*yachinya*), without which cultivation is impossible. In other words, the products of Fuga labor are essential for agriculture (Shack 1964: 52). Fuga also make objects required for processing *enset*, including the *zebangiba*, *watar*, and *sebisa*, implements used for scraping the plant's stem; the *zembora*, the wooden platform used to chop *qocho*, the *enset*-based staple food; the *yechochepwa ich'e*, the end piece used in chopping; and the wooden handle of the *yezenbore senda*, the knife used to chop the *enset*. Fuga also make three sizes of mortars (*meqet'qet'*), the smallest for coffee, a medium-sized one for pounding hot pepper, and a large one for grinding grain such as barley and *gesho*, used in fermentation. Another Fuga-made item associated with food preparation is a wooden bowl called *yebeser ich'e* (pl. 10e), which has a division in the middle and is used for chopping raw meat to make *kitfo*, a famous Gurage specialty.

Fuga also produce three types of seats: a three-legged stool (*berch'uma*), a two-legged benchlike seat (*qwanta*), and a legless round board (*t'eqesha*) (pl. 9d). In the past they also produced seats with backrests and openwork designs, though these have become extremely rare (Shack

1974: 112). Menjiye claimed that he made seats (*sofa*) with footrests and sunshades, though we were unable to find any evidence of this. Fuga also make *weskembya*, small low tables used for food and drink; *yesin yiwerepwe*, stands for coffee or *areqe* cups; and *yesin ich'e* (pl. 10b, d), footed trays for coffee cups. Other items include *waqema*, bowls for washing the hands and feet (pl. 9a). The largest trays are known as *gebete* (pl. 10c) and are used mainly on special occasions, notably Mesqel. Fuga also make *yeew mager*, dug-out salt-lick troughs for animals. Personal items include *mido*, combs (pl. 9e, f); and, in the past, *kobe*, flat wooden-soled shoes. Among the most interesting items are the *gyimme*, headrests (pl. 11). There are different kinds for men and women, though it seems that they are mainly made as presents for brides.

Fuga have always been and still are innovators. During the Italian Occupation (1936–41) they learned to make beds, chairs, cupboards, and shelves. Borrowed words, such as *komodino* (cupboard) and *sofa* (large chairs) testify to this. Beds, made without a single nail, are often intricately decorated, as Menjiye's superb examples show (fig. 6.5). Currently, Fuga sell small cupboards (*yegibir yiwerepwe*). We also saw signs of recent innovations, such as Menjiye's wooden coffeepot stands, *chifat* (pl. 9b, c), traditionally made from *enset* fiber. Gebre, another Fuga, showed us oil lamp stands (*yekuraz yiwerepwe*), which he claimed to have invented.

Some items follow traditional designs, while others display new forms. For instance, traditional coffee cup trays had a single leg, whereas recent ones have three or four legs. Likewise, there are both traditional and modern designs for headrests, and new fashions are observable in the markets.

The main trees used for making wooden objects are *zigba* (*Podocarpus gracilior*), *wanza* (*Cordia africana*), *shola* (*Ficus sycomorus*), *koso* (*Hagenia abyssinica*), *werer* (*Clausena anisata*), and imported eucalyptus. Menjiye told us that the best were *wanza* and *zigba*, since they are hardwoods. The wood should be cut on a moonless night when there are few insects and should be left for a couple of weeks before being roughly hewn. Then it should be left to dry for another fortnight before the final carving.

Traditionally Fuga used to produce wooden objects for their patrons. They also made objects as offerings for shrines.[30] Fuga were apparently forbidden to sell their wares in markets, where Gurage sold them at a

profit (Shack 1966: 10). Nowadays, Fuga produce goods on commission or for sale in markets. However, larger objects such as beds are carved at clients' houses.

Many objects produced by Fuga are decorated with paint and incisions, often with geometric designs. The main technique consists of painting stripes or sections in different colors and then chiseling lines to form rectangular or triangular designs, which stand out as white against the colors until these fade. Shack (1974: 112) noted that the principal colors were red, green, and purple. Nowadays, the preferred colors are pink and purple. However, Menjiye asked us to buy him red, yellow, green, and purple paints (fig. 6.6). Traditionally, red was obtained from a certain clay and black from soot rubbed off pots, as Menjiye demonstrated. Fuga often may be found applying the final incised designs to their products in marketplaces while waiting for customers (fig. 6.7). This is done with great dexterity using a narrow gouge not just by men but also by women and even young boys.

Fuga are best known for their bamboo work known as *muqe*, the sole craft in which only Fuga engage. Bamboo objects Fuga produce include *qurur*, a basket used to serve roasted grain; *mant'iret*, a sieve used for filtering cheese from whey; *t'equye*, round baskets for keeping belongings (fig. 6.8a, d); *qerch'at*, large baskets used to carry grain, vegetables, *qocho*, etc.; *shat*, granaries; *wezgeb*, doors; and *tebir*, bamboo woven mats. The smaller mats are used for food, middle-sized ones for small doors, and large mats for house floors (fig. 6.9). Large mats take several people more than a week to complete. Smaller bamboo items are made by women; men help with larger items. A husband and wife often work together on a large mat.

The Fuga and the Future

Fuga origins remain a puzzle. However, with their hunting traditions and their own beliefs and distinct vocabulary, they maintain a separate identity. Their status as the only craft group also involved in ritual is ambiguous. They are clearly looked down upon but are valued as essential for Gurage technology, notably house construction, and agriculture. However, with the exception of bamboo work, the craft activities of Fuga men in woodwork, and of Fuga women in pottery, are not exclusive to

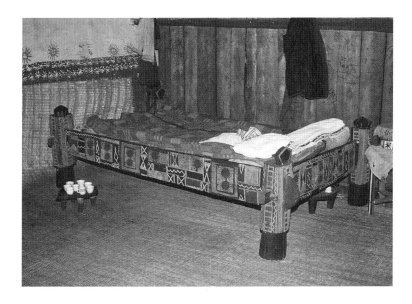

Fig. 6.5 A bed carved by Menjiye.

Fig. 6.6 Menjiye, assisted by his wife, Anchewat, painting recently carved objects.

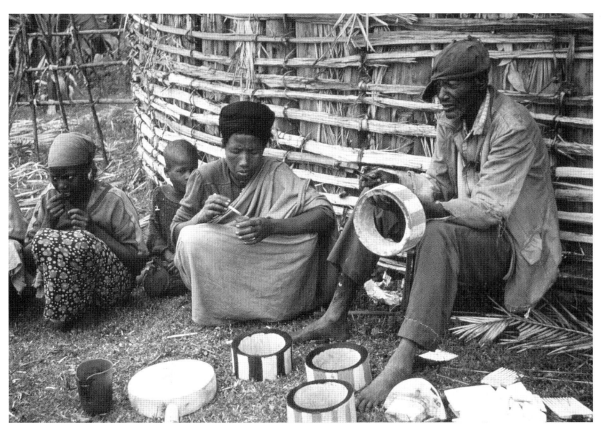

Menjiye Tabeta–Artist and Actor

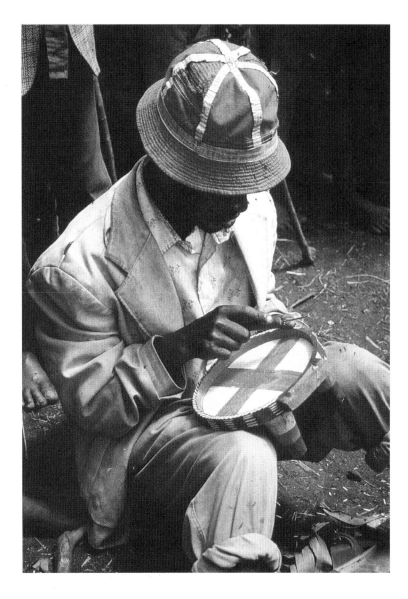

them and are performed without any stigma by ordinary Gurage. Thus, craft is not the defining feature of caste status.

The roles of the Fuga as circumcisers and in rites of passage render them crucial for the transformation of Gurage children, especially girls, into adults. Within the cults some Fuga can attain relatively high status, though they are debarred from entering the inner sanctuary of the shrine

128

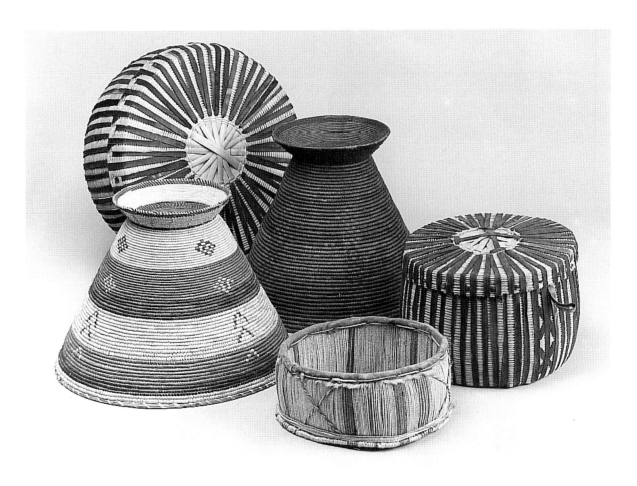

Fig. 6.8 Various types of bamboo basketry containers: (a) *t'equye*, (b) *qolo* container (*sef*) made by Getu Menjiye, (c) *sef*, (d) *t'equye* made by Zakwot Muhammed, (e) coffeepot stand (*chifat*).

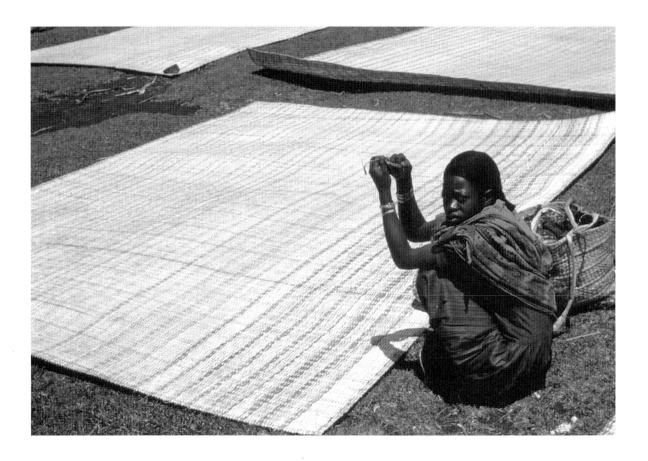

in Chaha. Fuga involvement in social and religious life therefore suggests that they are an integral, rather than a marginalized, part of Gurage society.

Certain signs indicate that the Fuga caste status may be changing. During the Italian Occupation Fuga crafts were admired and sought by the occupiers. More recently not just foreigners but Zhera Gurage themselves have gained a greater appreciation of Fuga crafts. Since the revolution and the land reform in 1975, Fuga have been able to own land. During the present generation some Fuga have attained the status of *qana*, master house builders. The beds made by professionals like Menjiye are appreciated to the extent that one man refused to sell his at any price. Zhera Gurage sometimes refer to Fuga as "Amarica," implying that they are skillful and ingenious like Americans.

Fig. 6.9 Large bamboo mats for sale in Bole market.

When Shack was carrying out fieldwork in 1957, there was little evidence of European goods in Gurageland. Imported articles had not "supplanted the need for potters, weavers, or the arts and crafts of the Fuga" (Shack 1966: 201). On the contrary, he noted that "the business of the artisan as a whole has improved as a result of an increase in the flow of currency" (1966: 201). Today, however, imported cloth has largely replaced woven materials, plastic containers have reduced the need for pottery, and imported tools are displacing local ones. Fuga woodwork is in decline with increasing deforestation, and master craftsmen no longer make many of the beautiful objects such as traditional chairs with backrests. However, the need for house building is permanent, and the demand for large "modern" houses with windows and large decorated beds has increased.

New designs for stools and headrests have become popular. Woodworkers paint their wares in bright colors, and there is still an important demand for basketwork. Fuga crafts are alive and responding to local needs and fashion. As Shack wrote, the Fuga "reinforce the aesthetic values of the tribe through their art, which is an extension of their craft activities" (1966:11–12).

The social status of the Fuga is also changing. Shack (1966: 9) noted that Fuga could only recently enter Gurage houses without asking permission. It seems that there is a greater permissiveness and less social distance between the Fuga and their former patrons. Since the monetization of the Gurage economy, Fuga have been allowed to pay contributions in cash to joint burial associations called *sera*, while the Zhera Gurage contribute in kind, since restrictions on eating together persist. Some Fuga have converted to Christianity or Islam. These Fuga may eat with Gurage and contribute to burial associations in kind. When we were talking with Menjiye's Muslim brother Ishaq, we learned that his wife belongs to an *iqub*, a rotating credit association, together with Gurage women. However, restrictions on conviviality remain, intermarriage is still unthinkable, and a degree of ostracism still persists. Like the work of artisans in other parts of Ethiopia, Fuga crafts remain undervalued, and notions of caste die hard.

Fig. 7.1 Qes Adamu Tesfaw.

Qes Adamu Tesfaw— A Priest Who Paints

Painting in the Ethiopian Orthodox Church

Raymond A. Silverman

I TRAVELED TO ETHIOPIA FOR THE FIRST TIME IN 1991. THE visit included a good deal of time spent at the Museum of the Institute of Ethiopian Studies at Addis Ababa University, where I viewed paintings spanning more than five hundred years. I remember being particularly impressed with the work of a contemporary artist, Qes Adamu Tesfaw, and was intrigued by his title, *qes*, which indicated that the painter was an ordained priest in the Ethiopian Orthodox Church. It was not until two years later, thinking that I might include some of Adamu's work in an exhibition I was planning at Michigan State University, that I decided to meet him.

I was introduced to Adamu in 1993 at the home of his old friend and fellow artist Wendemu Wende.[1] I found Adamu to be a warm, gentle man (fig. 7.1). When I told him how I admired his paintings, he expressed appreciation for the compliment but informed me that his skill was a gift from God. At the end of our initial meeting at Wendemu's house, I drove Adamu home.

My interviews with Qes Adamu Tesfaw were conducted in Addis Ababa during the spring of 1993. I would like to thank Qes Adamu for the time and knowledge he shared with me during these interviews. I would also like to acknowledge the assistance of Neal Sobania, who helped document Adamu's paintings; Degefa Rufo Etana, who served as interpreter during my discussions with Adamu; and Tibebe Eshete and Shiferew Assefa, who assisted in translating the tape-recorded interviews. Thanks also to Marilyn Heldman for her comments on an earlier version of this essay.

Adamu lives in a modest house located on the southwestern outskirts of the sprawling capital city of Ethiopia, Addis Ababa (fig. 7.2). When I entered his house for the first time, I was overwhelmed. Walking through the front door I was immediately confronted with a 5-foot image of a priest painted directly on the plaster surface of the wall. Turning to the right and walking into the dining area, I saw images of Saint George slaying the dragon and the Madonna and Child (fig. 7.3), and moving into the sitting room, there were paintings of King David, the Queen

Fig. 7.2 Exterior of Adamu's house.

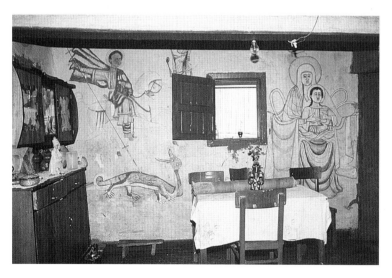

Fig. 7.3 Wall painting in Adamu's house depicting the Madonna and Child and Saint George slaying the dragon.

of Sheba, Menilek I, and priests playing various musical instruments. Every wall in the house is covered with paintings. Adamu told me that he had painted them roughly twenty years earlier, soon after he built his house. I had visited many Ethiopian homes but had never seen anything like this—I knew I was in the presence of a truly exceptional person. This essay is based on a series of interviews with the artist and while focusing on Adamu—his paintings and his life as a priest and an artist— attempts to place him in the broader context of the painting traditions of the Orthodox Church of Ethiopia.

A Brief Biographical Sketch

Adamu was born in 1933 in Bich'ena (Gojjam Province). His father, Tesfaw Getahun, was a priest, and like the children of most clergymen, Adamu pursued a church education. He began by attending a *nibab bet* (lit. "house of reading"), equivalent to a primary school where children are taught the Ge'ez alphabet and to read various religious texts, including the Psalms of David.[2] After completing this basic training, Adamu proceeded to a *qiddase bet* (lit. "house of mass"), where he first studied *gebra diquna*, the functions of a deacon. He then served the church as a deacon for twelve years while continuing his studies of *gebra qissina*, the functions of a priest.[3] Much of this study was undertaken under the supervision of a single teacher-priest, Qes Gebez Anteneh Gebru, who was also a painter. Adamu explained that Anteneh had been a student of Adamu's uncle, Aleqa Kassa Getahun, and was therefore obligated to take Adamu as a pupil. It was while working with Qes Gebez Anteneh on a number of painting commissions that Adamu first learned how to paint. His teacher soon realized that Adamu was a "natural"—the young artist quickly developed a keen interest in painting, an interest that became a passion. During one of our discussions Adamu confessed that he has a "love for painting" and that he "dreams about it most of the time." Qes Gebez Anteneh was aware of Adamu's "gift" and encouraged him to follow his dreams.

Adamu was ordained when he was twenty-six years old. But four years later, in 1963, he decided to abandon the life of a priest and move to Addis Ababa. When I asked him why he moved to Addis Ababa, he replied: "I came here to strengthen this profession, to promote my work.

There is a better supply of materials, the demand for the product is high, and you can also become well known here." The young priest knew that there was a larger, more diverse market for his paintings in the nation's capital. In Gojjam he could only work for the church and its patrons, but in Addis Ababa, a large community of foreign diplomats, merchants, and tourists sought "traditional" Ethiopian paintings. Adamu knew other Gojjami artists, like his friend Wendemu, who had moved to Addis Ababa and were supporting themselves and their families by painting for both churches and foreign visitors.[4]

Upon arriving in the city, he lived with his godfather, Yohannes Tessema, a well-known artist who taught painting at the Empress Menen Handicrafts School.[5] Like Adamu, Yohannes was born in Bich'ena, and his father was a priest. Yohannes and Adamu were kindred spirits. In an interview with Richard Pankhurst (1966: 45) Yohannes indicated that "when still a child he was consumed with the desire to draw and would use anything that he could find." Yohannes moved to Addis Ababa in 1933 to seek his fortune as a painter. Over time he became recognized as one of the leading "traditional" artists in the country.[6] Adamu acknowledges Yohannes as having had the greatest influence on his development as an artist. For the last thirty years Adamu has been actively engaged in Addis Ababa painting both for churches and for shops that cater to visitors to Ethiopia.

An Overview of Religious Painting in Ethiopia

In the Orthodox churches of Ethiopia painting functions in three contexts: on walls inside churches, in books as illustration, and as icons (i.e., devotional images on portable panels of wood). Religious painting, especially that appearing on the walls of churches, has played a critical role in introducing and sustaining religious thought and practice in highland Ethiopia (fig. 7.4).[7] Since the vast majority of Christian worshipers in Ethiopia have been illiterate, paintings have served as a means of conveying the message of the Holy Scriptures.[8] Virtually all Ethiopian church paintings dating from before the end of the nineteenth century illustrate various subjects from the New Testament and, to a very limited extent, the Old Testament.[9] Most of the exceptions depict local (Ethiopian) saints; a few represent historic events and notables. Manu-

script illuminations, though a more private mode of communication, have served a similar function in reinforcing the ideas conveyed in the religious texts they illustrate (e.g., Gospels, Psalms of David, Miracles of the Virgin Mary). Icons (single panels, diptychs, and triptychs) have served as devotional images for the clergy and aristocracy. Larger icons have been taken out of the church on holy days and carried in processions by the clergy, and there are traditions that in the past some were

carried to elicit divine assistance in battle. Smaller, personal icons, usually configured as double diptychs, could be suspended from the neck on a cord and were used by clergymen as portable devotional images and as spiritual protection against evil and misfortune.

Students of Ethiopian art over the last fifty years have offered various models for approaching the study of Ethiopian church painting.[10] The basic framework for these schemas is based on the view that the major catalysts for change in Ethiopian church art came from outside Habesha (i.e., highland Ethiopian) society.[11] Two broad periods may be delineated. The first, lasting until the end of the fifteenth century, is based on Late Antique and Byzantine stylistic and iconographic conventions. The second, lasting to the present, has been stimulated by Western European traditions. This is not the place to offer a detailed critique of this approach. May it suffice to say that its fundamental weakness is a biased premise. Ethiopian art is more than a series of assimilated external influences. It, like the art of all societies, needs to be understood from an Ethiopian perspective before it is set in a broader regional or global context. This problem will be discussed at greater length in the essay's conclusion.

At the moment, attempting to place the art of the Ethiopian Church in a unique social or cultural setting is difficult since so little work has been directed toward this end. The brief discussion that follows reflects the current state of Ethiopian art-historical studies.

The magnificent paintings of the Ethiopian Orthodox Church represent a tradition that reaches back almost fifteen hundred years. Christianity was first introduced in Ethiopia at the court of the king of Aksum in the early fourth century.[12] The most difficult challenge to historians of Ethiopian church art concerns reconstructing the early stages of the tradition. There are only a few known examples of paintings dating earlier than 1270, the date for the founding of the Solomonic dynasty. Many scholars believe that it was not until the sixth century that the artistic idioms associated with Late Antique and Byzantine traditions were first introduced in Ethiopia.[13] The earliest reference to Christian painting in Ethiopia is found in the *hadith* literature, traditions that recount the life of Prophet Muhammed. One of the traditions reports how two of the Prophet's wives, Umm Habibah and Umm Salama, described the won-

derful murals found in the Cathedral of Mary of Zion to the Prophet as
he lay on his deathbed. The two women had been members of a com-
munity of Muslim exiles in Aksum in the 620s (Sergew Hable Selassie
1972: 186).

Most studies of Ethiopian church art begin with the earliest known
examples of painting, which date from the period of the Zagwe dynasty
(1137–1270). The best-known monuments from this period are the
rock-hewn churches found in and around the ceremonial center of Roha,
today known as Lalibela.[14] Because virtually no contemporary accounts
from the period are extant, it is extremely difficult to say much about
the circumstances under which the art and architecture of this era were
produced. Most of the paintings found on the walls of the stone churches
at Lalibela are, in fact, impossible to date. It is generally accepted, how-
ever, that the paintings in Beta Mariam (Church of Mary) date from the
Zagwe period and represent some of the earliest extant examples of
Ethiopian painting.[15] A few manuscripts, like the Abba Gerima Gospels
(from the Monastery of Abba Gerima in Tigray), are also believed to
date from before 1270.[16]

These early works reveal the basic stylistic and iconographic canons
that have governed Christian painting since its introduction to Ethiopia
in the sixth century. A thorough study of these canons has yet to be under-
taken. Nevertheless, it is possible to specify some of the formal charac-
teristics associated with the earliest known paintings. In general, the art
of this era may be characterized as geometric with an interest in deco-
rative pattern. Narrative scenes are reduced to a few key figures and
objects. Compositional symmetry is employed to create a static, balanced
effect. Paintings are flat; there is no attempt to create an illusion of space.
There is no modeling, no use of light and shade, and backgrounds are
usually rendered in a single color. Figurative imagery is usually frontal.[17]
Painters had little interest in naturalism, for we see the human body
often reduced to geometric forms. An emphasis is placed on eyes and
hands; fingers are often elongated. Social perspective is employed that
represents an individual's status by his or her size relative to other figures
depicted in a composition. Conceptual clarity is enhanced by outlining
figures and objects using a dark pigment. And an accurate reading of
the narrative is ensured with strategically placed inscriptions that iden-

tify the key actors in the composition. Many of these characteristics have been maintained over the centuries and can be seen in the work of contemporary artists like Qes Adamu.

It is generally acknowledged that Ethiopian religious painting has its roots in Late Antique and Byzantine tradition. Though there is no concrete evidence, it may be assumed that Coptic and Greek icons and manuscripts were brought to Ethiopia, that artists from various parts of the Middle East and the Mediterranean world visited the royal courts and the monasteries of Ethiopia, and that Ethiopian monks and priests traveled to various holy sites in the Middle East (e.g., Jerusalem).[18]

Beginning in the late thirteenth century, with the founding of the Solomonic dynasty, more paintings, especially manuscript illuminations, are available for study. Examples of manuscript illumination from the fourteenth century, like the Four Gospels of Kristos Tesfana (dated to the first part of the century), reveal that most of the tenets that governed earlier work were still prevalent.[19]

Though there is some documentation from the early Solomonic period, it is still difficult to learn much about artists and their patrons. Almost nothing is known about where and how artists were trained and art was produced.[20] A few scant references to art-related activities occur in the hagiographies composed during this period. It is generally thought that most manuscripts and icons were produced in monastic settings and that monasteries were therefore the primary loci of artistic activity associated with the Ethiopian Orthodox Church.[21] We also know that most of the murals found in churches, as well as illuminated manuscripts, were commissioned by the ruling elite.

The fifteenth century appears to have been a particularly fertile period in the history of Ethiopian church art. During this period a number of monastic houses developed distinctive styles—variations on the stylistic and iconographic themes that had been developed centuries earlier.[22] In one of the few studies that attempts to deal with painting in a specific cultural and religious milieu, Marilyn Heldman (1994) examines the life and painting of the monk Fre S'eyon, who was associated with the court of Emperor Zara Ya'eqob (r. 1434–68). Fre S'eyon is one of only a few painters for whom there is limited information; most of Ethiopia's religious painters remain anonymous.[23] Heldman's work considers

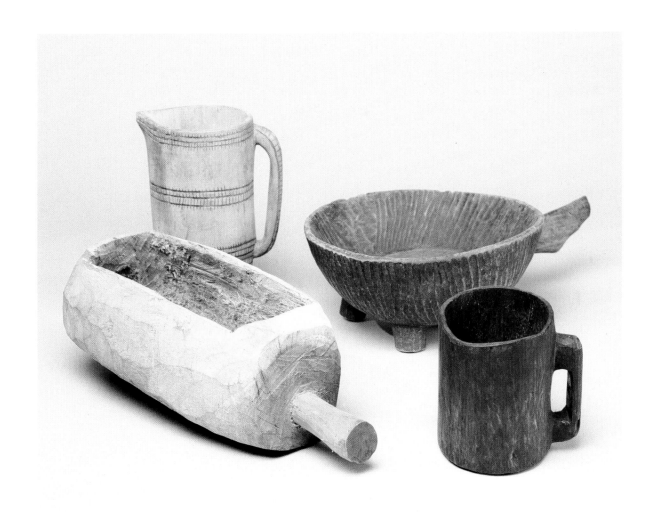

Pl. 1 Wooden bowls (*gongul*) and drinking cups: (front row, left) *gongul* made by
Bogine Shala, (front row, right) drinking cup made by Oniay Dargesha, (back
row, left) drinking cup made by Woyday Dorichali, (back row, right) *gongul*.

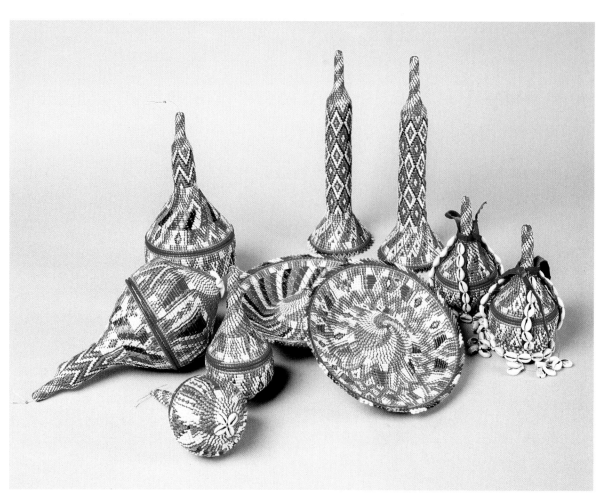

Pl. 2 Various types of baskets produced by Amina and her daughters Munira and Samiyya in 1993: (a) *finjaan gaar*, (b) *it'aan mudaay*, (c) *sehna segaari*, (d) *aflala uffa*, (e) *bissha mudaay*.

Pl. 3 (Opposite page) *Gidiir gaar* in the home of a former *qadi* (judge) of Harer. This house and its contents are now preserved as part of the City Museum of Harer.

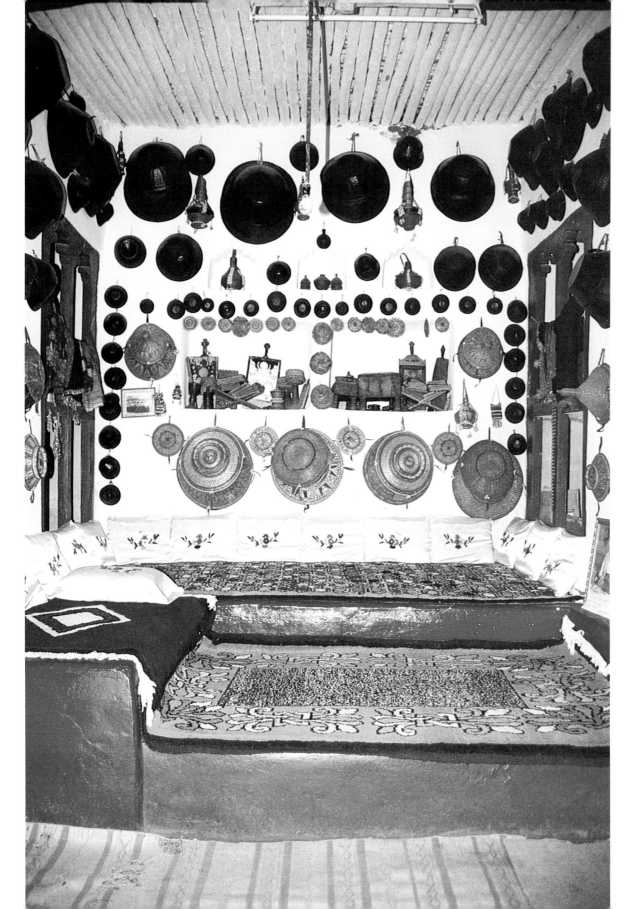

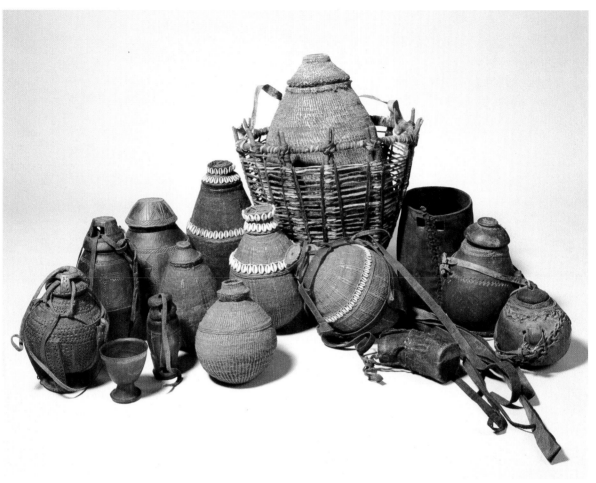

Pl. 4 Borana containers: (a) *buttee okollee* in a *cancala,* (b) *gorfa,* (c) *soroora,* (d) *dibbee,* (e) *dibbee,* (f) *buudunuu,* (g) *buudunuu dhadhaa,* (h) *ciicoo,* (i) *gorfa,* (j) *gorfa,* (k) *gorfa,* (l) *okolee,* (m) *soroora,* (n) *golondii,* (o) *buuda.*

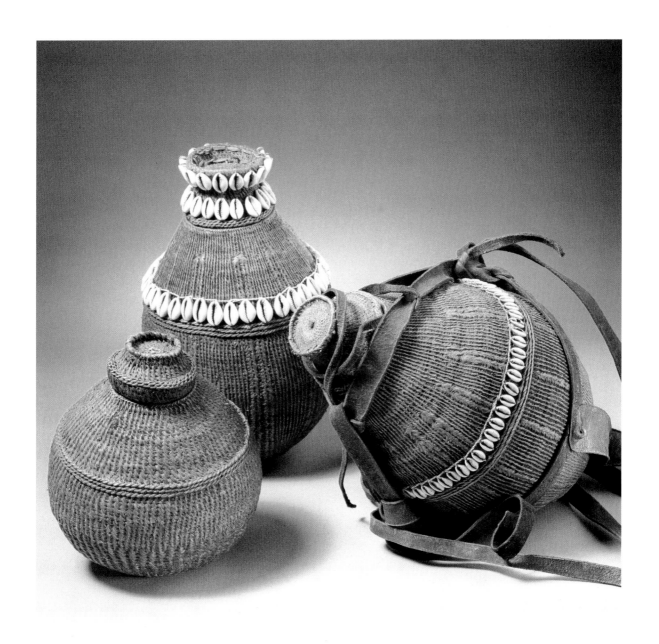

Pl. 5 Three *gorfa*: (left) made by Elema Mamu, (center) made by Jilo Dido, (right) made by Sake Tadi.

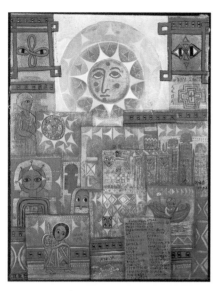

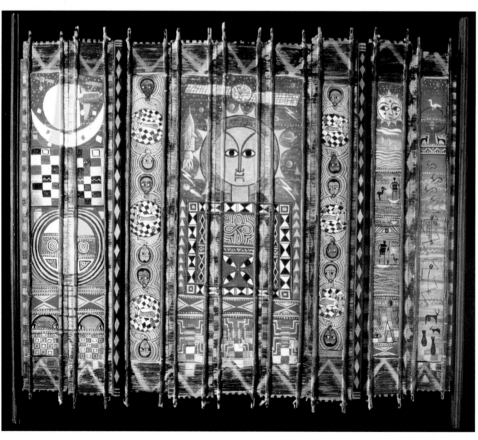

Pl. 6 (Left) *History*, by Zerihun, 1990. Oil on canvas, 90 × 70 cm. Collection of Dr. Carl Robson, Cleveland, Ohio.

Pl. 7 (Below) *Yesterday and Today*, by Zerihun, 1993. Acrylic on bamboo strips. 120 × 103 cm. Collection of the artist.

Pl. 8 (Opposite page) *African Mask Research*, by Zerihun, 1991. Oil on wood panel, 110 × 61 cm. Collection of the MacAuley Family, East Lansing, Michigan.

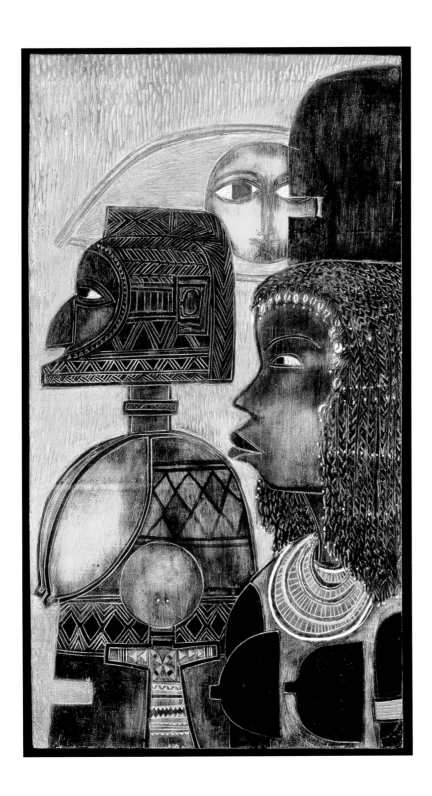

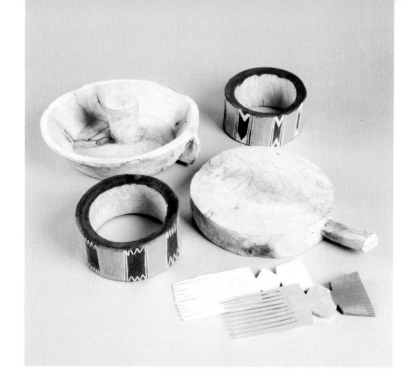

Pl. 9 Wood objects recently made by Menjiye: (a) *yegir waqema*, (b) *chifat*, (c) *chifat*, (d) *t'eqesha*, (e) *mido*, (f) *mido*.

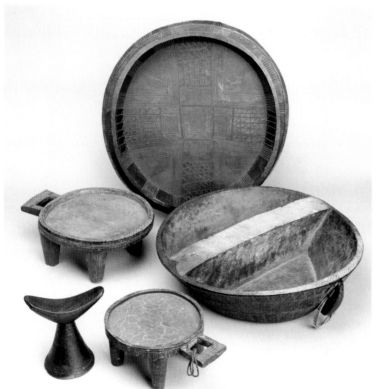

Pl. 10 Older objects made by Menjiye: (a) *gyimme*, (b) *yesin ich'e*, (c) *gebete*, (d) *yesin ich'e*, (e) *yebeser ich'e*.

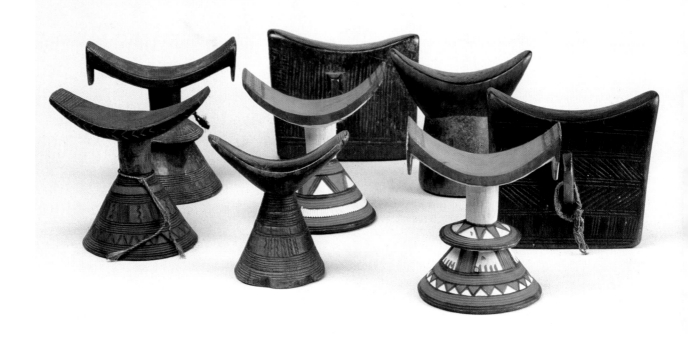

Pl. 11 *Gyimme* (headrests), both new and old. Objects d and h were made by Gebre Wolde Tsadik.

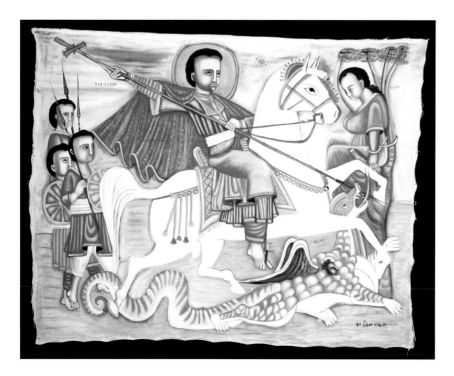

Pl. 12 *Saint George Slaying the Dragon,* by Adamu, 1993. 135 × 173 cm. Michigan State University Museum.

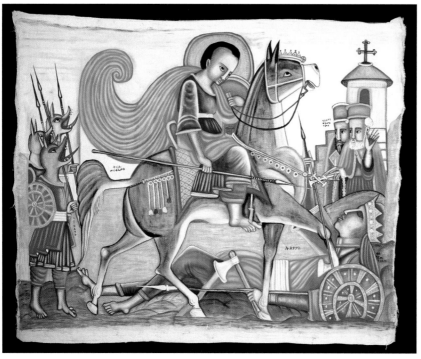

Pl. 13 *Saint Mercurius Slaying Emperor Julian,* by Adamu, 1993. 142 × 173 cm. Michigan State University Museum.

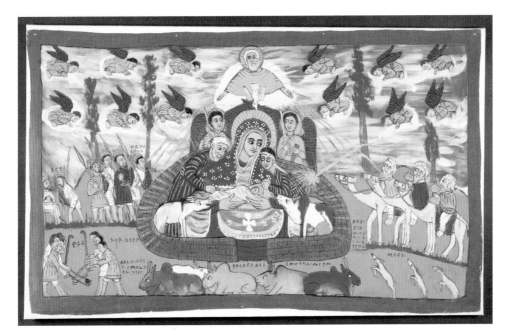

Pl. 14 *The Birth of Christ*, by Jembere, ca. 1960. Bayerisches Nationalmuseum, Munich.

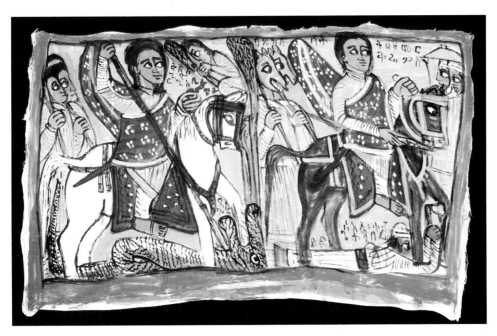

Pl. 15 *Saints George and Mercurius*, by Jembere, 1993. 93 × 151 cm. Michigan State University Museum.

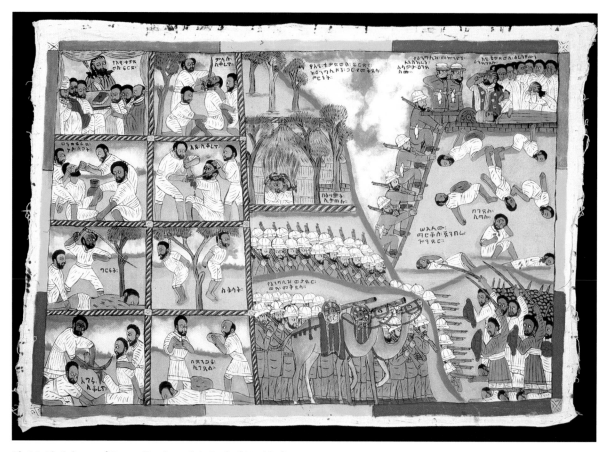

Pl. 16 *The Judgment of Emperor Tewodros and the Battle of Maqdela*, by Marcos, 1993.
91 × 135 cm. Michigan State University Museum.

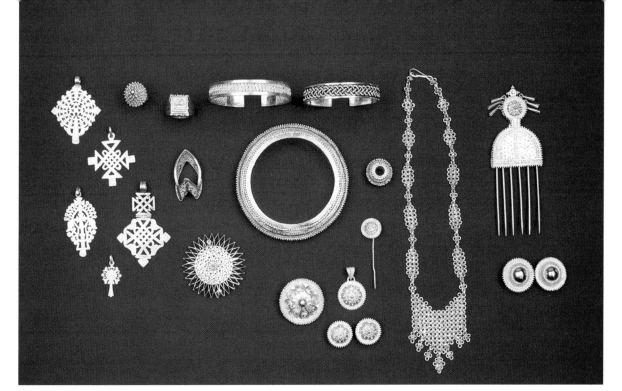

Pl. 17 Silver jewelry produced in Gezahegn's shop: (a–e) neck crosses,
(f–h) finger rings, (i) pin, (j–l) bracelets, (m) pin, (n) pendant, (o) earrings,
(p) hairpin, (q) neck bead, (r) necklace, (s) hair comb, (t) earrings.

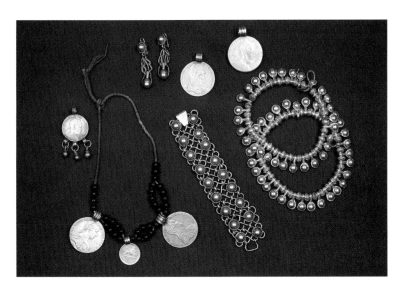

Pl. 18 Silver jewelry produced by Abib Sa'id: (a) neck pendant made from a
coin, (b) necklace with coin pendants, (c) earrings, (d) bracelet, (e) neck
pendant made from coin, (f) neck pendant made from coin, (g) anklets.

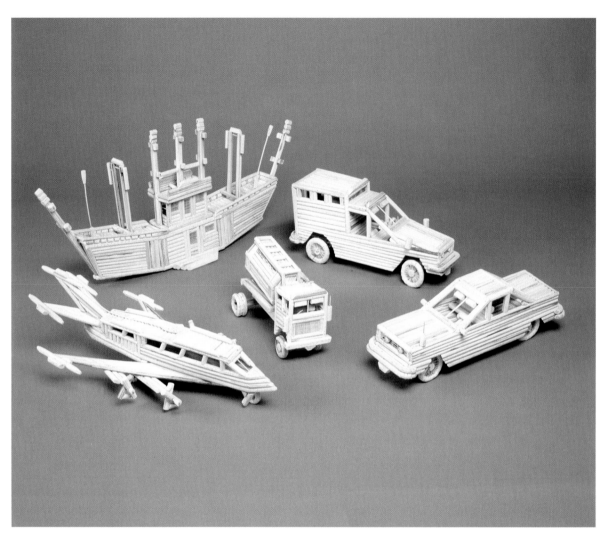

Pl. 19 Models made by Tolera in 1993: (from left to right) airplane, ship, gasoline tanker truck, *wiyiyyit* (taxi-truck), *mekina* (automobile).

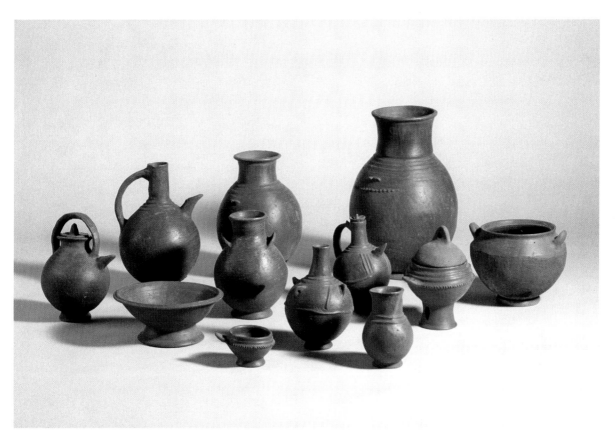

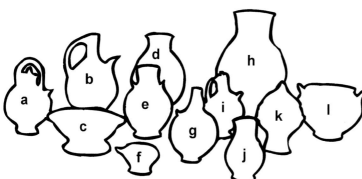

Pl. 20 Various types of pots produced in the village of Gurumu Wayde, near Shento: (a) pitcher (*makorkurya*), (b) pitcher, (c) shallow footed bowl (*gabate*) for serving *bulla* (a food made from *enset*), (d) pot (*chena*) for collecting water, (e) footed pot, (f) shallow footed bowl (*satya*), (g) pot (*gombuwa*) for transporting *t'ej* (honey-wine) or *t'alla* (beer) from market, (h) pot (*ottuwa*) used for cooking, (i) pot (*jabana*) for boiling coffee, (j) small pot (*bitirya*) for drinking, (k) footed bowl (*kachekerya*) for serving food, (l) bowl (*destiya*) for serving *wet'* (stew).

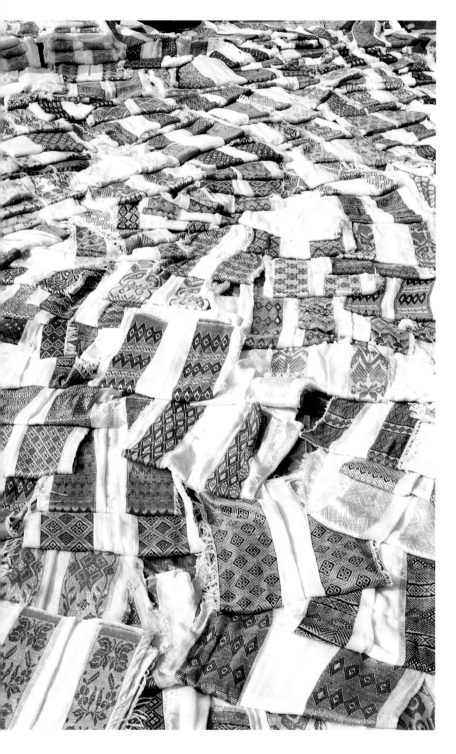

Pl. 21 Display of *net'alas* with *t'ibeb* (inlay border) patterns for sale at a cloth market in Soro Meda, Addis Ababa.

Pl. 22 *Fota, dancho, gabi,* and *net'ala* woven by Arba Desta and his son Malako.

how the emperor, aware of the didactic power of visual imagery, engaged Fre S'eyon and his circle of painters to give material form to his theological treatises involving the veneration of Mary.[24] New iconography and a distinctive style of painting were developed that influenced the production of Marian icons of the second half of the fifteenth century. Heldman notes that Fre S'eyon's "figures are depicted with round faces, almond-shaped eyes, and pursed lips, and the edges of their garments fall in a cascade of ripples. He developed this style from a synthesis of elements taken from Byzantine and Italian *quattrocento* devotional images" (1993: 182).

It was at this time that Western European art and artists began to have an impact on Ethiopian religious art. The earliest recorded European diplomatic missions to Ethiopia occurred during the first few years of the fifteenth century. As early as the first decade of the fifteenth century, artists from Italy were traveling to Ethiopia (Heldman 1994: 139–52; Chojnacki 1983a: 376–78). The most celebrated is Nicolò Brancaleon, a Venetian who was attached to the court of Emperor Lebna Dengel (r. 1508–40) and lived in Ethiopia from about 1480 to 1526.[25] He is credited with having introduced new modes of representing certain religious themes in painting. A number of the icons and manuscript illuminations that are either signed by or attributed to him are still maintained in Ethiopian churches.

There is also evidence that specific Western European works of art had considerable influence on Ethiopian religious painting. Beginning in the sixteenth century engravings and popular prints of European religious works were carried to Ethiopia, where they served as models for local artists. Three celebrated examples may be cited. The first is the *Madonna of Santa Maria Maggiore*, a venerated icon said to have been painted by Saint Luke, is maintained in the Church of Santa Maria Maggiore in Rome. Copies of the famous painting were brought to Ethiopia around 1610 by Jesuit missionaries.[26] The second, the *Evangelium arabicum*, is a copy of the Four Gospels written in Arabic that was printed in Rome at the end of the sixteenth century. Its engravings, inspired by miniatures from Albrecht Dürer's *Kleine Passion*, served as a model for Gospels illumination produced in the church workshops of Gonder during the second half of the seventeenth century.[27] And the third is the late-fifteenth-

or early-sixteenth-century image of the *Ecce Homo*, probably produced in a workshop in Flanders or Portugal and carried to Ethiopia. It is known in Ethiopia as the *Kwerata Re'esu* (lit. "the striking of His head") and depicts Christ wearing the crown of thorns, hands uplifted, and blood streaming from wounds on his chest.[28]

The next florescence in painting, the First Gonderine period, came in the middle of the seventeenth century when Emperor Fasiladas (r. 1632–67) established his court in the market town of Gonder. It remained the capital of the Solomonic dynasty well into the nineteenth century. In addition to serving as the political center, Gonder became the religious and artistic capital of the empire. To date, no paintings associated with the reign of Fasiladas have been identified; the earliest examples of the First Gonderine style are found in manuscripts produced during the rule of Yohannis I (r. 1667–82).[29] Workshops where painters were trained and where icons and illuminated manuscripts were produced appear to have been associated with churches and monasteries near the capital. European art and artists continued to influence the evolution of Ethiopian religious painting. Though the basic stylistic and iconographic tenets developed earlier still predominated, compositions became more complex, and modeling was introduced, but it was used as a decorative device—apparently Gonderine artists were uninterested in exploiting its intended effect (i.e., to develop a sense of three dimensions). The themes of paintings were still almost always religious, but the repertoire of subjects was expanded to include scenes from the Old Testament and local (Ethiopian) saints.

What is generally referred to as the Second Gonderine period started at the end of the seventeenth century and has continued to the present day. It reached its peak between the reigns of Emperors Iyasu I (r. 1682–1706) and Iyasu II (r. 1730–55) and has proven to be the most durable style in Ethiopian painting (Chojnacki 1973b: 82). Some scholars feel that by the middle of the eighteenth century the tradition had deteriorated into a "decadent" or "degenerate" phase brought on by the onslaught of new Western models and values (see, e.g., Chojnacki 1964: 11, 1973b: 82). This is an interesting perception that requires further comment and will be discussed below.

Icons, manuscript illuminations, and church murals from this era

reveal the influence of Renaissance and Baroque painting from Europe. In addition, one may see elements of Mogul painting in some of the work produced during the Gonderine period.[30] Eighteenth-century compositions are more animated and the human actors, depicted in a growing variety of religious scenes, are rendered with greater corporeality —they are fuller, rounder, fleshier. There continues to be little sense of depth in most paintings; only the simplest devices—overlapping and vertical positioning—are used to create an illusion that action is occurring in a three-dimensional space.[31] Backgrounds remain flat and artists still demonstrate little interest in a naturalistic organization of the composition. Painting is still largely conceptual—its primary function remains the clear, concise visualization of religious doctrine.

Before turning to Adamu's paintings, it is worthwhile to consider briefly the social status and training of painters in Habesha society. Only a limited amount of information is found in hagiographies and European travel accounts about either of these subjects.[32] There are a few references to painters in the hagiographic literature, such as an account of the life of the fifteenth-century abbot Maba'a S'eyon, but none of the hagiographies include descriptions of how artists were trained, the technical processes they used, or the status they held in the church community and in society at large (Heldman 1994: 81, 83).

Today artists like Adamu commonly sign their work.[33] But prior to the present century, painters' names only rarely appear on icons, occasionally in the colophons of manuscripts, and it is only since the eighteenth century that artists have inscribed their names on mural paintings.[34] It is the patrons rather than the artists who are occasionally identified in paintings. There are a few exceptions, like the mid-fifteenth-century work of Fre S'eyon and Maba'a S'eyon.[35] When they do occur, signatures can yield important insights for setting the painting in a specific time and place.

What we know of the social standing of church artists is very limited. Throughout highland Ethiopia artists and artisans hold a lower social status than farmers and the clergy. It is noteworthy that the little evidence that does exist suggests that these values did not apply within the Ethiopian Orthodox Church. It seems that in addition to painting, monks and priests produced church lamps, hand and processional crosses, and

chalices and patens—objects made of brass, bronze, silver, or gold.[36] Saint Iyasu Mo'a, the thirteenth-century monk who founded the monastery of Debre Hayq Estifanos, is said to have made a number of lamps (probably of brass or bronze) with his own hands.[37] Local tradition also credits him with producing one of the earliest extant copies of the Four Gospels, dating from 1280–81.[38]

Little has been written about the training of church artists.[39] We know that before the present century, there were no schools of painting (Heyer 1971: 54).[40] Historically, the production of religious art occurred in monasteries and it is likely that this is where one learned to be a painter. Other opportunities may have existed outside the monastery, like Adamu's experience as an apprentice with a master priest-painter.

Patronage is another important aspect of artistic production. In the past, emperors and provincial rulers supported painters attached to various monasteries and churches. As indicated above, we know, for instance, that Emperor Zara Ya'eqob was a major patron of Fre S'eyon and that Emperor Lebna Dengel actively sought and supported the talents of European artists. But what was the nature of their support? Adamu recalls how Ras Hailu Teklehaimanot, the ruler of Gojjam Province from 1901 to 1932, used to order imported paints for the monks and priests whom he commissioned to paint murals for churches and royal residences. We also know that artists, especially those who were working in a church or palace, were often housed and fed and, when finished, rewarded with gifts, which included clothes, money, and occasionally land.[41]

In summary, it is important to emphasize that little is known about the context in which religious paintings were produced and functioned in Habesha society. Our lack of understanding is not necessarily due to a dearth of information on the subject. I will argue later in the essay that the problem lies with how scholars have approached the study of this tradition.

The Paintings of Qes Adamu

Adamu is very much part of the long and rich tradition of Ethiopian painting. However, his primary patron is not Ethiopia's aristocracy or the Ethiopian Orthodox Church; it is the visitor to Ethiopia. Individu-

als and priests from churches come to him and ask him to paint specific subjects. He also paints for tourist shops around Addis Ababa. Adamu mentioned that customers sometimes see his work in shops and then come and ask him to paint something similar for them. Like most modern painters who work in a traditional idiom, he paints on a variety of media, including goat skin, wood, and cloth, but he is particularly skilled at large-scale paintings on cloth.

Painting is a passion for Adamu. It is quite clear in speaking with him, observing him at work, and sitting among his murals in his house that painting is not just an occupation—it is his life. As mentioned earlier, Adamu chose to leave the priesthood to devote all of his time to his art. It does not matter whether his work is destined for a church or a shop; Adamu applies all his skill, knowledge, and creative energy to each and every painting. He approaches each as a unique challenge, and no two paintings are the same. One can see this in two recent renderings of the subject of Saint George slaying the dragon, one painted for Michigan State University Museum in 1993 (pl. 12) and the other painted in 1992 for Mutti Qiddus Giyorgis, a church located a few kilometers from Adamu's house (fig. 7.5).[42]

Formerly, artists made their own pigments from various minerals and plants. Adamu mentioned that his artistic education included learning how to make these paints, as well as the brushes used to apply the colors to a wall, cloth, vellum, or wood panel. But today, Adamu uses commercially produced paints. Because it is difficult to obtain paints in Addis Ababa, he must rely on gifts received from his European patrons as well as what is locally available. He prefers to use artist's oil-based pigments, but these are hard to find in Ethiopia, and even when available they are expensive. Most of the time he paints with general-purpose oil-based enamels that he thins with turpentine or kerosene.

Most of Adamu's paintings are produced on a heavy canvas-like cloth that is factory-made in Ethiopia. Adamu mentioned that he has also used a lighter cloth called net'ela that is locally woven and most commonly used for clothing.[43] The earliest mural paintings, such as those found in the rock-hewn church of Beta Mariam at Lalibela, are painted directly on the wall surface or on a layer of plaster. Later, cloth became the preferred surface for church murals. Adamu explained that one can either

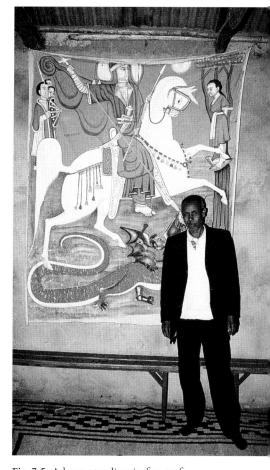

Fig. 7.5 Adamu standing in front of his painting *Saint George Slaying the Dragon*, painted for the Church of Mutti Qiddus Giyorgis, Addis Ababa, in 1992.

paste the cloth to the wall and then work in situ or the cloth can be stretched on a wood frame and painted. When the painting is finished, it is cut from the frame and attached to the wall of the church. The latter technique is the one Adamu uses most often—it allows him to work in the solitude of his house.

Adamu stretches his canvas on a frame made from tree branches (fig. 7.6). This provides a rigid surface on which to paint. He first draws the composition on the cloth using a pencil or piece of charcoal and then proceeds to apply large areas of pigment to the cloth surface, one color at a time, beginning with the lightest colors. He thus builds areas of color. It is only during the final stages of painting that he applies detail (fig. 7.7). Like his predecessors, he outlines many of the forms so that they can be easily read.

Fig. 7.7 Adamu applying detail to his painting *Saint Yared*.

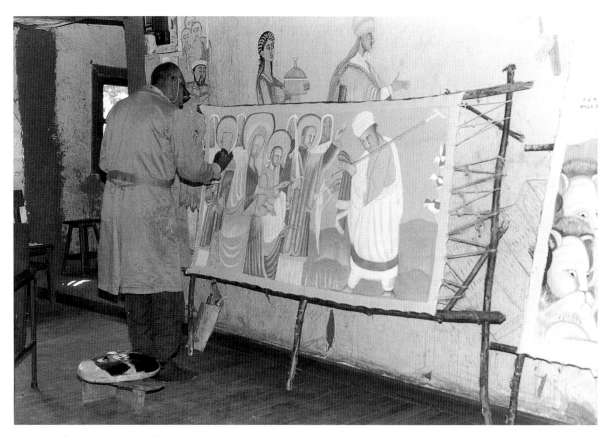

Fig. 7.6 Adamu working on the painting *Saint Yared*.

The reproductions of Adamu's paintings that accompany this essay reveal they generally conform to the canons of the Second Gonderine period. However, his works possess a monumentality not often seen in contemporary traditional painting. The figures in his paintings are boldly drawn. It is a distinctive style. Adamu's rendering of faces, for instance, is easily discerned. The forehead and long straight nose are drawn on the same flat plane, and the brow line runs perpendicular to the nose, creating an angular, almost faceted effect that contributes to the monumental stature of the figures in his compositions.

Adamu used the same basic palette for all of the Michigan State University Museum commissions. The colors red, blue, and green predominate. Yellow is used to a lesser extent, often for highlighting important features, like the halos of holy personages. For this series of paintings Adamu seems to have mixed a good deal of white in the pigments, and the colors therefore have a pastel-like quality. This treatment gives the paintings a luminosity that is rather unusual for Ethiopian traditional painting. Additional information about the iconography and style of Adamu's paintings can be found in the appendix to this essay, which offers some comments about four paintings that we commissioned while working with Adamu in 1993.

Conclusion: A Skewed View of the Past, a Sad View of the Present, a New Direction for the Future?

Most art-historical inquiry in Ethiopia has been devoted to searching for the iconographic and stylistic origins of Ethiopian religious art. Most scholars have approached this challenge from *outside* Habesha culture. Their studies leave one with the impression that the sources of creativity, innovation, and change always come from *outside* Ethiopia.[44] Scholars have successfully identified various foreign sources, and they duly acknowledge the creative genius required to integrate these ideas into an Ethiopian setting, but there is little written on *how* or *why* these models were assimilated and transformed to become part of a distinctive Ethiopian canon.[45] What was (and still is) the nature of the syncretic process that students of Ethiopian religious art have acknowledged as being such a vital element in the history of religious painting in Ethiopia? To ascertain this it will be necessary to seek a better understanding of

the tradition in an Ethiopian context.

Ethiopian religious art has yet to be interpreted on its own terms, that is, in the unique social and cultural setting of central and northern Ethiopia. Years ago, Berhanu Abbaba (1961:164–65) argued that Ethiopian painting needed to be examined from an Ethiopian point of view. Many authors have described distinctive Ethiopian traits that emerge from the practice of rendering religious themes within a specific (Ethiopian) context (e.g., portraying holy figures in Habesha dress), but only a few studies attempt to move past the descriptive and consider why, for instance, Ethiopian priests and monks chose to integrate specific foreign models while rejecting others. Indeed, there has been very little discussion of the *internal* forces that served as catalysts for innovation and change.[46]

It is not surprising that Ethiopian art scholarship characterizes Ethiopian religious painting as conservative, suggesting that the artist, as part of his aesthetic training, is taught to present a subject in a very specific manner, that he does so time and again, and that there is little room for creativity and innovation.[47] Though this certainly is a factor associated with the Ethiopian tradition (indeed, conservatism is a trait associated with the religious arts of many cultures throughout the world), it has been overemphasized and has contributed to a somewhat skewed interpretation of the tradition.[48] This, however, is a logical complement to the perception that the impetus for change always comes from outside Ethiopia. It is true that uniqueness and individuality may not have been valued as highly as they are in modern European society; nevertheless, it is apparent that social and cultural factors in Habesha society have served as stimuli for change. How does one explain the creative genius that spawned the works attributed to Fre S'eyon in the fifteenth century? Today, we know that Adamu consciously approaches his paintings with some degree of creativity. Adamu's philosophy, at least in part, is a product of his living in the twentieth century and in Addis Ababa, where he is likely to have been influenced by modern Western attitudes about art, but one wonders if Adamu's outlook has been shared by other priests and monks who have painted in the past.

Another common perception, alluded to earlier, deserves comment. It is generally held that by the middle of the eighteenth century Ethi-

opian religious painting began to deteriorate and entered a "decadent" or "degenerate" phase. Some scholars believe that by the early twentieth century the tradition was dead. Chojnacki (1978a: 74) suggests that several factors contributed to the demise of church painting in Ethiopia, namely, the influence of foreign models, the introduction of foreign pigments, and the change of artists' attitudes toward their craft—in his words, "the creative spirit of Ethiopian art based on faith" was lost.

There is no denying that Ethiopia has experienced many social and cultural changes over the last hundred years. But these changes have not resulted in the demise of Ethiopian church painting. The "creative spirit of Ethiopian art" is alive and thriving throughout the central and northern highlands of Ethiopia. It is true that artists are not painting like their predecessors did five hundred years ago. It is true that the aristocracy and church are no longer the primary patrons of religious painting. It is true that many artists who today work in the traditional idiom were not trained in a church or monastic setting. Many of them are self-taught and some received formal training in state-supported trade schools. Indeed, even Adamu augmented his knowledge and skills by studying with Yohannes Tessema at the Empress Menen Handicrafts School. And it is true that many "traditional" painters work by rote, producing the same compositions over and over again with little, if any, variation— admittedly, there is little, if any, "creative spirit" in such a context. But this is not true of all artists; it certainly is not true of Qes Adamu.

It is significant that most studies of Ethiopian painting end in the eighteenth century. The scholars who have studied these traditions have created a dichotomy between what they see as two related but distinct traditions, one historic, the other modern. Most scholars do not deal with the later, "modern" phase of Ethiopian art. I would like to suggest that this dichotomy is a Western construct that has been an impediment to the study of Ethiopian art. We, in fact, are dealing with a continuum.[49] Some modern paintings (especially those destined for use in churches and religious texts) and the contexts in which they are produced may upset the aesthetic sensibilities of Western scholars, but they *are* part of the same tradition that produced the revered works of five or ten centuries ago.

The dichotomy and the values associated with it are unfortunate. The

discipline has in effect denied itself access to the richest sources for interpreting religious painting on its own terms. It is not until the eighteenth and especially the nineteenth century that there is a proliferation of European accounts of highland Ethiopian society full of information that surely would enhance our understanding of the social, religious, and cultural milieux that spawned religious art.[50] Failing to acknowledge this continuity has denied scholars an even more valuable source of insight—living artists and their patrons.

If students of Ethiopian art accepted twentieth-century "traditional" painting as a modern-day manifestation of a 1,500-year tradition, we might consider a research agenda that requires coming to grips with the recent past, to attempt an understanding of what is most accessible. Surely, such an exercise would yield significant insights into the meanings of art from more distant eras. This of course assumes that students of Ethiopian art are interested in understanding Ethiopian art on its own terms and that they seek to write a social or cultural history of it.

To do so, scholars are going to have to engage culture, society, and the people who make art much more than they have in the past. This is nothing radical; I am simply suggesting that scholars who seek an understanding of Ethiopian art have to talk to people—priests and monks who paint, the Ethiopian Orthodox clergy and wealthy individuals who commission(ed) religious paintings, the people who worship at churches that display mural paintings and icons, and even the tourists who buy "traditional" paintings. They are going to have to become more familiar with the society and culture that produced these paintings.

Some might argue that talking with today's artists and patrons of religious painting would yield scant insight into the past—things have changed too much. Significant changes have occurred during the last thousand years, especially in the last hundred years, but there is a good deal from the distant past that survives in the paintings of today. Most of the formal and iconographic canons prevalent a thousand years ago are still intact. In addition, many of the basic religious and social values that have driven the tradition for the last thousand years are still prevalent.[51]

An initial step in achieving this goal might be developing in-depth biographies for living painters who received their artistic training

under the auspices of the church.[52] No one has yet documented the entire oeuvre of a single traditional artist. We have no sense of how an artist evolves over the course of his career. Nor do we know much about the forces that motivate an artist to introduce an iconographic element or a new stylistic treatment of a traditional subject.

This essay has been offered as an introduction to the work of a single Ethiopian artist. The product of only a few interviews, it is far from exhaustive. Many more questions need to be asked, and many more insights need to be gleaned from talking to Adamu and examining not only his contemporary work but his earlier work. It would be worthwhile, for instance, to travel with him to Bich'ena, to visit some of the churches where he and his teachers, Qes Gebez Anteneh and Aleqa Kassa, produced paintings before Adamu moved to Addis Ababa. It would also be useful to learn more about the program at the Empress Menen Handicrafts School and about the artists who taught there, like Yohannes Tessema. Many lines of inquiry need pursuing if we are to build a thorough biography for Qes Adamu and begin to understand religious painting from an Ethiopian point of view.

Appendix

Four Paintings by Qes Adamu Tesfaw

Saint George Slaying the Dragon (pl.12)

Saint George, especially his feat of slaying the dragon, is the most popular subject in Ethiopian religious painting, with the exception of Saint Mary. It is found everywhere, on the walls of churches, in manuscripts, and on icons.[53] Ethiopians have a penchant for the victorious equestrian saints, especially Saints George (Giyorgis), Mercurius, and Tewodros.[54] Usually they can be easily distinguished by the color of their horses: George rides a white horse, Mercurius a black horse, and Tewodros a red one.

Chojnacki (1973a, 1973b, 1974, 1975) has examined the evolution of the iconography associated with Saint George from the thirteenth through nineteenth centuries. Adamu's paintings of the saint are consistent with the characteristics of the Second Gonderine period—they possess the iconographic attributes found in works produced after the last few decades of the seventeenth century.[55]

In the Michigan State University Museum painting, we see Saint George riding a white horse. He is depicted as a young man thrusting a spear through the snout of the dragon. The theme, popular throughout both the Eastern and the Western Christian world, is here "Ethiopianized." George wears the sumptuous dress (including a luxurious red cloak) of a Habesha nobleman, and his horse's trappings (including the distinctive "toe-stirrup") are products of highland Ethiopia.[56] Earlier representations of the theme portray George killing a snake (not a dragon) and do not incorporate all of the ancillary characters present in modern-day renderings of the drama. Chojnacki (1973b: 57–58) argues that the transformation of the snake into a dragon and the introduction of

the maiden, Birutawit, can be attributed to foreign influence dating from the end of the fifteenth century.[57] In early (i.e., sixteenth- and seventeenth-century) paintings Birutawit is depicted standing in front of the horse. Later, during the Second Gonderine period, another mode of interpretation was introduced, in which the maiden is depicted tied to a tree—as seen in Adamu's painting. The visage of the devil (representing evil) emerging from the body of the dragon is an iconographic element that Chojnacki (1978a: 69) suggests developed in the eighteenth century and is unique to paintings produced by artists from Gojjam.[58] George's faithful servant, Saqrates, is first integrated into the scene during the First Gonderine period (i.e., seventeenth century). He follows the mounted saint on foot carrying the weapons (spear and shield) and wearing the garb of an Ethiopian warrior. In Adamu's painting two additional attendants accompany Saqrates. Chojnacki (1973b: 89) locates this development in the Second Gonderine period and suggests that the additional figures may represent the servants Lolis and Herpas.[59] However, in the Michigan State University Museum painting, Adamu does not identify these three figures in an inscription.

Saint Mercurius Slaying Emperor Julian (pl. 13)

Since Mercurius is one of the victorious equestrian saints, his slaying of Emperor Julian is one of the more popular themes in Ethiopian art. The earliest extant image of Saint Mercurius dates from the end of the thirteenth century and is found in the Church of Genneta Mariam, located about 9 kilometers east of Lalibela.[60]

Saint Mercurius was a Roman army officer martyred in the third century in Caesarea in Cappadocia and is credited with a number of miraculous appearances.[61] In Ethiopia, his most popular miracle is his appearance at a battle between the Roman forces of Emperor Julian (the Apostate) and the Persians in 363. Prior to the Persian campaign Julian had destroyed the nunnery at Edessa, killing all its inhabitants, including its abbess, Sofia. According to Christian tradition, God sent Mercurius to kill the emperor.[62]

The formal arrangement of this composition is similar to Adamu's *Saint George Slaying the Dragon*, but of course the iconography is different. We see Saint Mercurius on a black horse; in place of the maiden are the

figures of Saints Basil and Gregory (two monks imprisoned for confronting Julian who are said to have had visions of the emperor's imminent demise at the hands of Mercurius); the fallen body of emperor Julian has taken the place of the dragon; and the three attendants that follow Saint George are replaced by three ferocious dog-headed soldiers who accompanied Mercurius on his mission of retribution.

The painting carries inscriptions that identify the various characters in the scene. On the left we see the cynocephalous soldiers identified as "dog face"; Saint Mercurius is identified by an inscription over his horse's tail; "Ulianos" (Julian) is written above the abdomen of the fallen emperor; and the names "Basilios" and "Gorgorios" are written just to the left of the two monks. Again, the "Ethiopianized" version of the tradition portrays the various actors wearing the dress and carrying the accoutrements of highland Ethiopia.

Abba Gebre Menfas Qiddus (fig. 7.8)

One of Ethiopia's most popular saints, Gebre Menfas Qiddus, is thought to be a historic figure who lived in the thirteenth or fourteenth century. He is the subject of an extensive hagiographic tradition that recalls his many miracles—all celebrate the saint's piety and special affinity with animals.[63] He was born in Egypt but is said to have lived most of his life in the wilderness around Mount Zeqwala in central Ethiopia.

Adamu's painting incorporates the distinctive iconographic elements associated with Gebre Menfas Qiddus that, according to Heldman (1993: 251), developed during the seventeenth century. We see the figure of an elderly man with a halo. According to one tradition "he lived standing upright like a pillar for six months, and he gazed into heaven, and he neither dropped his eyelids nor bowed his head, and his hands were stretched out towards heaven" (Budge 1928: 3. 765–66). Gebre Menfas Qiddus is usually depicted with his long, flowing hair (said to be 7 cubits long) covering his body. He carries heavy chains as an act of mortification.[64] He is flanked by lions and leopards, who were "tamed by his holiness" and who were his companions during his long life in the wilderness. His special relationship with animals is further affirmed by the white bird, a creature he encountered while living in the desert and he fed with water from his eyes.

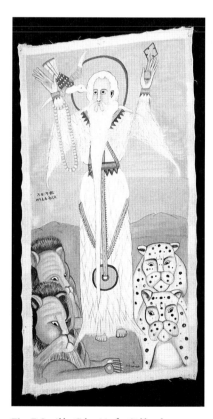

Fig. 7.8 *Abba Gebre Menfas Qiddus*, by Adamu, 1993. 176 × 91 cm. Michigan State University Museum.

An inscription, "Abba Gebre Menfas Qiddus," appears below the right elbow of the saint. The only other writing is Adamu's name, which appears at the base of the painting.

Saint Yared Greeting Christ, Mary, and the Archangels Michael and Gabriel (fig. 7.9)

Yared is said to have lived during the sixth century and is reputed to have introduced music to the Ethiopian liturgy.[65] The figure of Yared occupies the right third of Adamu's composition. Adamu has depicted him wearing the vestments of a deacon of the Ethiopian Orthodox Church and carrying a prayer stick (maqwamiya) over his left shoulder and a sistrum (s'enas'el) in his right hand.[66] Yared is identified by an inscription. The scene depicts the episode in the saint's life when three birds (seen on the far right) from the Garden of Eden came to Yared "and took him to the heavenly Jerusalem," where "he learned the songs of the Four and Twenty Priests of heaven."[67] Yared encounters the Virgin Mary (also identified by inscription) with the infant Christ sitting on her lap, flanked by two sword-bearing figures, the archangels Michael and Gabriel.[68] The group of holy figures is distinguished by their halos and by their elegant garments, reminiscent of highland Ethiopian dress.

Fig. 7.9 *Saint Yared Greeting Christ, Mary, and the Archangels Michael and Gabriel*, by Adamu, 1993. 172 × 93 cm. Michigan State University Museum.

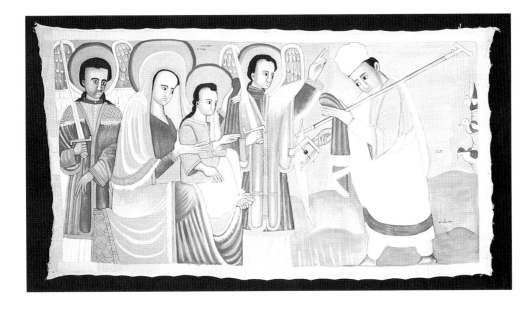

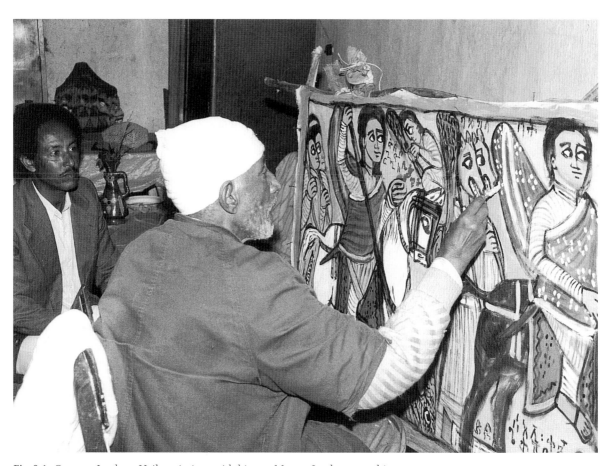

Fig. 8.1 Qengeta Jembere Hailu painting, with his son Marcos Jembere watching.

Jembere and His Son Marcos

8

Traditional Painting at the End of the Twentieth Century

Raymond A. Silverman and Girma Fisseha

This naturalistic trend has become more and more
pronounced in paintings of this century, the period of
growing Europeanisation, and has resulted in a new era of
painting. Nowadays the traditional production has reached
the last stage of the Gondarine style, "degenerate" as the
historian of art would classify it, and to a great extent natu-
ralistic. Starting with the last years of the 19th century
and especially during the period from 1930 up to now,
the Ethiopian traditional painters have turned out a very
impressive number of paintings on various topics, ranging
from the Queen of Sheba to the battle of Adwa, from the
traditional saints to various subjects taken from everyday
life. . . . this mass production has not much in common
with the great achievement of the past, but it is, just
the same, a delight for tourists thirsty for exoticism.
(Chojnacki 1964: 11)

This brief characterization of twentieth-century traditional painting
offered by Stanislaw Chojnacki, a leading authority on Ethiopian art,
touches upon many of the issues that confront anyone who seeks an
understanding of modern Ethiopian art. There is a genre of painting

We would like to thank Marcos Jembere for his interest in our inquiries and
for the time he spent talking with us about his life and work. We would also
like to recognize the time and knowledge that his father, Qengeta Jembere Hailu,
shared with us just half a year before his death. We dedicate this essay to Jem-
bere's memory.

produced in Ethiopia today that has its roots in the ancient artistic traditions of the Ethiopian Orthodox Church. Its subjects include traditional religious themes, episodes from Ethiopian history, and scenes of everyday life in Ethiopia. It is viewed by many students of Ethiopian art as representing the end of a long and magnificent tradition of painting. As such it has been described as "debased," "decadent," or, as Chojnacki suggests, "degenerate." Many, in fact, feel that it has little if anything to do with the religious art of the past. Many changes have come to Ethiopia over the last hundred years and the religious art of Ethiopia is generally considered one of the casualties of modernization, or "Europianisation." At best, the "traditional" paintings of twentieth-century Ethiopia are accepted as delightful souvenirs for "tourists thirsty for exoticism."

It goes without saying that this is a rather bleak picture. It is, however, a picture painted by European and American scholars who have chosen not to examine the tradition on its own terms. Their perceptions are heavily influenced by Western notions of authenticity. Viewed from another perspective twentieth-century painting is a dynamic, vital tradition that has produced works of art that are every bit as stunning as those produced in former eras. It is, in fact, a latter-day manifestation of an ancient artistic tradition. This essay attempts to reconcile these two views through the work of two Ethiopian traditional painters: Qengeta Jembere Hailu and his son Marcos Jembere (fig. 8.1). The essay begins with overviews of the lives and work of Jembere and Marcos. We then place their work in the broader context of traditional painting during the twentieth century by exploring some of the factors that have shaped the tradition over the last hundred years. Finally, we examine the bias against twentieth-century traditional art and the challenges of interpreting the modern art of Ethiopia.

A Short Biography of Jembere Hailu

Before his death in January 1994, Qengeta Jembere Hailu was the best-known "traditional" artist working in Addis Ababa. Richard Pankhurst referred to him as "perhaps the most versatile of Ethiopia's old-style artists" (1989a: 98). Qengeta Jembere Hailu was a priest in the Ethiopian Orthodox Church. His title *qengeta* indicates that he was responsible for the priests who stand on the right side of the altar during Mass. For

over sixty years, Jembere was also an artist who painted religious and historical themes for various patrons, including provincial rulers and visitors to Ethiopia. Today his paintings can be found in churches in Begemdir, Wello, and Gojjam Provinces, as well as in museums and private collections in Ethiopia, Europe, and the United States.[1] In 1993 we had the opportunity to meet with Jembere and talk to him about his life and work. Our inquiries were far from exhaustive; nevertheless, we were able to learn a good deal about the experiences that shaped Jembere's life and drove his career as an artist.[2]

Jembere was born in October 1913 near the Church of Jemal Mikael, in Andabiet, a little village southwest of Debra Tabor. He is one of a number of traditional Ethiopian painters living in Addis Ababa who received a traditional church education. It is in this context that he acquired the knowledge and developed the skills of a painter. During Jembere's youth, this was the only way one could pursue a career as a painter in Ethiopia.

Jembere, in accord with Ethiopian Orthodox tradition, was baptized forty days after his birth and given the Christian name Welde Maryam (Servant of Mary). He informed us that he started school a year after the Battle of Segelle (i.e., in 1917) when he was four years and four days old.[3] He received a traditional church education, first learning to read by studying *Dawit* (the Psalms of David) and various aspects of *zema* (religious music) near his home. He completed this first stage of his education in seven years and in accordance with Ethiopian custom was rewarded with gifts and a big celebration from his family.

Jembere then traveled to the famous monastery of Dega Washera Mariam in Gojjam, where he studied *qine* (liturgical poetry). He proceeded to Welda to continue his study of *qine*. Finally, he moved to Kidane Mehret in Gaynt, where he studied *zemmare* (hymns sung at the end of the Mass), *mewasit* (hymns sung at funerals and memorial services), and *aqwaqwam* (choir performance). In this monastery he was under the tutelage of the famous priest Merigeta Welde Libanos.

In 1927, his uncle Aleqa Alemu, who was an accomplished painter, asked Jembere to join him in Amhara Sayent. Alemu had been commissioned by Empress Zawditu to paint the church in Tegbabe Mariam. It was here that Jembere began to learn how to paint. Jembere's uncle guided the young artist as he studied the Old and New Testaments and

the art of writing (i.e., calligraphy).[4] At his uncle's side, he learned the canons that govern Ethiopian church painting. Jembere told us these rules included knowing that the Madonna should be depicted wearing a "heavenly" blue cape; the devil should always be depicted in dark colors; Saint George is painted riding a white horse whereas Saint Mercurius rides a black one; Saint Michael protects Mary on the right and Saint Gabriel stands on the left; nonbelievers are portrayed with one eye but believers have two big eyes; and angels are rendered in pastel colors. Undoubtedly, these are but a few of the many rules that he learned from his uncle, for Jembere's paintings conform to the compositional and iconographic tenets of traditional Ethiopian painting.[5]

Two years later, Aleqa Alemu and Jembere were asked by the governor of Begemdir, Ras Gugsa Welle, to paint Enatitu Mariam, a church in Debra Tabor. They worked with three other painters until 1930, when their work was interrupted by the rebellion led by Ras Gugsa against Ras Tefari Mekonnen (Haile Selassie). Gugsa was defeated and killed in the Battle of Anchem. General turmoil ensued, and Jembere, then seventeen years old, returned to his parents' home. By this time he had acquired some reputation as a painter and within a year he was asked by the new ruler of Begemdir, Dejazmach Wendwossen Kasa, to paint the reception hall of his palace. As payment for this Jembere was presented, as was customary, with a set of clothes given only to honored personalities by the emperor.[6] During his work on the palace he was also given, every month, a sheep, 3–5 *dawilla* of wheat, 1–2 *gwendo* of butter, 1–2 *gwendo* of honey, and 10–20 birr. He also received 10 *injera* "cakes" and part of a slaughtered deer.[7] After the job was completed, Wendwossen, in appreciation, offered Jembere a position as a secretary.

Jembere met his first wife in 1932 and they were married the following year. In 1934 his first daughter, Tesfaye, was born, and a year later, his first son, T'obia.

In 1936 Jembere and his father went to fight against the Italians, who had occupied Ethiopia. His father was killed that year in the Battle of Maychew. Jembere spent the next five years fighting as a guerrilla against the Italians in Begemdir. Girma Kidane's account of his life indicates that during this period Jembere did not paint, "he did not even dream of drawing" (1989: 74). In 1939, his uncle Aleqa Alemu died on the

battlefield—Jembere was devastated by this loss. Then in 1940 Jembere accompanied Fitawrari Yalegal to Beleya on the Sudanese border to receive Haile Selassie, who was returning from exile in England. Jembere accompanied Fitawrari Biru to Gonder, where they fought against the Italian general Nasi. With the assistance of the British they finally succeeded in defeating Nasi in 1941.

Girma Kidane (1989: 74) reports that in recognition of his patriotism, Jembere received medals from the emperor and the British. He should have received a government appointment, but he had some difficulties with the law. The next few years of his life are difficult to discern. Two conflicting accounts of the problem have been recorded. One rather vague reference claims that he had to leave Gonder for "family reasons" (Girma Kidane 1989: 74). Another suggests that he became involved in a quarrel during which he accidentally killed his adversary and that he was forced to flee the scene and lead the life of a *shifta* (a renegade or outlaw).[8] Both versions indicate that Jembere traveled to Wello, where he painted in the famous monastery church of Gergera, near Lalibela. According to the second account he sought refuge in the church of the monastery and, in gratitude, Jembere painted the church. He apparently encountered another problem around this time. In our 1993 discussions with Jembere, he related how he was arrested in 1946 for allegedly participating in the activities of the Muslim League (Rabita al-Islamia), an organization founded in 1946 that sought Eritrean independence.[9] He was imprisoned for two years. During this troubled period Jembere divorced his first wife, or perhaps she divorced him.

In 1948 Jembere came to Addis Ababa and settled in Arat Kilo. He felt he deserved to be rewarded for his service to his country as a patriot during the Italian Occupation and he appealed to Emperor Haile Selassie. He was given some land and funds for building a house.[10] Around 1953, he married his second wife, Bezunesh Zeleqe. Only one of their children, Marcos, born in 1958, followed in his father's footsteps and became an accomplished artist. After Jembere's arrival in the capital, he met the famous artists Balatchew Yimer (1869–1957) and Hailu Weldeyesus, as well as other painters who had been trained in the church but now, living in Addis Ababa, produced paintings for visitors to Ethiopia. Jembere also began painting for this growing market.[11]

He earned a good living from his paintings until 1974. According to Jembere, after the 1974 Revolution most of the people who purchased his paintings disappeared—tourists stopped visiting the country. The Derg confiscated most of Jembere's property. The painter, greatly demoralized, produced very little until Mengistu Haile Mariam was overthrown in 1991.[12] When we spoke with Jembere in 1993, he observed that there still were few tourists coming to Ethiopia but he had hopes that the traditional-painting market would soon be resuscitated. During the last few years of his life he produced a limited number of paintings.[13]

Jembere's Paintings

Like most of the church-trained painters who emigrated to Addis Ababa to engage the expatriate and tourist art market, Jembere had a repertoire of religious, historical, and secular themes that he painted. He is especially known for his scenes of daily life set around the shores of Lake Tana, the area where he grew up and lived as a young man (fig. 8.2). In addition to these idyllic scenes he is remembered for his interpretations of various religious subjects like the birth of Christ (pl. 14), the Crucifixion (fig. 8.3), and the popular equestrian saints, George and Mercurius (pl. 15). His renderings of historical events, especially famous battles, have attracted the attention of collectors and scholars. Pankhurst, for example, in his studies of paintings depicting the Battles of Adwa and Maqdela, has commented on the artist's innovative treatment of these subjects.[14] Like the traditional artists who preceded him for well over a thousand years, Jembere's work has a strong narrative element. Most of his paintings incorporate inscriptions identifying the key characters in the composition; occasionally he provides a sentence or two describing the action. He proudly signed many of his paintings "Jembere Hailu from Gonder."

Though Jembere followed the basic canons of Ethiopian traditional painting, he felt that his compositions were distinctly his own. He was very much aware that the themes, style, and techniques that he employed were part of an ancient tradition, but he insisted that it was his own imagination and creativity that made his paintings unique. Indeed, Richard Pankhurst recently commented that Jembere is particularly "noted for his reinterpretation of traditional themes" (1994: 287). This

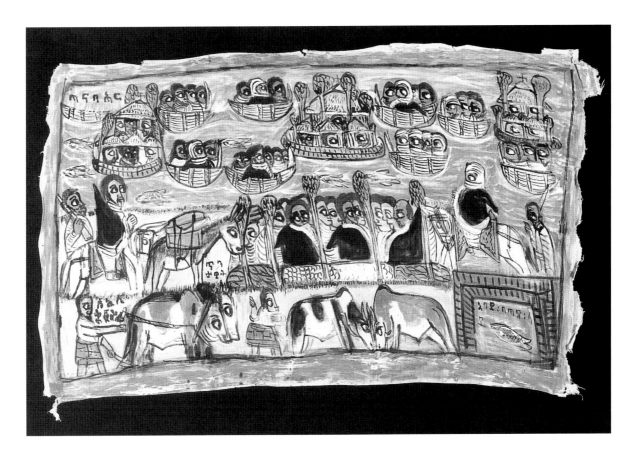

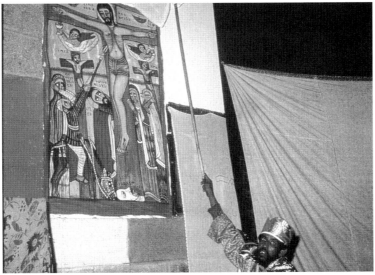

Fig. 8.2 *Daily Life on the Banks of Lake Tana,* by Jembere, 1993. 90 × 150 cm. Michigan State University Museum.

Fig. 8.3 *Crucifixion,* painted by Jembere in the Church of Qeranno Medhane Alem, Addis Ababa, in 1986.

Jembere and His Son Marcos

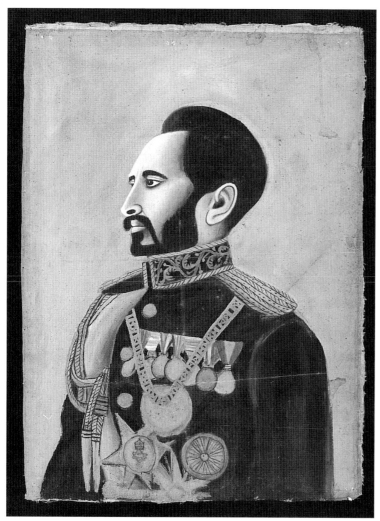

Fig. 8.4 Portrait of Emperor Haile Selassie I, by Jembere, ca. 1955. 83 × 82 cm. Michigan State University Museum.

outlook does not conform to the general perception of the traditional Ethiopian artist. Ethiopian traditional art is generally characterized as extremely conservative. But changes have occurred and there is room for innovation, especially since the turn of the century.[15]

Jembere is not alone; there are other twentieth-century artists working in the "traditional" idiom, such as Qes Adamu and Jembere's son Marcos, who see themselves as artists, that is, creative individuals. A num-

ber of factors have contributed to the evolution of this attitude over the last hundred years. Addis Ababa, an international city with a large expatriate community and tourist presence, has certainly been a fertile arena for the introduction and assimilation of Western ideas concerning art and creativity. Over the course of the last century, artists like Jembere have offered a bridge between the "traditional" and a modern "global" culture.

Examining Jembere's recent work, like his *Saints George and Mercurius* (pl. 15), one is struck by the bold, almost Expressionistic brushwork, as well as by the somber colors. Viewed next to other Ethiopian traditional paintings, these are quite unusual. Examples of the same themes painted by Jembere less than ten years earlier reveal that his style has changed dramatically.[16] The change was not a conscious effort but was due to the elderly artist's failing vision.

In addition to his traditional-style paintings, Jembere worked in another idiom. Like many of the artists who found their way to Addis Ababa, he developed a more naturalistic style reserved for portraiture. One of the most compelling works that we purchased from Jembere was a portrait of Emperor Haile Selassie that he painted about forty years ago (fig. 8.4). It is modeled after one of the emperor's official photographic portraits dating from the era during which the painting was made. Jembere painted it for himself and never signed it. When we first saw the painting, it was hanging in the living room of his house. As mentioned in his biography, Jembere was a staunch supporter of the emperor and a patriot. Jembere loved Haile Selassie and was deeply saddened when he was overthrown in 1974 and died in prison in 1975. The creases found in the painting are the result of Jembere folding and hiding the portrait for seventeen years during the period of the Derg. He was happy to take it out again and put it back on the wall in 1991 after Mengistu Haile Mariam fled the country (fig. 8.5).

We showed the painting to a number of colleagues, specialists in Ethiopian art. It is interesting that several of them insisted that Jembere could not have painted the portrait. Stylistically this portrait and his paintings of religious and historical themes are very different. Our colleagues' assessments were based on the assumption that the traditional artist works in only one style. Jembere told us he had painted the portrait; there is

Fig. 8.5 Jembere and his portrait of Emperor Haile Selassie I in Jembere's living room.

no reason he would have lied to us and we believe he could have very easily produced the portrait.

Like Father Like Son?

Only one of Jembere's children, Marcos, learned to paint. Born in 1958, Marcos began painting when he was only four (fig. 8.6). He learned by observing his father. Early in his training Marcos copied his father's work very closely but then began to experiment with his own interpretations of religious and historical subjects. Jembere showed him how to stretch the cloth on its frame, prepare the pigments, sketch the outline of compositions on the cloth (i.e., the painting surface), and then apply the pigments in layers, one color at a time. Marcos learned to work on several paintings at one time—while the paint dries on one, the artist turns his attention to another. He also learned the importance of preparing

Fig. 8.6 Marcos standing in front of one of his paintings.

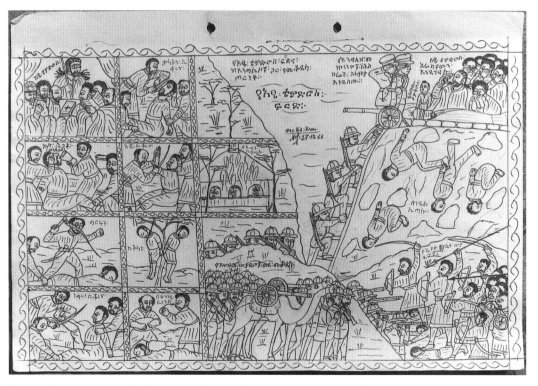

Fig. 8.7 Marcos's sketch for *The Judgment of Emperor Tewodros and the Battle of Maqdela*. Compare with the finished painting of the same theme, pl. 16.

166

sketches of the basic compositions of his paintings. In addition, Jembere taught his son about the subjects depicted in traditional paintings. The important figures presented in his compositions are often labeled and there usually is a rich narrative associated with the religious, historical, and genre scenes that both father and son have painted.

Marcos has produced a set of cartoons that he is constantly updating. These sketches serve as basic patterns for his compositions (fig. 8.7).[17] But Marcos is quick to point out that he approaches each painting as a new challenge and no two paintings are the same. One can observe this in his two renderings of the Battle of Adwa, both painted in 1993 (figs. 8.8 and 8.9).[18] Though the composition and iconography are basically the same, there is a good deal of difference in detail.

Unlike his father, Marcos did not receive a formal church education. Instead he attended public schools in Addis Ababa, completing the twelfth grade. Marcos's artistic education was further enhanced by the art lessons he obtained while in school. He indicated that he was always the best painter in his class, and his teachers encouraged him to continue his studies at a professional art school. Indeed, this has been his dream. Marcos would like to attend the School of Fine Arts in Addis Ababa or a foreign art school. Regrettably, he has been unable to pursue this dream and this caused a serious rift in his relationship with his father. Roughly fifteen years ago he required his father's sponsorship to leave Ethiopia to pursue an arts education abroad. According to Marcos, his father refused to sign the forms and Marcos was not allowed to leave Ethiopia. They ceased talking to one another and despite living close to one another, father and son rarely saw each other. Instead of pursuing a career as an artist, Marcos has been a civil servant for the last thirteen years. He is currently a supervisor in a government motor pool. It is still his dream to go to art school.

Marcos is a gifted painter. Comparing Jembere's recent work with Marcos's paintings, it is difficult to see much similarity. However, if one looks at Jembere's earlier paintings, an affinity is quite apparent. For example, there is a good deal of similarity in composition and style between Jembere's rendering of the birth of Christ (pl. 14) and the same subject painted by Marcos over twenty years later (fig. 8.10).

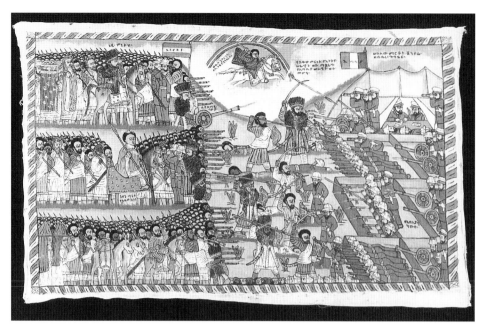

Fig. 8.8 *The Battle of Adwa*, by Marcos, 1993. 91 × 150 cm. Michigan State University Museum.

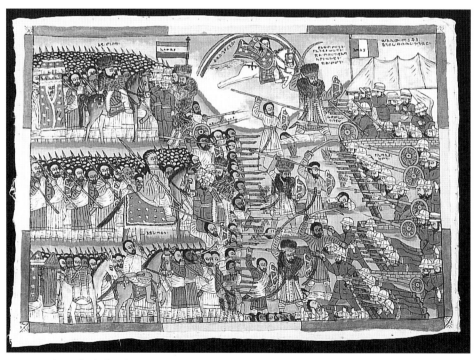

Fig. 8.9 *The Battle of Adwa*, by Marcos, 1993. 93 × 131 cm. Michigan State University Museum.

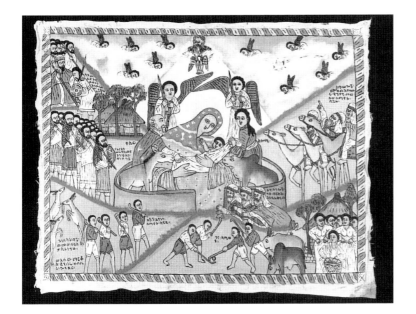

Fig. 8.10 *The Birth of Christ,* by Marcos, 1993. 89 × 115 cm. Michigan State University Museum.

Marcos's paintings, like most traditional paintings, have a strong narrative element—they tell a story.[19] Inscriptions identifying the key actors and action are integrated into his compositions. In addition, Marcos enjoys offering an oral commentary on the religious and historical scenes that he paints. His knowledge of these subjects comes from working with his father, his public school education, and his independent reading of history books. See, for example, his comments about his painting *The Judgment of Emperor Tewodros and the Battle of Maqdela* (pl. 16) that we have reproduced in the appendix to this essay.

These brief biographical sketches of Jembere and Marcos admittedly are incomplete. Further interviews and detailed analyses of the paintings of father and son are required if we wish a fuller understanding of the lives and works of Jembere and Marcos.

Traditional Art in the Twentieth Century

The capital of Ethiopia, Addis Ababa, is not an old city. It was founded in 1887 by the king of Shewa, Menilek II, during a period when much of the rest of Africa was being partitioned and claimed as the colonial domains of various European nations. After the "Scramble for Africa," Ethiopia, or Abyssinia as it was then called, remained the only inde-

pendent nation in Africa. Menilek's successful campaigns of aggrandizement brought much of what is included within the current boundaries of Ethiopia under his control, and in 1889 he was crowned emperor of the sovereign nation of Abyssinia.[20] Addis Ababa was perceived by the people of the country as a place of opportunity. The large imperial court, the many government officials, and a growing foreign community of diplomats and merchants required support. People from all parts of the empire flocked to the capital and it soon became a bustling cosmopolitan city.[21] For the last hundred years, Addis Ababa has been the primary locus for international activity and the exchange of ideas in Ethiopia. Indeed, it has been the site for most of the major changes and innovations that have driven the evolution of Ethiopian society and culture over the last century. The art produced in Addis Ababa bears testimony to these changes for it represents the melding of long-standing Ethiopian tradition and the traditions of a twentieth-century global society. It is in this setting that the art and artists of the Ethiopian Orthodox Church met the world.

References in early European travel accounts suggest that until recently, the production of paintings was the exclusive domain of monks and priests who learned the art as part of their religious education.[22] There is an ancient tradition in the highlands of central and northern Ethiopia, stretching back to the advent of Christianity in Ethiopia over 1,500 years ago, of wealthy individuals commissioning monks and priests to paint religious subjects on the interior walls of churches, or icons and manuscripts that they would then give to specific churches or monasteries. Their support of the church in this manner served both as an act of piety and as a means of affirming their elevated position in Ethiopian society. Ethiopia's aristocracy continued to be the primary patrons of painting until the present century.

Paintings apparently were also produced in the palaces of the ruling elite.[23] The subject matter of these palace paintings from earlier periods is largely unknown. We may speculate, however, that they were in part religious but also included some scenes recalling the exploits of earlier rulers or recording the life of the reigning aristocracy. There is evidence that secular themes were being painted in palaces by the eighteenth century, perhaps even earlier, and that by the nineteenth century

they were appearing in churches around the country.[24] Among the most popular subjects were recent battles and the portraits of regional rulers.[25]

Elisabeth Biasio (1994) has recently argued that this development is not surprising, for it reflects the close ties between the political and religious values of the peoples of highland Ethiopia. Indeed, this same observation was made almost a hundred years ago by Viscount du Bourg de Bozas, who visited the Int'ot'o Church of Saint Mary (Addis Ababa) and commented on the portraits of Emperor Menilek II and Ras Mekonnen: "It was not without some intention to divinize or at least to sanctify the rulers of the country that the portrait of Menelik was next to that of Christ on the day of the Last Supper and that of Ras Mekonnen was placed next to that of the four evangelists" (my translation; 1906: 214). He concluded that the paintings reflected the contemporary political scene. Biasio suggests that the roots of the tradition may be found in the Zemene Mesafint (1769–1855), a period of political instability during which local rulers may have exploited such imagery to affirm their political stature.[26]

New Patrons for the Arts

At the end of the nineteenth century, the members of the ruling class continued to be the primary patrons of painters in Addis Ababa. However, in addition to commissioning artists to produce paintings for churches and their royal residences, they also had them paint large-scale compositions on cloth that they gave to visiting dignitaries as gifts.[27] Visitors to Ethiopia also sought to obtain their own paintings. One of the first Europeans to do so was the British emissary Henry Salt (1967: 394), who visited Ethiopia in 1809 and engaged the chief painter of Ras Welde Selassie, ruler of Tigray (r. 1788–1816), "to paint him one of his best pictures."[28] During the nineteenth and first third of the twentieth centuries, most paintings were acquired directly from artists. A number of foreign residents, like the Russian physician A. I. Kohanovski, who lived in Addis Ababa from 1907 to 1913, were able to collect paintings.[29] C. Keller (1904: 33), in one of the first articles devoted to Ethiopian traditional painting, reports that many artists were reluctant to work outside the traditional patronage system and it therefore was

sometimes difficult to locate artists willing to paint for foreigners. Even more difficult was finding ready-made paintings—in the late nineteenth and the early twentieth centuries, paintings were not produced for an open market (see, e.g., Bent 1893: 39–40; Powell-Cotton 1902: 120; Norden 1930: 32; Coon 1935: 122). Powell-Cotton (1902: 118), a British sportsman who visited Ethiopia in 1899–1900, offers the first reference to a dealer of Ethiopian paintings in Addis Ababa, a Greek merchant named Balambaras Giyorgis, but even he had difficulty maintaining a stock of good-quality paintings.[30]

Workshops and Schools

The commercialization of traditional painting may be seen as a response to a growing foreign presence in Addis Ababa. Pankhurst (1966: 39) reports that the production of oil paintings for visitors to Ethiopia really took off after 1930 and the coronation of Haile Selassie. Adrien Zervos (1936: 242) lists eleven painters working in Addis Ababa in the 1920s and 1930s whose work could be purchased for anywhere from 2 to 10 thalers, the equivalent of 10–50 francs at the time.[31] But paintings were still relatively scarce until the Italian Occupation (1936–41), when an increased foreign presence created an "almost insatiable demand for all kinds of tourist goods" (Pankhurst 1966: 39). The commercialization of Ethiopian painting at this time owes a great deal to the Georgian entrepreneur Djougashvilli, who called himself Prince Amaradjibi and established a hotel and a "factory" for the production of Ethiopian paintings of religious themes, scenes of traditional life, and battles (Pankhurst 1966: 39).[32] He is said to have employed between ten and fifteen painters who lived in their own homes but spent the whole day in Amaradjibi's workshop, where they received a wage of from 100 to 1,000 lire a month in addition to their food. Molesworth tells us that most of the "freelance" painters of the day were engaged by Amaradjibi.[33] Most of them had received their initial training as artists as part of a traditional church education in Gojjam, Tigray, Wello, or Begemdir. They came to Addis Ababa in search of the opportunities available in the country's new capital (Molesworth 1957: 362).[34] Workshops have continued to be important loci for the production of traditional painting, especially that destined for the tourist trade.

Jembere worked independently, as does Marcos, but many traditional painters have been attached to a workshop or school. A number of these workshops have been private. M. E. W. Molly, a Swiss engineer who visited Addis Ababa in the 1920s and collected a number of paintings by Behailu Gebre Maryam from Tigray, reported that Behailu had founded a school in Addis Ababa and that two or three of his students had become painters, more or less accomplished, but that they continued to paint the subjects of their teacher (Pittard 1928: 88). Today, one of the more active private workshops is maintained by the art dealer Welga Mehretu.

The most important government-sponsored institution involved with traditional painting was the Empress Menen Handicrafts School, founded in 1930/31 to offer instruction in various crafts.[35] One of its primary mandates was to preserve "the beautiful handicrafts which had flourished in former times" but were beginning to disappear "under the impact of factory-made wares from abroad" (Anonymous 1957: 80). A number of church-trained painters have been affiliated with the school in one way or another. The well-known painter Yohannes Tessema, for instance, worked at the school as a painter and teacher for a number of years. Some of Addis Ababa's painters, especially those who did not learn to paint as part of their religious education, received their training at the school. The products of the Empress Menen Handicrafts School and related institutions, like the Ethiopian Tourist Trading Corporation (ETTC), have been directed toward the tourist market.[36] Since these institutions were production oriented, paintings were produced quickly, and a division of labor had talented artists "drawing" the compositions and the less-skilled artists "painting" them (filling them in with color) (Biasio 1993: 17). Among the more popular products were small "traditional" paintings on goat skin that depict various religious and genre themes.[37] The quality of "craftsmanship" of these "skin paintings" varies. Though "handmade," paintings of the same theme, produced by the same team of workers, are virtually identical. The products of these workshops are not as good as the paintings of some of the better independent artists, like Qes Leggese Mengistu and Zeleqe Unetu, who also produce goat-skin paintings for the tourist market.

Another venue for training outside the church has been the School of Fine Arts in Addis Ababa. Biasio reports that a number of church-

trained artists—for example, Qes Leggese Mengistu, Gebre Kristos Solomon, and Taddese Welde Aregay—received additional training at this school, which specializes in the training of modern artists in Ethiopia (Biasio 1993: 14).

Traditional Artists Working in Traditional Contexts

Today's traditional artists, especially those who live in Addis Ababa, work for a broad clientele. Indeed, the paintings of a single artist may be destined for any number of venues. Jembere has produced paintings for churches, political leaders, tourists, expatriates, t'ej bets (drinking houses), and museums. Often there is nothing inherent in the painting itself that determines its destination. This is especially true of religious subjects. The largest market, at least since the turn of the century, has been foreign visitors to Ethiopia. But there is still a demand for paintings that are destined for churches and many of the artists who produce work for the foreign market also decorate churches and illustrate religious manuscripts. In 1986, for instance, Jembere was commissioned to paint a Crucifixion in the church Qeranno Medhane Alem in Addis Ababa as a votive offering (Biasio 1993: 22) (fig. 8.3).[38]

Similarly, some traditional artists are still engaged in illuminating and illustrating religious texts. With the advent of mechanized printing in Ethiopia, the scriptorium has become an outmoded institution. Nevertheless, there is still a need for artists to produce the decorative and pictorial images for printed editions of religious books. Qes Leggese Mengistu, for instance, showed us a copy of a "Qiddase" book published in 1967 by the Imperial Press for which he had designed the hareg (the decorative designs that separate the sections of the text).

Themes in Traditional Painting

Today, a common set of themes is associated with traditional painting. Walter Raunig (1989: 69) offers the following categories: the story of the Queen of Sheba; religious activities; daily life; outbreaks of aggression; ruler, court, politics, and diplomacy; hunting; feasts (both secular and religious); animal societies; courts of justice.[39] The most popular subject, especially among tourists, has been the Queen of Sheba's visit to King Solomon. The standard artistic interpretation of this popular

tradition is a fairly recent development dating from the end of the nineteenth century and presents a serial recounting of the founding of Ethiopia's Solomonic dynasty.[40] An interest in the "exotic" has certainly driven the development of the themes that portray aspects of "traditional" life in Ethiopia. A question that we can only briefly consider in the present context concerns whether these subjects represent Ethiopian values or the values of the foreigners who purchase the paintings.

The advent of a foreign visitors' market and the commercialization of traditional painting certainly stimulated the evolution of specific themes. During the first few decades (ca. 1890–1920) of the modern tradition, virtually all of the painting produced for export represented religious subjects or scenes of battle. By the late 1920s scenes of festivals, everyday life, the hunt, and contemporary events were being produced, and in the 1930s an interesting allegorical genre known as "Society of the Animals" was introduced.[41] Scenes of battle, hunting, and torture (e.g., the Judgment of Tewodros) have been particularly popular (pl. 16). Molesworth, commenting on the production of painting in Amaradjibi's workshop, observed that the "lurid representations of battles, Ethiopian punishments and coarser practices which he [Amaradjibi] sponsored and encouraged for foreign taste may not have had much to do with traditional iconography" (1957: 362). The development of this "genre of violence" concerned even Emperor Haile Selassie, who banned the export of such paintings because he felt "they make the people [Ethiopians] appear barbarous" (Coon 1935: 119). Their popularity may very well represent a point of convergence between Ethiopian and European culture—a penchant for violence and hegemony has long been prevalent in both highland Ethiopian and European society.[42] It would be safe to guess that most of the previously mentioned themes represent a coalescing of the values of both producer and consumer. One may view them as the products of a dialogue between the Ethiopian artist and the foreign visitor. This is an important factor for understanding twentieth-century Ethiopian art and requires further study.[43]

Portraiture

Another genre of twentieth-century traditional painting needs to be considered—portraiture. Portrait painting is not a recent phenomenon. The

tradition of including portraits of important historical figures in manuscripts has probably been practiced to a greater or lesser extent since the advent of religious painting in Christian Ethiopia.[44] It seems to have been particularly popular during the Gonderine period (mid-seventeenth to late eighteenth century).[45] The tradition continued in the nineteenth century. For instance, a number of manuscripts produced during the reign of Sahle Selassie, king of Shewa from 1813 to 1847, contain illustrations of the king and members of his court engaged in various activities.[46] The practice of including portraits in mural paintings in churches also has some antiquity, though they are only rarely mentioned in the chronicles, hagiographies, and travel accounts before the nineteenth century.[47] Nor are there many extant examples of such paintings dating before this time. However, beginning in the second half of the nineteenth century European visitors often observed portraits of the ruling elite in the murals of churches located throughout Abyssinia, especially in the towns and cities that served as capitals of provinces, kingdoms, or the empire.[48] These portraits are rendered in a style consistent with the paintings of the Ethiopian Orthodox Church. They are not naturalistic—the individuals depicted are rendered as human "types" distinguished only by their accoutrements and inscriptions.

Jembere's portrait of Haile Selassie represents a new type of portraiture that attempts to offer a naturalistic rendering of the subject. This genre appeared in the 1920s or 1930s, inspired by the European tradition of formal portraiture, and can easily be differentiated from earlier "type-portraits" by its higher degree of verisimilitude.[49] The introduction of photography in Ethiopia at the end of the nineteenth century certainly served as a catalyst for the genre.[50] Photographic images of important personages offered artists a naturalistic model from which to work. Earlier, the identification of an individual was based on iconographic or stylistic conventions (i.e., social perspective) and inscriptions; now it was possible to identify a person based on likeness. A marvelous selection of portraits by Hailu Weldeyesus of various contemporary (ca. 1935) world leaders is reproduced in Zervos's L'empire d'Éthiopie: Le miroir de l'Éthiopie moderne, 1906–1935.[51]

In our discussion of Jembere's paintings we mentioned that some scholars find it difficult to accept that Jembere painted the portrait of

Emperor Haile Selassie (fig. 8.4). There actually is plenty of evidence that Ethiopian "traditional" artists, especially those working in Addis Ababa in the twentieth century, have worked in more than one idiom. To offer a single example, one might consider the work of Hailu Weldeyesus, a painter from Wellega Province active in Addis Ababa in the 1920s and 1930s. Zervos reproduces on the same page in his book a naturalistic portrait of Ras Mekonnen and a more traditional composition depicting a historical subject, *The Defeat of Mohammed Gragn by the Portuguese*, both painted by Hailu (Zervos 1936: 244).[52]

Conclusion: Changing Traditions

Finally, we return to the observations that were made at the beginning of the essay, especially those concerning the commonly held notion that the assimilation of foreign ideas associated with the modern era has brought about the demise of traditional painting. Traditional painting of the modern era has been relegated to the status of "folk" or "popular" art, *Western* categories for art that do not carry the same import as the fine church art of the past. As mentioned in our introduction, this is a curious view that reflects the strong bias held in the West for things that are old, things that are "authentic."

Some authors have cited the introduction of Catholic devotional paintings and prints and of modern Russian, Armenian, and Greek icons at the end of the nineteenth century as contributing to the degenerative process. These were distributed throughout the country—walking into most churches, even in rural towns, one can see these imports displayed side by side with local paintings; one can also see the prints pasted in religious manuscripts (Biasio 1989: 57). In addition, we know that there were a number of foreign artists residing in Addis Ababa at the beginning of the present century who must have had some influence on the traditional painters living in the capital.[53] But this is not the first time foreign imagery has been introduced in Ethiopia or that foreign artists have worked in the country. European artists, as well as reproductions of European paintings and prints, have been coming to Ethiopia since at least the fifteenth century.[54] In fact, it is interesting that most of the scholars who have written on the history of Ethiopian art have been preoccupied with tracing the influence that these external elements have

had on the evolution of Ethiopian religious painting. These authors celebrate the ingenuity with which these foreign traditions were assimilated by Ethiopian artists. Yet they fail to appreciate the same processes of integration operating in a modern context. The paintings associated with the Ethiopian Church prior to the modern era are esteemed as fine art and are studied as such. But works of modern-day priests and others who paint in a "traditional" manner are viewed as "degenerate" vestiges of the past. Apparently we are dealing with a double standard that emerges from a set of *Western* criteria for evaluating the material culture of other (i.e., non-European) people.

If we could somehow transport today's students of Ethiopian art back to the sixteenth-century court of Emperor Lebna Dengel (r. 1508–40), how would they deal with the presence of the Venetian painter Nicolò Brancaleon and the impact he had on the religious painting of that era? Would the art historians suggest that the paintings produced by the priests and monks who had come under Brancaleon's influence were degenerate or inauthentic? Perhaps so. But five hundred years later, given temporal distance and the opportunity to observe change in a broader historical context, the impact that Brancaleon had on Ethiopian painting is not viewed in a negative light.

The double standard is in fact a product of a tension existing in modern Western society between "tradition" and "modernity," a reverence for both the old and the new. This manifests itself in different ways— for instance, in the necessity to differentiate between that which is traditional and that which is not. The situation is further complicated when dealing with other cultures, where the related issue of identifying that which is "authentic" and that which is not also comes into play. This is a fascinating phenomenon that we can only briefly touch upon in this essay. May it suffice to say that these processes of differentiation have required the development of schemes for classifying material traditions that are based on *Western* criteria for evaluating cultural experience. In short, our preoccupation with differentiating between these categories has influenced how we have approached the interpretation of Ethiopian art.

Several scholars recently confronted this issue and they have all concluded that Western criteria or categories for artistic expression in

twentieth-century Ethiopia simply do not work (see, e.g., Ricci 1986, 1989; Bender 1982, 1989; Biasio 1993; Benzing 1994). Their frustration is reflected in a series of questions that Brigitte Benzing (1994) poses: What is "modern" in Ethiopian art? How "Ethiopian" is modern art in Ethiopia? What is traditional in modern Ethiopian art? The necessity of seeking an understanding of Ethiopian painting on its own terms has become apparent. The works of artists like Jembere and Marcos need to be interpreted as products of a unique cultural and historical setting. Talking to living artists, such as Jembere and Marcos, offers the student of Ethiopian art a marvelous opportunity to acquire fresh insights into the past as well as the present.

Appendix

Marcos Jembere's Narrative concerning His Painting *The Judgment of Emperor Tewodros and the Battle of Maqdela* (pl. 16 and fig. 8.7)

THIS PAINTING HAS TWO PARTS. ONE IS THE BATTLE OF MAQDELA, and the other is Tewodros punishing those who oppose him. The painting shows Tewodros and his advisors discussing how to deliver the right decision and judgment based on the law. The Bible signifies that they are under oath.

At the beginning, Emperor Tewodros was poor and a *shifta*. His poor mother used to sell *koso* [a local medicine used for tapeworm] and was therefore despised and looked down upon by some people.

Wendyerad, Empress Menen's most trusted servant, promised his queen that he would go to the forest and bring back "the son of the *koso* seller" alive. He went to the forest to catch Tewodros. When Tewodros heard the news, he instructed his soldiers to catch Wendyerad alive. If this was not possible, he alone would fight Wendyerad. Somehow, Wendyerad was wounded and captured by a soldier and then taken to Tewodros. Tewodros asked Wendyerad what words were used to insult him. Tewodros then told Wendyerad that his mother raised him by regularly feeding him *koso*. He also said he was as poor as *koso* and that Wendyerad should taste how sour *koso* is. Consequently, Tewodros sentenced Wendyerad to drink *koso* continuously until he died.

The other side of the painting shows criminals as they are flogged and their hands, legs, and tongues cut out. Some were hanged; others, stoned to death or thrown down cliffs.

At the bottom of the painting, there are British soldiers and camels. Emperor Tewodros kept fighting his enemy, and when he knew he could not win the war, he killed himself with a pistol. When the British soldiers approached him and found him dead, they saluted him. Before

his death, Tewodros ordered the prisoners released. The prisoners continuously shouted: "It is without your wish and will that you are releasing us now." Tewodros got mad and ordered his soldiers to throw them all into a deep gorge.

In the right corner we see Tewodros's relatives, particularly his son, Alemayehu, standing by his bedside crying. We also see the British soldiers using a ladder to climb a cliff in Maqdela, and controlling the area.

Fig. 9.1 Gezahegn Gebre Yohannes working on a bracelet.

Fig. 9.2 Abib Sa'id breaking a Maria Theresa thaler in half before melting it in the crucible.

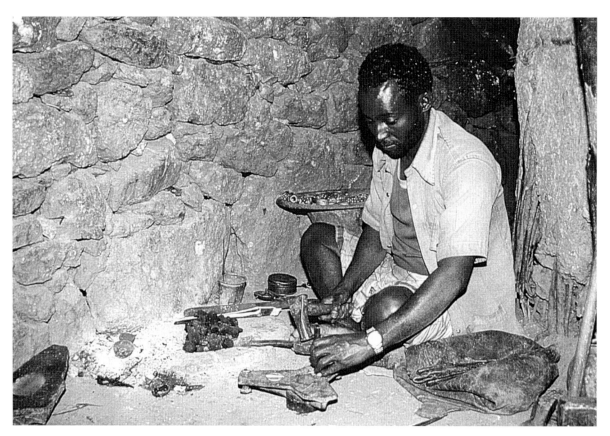

Silverwork in the Highlands 9

The Life and Work of Gezahegn Gebre Yohannes and Abib Sa'id

Raymond A. Silverman and Neal W. Sobania

ALTHOUGH A MAJORITY OF ETHIOPIA'S POPULATION LIVES more than a day's walk to the nearest road, people are seldom more than a few hours' walk to a market. For centuries markets have provided a focal point for exchange—the exchange of news, goods, and ideas. In the summer of 1993, while conducting research for the exhibition "Ethiopia: Traditions of Creativity," this notion was reinforced when in different parts of Ethiopia we encountered artisans who work in precious metals. In particular we had the good fortune to spend considerable time with Gezahegn Gebre Yohannes, who maintains a thriving shop in Addis Ababa, and Abib Sa'id, a silversmith working in the historic market town of Aleyu Amba on the eastern edge of the highlands, and briefer periods with Gebre Mikael Tizazu in the ancient city Aksum in Tigray Province in northern Ethiopia, and al-Hajj Ali Sherif and Abdul Wahid in the old Muslim city of Harer in the eastern part of the country. During the time spent with each of these artisans, we asked a number of questions about their lives, studied examples of their work, and observed them as they fabricated various types of silver wares. Whether in an ancient capital or a modern one, in lowland or highland towns, or in rural villages, markets have provided an arena for artisans to live and work in while learning, refining, and mastering the specialized skills that make them valuable members of their communities.

We would like to thank Charles Schaefer for introducing us to Abib Sa'id and the market town of Aleyu Amba. Special gratitude is extended to the silversmiths who generously shared both their time and their expertise: Gebre Mikael Tizazu in Aksum, al-Hajj Ali Sherif and Abdul Wahid in Harer, and especially Abib Sa'id in Aleyu Amba and Gezahegn G. Yohannes in Addis Ababa.

The silversmiths introduced in this essay represent both the tremendous range of aesthetic expression found in modern-day Ethiopia and the varied tastes of some of its peoples. The objects they create reflect the historical and cultural roots of the traditions in which they labor—traditions whose histories include interaction with the peoples and cultures of the Horn of Africa, the Middle East, and the Mediterranean world. This essay, therefore, is intended both to consider the lives and work of these artisans, particularly Gezahegn and Abib, and to introduce the context from which at least some of this expression is derived.

The latter must of necessity be introductory since scholarship dealing with the social, historical, or technological aspects of metalworking in Ethiopia is very limited and that which has been undertaken is narrowly focused on the Christian peoples of the Ethiopian highlands.[1] To illustrate this point, one cannot begin without first addressing the issue of nomenclature. We are dealing with a group of traditions for which there is no inclusive descriptive term. There is no word or expression that succinctly describes the production of objects that include those of personal adornment (i.e., jewelry), ecclesiastical paraphernalia, and luxury utilitarian wares in precious metals. Nor is there a single term for an individual who works with precious metals, primarily gold and silver but also various alloys of copper, to produce objects of status and adornment. We have chosen to refer to these specialists as silversmiths, and to the general body of objects that they produce as silverwork. We do so because silver is more commonly used than the other metals. It is important to keep in mind, however, that most of the objects that are produced in silver have also been, and can be, made from gold and copper (and its alloys) using the same techniques.

Similarly, the unqualified use of the term "smith" is problematic, since this would also include blacksmiths, and in Ethiopia those who work primarily with iron occupy a special occupational, social, and at times ethnic niche that may not apply to specialists we are identifying as silversmiths.[2] Many observers of highland Ethiopian society have noted that, aside from farming, the manual labors of artisans and craftsmen are looked down upon by the majority population, who are farmers.[3] These groups were (and in some cases still are) "considered inferior either because they deviated from the customs of the majority or on

account of their practice of engaging in manual crafts, such as those of the blacksmith and other metalworkers, the weaver, the leatherworker or the potter, which, though necessary, were considered degrading" (Pankhurst 1961: 22). And although the implements they produce are vital to sustaining the lives of the farmers among whom they live, the blacksmiths and their families live as an endogamous group that is feared, despised, and denied many of the privileges (like owning land) enjoyed by most other people.[4] One of the earliest references concerning the status of this group of artisans is found in Alvares's (1961: 1.149) sixteenth-century account of his visit to Aksum, in which he refers to a village located near the ancient city that was completely occupied by blacksmiths—an allusion to their endogamous status. A century later Almeida (1954: 55 n. 1) related the popular tradition that the fifteenth-century emperor Zara Ya'eqob had all of the goldsmiths and blacksmiths in his domain put to death as sorcerers—an allusion to their alleged supernatural powers (see also Levine 1965: 70).

There is a tendency in much of the writing about these occupational groups to treat them as a whole. Many authors, like Pankhurst, suggest that all smiths were treated in the same manner. But evidence found in traveler accounts, hagiographies, and ethnographies suggests that there is some variation and stratification among the various artisan groups. Conflicting observations suggest that precious-metal specialists, though historically of lesser status than farmers, may have been better off than blacksmiths. The reason for this may have been that the objects they made were accessible to people who controlled the wealth in Abyssinian society. The raw materials that they manipulated had considerable intrinsic economic value, some of which, as we will see, remained in their hands.

Contemporary Silverwork in Ethiopia

Numerous small shops crowd the main streets that radiate from the Piazza, the central shopping area below City Hall in Addis Ababa. Once known as Arada, this area has been the site of a major market since the founding of Addis Ababa at the end of the nineteenth century. Whether one walks east along Adwa Avenue, south down Churchill Road, or west from Abuna Petros Square to the Mercato, what stands out to the outside observer are the numerous jewelry shops. In a country with lim-

ited consumer goods, but in which personal adornment is crucial to self-identity and a sense of beauty, gold and silver jewelry sells well. This is not, however, a recent phenomenon. Evidence of the silversmith's art—the fabrication of jewelry, liturgical paraphernalia, various accoutrements of leadership, and especially coinage struck by various rulers—is found in the more than 2,000-year-old archeological record at Aksum and related northern Ethiopian sites.[5] With the exception of neck crosses, the designs of these early objects share few affinities with contemporary jewelry, although the various technologies that were used in fabricating these early objects, namely, casting, hammering, engraving, repoussé, gilding (of bronze, copper, and iron), drawing of wire, inlay, and die stamping (for the coins), remain in use. Today Aksum is generally held to be the historical center for metalworking in highland Ethiopia and is regarded as one of the major centers for the production of objects in fine metals (see Simoons 1960: 177). Indeed, a number of silversmiths, including Gebre Mikael Tizazu, maintain shops in the center of Aksum where they still fabricate a variety of liturgical objects, like silver hand crosses and the larger processional crosses using the ancient lost-wax technique, as well as a variety of silver and gold jewelry. Even today, many, if not most, of the silversmiths in Addis Ababa come from either Aksum or the neighboring community of Adwa.[6]

Gezahegn Gebre Yohannes, one of the finest jewelers in Addis Ababa today, is a product of this tradition (fig. 9.1). Born in Aksum in 1953, he came to the nation's capital when he was eleven years old after completing the sixth grade of public school. Unlike many silversmiths in Ethiopia, his father, Gebre Yohannes Tossi, was not a jeweler but a farmer.[7] As he describes it, after spending a long, cold night in the precincts of the Church of Saint George, he met a well-known, Aksum-born silversmith named Haile Abraham, who invited him to come and work in his shop. Gezahegn spent nine years as an apprentice and worker learning his trade under Haile's tutelage. In 1972 he left to establish his own business, at least in part because he wanted to continue his schooling. He set out on his own because Haile required that his employees work until 8 p.m. and night classes began at 6. Today Gezahegn has completed the twelfth grade, finished a two-year accounting course, and taken English classes to improve his language skills.

Upon first entering Gezahegn's shop, one is immediately struck by the tremendous variety of jewelry designs displayed in his glass showcases (fig. 9.3). These are not showcases that highlight a few individual pieces but rather ones in which numerous earrings, rings, neck crosses, necklaces, and bracelets are set side by side nearly on top of each other. In looking through his display cases, one can recognize traditional designs associated with peoples from various parts of Ethiopia, some are reminiscent of European motifs, and other designs are difficult to place— some are in fact Gezahegn's own designs (pl. 17). The breadth of his repertoire is wide and he utilizes many different processes in fabricating silver and gold objects, including lost-wax casting, cloisonné, engraving, repoussé, filigree, granulation, hammering, soldering, inlay, cut-out, chasing, and gilding. Gezahegn explained that every silversmith specializes in certain designs but that a good one, who had mastered the techniques associated with the working of precious metals, should be able to copy any piece of jewelry. He went on to explain that designs often change. "Designs change every day. If I come up with one, the next day another goldsmith will pick it up, and copy it or modify it. Soon it is copied by other goldsmiths and is found everywhere." Gezahegn's specialty is the finger ring, which he creates for both men and women. That some of his creations are copied and show up in shops off the Piazza does not anger this soft-spoken, even-tempered artist. He accepts it as a compliment and recognizes that this is just a feature of doing business, and one that has long been present in Ethiopia. Wylde, who spent considerable time in Adwa in the 1880s with Negradas Mared, the jeweler of Emperor Yohannis IV, was impressed by the skills he saw demonstrated in the silversmith's workshop and commented that "they can also copy any pattern given them" (1888: 1.289).

Addis Ababa is a cosmopolitan city and Gezahegn's customers come quite literally from all corners of the world. Not only Ethiopians but diplomats and employees from different embassies, particularly those of Africa, Europe, and North America, frequent his shop. Each has his or her own preferences. Gezahegn finds it interesting that Europeans and North Americans prefer the more traditional jewelry, such as the neck crosses of Lalibela, Aksum, and Gonder, while Africans, including Ethiopians, buy both Ethiopian and European designs (pl. 17). The large

Fig. 9.3 Exterior of Gezahegn's shop in Addis Ababa.

volume of business that these customers generate allows him to maintain a considerable inventory of jewelry for walk-in customers, but Gezahegn also works on commission. In addition to his jewelry, he receives orders for processional crosses for churches, and priests occasionally ask him to make silver hand crosses. Typically the former are made at the request of a thankful donor who, grateful for a special blessing in his or her life, will present the cross as a gift to a particular church.

Prior to this century, however, solid-gold jewelry, for which Gezahegn is widely known, was seldom seen. Several observers have commented on the popularity of gilded objects but noted the rarity of solid-gold jewelry. Charles Johnston (1844: 2.337), a British naval surgeon who visited Ethiopia in 1842–43, observed that in Shewa gold objects were the prerogative of the royal family and that there was an edict forbidding commoners from using the yellow metal. Today objects of 24k, 22k, and 18k gold are readily available but, given their cost, not widely attainable. Few Ethiopians outside the ranks of the professional and merchant class, military officers, and upper-echelon government workers can afford gold. Silver, however, as it has so often been, is commonly worn by those of lesser means.

For Gezahegn, business is good. In 1993 he employed eight workers, including one receptionist, in a well-lit, spacious workshop. Some are apprentices and others are already highly skilled silversmiths (fig. 9.4). Each is trained to produce in part or in its entirety a wide range of necklaces, bracelets, pendants, finger rings, hairpins, and earrings, yet all the items are considered to be the work of Gezahegn.

The conditions under which Gezahegn's employees work are in stark contrast to those under which the employees of Abdul Wahid work in Harer. When visiting his workshop in 1993 we observed just one type of jewelry being mass-produced, the well-known necklace called *waqari*, by several men who worked in the basement of Abdul's house under the light of a single, bare light bulb (fig. 9.5).[8] It is important to note that these popular necklaces were destined for the tourist market, and unlike the traditional silver *waqari*, these were made from a base metal (nickel?). These necklaces are often deliberately oxidized to look old[9] and can be compared with the more carefully made *waqari* fabricated in the shop of al-Hajj Ali Sherif, a silversmith in Harer who produces jew-

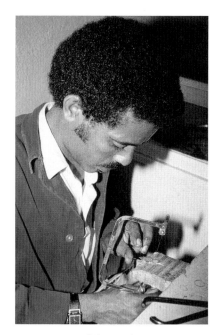

Fig. 9.4 One of the workers in Gezahegn's shop.

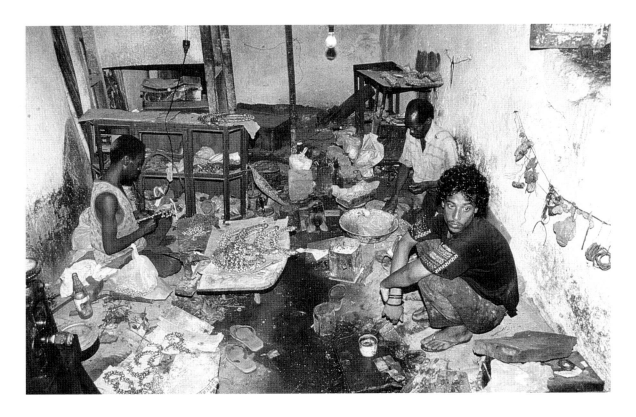

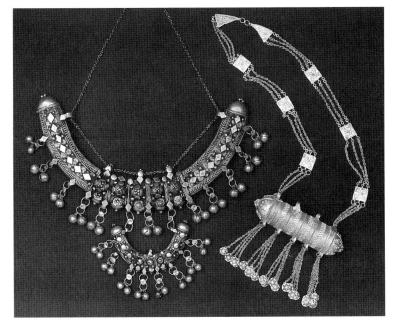

Fig. 9.5 Abdul Wahid's workshop in Harer.

Fig. 9.6 Two *waqari* (necklaces), the one on the left produced for tourists in Abdul Wahid's workshop, the other produced for Harari customers in al-Hajj Ali Sherif's workshop.

Silverwork in the Highlands

elry for a local clientele (fig. 9.6). Ali's shop is quite different; it is a cross between a "big-city" shop like Gezahegn's and the rural workshop of a jeweler like Abib Sa'id.

As already noted, silversmiths are found throughout Ethiopia. Aleyu Amba, where Abib now lives and works, is a town of barely a few hundred souls that burgeons to several thousand on Sundays for the weekly market (fig. 9.7). Once the commercial center of Shewa Province, in which today's capital, Addis Ababa, is located, Aleyu Amba was strategically situated along the major trade route that ran east to Harer and the sea. Ideally located at the top of a small mountain in the eastern highlands, the town is a couple of thousand feet below Ankober, the former political capital of Shewa, and a couple of thousand feet above the lowland floor. Each Sunday the Christian Amhara descend from the villages and towns on the escarpment above with the products of their

Fig. 9.7 The Sunday market at Aleyu Amba.

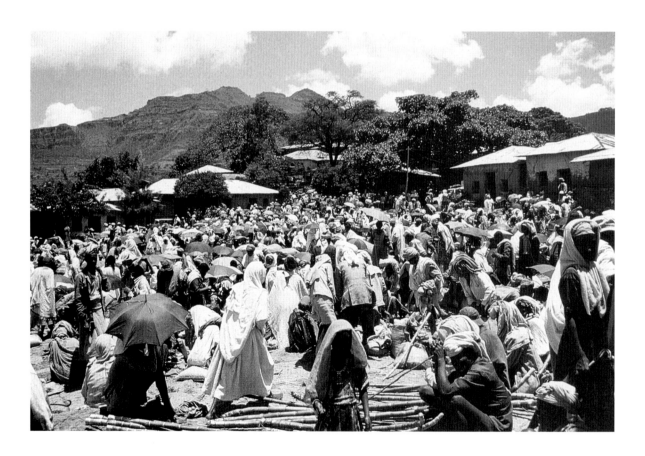

highland farms, eager to trade with the Muslim Afar, who ascend from the arid plains below, their camels carrying the products of their herding economy. It is from among those arriving to trade, as well as the town's permanent population of Amhara and Argobba merchants, that Abib receives new commissions and requests to repair old jewelry.

Abib, who is roughly the same age as Gezahegn, moved here a few years ago from Kemisa, where he was born. Abib informed us that in Kemisa, a large town located north of Aleyu Amba in southern Wello Province, there are more than a hundred competing silversmiths; in Aleyu Amba, Abib is the only one. Business is so good in Aleyu Amba that his younger brother, Ahmed, has started to work with him, and he has begun to train his oldest son, who, in 1993, was ten years old. In doing so Abib is passing on the specialized knowledge associated with silverworking that came to him from his father, Sa'id Abdul, and from his grandfather before him, each of whom was a silversmith. It is only in Addis Ababa that young men can apprentice themselves, like Gezahegn did, to a nonrelative. Abib, who never attended school, used to watch his father and grandfather work. Later they began to teach him the various techniques used to make certain types of silver jewelry, and when he was about nine years old, he began to make objects from silver. The first item he made on his own was a type of earring consisting of three silver "bulbs" called a *sadi*. As a young man he initially split his time between farming and working silver, but since turning thirty, he has devoted all his time to making jewelry.

The clientele that Abib Sa'id serves is not as diverse as Gezahegn's. Their tastes are more traditional. Unlike Gezahegn, Abib does not maintain an inventory of jewelry but instead does virtually all of his work on order or commission. For both the townspeople, who as already noted are few in number, and those who come to trade at the Sunday market, he makes only silver objects. Even though by his reckoning half the town is Christian and Christian Amhara come on Sunday in large numbers to trade with the primarily Muslim Afar and neighboring Argobba, he does not make crosses for them. Instead Abib, who is Muslim, specializes in other common objects, such as anklets, necklaces, bracelets, and finger rings, all of which he fashions in an "Islamic" style (pl. 18). Attending the Sunday market in Aleyu Amba one encounters Argobba and Afar

women wearing earrings, necklaces, anklets, and bracelets very similar to those produced by Abib (fig. 9.8). Many of the designs are reminiscent of the jewelry produced in Harer. Indeed, some types of jewelry are found throughout the Red Sea region—the Horn of Africa and the Arabian Peninsula.

Religious and ethnic differences have long been reflected in preferences for particular styles of personal adornment, and many traveler accounts note these distinctions. For example, Johnston commented on the different tastes in jewelry of the Christian Amhara and of the Muslim peoples living in Shewa: "The silver bracelets of the Islam are also different in form from those worn by the Christians, consisting of two or three thick silver wires, twisted upon each other, and finished at each extremity by a beaten square head" (1844: 2.337). And from the same period, Major Harris, the British envoy to the Shewan court at Ankober, on the escarpment above Aleyu Amba, noted the distinguishing ornaments worn by Gurage and Amhara women. For the former these included "bars and studs of solid silver" in their perforated ears and "ponderous pewter bangles" on their wrists and ankles, while on special occasions wealthy Amhara women wore massive earrings of silver or pewter "resembling a pile of hand grenades, or the teething rattle employed in nurseries" (Harris 1844: 141, 275; see also Johnston 1844: 2.335).

Abib's workshop, where those who wish to commission or order a piece of jewelry come, is a covered open-air space next to his house—a short walk from the market area. Here he and his brother—using very basic tools, a goat-skin bellows, and a charcoal fire—melt, mold, shape, and fabricate silver into highly sought-after creations (figs. 9.2 and 9.11).

The silver that Abib, Gezahegn, and virtually all other Ethiopian silversmiths use comes from imported silver coins. From at least the second quarter of the nineteenth century, the principal source of silver in Ethiopia has been Maria Theresa thalers (talers). Also known as Austrian dollars and German crowns, these coins were called *set birr* (woman silver) by Ethiopians. Named for the queen of Austria whose portrait is found on the coin, the Maria Theresa thaler was first minted in Austria in 1751 and struck many times thereafter, including well into this century, to satisfy the demand of peoples trading along the Red Sea and the

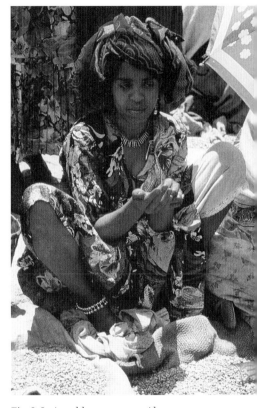

Fig. 9.8 Argobba woman at Aleyu Amba Sunday market wearing a silver anklet similar to one of the types that Abib makes.

Arabian Peninsula who recognized no other currency. When Maria Theresa died in 1780 all subsequent thalers carried this date, and it is this particular one that became the coin of choice in commerce. But not just any 1780 Maria Theresa thaler would do. Historically, to satisfy themselves that a coin was genuine, Ethiopians looked for three particular features: that the queen was wearing a tiara, that there was a decorative star of many points on her shoulder, and that the letters "S.F." were clearly delineated (Johnston 1844: 2.234; Harris 1844: 29, 172).

Today, Abib finds a ready supply of thalers and other silver coins in the market.[10] Some he uses as pendants in necklaces by soldering a small ring along the coin's edge (fig. 9.10). However, most of the coins used for silver jewelry are melted in the crucible and then formed into ingots or wire. Abib first breaks the silver coins in half and melts them in a small crucible (fig. 9.2). The molten silver is then poured into a mold that produces a narrow rectangular ingot. This he either hammers into strips or ribbons, pulls through a drawplate to produce thin lengths of wire, or melts into small balls (grains). He then employs filigree, granulation, hammering, soldering, and chasing techniques to fabricate a variety of jewelry.

We had the opportunity to observe Abib make some hollow beads. He begins by melting a couple of thalers and casting the metal into a narrow ingot about 8 inches in length. He then flattens the ingot, using a hammer and anvil, into a thin sheet, which he then cuts into narrow strips about an inch in width. Next, using a hammer, punch, and cow-horn die (a cow's horn in which hemispherical depressions roughly three-eighths inch in depth had been carved), Abib forms small half-beads (fig. 9.9). These are cut from the ribbon and two soldered together to form a spherical bead. These beads, along with silver wire that Abib makes using a drawplate, are combined to make a variety of jewelry (pl. 18, esp. g).

It is not surprising that the tools of this rural silversmith contrast sharply with those of an urban silversmith. Where Abib uses a drawplate to produce wire, Gezahegn has been able to purchase a hand-powered metal-rolling machine. Living and working in the capital and having traveled to Europe and the United States, Gezahegn has access to and has purchased modern metalworking tools and utilizes this wider array

Fig. 9.9 Abib using the cow-horn die to shape silver beads.

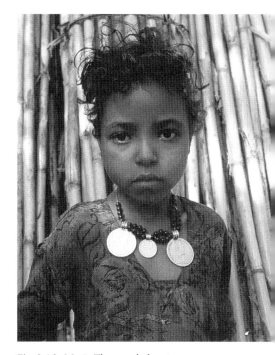

Fig. 9.10 Maria Theresa thalers in a necklace made by Abib and worn by one of his daughters.

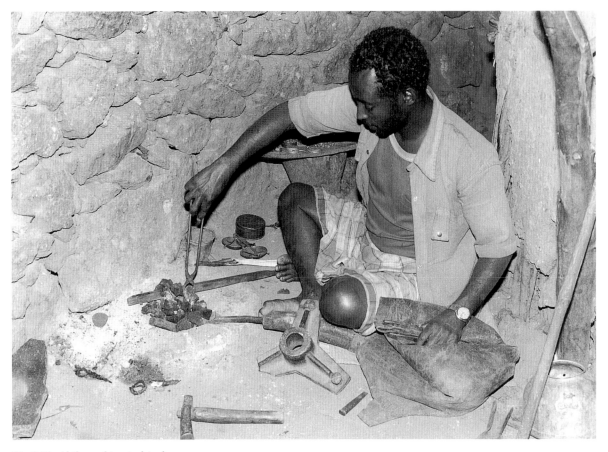

Fig. 9.11 Abib working in his shop.

in his work. Gezahegn and all his workers sit at benches in a workshop with bottled-gas burners (fig. 9.4); Abib and his brother sit on the ground in a covered open-air space next to Abib's house with an open fire and goat-skin bellows (fig. 9.11). Gezahegn has both a mechanical and an electronic scale and employs a wide range of commercially produced tools. Abib also uses factory-produced tools: pliers, scissors, file, wire brush, and a hand-held balance scale. The difference is that he does not use as many and they are used in tandem with locally produced tools, including hammers and punches (probably made by another metal specialist, a blacksmith) and cow-horn dies. The wider range of technologies that Gezahegn employs enables him to produce the wider range of

designs demanded by the market in which he works. For the market that Abib and other rural silversmiths must satisfy, the tools they have are both adequate and effective. Observations made in the nineteenth century about the production methods of silversmiths might very well be made by observers of rural smiths today. Wylde, commenting on what he observed in Adwa over a hundred years ago, wrote: "The tools employed by the gold and silversmiths are of the roughest, and consist of very bad shaped hammers, pincers, anvil, blow-pipe, and bellows, and it is astonishing what delicate work they turn out with such rude means" (1888: 1.288). Sir Charles Rey, a British merchant, noted some forty years later that "their outfit is simple—a hammer and anvil, a pair of pincers, a charcoal fire, and a goat-skin bellows seem to constitute the bulk of the necessary stock-in-trade; and with this primitive equipment they certainly produce some very attractive things" (1923: 225). He was especially impressed with "a really artistic bracelet made by an Abyssinian" that was given to his wife; "it was composed of gold wire strands and elephant hair woven together in a very pretty design, and the workmanship left nothing to be desired" (Rey 1923: 225). The bracelet he describes is quite similar to one produced in Gezahegn's shop in Addis Ababa (pl. 171). Other accounts include references to various technologies commonly used by the smiths, particularly filigree work. Rey described it as a process using "silver wire, very often gilt, worked in a filigree design and soldered on to silver plates which have been previously hammered out to the shape desired" (1923: 225; see also Wylde 1888: 1.288).

A particularly interesting aspect of silverworking is the manner in which the price of objects is determined. Observers of specialists working not only in Ethiopia but in other parts of Africa have noted that gold- and silversmiths often do not get paid or that customers pay for their products solely by weight.[11] Customers often bring the gold or silver that they wish transformed into jewelry (or into crosses, crowns, and other items) to the smith. Hermann Norden (1930: 165–66), a German traveler who visited Ethiopia in 1928–29, in a description of his encounter with Tessemma Werada Hei, a silversmith in Gonder, mentions having commissioned some silver bracelets and a christening cup for which he supplied the "thalers for the melting, it being the Abyssin-

ian custom to furnish one's own metal and make extra payment for the work itself." He indicates that the price he paid for the silverwork was equal to the value of the silver he had given to Tessemma (see also Rey 1923: 124).

A number of the early traveler accounts record the "stretching" and thus "adulterating" of the gold and silver by the addition of base metals like zinc, tin, or copper. The customer received a product that weighed as much as the metal originally given to the silversmith, as occurred with Norden's commission, but its purity had been reduced.[12] The practice of "cutting" precious metals was common among silversmiths; this is how they "extracted" their payment during the fabrication process. Mansfield Parkyns, who spent three years in Ethiopia, primarily in Tigray, during the 1840s, reported that the silversmiths of Adwa "make a tolerably good thing of their business, but it is entirely by appropriating a large proportion of both gold and silver intrusted to them for work. The silver they receive is in Maria Theresa dollars: what they return is, I should think, scarcely so good as a Turkish piastre, and in fact contains scarcely one-third of silver, if so much" (1966: 233). He added that he had "known a man [a silversmith] to receive thirty Venetian sequins for a job, on which he employed only seven and a half" (1966: 234). Similarly, Nathaniel Pearce, who visited Gojjam during the first decade of the nineteenth century, recorded the cutting of gold with silver. Pure gold arrived from the west in small pieces "from the size of a pin head to a pea" and was combined in the crucible with one-eighth part silver and cast into ingots (1820: 57–58).

Today, especially in the shops of urban silversmiths like Gezahegn, the silversmith procures the metal himself and sells his products by weight, but usually after having employed a similar process to reduce the purity and increase the hardness of the gold he uses in his work. In this context, a per-gram price is fixed that takes into account costs and profit. Gezahegn explained his formula for estimating the profit he makes in producing gold jewelry (the prices he cites were those current in June 1993). He begins with 30 grams of 24-karat gold, which costs him 76 birr per gram. Most of the jewelry he makes uses 18k gold; to produce this he adds 6 grams of copper and 2 grams of silver to the 30 grams of 24k gold. He ends up with 38 grams of 18k gold; 18k gold is worth

60 birr per gram. Taking into account the amount of gold that can be lost during the fabrication process (up to 10%), a gram of 18k is then worth 66.6 birr. On the average, he pays the worker who produces the piece 4 birr per gram of worked gold. The cost of the gold is now 70.6 birr per gram. The current market rate for finished 18k gold jewelry is 85 birr per gram. His gross profit is therefore 14.4 birr per gram, out of which he must still pay for rent, tools, supplies, and the wages of his receptionist. He employs a similar formula for his silver jewelry but of course the prices are much lower because the value of the metal is much less than gold.

Less clear is how Abib makes this calculation, although he explained that "adding the cost of raw materials to the cost of labor will determine the price of the object made." In May 1993 Abib paid about 30 birr for each thaler, although he noted that the price had been rising over the past five years (during the time of famine in 1984–85, he bought thalers for as little as 12–15 birr). He indicated that the pair of silver anklets he was making during our visit to Aleyu Amba would require six thalers of silver and when finished he would sell them for 300 birr— a margin of 120 birr more than the cost of the silver used.

Conclusion

The observations that we have offered here are simply an introduction to a complex and rich set of traditions. Obviously, there is much work to be done. There are hundreds, perhaps thousands, of different types of silver and gold objects produced by silversmiths in the highlands of Ethiopia. Developing typologies for the range of objects might be an initial step. Many cultural history museums and art museums in Europe, North America, and Ethiopia maintain significant collections of historic Abyssinian gold- and silverwork, objects dating from as early as the eighteenth century. A systematic survey of these, and private collections, would surely yield valuable insights into the variety of objects produced over the last two hundred years.[13]

One of the most promising lines of inquiry for reconstructing the history of gold- and silverworking—the documentation and interpretation of contemporary traditions—has yet to be pursued. As stated earlier, very little work in this arena has been undertaken. Though many

of these traditions are still practiced throughout much of Ethiopia, some of them certainly are beginning to atrophy, and urbanization, as illustrated by Gezahegn and his workshop, is resulting in major changes in the tradition of working nonferrous metals. There is a pressing need for documentation—specifically, vocabularies of technical terms and the names of objects; oral histories concerning the fabrication and use of gold, silver, and cuprous objects; and biographies of individual silversmiths. Still another body of evidence is found in paintings associated with the Ethiopian Orthodox Church. One of the distinctive characteristics of these paintings is the "Ethiopianization" of religious themes— the depiction of religious subjects in an Ethiopian setting. The figures portrayed in these paintings often wear the clothing and carry the accoutrements of the period. Studying these works may provide information about the silver- and goldwork that was made and used during specific eras.[14] A complete interpretation of these metalworking traditions will require not only the study of technology, the formal analysis of objects, and the contexts of use but the detailed investigation of the social status and the role of silversmiths in Ethiopian societies.

Once we have a better understanding of these Ethiopian traditions, we may begin exploring a further set of questions that concern the meeting of cultures in Ethiopia. We can pursue comparative analyses of the precious metalworking traditions of the Arabian Peninsula and Mediterranean world, especially Armenia and Greece. Cursory comparisons of the jewelry produced in these areas with specific types of Ethiopian jewelry reveal remarkable affinities. Jewelry like Abib's and that made in Harer is very similar to that produced to this day by Bedouin and Jewish silversmiths living on the Arabian Peninsula, and many of the designs, especially those involving filigree-work, of the central and northern highlands of Ethiopia, share many affinities with Armenian and Greek gold- and silverwork. In fact, traveler accounts of the eighteenth and nineteenth centuries are full of references to Armenian and Greek artisans living and working in Ethiopian commercial and political centers. Similarly, there is abundant historical evidence of the close commercial and cultural ties that have been maintained for thousands of years between eastern Ethiopia and the Arabian Peninsula.

Ethiopia has been a crossroads for African, Middle Eastern, and Mediterranean tradition for at least three thousand years. The contemporary products of jewelers like Gezahegn and Abib reflect the dynamics of integration and innovation, which continue to be vital elements of highland Ethiopian society. The study of their lives and work, as well as those of their predecessors, will certainly yield important insights into the social and cultural history of Ethiopia.

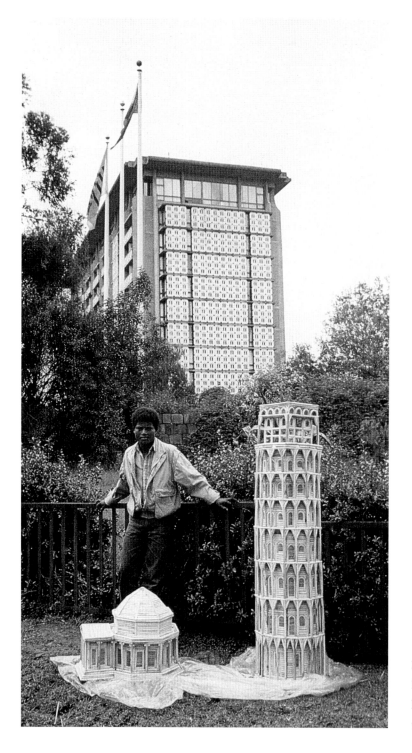

Fig. 10.1 Tolera Tafa in front of the Hilton Hotel in Addis Ababa with his models of the Tower of Pisa and the Jefferson Memorial.

Sorghum Surprise

10

The Models of Tolera Tafa

Neal W. Sobania

Step outside your hotel and even the seasoned visitor to Ethiopia is quickly reminded that this is a land of young people and children. That kids seem to be everywhere will not come as a surprise if it is understood that nearly 70 percent of the country's population is below the age of twenty-five. Sit in a coffee shop and they are ready to shine your shoes. Walk along the street and they will follow trying to sell you cigarettes or chewing gum or hawk a paper or magazine. Park your car and they will direct you into a space, tell you they will watch it for you and even wash it. And persistent they are, but then getting you to part with some change is the way they make their living. Sometimes a firm *yellum* (no) can impart your disinterest, but if you are already sitting and sipping your coffee, twenty-five cents for a shoeshine will not break the bank and fifty cents to have your car watched is a good investment. Travel the back streets of the city where the school-uniformed kids live, or in the countryside where families of five, six, and seven children are common, and your presence is likely to be announced by shouts of *ferenji* (foreigner) or "Father, give me money." Begging is another acceptable way to make a living, and indeed parting with a few coins is earnestly counseled by the Ethiopian Orthodox Church. But then perhaps this shouldn't be a surprise in a country that has a per capita income of U.S. $123.[1]

However, go beyond appearances and statistics and it is Jimmy who wants to wash your car and remembers you between visits that may be two or more years apart, and it's Solomon who shines your shoes; each has a story. Pass by the "pith boys" in front of the Hilton Hotel, where they sell their sorghum-stalk models of churches, cars, and airplanes,

and you miss getting to know a unique group of young people who have shaped a distinctive niche for themselves. Fail to examine carefully their models and you miss discovering the breadth of their talent.

Among them is Tolera Tafa, pith sculptor and model maker. Creative and precise, yet working only with a razor blade and the discarded stalks of the sorghum crop, this self-taught designer has perfected a skill that earns him the admiration, and money, of foreigners and Ethiopians alike. Recently his work has also begun to earn him commissions. Look closely at the models displayed curbside at the Hilton and a number immediately stand out for their meticulous detail; these are Tolera's (fig. 10.1). The other assorted pieces are the work of different young, and not-so-young, men who live in Necho, a small traditional roadside farming village of thatched-roof houses some seventy kilometers west of the capital.

Leaving the city on the Ambo Road one easily observes how far the outskirts of Addis Ababa have sprawled into the countryside. Everywhere are the corrugated-iron roofs of houses, the eucalyptus pole frameworks that demarcate new construction, and the whitewashed mud-and-daub storefronts from which fresh vegetables, recently butchered meat, newly baked bread, and assorted pens, plastic bags, and tin cups are sold. The same urban sprawl is also apparent on the road—in the middle of it and next to it. Here the space is actively contested by donkeys that jog helter-skelter with loads of firewood, by precariously overloaded trucks that lurch along in the clouds of personalized black smoke they belch, by ubiquitous blue-and-white taxis and wiyiyyit (taxi-trucks) that dodge in and out of traffic to pick up and drop off their passengers. And as if this were not enough for the limited road space available, there are countryside buses whose loudspeakers blare a cacophony of distorted music into the air. It is on these buses, the principal mode of transport for the rural peasant, that Tolera and his friends from the village find seats to Addis Ababa to sell their models.

At twenty-two years of age (in 1993), Tolera is the fourth child of eight—four boys and four girls. His father is a farmer, his mother a housewife, although that title scarcely covers the many burdensome chores associated with a rural farm wife and mother. On the small farm they own, which is the same land that Tolera's grandfather and great-grand-

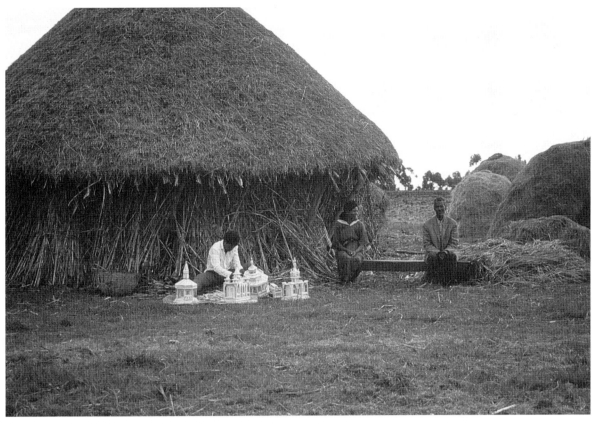

Fig. 10.2 Tolera's home and the surrounding countryside in Necho. Tolera's parents are sitting on the bench to the right of the house.

father tilled, the family grows sorghum, t'*ef*, maize, and chickpeas (fig. 10.2). With his single-tine wooden plow drawn by the family's two oxen, Tafa Bikila, Tolera's father, plows and plants his 2.5 hectares (a little over 6 acres) of land, praying that God's blessing and rain will allow him to harvest enough to meet his family's food requirements, provide the seed grain for next season, and leave some to sell in the local market.

Such a rural household is typical of Ethiopia's population, the majority of whom are sedentary, cereal-growing agriculturalists. The nuclear family is the primary unit of production and consumption. With three cows and the two plow oxen, Tolera's family might be perceived as well-off, although they had more land prior to the land reform of the pre-

vious regime, which limited family landholdings. Their expectations in a good year are to harvest 5 quintals of t'ef, retaining one for seed, 1.5 quintals of sorghum, 1 of maize, 1 of chickpeas, and 1 of nug, with 20 kilograms of each held back for seed.[2] The non–seed grains are consumed either by the family or by their animals, except for some of the nug and all of the chickpeas, which are sold to townspeople or merchants for cash. With this cash Tolera's family is able to purchase other needed foodstuffs, including onions, peppers, salt, and oil. Most of the cash, however, goes to pay the government land tax of 100 birr and the children's school fees. The support of such an averaged-sized peasant family is no mean feat.

The ongoing economic and environmental pressures that the small-scale peasant family faces in Ethiopia are exacerbated by the tug on its youth from nearby cities. The attractiveness of the capital with its greater job opportunities is evident in the lives of Tolera's two older brothers, who today live independently in Addis Ababa. The eldest, age thirty-three, is employed as a wiyiyyit driver, while the other, who was wounded while serving in the Derg's militia, is trying to adjust to being a student again at the age of thirty-one. Two of Tolera's sisters, one of whom is younger than he is, are married; Tolera is the oldest child still at home.

In the ninth grade, where he enjoyed history, math and English, Tolera ranked third or fourth out of more than sixty students. Outside the classroom he played volleyball and on the defense side of the soccer ball. Given a choice, he would have gladly skipped classes in physics and Amharic. The more widely known name of his village, Yehudge-baya, is the Amharized name of this roadside community,[3] but ethnically this is an Oromo area. Tolera's family and the others who live here and nearby are all Oromo, speak afan-Oromo, and call their village Necho.[4]

Tolera, however, is a school dropout, as are far too many other young men and women of his age, who often do not begin school until the age of seven or eight and then delay high school until the family can afford to pay the necessary fees. In 1988, while in the sixth grade and frustrated with only a morning or afternoon of classes (a framework of double shifts that since its implementation under the previous

regime has effectively halved the education the children of Ethiopia now receive), Tolera began to use his free time to make sorghum-stalk models. Then in 1992, when financial difficulties plagued his family, he opted, as the eldest child still at home, not to begin the tenth grade but instead to take up full-time model making.

Model making has for some time been associated with the Ambo Road, and in particular with the villages of Necho and Kimoy (also known as Hamusgebaya).[5] Local tradition states that the making of models from sorghum stalks originated more than thirty-five years ago at an irrigation site near Kimoy. Here boys constructed tiny toy waterwheels that were made from sorghum stalks held together with thorns and that turned in the flowing water of the irrigation channel. The use of the outer layer of the sorghum stalk to tack the pith, or soft inner portion, of the stalks together is an innovation attributed to two fifteen-year-old boys, Kumsa Tessemma and the late Hailu Laku. Kumsa, who is now a merchant in Addis Ababa, is remembered for his special ability to construct models of houses with multiple floors, along with fine cars and trucks; Hailu is recalled for the quality of his churches and Italian cars.

The process of learning to make objects was then, as it is now, one of observation. Among those who learned by observing these early innovators were Ibsa Demeksa, Mulatu Demissie, Bekele Badada, and Negussie Mekuria. Negussie's first sculpture, which he made at the age of nine, was a Dakota airplane that sold for $5 Ethiopian.[6] Today Negussie still lives in the village of Kimoy but has stopped making pith sculptures, which he describes as "a simple thing to do"; he works as a guard for the Ministry of Agriculture. His comment suggests a range of questions that deserve further investigation, the most obvious of which is that of the local status attributed by the community to those who make the sculptures. No one in the villages keeps sorghum-stalk models in their houses, and to Tolera and Negussie, the question of whether either had ever given one to his mother as a gift to display was particularly strange. Clearly, however, these women, as well as other mothers and fathers in these two villages, have been the recipients of money earned by their sons from the sale of the models. For example, the materials for the new house in which Tolera's family now lives, which cost nearly 600 birr, were paid for entirely by Tolera from his earnings.

With the possibility of learning to construct pith sculptures by observing others, the door of opportunity has been left open to many. Today a number of eight- to twelve-year-olds display their work for sale along the roadside at Kimoy. There are, however, certain families whose sons have definitely gravitated toward making the sculptures. Tolera fits such a pattern, having followed in the path of his two older brothers. So does another well-recognized producer, Sorri Tafa, who is not related to Tolera but is a nephew of Negussie Mekuria, one of the earliest modelers. Thirty-two years old in 1993, Sorri describes his present-day occupation as three-quarters farmer, one-quarter model maker. With a sixth-grade education, Sorri has been making and selling pith sculptures along the Ambo Road for twenty-one years, absent only for the four years he spent as one of Mengistu Haile Mariam's drafted militiamen fighting in the north. He recalls his first successful efforts were an Italian car and a heavy truck, which he sold for $4 Ethiopian. Today Tolera still admires the work produced by Sorri, and indeed a careful examination of the detail of Sorri's models, from the front seat inside his cars (*mekina*) and the gearshift next to the steering wheel, to the seats that line his airplanes and the pilot's cockpit controls, suggests that this praise is richly deserved (fig. 10.3). When the issue is probed of what is the most difficult feature of a model to construct, invariably the tires of cars and trucks and the vertical dividers in the windows of churches and houses are cited. And Tolera is quick to identify Sorri's tires as the best.

Others, however, point to Tolera's windows as the best (fig. 10.4). And the general consensus on the Ambo Road is that the leading position once held by Sorri as the best model maker has now been assumed by Tolera. Today's other recognized master, who as it happens is also from Necho, is Bekele Bedada. But even Bekele, who has been making and selling pieces along the Ambo Road for over twenty-five years, considers Tolera "the best in the area." Tolera, however, finds such praise embarrassing; he is an exceedingly modest young man. When questioned about what distinguishes good work from that of lesser quality, and in particular if his work is better than Bekele's, he shrugged off the question, noting only, "You can see the difference; it's better if people admire your work than your telling them [about it]."

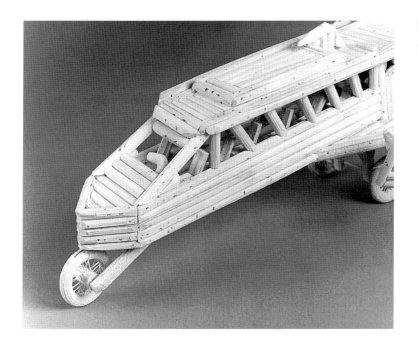

Fig. 10.3 Detail of airplane model made by Sorri Tafa.

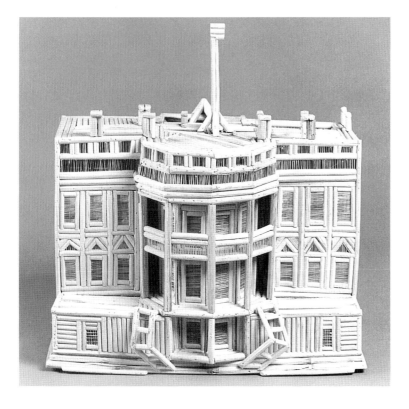

Fig. 10.4 Tolera's model of the White House.

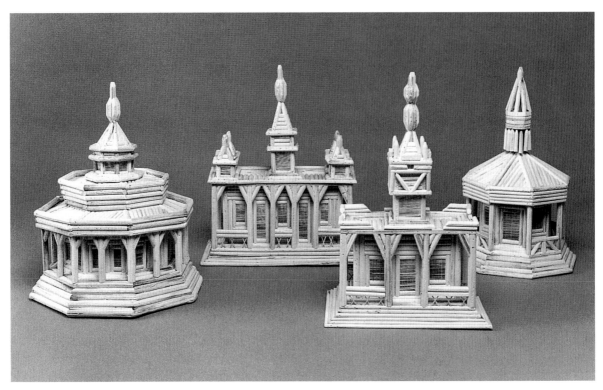

Fig. 10.5 Models of various churches made by Tolera in 1993. The one on the far left is a model of the Church of Saint George in Addis Ababa.

Inevitably the comparison between Tolera's work and that of Bekele is made, if only because they live in the same village. Tolera's specialties include taxis, cars, ships, and a number of new church types, with whose creation he is credited. The first sorghum-stalk church, however, is said to have been made by Bekele more than ten years ago. Bekele modeled his church on Saint Gabriel's Church in the nearby community of Olaukomi. His church is the yardstick by which others' churches are measured. Complete with a circular Orthodox cross and fringed finial, elaborate windows, and outer porch, the circular plan of an Ethiopian Orthodox church is immediately recognizable.

Tolera makes at least four styles of Ethiopian churches, and with his model of the octagonal Qiddus Giyorgis (Saint George's) Church of Addis Ababa, he comes close to Bekele's deftness (fig. 10.5). Tolera's church

models are as often square or rectangular as round or octagonal, and sometimes they lack the circular-cross finial, but he always emphasizes solid construction. Foreigners, some of whom are tourists and others diplomats and aid workers, are the major market for pith sculptures. From selling to them Tolera has concluded that the major deterrent to their buying models is their concern about getting them home in one piece. Therefore, to increase the durability of his work, even if it is more in appearance than in reality, Tolera has abandoned certain decorative features, for example, the circular cross and roof ornaments on his churches. Although these features add greatly to the distinctiveness of Bekele's churches, they also add considerably to their fragility.

Sorri, Tolera, and the others take great pride in the models they make. Their sense is that tourists buy the sorghum-stalk sculptures for their beauty and detailed decoration, and they add that the tourists probably use them to introduce others to the things Ethiopians make. While probing this subject with Tolera the question was asked, "What do you think of tourists who buy these pieces from you; are they foolish?" His response was quite telling. "We like modern things—fabricated outside [imported]; we admire these things. For example, my sweater is from outside. And so you must admire our craft and what we make. It's not foolish."

Each sorghum-stalk sculptor creates his own designs and makes his own models. Piecework is nonexistent. An inquiry into whether or not the modelers had ever attempted the mass production of their work, for example, by having one individual who is particularly adept at the construction of tires making them for those who are better skilled at axle, chassis, or basic car/truck frame construction, brought forth comments about competition. Just as individuals acquire the skills to make the models without the active teaching or instruction of others, so too do they sell them: "We compete for dollars." And while admitting that the basic shapes of objects are in fact the same, they nevertheless recognize differences in quality; this is understood to be especially evident in the construction of tires, windows, and the other finishing details. It may be overstating the issue to talk in terms of competition, since no one prevents a young boy from sitting nearby and observing the process of construction, or frowns on someone making the same object

type. Nevertheless, the sense among the modelers that one must learn by observation is so strong that the question, put to Sorri, as to whether or not he had ever actively helped someone or demonstrated a particular technique to an aspiring modeler took him completely by surprise, and he responded, "It never even came into my mind."

The counterpoint to this underlying notion of competing for the money the limited market offers is equally apparent. For example, because Bekele Bedada is older and to some extent has a harder time getting around, a younger man, Kebbede Melketcha, takes and sells Bekele's work in Addis Ababa. And when questioned about this arrangement, Kebbede simply stated that he sells the pieces for his "brother" (they are not related). A similar cooperative element in the relationship of modelers is found in there being no sense that one individual has a particular proprietary right to a certain design. Kebbede Melketcha also provides an example in this area with his recently introduced design innovation: the construction of ships, especially cargo freighters complete with smokestacks, cranes, and booms. And although most of the model makers are capable of working from pictures, Kebbede is understood to have introduced the ships based on his personal experience. Having enlisted in the militia because there was no employment, and in part to avoid being "drafted" during one of the Mengistu regime's infamous sweeps through peasant villages, which snared many unsuspecting youth who provided the cannon fodder for the war in the north, Kebbede found himself in Asab and later Massawa, the two Eritrean seaports that were once part of Ethiopia. Upon safe return from his militia years, Kebbede combined his skill as a model maker with his recollection of the ships in the Massawa and Asab harbors to create a cargo ship, a design after which Bekele, Tolera, and others today model theirs (pl. 19).

In the actual construction process the model makers work with only a double-edged razor blade and discarded stalks of sorghum. The razor blades can be purchased for twenty cents apiece (U.S. $.04) in the local shops; the sorghum (*chate* in afan-Oromo) usually comes from the family's farm but can also be purchased from local farmers, who charge 1 birr (U.S. $.20) for a large bundle (*ba'a* in afan-Oromo).[7]

Using teeth or razor blade, often in combination, the outer layer of the stalk is stripped or peeled away to reveal the softer inner cortex, or

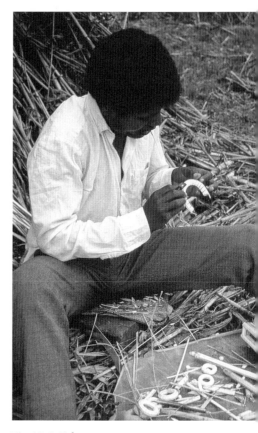

Fig. 10.6 Tolera constructing a car tire.

pith. With amazing dexterity, and especially so for Bekele, who stores his razor blade in his mouth between cuts, the model maker cuts and trims the pith to the required lengths. These pith lengths with either squared or mitered cuts are then fastened together with thin toothpick-width pieces of the outer layer that serve as "pins." The modeler pushes a 3- to 6-inch "pin" through one piece of pith and into another. Then with a quick, sharp flick of the wrist, he breaks off the excess even with the surface of the pith.

To make the curved or round pieces that are required for tires, bumpers, and the like, a thin strip of outer layer is left on the stalk. Then wedges are cut from the side of the pith opposite the outer-layer strip. When a length of pith cut in this manner is bent, the outer strip lends integrity to the piece, which can be tacked in place. For the tires required on cars, trucks, and taxis, the same thin outer strips that are used as fasteners are cut to the desired lengths to become the spokes that connect a wheel hub to the inside rim of the wheel, which is a piece of inner stalk with cut-out wedges (fig. 10.6). The truly exceptional model makers will sometimes look for an inner piece of pith that is dark red or maroon to make a more "naturalistic" dark-colored tire.

Windows, most often rectangular or square in shape but on some churches triangular, are filled horizontally by evenly spaced, thin pieces of the outer stalk and completed with the positioning of a single vertical divider of the same material. This, as already noted, is considered, along with the making of wheels, to be the most difficult aspect of construction. Indeed, it is the windows, wheels, and other carefully crafted details that make the pith sculptures so exceptional.

For example, the Ethiopian wiyiyyit model (in real life most taxi-trucks are light Toyota pickup trucks that have a fabricated metal "cap" in which passengers sit on benches) comes with steering wheel, windshield wipers, radio antenna, headlights, license plate, the interior bench seating, spinning wheels, and a back door that opens, complete with jump seat (fig. 10.7). (The young boy who sits on this seat in a real taxi calls out the destination at taxi stops, collects the fares, and indicates to the driver when a passenger wants to disembark.) Similarly, helicopters and airplanes are constructed with cockpit seats, control sticks, and propellers and rotary blades that turn. And dump trucks are made with hydraulic

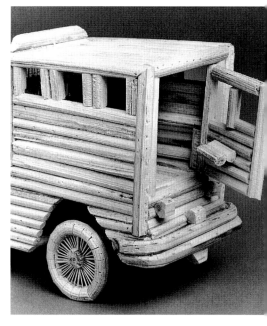

Fig. 10.7 Detail of the back of the *wiyiyyit* shown in pl. 19, complete with an opening back door and jump seat.

structures that allow the backs to rise. The details that can be incorpo-
rated are numerous, and with each viewing of a model new ones become
visible. For the model maker the details are most important to the over-
all effect and are not taken lightly (fig. 10.8).

If each model maker works daily from eight o'clock in the morning
until late in the afternoon, up to sixteen models can be made in a week.
Such a pattern, however, is not typical. For Tolera and those in Necho
and Kimoy, seven or eight sculptures in a week is a more typical out-
put. Not working to full capacity undoubtedly relates to issues of demand
and supply, but then Tolera in describing his day also mentions quite
specifically, for he is a devout Christian, his need to set aside time to
read the Bible. And of course some days are taken up with marketing.

Usually once a week, with a number of models in hand, Tolera and
his friend Kebbede Melketcha flag down one of the many local buses
that ply the Ambo Road. Paying either 6 birr for a one-way ticket or 12
birr for a round-trip, depending on their cash on hand, they set off for
Addis Ababa to sell their week's labor. Only if the bus is crowded will
the driver charge them extra for carrying their sculptures. Once in the
capital the challenge begins to sell the pieces as quickly as possible. Gen-
erally the modelers stay in the city until they sell all their pieces. Their
time in Addis Ababa is not considered a production cost as such, but
clearly the ideal is to sell one's works and return to the village to make
more—especially with overnight accommodation at 6 birr and meals
at 2 or 3 birr each.

In what Tolera and Kebbede describe as a good week they can sell
seven models each and earn as much as 150 birr (U.S.$30). But this is
in Addis Ababa at the Hilton (fig. 10.1). There is a significant difference
between the prices they can ask, and get, in the capital and what can be
earned on the Ambo Road. Whereas 15–25 birr a model is considered
a good price in Addis Ababa, 10 birr is more common on the Ambo
Road. The lack of transportation cost might be calculated in the lower
sale price on the Ambo Road, but the reality is based more simply on
supply and demand. Further, the Ambo Road has for the past twenty or
more years lacked tourist traffic, both Ethiopian and foreign. In part this
absence can be accounted for by the road, especially west beyond Necho,
being less than safe; in 1993 this was due to real or imagined con-

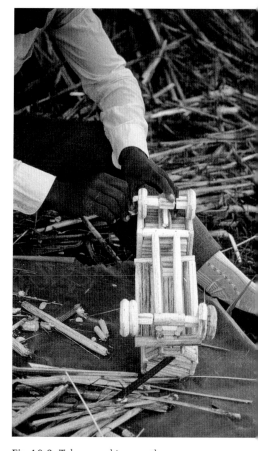

Fig. 10.8 Tolera working on the
undercarriage of a truck and checking
whether the tires turn smoothly.

frontations, including fighting, between the soldiers of the Transitional Government of Ethiopia (TGE) and various forces said to be associated with the Oromo people. But for the modelers the size of the piece and the corresponding time required to make a model are the factors taken into account when pricing a piece.

For Tolera his churches and ships are proven sellers at 50 and 30 birr respectively, although he considers cars, along with his churches, to be his best work. And for the recently commissioned models, he determined his price by calculating how many of the smaller standard pieces he could have made in the time it took to make the commission. For example, two recent commissions, a six-foot model of the Tower of Pisa and a five-foot rendering of the Palazzo Vecchio and Loggia della Signoria bell tower (in Florence), both for the Italian Cultural Center in Addis Ababa, were priced at 400 birr apiece (the equivalent of thirty-six smaller pieces, the number he could have made over the fifteen days it took to complete each commission). For the "Ethiopia: Traditions of Creativity" exhibition, Tolera constructed models of the White House and the Jefferson Memorial, which took two weeks and one week respectively (fig. 10.9). In each case these commissions were accomplished by working from magazine pictures and interpreting the two-dimensional images into three with tremendous success. Tolera was so pleased with the results of his Tower of Pisa that he "invested" in making a second in the hope of earning another large sum of cash, which eventually he did a few weeks later.

For Tolera 1993 was time well spent. He clearly raised his modeling skills to a new level. And with the realization that he can produce models from pictures of buildings he has never seen before have come commissions. Obviously related, but more important to him and his family, is that he has money in his pocket. With his earnings he has assisted his parents in building a new house—a traditional one—with which his family is extremely pleased. With his savings he had money for new clothes and the school fees that allowed him to return to school to begin the tenth grade.[8] The money also enabled him to procure a bed frame, mattress, and blanket, since to attend high school he must rent a room in the town of Addis Alem, ten kilometers east of Necho. Other funds have been invested. With his eldest brother in Addis Ababa he has become

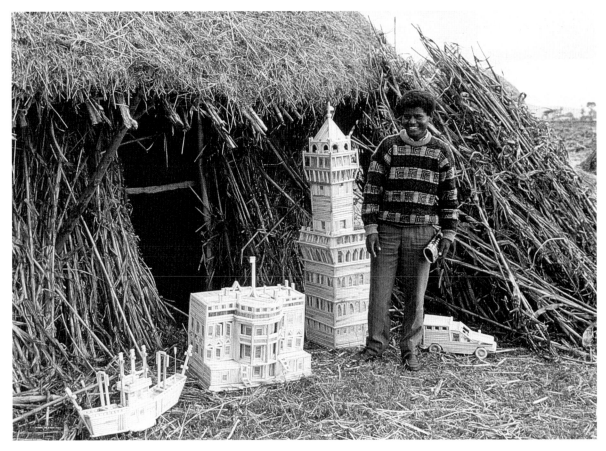

Fig. 10.9 Tolera with his commissions of the White House and the Palazzo Vecchio (Florence, Italy).

a modest entrepreneur; together they have purchased a bicycle which they rent to others.

For the immediate present Tolera's future would seem secured. But can his modeling skills be turned into a profession? Will he find work in the building trades? Will attending high school classes for three more years provide him with the knowledge and skills to make him competitive for university admission and allow him to follow his dream of becoming an engineer or architect? Tolera's drive, ambition, and venturesome spirit can take him far but may not be enough without the sustained economic development that a country like Ethiopia requires

to support its poor, young, ever-growing population. The reality may be that twenty-five years from now Tolera will be like Bekele today—sitting beside the Ambo Road selling his sorghum-stalk sculptures to those who take the time to stop and discover and experience the great ingenuity seen in his models. Returning to the modesty that this young man exhibits, it was pointed out to him that "unless you speak about the quality of your work, others may not know"; Tolera responded with a laugh and remarked, "Now you have seen—you can tell [others about it]."

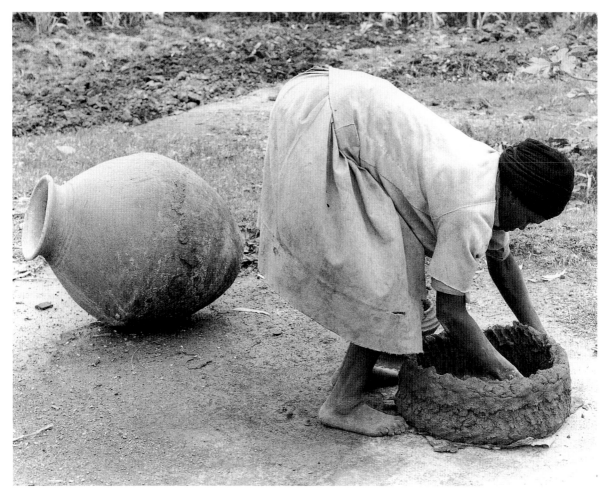

Fig. 11.1 Tabita Hatuti "pulling up" the walls of the upper section of a *gan* (a pot for brewing beer).

Tabita Hatuti

11

Biography of a Woman Potter

Tsehai Berhane-Selassie

Introduction

Tabita Hatuti comes from the community of potters who live alongside farmers in rural Wolayta, located in the newly formed Southern Administrative Region and administered from Awasa (fig. 11.2). Tabita speaks Wolayttatto, a language spoken by about two million people.[1] The Wolayta classify their society along occupational lines: the dominant *goqa* (farmers); the lowly *chinasha* (artisans), including potters, who are politely referred to as *hilansha*; and the *ayele* (slaves), who existed historically.[2] There are about ten thousand potters in Wolayta,[3] and as elsewhere in Ethiopia, they are looked down upon by farmers, who treat them almost as if they belong to a despised "caste."[4] They have a myth that associates potters either with "newcomers" or with a sibling who lost his seniority for violating a food taboo.[5]

Tabita is one of the best potters in her community. This evaluation is based on the variety of durable household utensils that she knows how to "create," to use the terminology used by the potters. "Creating" pots in all sizes, identifying sources of good-quality clay, and organizing her time effectively to perform both her household chores and her pottery

My fieldwork in Wolayta owes a great deal to my friend and assistant Werqnesh Weltamo and her husband, Bekele Mume. They both did their best to teach me Wolayttatto, to translate for me, and to smooth my relations with the Wolayta potters' community. I also wish to express deep appreciation to all the other Wolayta people who befriended me and who facilitated my research by answering my questions and volunteering information. Like Tabita and Busho, they have been very patient with my frequent visits and unending curiosity, and I would like to express my deeply felt gratitude.

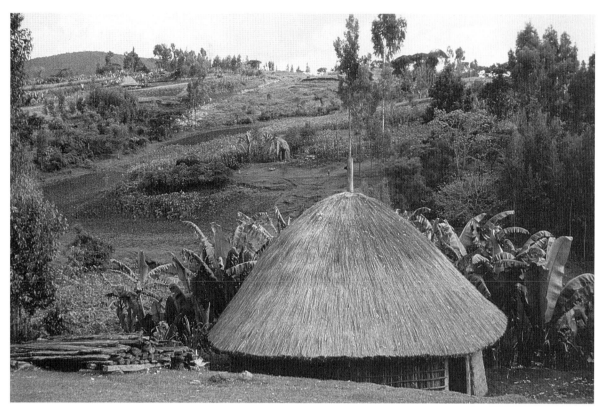

Fig. 11.2 The countryside around Shento in south-central Ethiopia.

production, which is considered part of it, give a potter a reputation for industriousness and accomplishment in her community. Like all good potters, Tabita has trained all her six boys in the art of pottery production so that they can participate in it as much as men can; though they are all boys, her children also participate in running her household.

Tabita was born in 1963 in Shento, which is on the plain to the west of the mountain called Damota, in the heart of Wolayta country. In 1982 she married Busho Anjajo, who comes from the village of Qontola, in northern Wolayta. She and her husband are bringing up their six children on their income from the sale of the pottery that Tabita makes and the food that Busho grows on the land he cultivates.

Tabita's biography highlights her work as an artist while placing her in the broader context of the lives of artisans in her part of Ethiopia; it

also offers a glimpse of the art of pottery production and evaluation in Ethiopia.

Family Background

One of the most difficult aspects of documenting a potter's life is reconstructing her family history, including the genealogies of her ancestors. Tabita could recall the names of only three paternal ancestors, Hatuti, Godola, and Bombe, and two maternal ones, Anjulo and Chacha. Such short recollection was fairly common among the potters of her area: women simply say, "We do not know the dead ones." This is ironic, given the stereotypical view that potters relate to "the dead ones" better than farmers do. Tabita considers herself a member of the Zato clan, to which her father belonged.

Her parents had always lived in Shento, where she was born. Her father was a part-time farmer with access to land which belonged to a local landlord. He used to farm both his own plot, which was on a semi-arid hillside, and that of the owner, which was further up the hill. For the privilege of using the farmland, Tabita's family used to pay annual tributes of pottery to the landowner. The number of household utensils supplied varied from year to year, but it never exceeded four. Her family also provided other menial services and were generally treated as though they were servants.

Shento, where Tabita grew up, is in a temperate zone although it is rather hot and uncomfortable for most parts of the year. When she was a child, the women of her family dug clay from land which belonged to a farmer about a kilometer from their house. Despite her father's position as a subordinate to a farmer, her family was comparatively better off than other potters in the area.

Her mother was a co-wife, and Tabita had other siblings besides those born to her own mother. She has three sisters and one brother. One of her sisters is married to a blacksmith; another is an expert in female circumcision. Her brother sings, which in Wolayta is a specialty of the potters' community. In addition to making pottery, therefore, members of her natal family are engaged in all areas of work that potters are known for.[6] This has shaped Tabita's experience and knowledge of her social environment. Unlike her mother, however, Tabita, who is a Protestant

Christian, is an only wife and, contrary to traditional virilocal custom, she now lives in her natal village, Shento.

Growing Up

Like all little girls in the potters' community; Tabita learned to handle clay and make pottery when she was quite small. Judging by what she recalled by pointing to a little girl standing nearby, she may have been about three years old when she started to process clay for making pottery (fig. 11.3). She accompanied her mother on clay-collecting expeditions at that early age but did not collect water or wood for fuel until much later. She learned to handle clay by imitating her mother and other adults around her. She recalled that "when she broke her [milk] teeth," she was already making small *kere* (saucepans) and *satya* (serving bowls), "which sold well in the market."[7] At the same time she learned to help her mother with the household chores, including making fire, cooking food, and serving it. "It is not easy to put time on what I did as a child," she remarked when we asked her about how she learned to make pots. Before she reached puberty she had acquired all the skills necessary to be an accomplished potter.

Fig. 11.3 Kulay Torcha, a three-year-old boy living in the village of Gurumu Wayde (near Shento), beginning to form a pot.

Growing up, she had to learn more about the physical environment than farmers' daughters did. She knew where the best clay was and where to find water during both dry and rainy seasons. She also knew where to get wood for fuel, which the potters' community used more of than the farming community. "We went to collect fuelwood for firing pottery as well as for cooking purposes," she said. "We never cut trees down; men did that. Women collected twigs and undergrowth. My mother collected fuelwood only. Occasionally, my father and 'brothers' acquired all the bigger pieces of fuelwood needed for her work."

Her statement reveals how environmental resources were used and the division of labor in the making of pottery. The period during which she grew up, before 1976, was a time when private property and the use of fuelwood were regulated by landlords in a customary fashion.[8] At that time the potters' community had to make do with what was provided by the individual farmers with whom their families had historical associations. Although her father had access to some farmland, his use of it and his access to the forest were restricted. The women of the household had to be careful about the amount of fuel they collected. Such sensitivity to the environment, especially guarding against the overuse of necessary resources, was a large part of her upbringing. Particularly important in this context was an awareness of the cost of fuelwood, which could affect the amount and quality of the pottery produced and, ultimately, the income derived from it.

Tabita was taught by her mother to be aware of the market demand for pottery. Like all young girls in the potters' community, Tabita used to go to all the weekly markets, sometimes taking pottery she or her mother produced and sometimes only buying supplementary food items needed for the household. These expeditions were used for determining pottery prices and for gauging where their products were most needed. "I was taught by my mother to know these things," she said. By comparison to farmers' daughters of her own age, her knowledge of market layouts, natural resources, and the general environment was quite extensive. In this sense, the lives of girls from potters' families were more similar to those of boys than they were to those of girls from farmers' families. Nevertheless, Tabita's experiences were more restricted than those of her own "brothers," who, like other boys in their com-

munity, traveled further afield, taking their mother's pottery to markets in Kambaata, located to the north of the area where Tabita grew up. Closer to home, they also went to the main local markets of Boditti and Sodo. The farthest main market Tabita traveled to before her marriage was Boditti, about 10 kilometers from where she grew up. Like household chores and pottery production, knowledge of the natural environment was, and still is, gender specific.

Her most formative years also coincided with the time when the Protestant Church was expanding in the southern regions of Ethiopia, especially in Wolayta. Many youths were attracted to it because of its novelty and because of the perceived economic benefits it offered. Visiting prayer halls was thus also part of her experience. The new religion also provided her with the willpower to rebel against injustice: "I ran away to Qontola because landlords used to force people to produce [pots] with no compensation." She went to Qontola with her parents. Through the prayer halls too she met her future husband, who was introduced to her by his friends.

Marriage and the Family

Despite the coming of a new religion and her involvement with it, Tabita's married life was largely dominated by traditional practices. Potters practice occupational endogamy, intermarrying only with potters or weavers, either of their own locality and linguistic group or outside it.[9] Girls in Wolayta get married in one of two ways: kidnapping and arranged marriage (Amarech Agedew 1983: 2). Tabita's was an arranged marriage, with the two families having negotiated the couple's future wealth, the families' compatibility, and so on.

Her husband, Busho Anjajo, comes from a potter's family in Qontola. His father had his own plot of farmland, which he had inherited from his ancestors because one of them was a particularly brave warrior. The land was on the plateau and very fertile, and Busho had his own house next to his father's. Busho is literate, having attended school up to the fifth grade.

The extent to which both Busho and Tabita were able to break with tradition was reflected in their wedding, during which, contrary to tradition, there was very little singing and dancing. However, Tabita was

subjected to the ordeals of circumcision shortly before her wedding.[10] The births of her children were marked by the rituals which made them part of their father's clan. A month before she delivered her first child, Busho sent Tabita back to her mother with gifts of food and clothing. She stayed with her mother until she had her son, and when Busho came to visit, he completed the period of "avoidance relationship" with his in-laws. The birth of the first son obliged society to accept Busho and Tabita as full members of the community. Like all newlyweds in their society, they were considered immature people until the birth of their first child. The umbilical cords and the afterbirths of all six of their sons were buried on the land that Busho farmed. This made the children members of their father's clan, called Damota.

Pottery and Marriage

> When I married Busho and went to live with him in Qontola, I found the women in his family were potters like me. I noted, however, that my skills far exceeded theirs in terms of the variety of pots I created. The local market, even that in Shone, was not large enough for my products. I began to sell my pottery for very little. I noticed that [long-distance] Maraqo traders from Kambaata were traveling through Shento and Boditti. So I decided to sell my pottery to them. I decided to move our house to an area nearer that trade route. I persuaded my husband to change houses, and we moved to my birthplace, Shento.

According to the virilocal tradition of Wolayta, it is considered bad luck for a married woman to set up house in her natal village. However, in the case of Tabita, sensitivity to market prices and trends, which was part of her upbringing, influenced the choice of her new residence. In this too Tabita was a woman of her community. Potters are expected to assess their environment for resources and market potential and make decisions accordingly.[11] Tabita's assessment of economic factors also provided her with an excuse to move away from her in-laws, with whom relations had become strained.

In her new house in her own village Tabita began again to use the "best clay" and realized her dream of selling her pottery to traders and clients coming from Kambaata. The place was also quite close to two other important markets, Shento and Boditti, both within walking distance of her house. Some of her larger pots, such as the storage and brewing pot (*gan*) that holds about 5 quintals of barley, could easily be transported by her husband, either hanging from sticks slung across his shoulders or on donkey back (fig. 11.4).

Tabita's pots sold well and she joined a small credit association with her neighbors. The association was a small-scale and temporary enter-

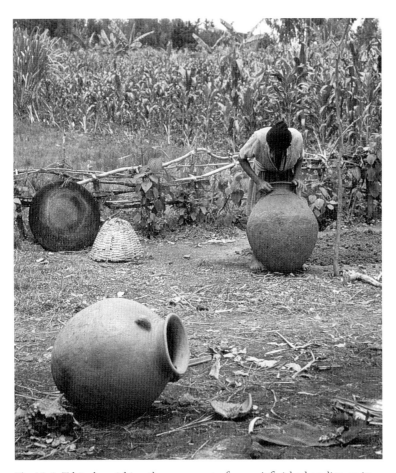

Fig. 11.4 Tabita burnishing the upper part of a *gan*. A finished *gan* lies on its side in the foreground.

prise that enabled Tabita and her neighbors to acquire small amounts of cash for pressing needs. The proceeds from her weekly pottery sales have made it possible for her to send her boys to the local elementary school. In time, she and her husband were also able to build a house with a galvanized iron roof (fig. 11.5).

Revolution and Change of Status

By the time they were married and set up house, the 1974 Revolution had already been under way for about four years. The revolution brought new ideas and policies that influenced Tabita's life considerably. People in Shento were required to organize peasants', youths', and women's associations, as well as farmers' service cooperatives.[12] Men and women were also involved in literacy classes, skills-training programs, and local administration. Tabita was obliged to be a member of the local Revolutionary Ethiopian Women's Association (REWA) and through it to attend its literacy program. About this she said: "I had difficulty with my eyes and although I was able to learn the alphabet, I did not learn enough to retain it to be able to read and write. Now I cannot do anything more than read and sign my own name."[13]

Another source of revolutionary influence on Tabita's life came from its impact on the men, including her husband. Potters were given the right to own land, and individual households received their own plots of farmland. This was a major departure from tradition, as potters usually did not have this right except in special circumstances, like that mentioned above in the case of Busho's family. Busho began farming as well, and when the farmers were obliged to form a peasants' association, he was involved in it.

In this way, the potters also acquired free access to land with clay on it. Instead of having to pay money to the landlords, women could quarry clay for free. Land was also allocated for harvesting the necessary grass for firing their pottery. From a potter's perspective, especially with regard to these issues, the revolutionary years should have been idyllic.

A development program in the form of villagization undermined these gains by upsetting property relationships and by reinforcing unbalanced gender relations.[14] Despite the revolutionary ideas of equality, the local authorities relocated the potters and the farmers in Shento into sepa-

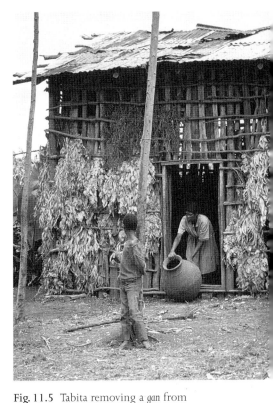

Fig. 11.5 Tabita removing a *gan* from her house (note the corrugated iron roof).

rate villages; almost one hundred potter families were organized in their own village.[15] As in all other villages, the houses were lined up in straight lines, all facing the thoroughfare and all surrounded by their own gardens. Each household also had its own plot of farmland. In spite of the traditional expectation that men help the women in pottery making, the men of the potters' community were expected only to farm. They began to find it difficult to find the time to assist the women in the production of pottery. Like many other women, Tabita explained the situation in terms of her reluctance to participate in the activities of the local branch of the REWA, saying that it stemmed from Busho's inability to assist her with her work.

The worst and most profound effect came from the development program that tried to involve the potters in a cooperative. In 1984, Busho was recruited to learn how to use the potter's wheel, an appropriate technology that had been brought to Shento in 1976 by a Ministry of Agriculture development agent.[16] It was part of the program aimed at organizing the potters into a producers' cooperative. The development agent had the misfortune of being misunderstood and was removed, and the potter's wheel was locked away. In 1984, when the service cooperative was organized to provide a physical space for a pottery producers' cooperative, the potter's wheel was brought out and used to train Busho and other men in the service cooperative. They, rather than the women, were selected because they were literate, a requirement for joining the "modern" sector of the development process. At about the same time, the government decided that rural women should not be involved in local government, because their families were being neglected. Officially, the women were left out of the training scheme because "they were illiterate." Busho was the only participant from the village of Shento; the idea was for him to train the other potters, who, of course, were all women.[17] In the eyes of the women, Busho was an anomaly, to say the least, because, except for making roof tops and occasionally drinking vessels, pottery making in Wolayta was woman's work.[18] The women therefore resented his new role. Nonetheless, Tabita agreed with Busho that it was good for him because "it was good to have the training."

A problem arose, however, when the men had to convince the women to change their traditional ways of working to suit the rules of coop-

erative production and marketing. A neighbor of Tabita and Busho, who had acquired sufficient education to be a primary-school teacher, was nominated to organize the women trained by Busho on the wheel into a producers' cooperative. This man's wife was a potter, but unlike Busho and Tabita, who were proud of their situation, it was difficult for him to acknowledge his wife's skills in public: "I am a schoolteacher and recognizing the fact that my wife is a potter would affect my reputation with my colleagues." He had reason for this fear because those involved in the "modern" sector still retain the traditional prejudice against potters and other artisans. He had to perform his organizing through a proxy who would not mind being seen as belonging to the "traditional and despised" sector and had nothing to lose from the "modern" sector. He therefore involved his friend and neighbor Busho in the local politics of organizing the cooperative. For a long time Busho abandoned both his farm and his role as a potter's husband. Thus, Tabita and her family found themselves caught in the midst of a local political process that was resented by the women.

Nevertheless, the potters' community in Shento, which was traditionally despised, greatly benefited from the social, economic, and political processes associated with the 1974 Revolution, if only for a brief period. In their eyes, one of the positive outcomes was that, like farmers, potters could choose their own peasants' association leader from among themselves. Taking advantage of the new reforms, the peasants' association leadership, which included Busho and his teacher friend, organized free access to the source of clay. It was on the land of a local landowner, and the villagers were given the mandate to manage it. The association leadership also built a store in which pottery could be sold cooperatively. Shento was the only village, as far as I know, where potters had full control over local politics and used this situation to their benefit.[19]

Both Busho and the schoolteacher began to have discussions with the women about the importance of selling their wares in a cooperative store. Initially, a few of the women were elected to the local committees of the cooperatives and associations, and they were able to convince their friends to sell their pottery through the cooperatives. Subsequently, however, the regional administration at Awasa decided that

women were unsuitable for decision making and high-level administrative work and ordered the men of the potters' community to take total control of organizing the potters into production and marketing groups. This was the beginning of the end for the new cooperative process. Although Tabita and her neighbor and friend, the schoolteacher's wife, cooperated in the beginning, Tabita later decided to have nothing to do with the new initiatives beyond learning how to use the potter's wheel. She did not see them as contributing anything of value and made strong statements to that effect:

> There was only one wheel and it was kept locked in the cooperative store. Very few women used it at all. The men also said that women were not good at keeping the books of the cooperative and that the cooperative was losing out as a result of their involvement in running the cooperative. The men were meant to collect the pottery that women made.

Every month women were supposed to contribute a certain quota of what they produced, and the men would record it in the book and sell it. "The women did not know what they gained from that work. The cooperative took away our market. Traders came from Kambaata and bought directly from the cooperative, not from the women." The proceeds went to the cooperative, which was supposed to provide basic goods for the villagers.
By all accounts, individual women potters like Tabita feared losing their markets. Eventually, therefore, many women refused to contribute their quotas. Tabita added:

> The only good thing about the cooperative was that we did not pay for the clay. I did not want to be elected to the committee that ran the producers' cooperative because I had a lot of work to do. Yes, Busho continued, but he was paid for his work, and he is now an employee of the Ministry of Agriculture. That takes up a lot of his time, and he does not get his pay regularly.

Given the consciousness-raising that the national REWA had undertaken at the beginning, it is possible that Tabita's and the other women's objections to the cooperative were provoked by the dismissal of the women from its leadership. More important, pottery making is one of a woman's household chores, to be performed for the benefit of her household alone. The cooperative interfered with this routine, and the women saw few benefits from the organization. The cooperative was never easy to run, and it came to an end in 1990.[20] On the eve of the demise of the government of the Derg, the local people divided the money among themselves and closed it down. Tabita recalls: "It was a relief when it closed down because the men were bothersome, expecting us to contribute our products every month and never giving us the money they made from it."

The Effects of Democratic Changes

By 1992, almost all rural people had devillagized and returned to their original homes. The residents of the potters' community also devillagized and resumed their work on the plots of land they owned. Tabita and Busho went back to their land, which was closer to the market at Shento, and once again their lives began to revolve around the marketplace. Not only was their home nearer the market, but it was also very close to the route taken by traders from Kambaata. To make ends meet, Tabita now concentrates on making large pots that her neighbors do not produce.

An unexpected major change that has affected Tabita and the other potters in the area is the return of land to its former owners. Even though the government has not made any clear statements on the issue, former landowners have asserted their rights and are now claiming rent from the potters. In Shento, Tabita and her neighbors pay one birr a week to the local landlord for the privilege of extracting clay from his land. He said:

> I have stipulated this payment because the extraction
> of clay renders the land unsuitable for farming. It becomes
> full of holes and [is therefore] difficult to farm. Despite my
> request for payment, I have no way of enforcing it. They

are supposed to pay every Friday, but the women avoid pay-
ing by not coming to the place to collect clay on Fridays.

Tabita explains the potters' behavior simply by saying that another farmer
wants to sell his clay for half the price and she goes there instead: "The
clay on the other farm is running out anyway; besides, we are too poor
to afford any money at all." The return of landlordism does not obvi-
ously entail the traditional obligations that potters have toward own-
ers; they can buy the clay from anybody who wants to sell it and not
just from the landlord who owns the plot of land on which they live.

Another challenge stems from losing access to the free use of the
grass needed for firing their pottery. Now the potters have to make do
with what they can buy either when thatched houses are pulled down,
which is happening a lot during the devillagization process, or when a
landowner has grass to sell. For the same reason firewood has also become
expensive. Tabita's and the other women's relationship to resources has
come full circle: they are no longer in control of the environment. As
in the old days, landlords try to extract what they can from it and from
the potters.

The Art of Pottery Production

Two major points need to be made here. One of them is that Tabita sees
herself as endowed with a special knowledge. In terms of the thinking
in her society, this attitude is a mark of self-confidence and is charac-
teristic of all potter women her age. In her community the knowledge
required to produce fine pots is regarded as a major asset—it is some-
thing that becomes part of one's nature, so to speak. In her own words:
"Once they learn pottery, very few women forget the art of production.
Some farmer women marry men of the potters' community and they
learn to make pottery as adults. All others learn pottery as children, and
they always continue to produce."

The other point that needs to be made is that pottery is associated
with the creation of human life. In other words, pottery is perceived by
the potters as a divine gift made to the mythical ancestor and passed
from generation to generation. "We have always made pottery. . . . God
taught human beings to make pottery. I learned my skills from my mother

and she learned it from her mother." Statements like this were made by everyone we interviewed. When she went beyond this, Tabita reluctantly spoke of pottery in terms of her immediate social environment. It is impossible to reconstruct the history of pottery production from oral tradition.

The instruments required for making pottery are gathered by each potter. These include ropes for carrying things, baskets for transporting clay soil and products, pieces of gourd and sheep rib bones for scraping excess clay while producing work, pieces of sheep or cattle hides for smoothing the surface, and stones for burnishing the surface.[21]

For Tabita, describing the everyday activities around the creation of pottery is not only an expression of pride in her work but also a way of attributing an identity to the particular piece of art she creates.

> First I bring the clay from the river. I then spread it to
> dry. Once it dries I take a stick and break it by beating it
> into a powder. I then sieve it to separate the fine dust from
> stones and other hard clay. Then I bring water and mix it
> with my legs. I gather it together and continue to knead it
> with the palms of my hands.

Bringing clay from the quarry near the river involves carrying about 10 kilos of moist earth on her back at least twice a week. Women socialize while they fetch clay, and those who have daughters leave the carrying to the young girls (fig. 11.6). Tabita carries all the clay she requires on her own because men are normally forbidden to help in that. In order to meet her weekly supply requirements, she collects clay twice a week.[22]

Tabita mixes four types of clay, which she distinguishes by color: brown, which makes the pottery strong; red, which gives it color; black, which is porous and brittle; and dark brown, which she uses in large quantities. She also adds finely ground and sifted pottery sherds (the remains of pots that broke during firing) and kneads the mixture thoroughly (fig. 11.7). Potters then leave the wet "dough" to mature, either covered with a broken pot or in a hole dug in the ground specifically prepared for storing the clay (Hakemulder 1980: 16–17). For this purpose Tabita always has at hand a *gan* that had cracked while she was try-

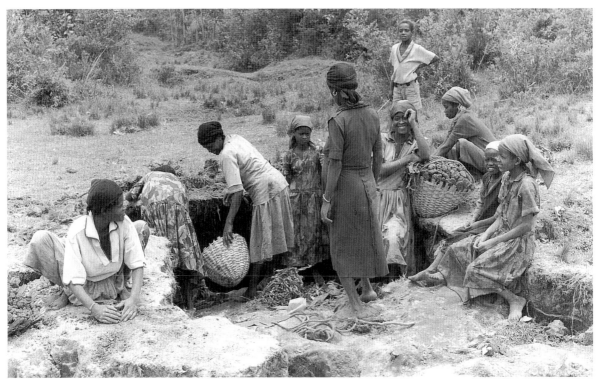

Fig. 11.6 Collecting the clay used for modeling pots in Shento.

ing to fire it. Additional water must not be allowed to get into the clay; nor should it be allowed to dry out. The length of time needed for the clay to mature depends on the weather, how firm a piece of pottery the potter wants to make, and how soon she wants to make and sell it. In the rainy season, Tabita leaves the clay for ten days or even longer because the weather does not allow for quick production, drying, and selling; often potters make new pottery only after they sell what they have already made. The question of storage does not arise. In Wolayta customers prefer to buy pottery processed slowly over a longer time because it tends to be stronger than that produced faster during the dry season.

After a while I start to create. I finish shaping the piece by smoothing it with a piece of gourd. Then I use hide dipped in water for smoothing [the surface] further. Then

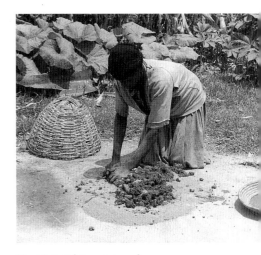

Fig. 11.7 Tabita mixing clay, grog, and water.

I take a rib bone and scrape off the excess clay and further reshape it using both my fingers and the palm of my hand.[23]

Tabita shapes her pottery by bending over the portion of clay she has placed on a piece of hide, soft ground, or the broad leaves of the *enset* plant and moving around and around the pot and "pulling" the clay up to give it the shape she wants (fig. 11.1). She places the index, middle, and fourth fingers of her right hand inside the vessel while pressing and scooping from the outside with her left hand. The *gan*, a pot for brewing beer and for which she has achieved fame, is made in two halves, which are joined afterward (fig. 11.4). Handles, which are rarely made in Wolayta and the south, and necks and spouts are made separately by using coils and are added to the main body. "I then leave it [the finished product] for a while in the shade to dry out on its own." Pottery making can be very tiring. Some potters rest by sitting down to smoke tobacco from pipes. Co-wives and neighbors join in the smoke break. The noon break is often accompanied by coffee and snacks of parched grain or boiled beans and maize. Because of her fundamentalist Christianity, Tabita does not smoke. "I am Christian," she says. "The Orthodox [Christians] smoke tobacco."

As in other parts of Africa, decorating pottery is part of the expertise potters acquire, and in Wolayta not all women can decorate (Pofliet 1978: 13; Fagg and Picton 1970: 13–16). For those like Tabita who have the expertise, most decoration involves incised lines, raised ridges, and other raised motifs. Big pots have raised ridges near the neck, smaller pots, such as serving bowls, can have ridges and other raised motifs elsewhere on their surfaces. Drinking vessels are decorated by painting them with contrasting colors made from earth pigments after firing. Small serving bowls have holes by which they can be suspended with strings on the walls of Wolayta houses. The amphora-shaped *chena*, a common pot type used for collecting and storing water, is found among the Wolayta and related people; it has an elegant profile and is a beautiful object in its own right (pl. 20d, fig. 11.8).[24]

Pottery is left to dry in the shade for a few days before it is exposed to the sun. Exposure to the sun is done gradually, and the pot is initially

Fig. 11.8 A *chena* made by Tabita.

covered with leaves. Like the rest of the potters, Tabita makes a number of articles before she starts to fire her pottery. Having collected firewood and *sunbelt* (savanna grass) while the pottery dries, she always does her firing outside, never in a closed space. Because kilns are not used, meticulous care is needed to maintain a high temperature.[25] Large pots are placed around smaller ones; *mit'ad*, large round baking pans, often serve as the outer layer and are themselves covered with a thick layer of grass and wood (fig. 11.9). The smaller pots are fired both inside and out at the same time. When firing the big brewing pot, Tabita first lights the fire inside it. "After it dries inside, I completely cover it with grass and firewood and fire it further." Unlike in other parts of the country, maintaining the fire is an art in which both men and women participate and achieve expertise.[26] The fire must be maintained for roughly an hour and often this requires the attention of every member of the family.

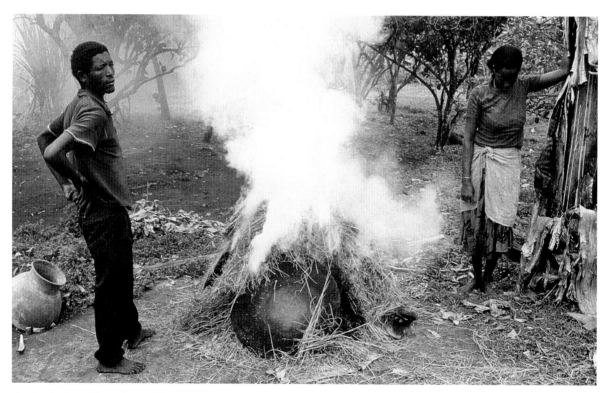

Fig. 11.9 One of Tabita's neighbors, Wagete Wodebo, and her husband firing pots.

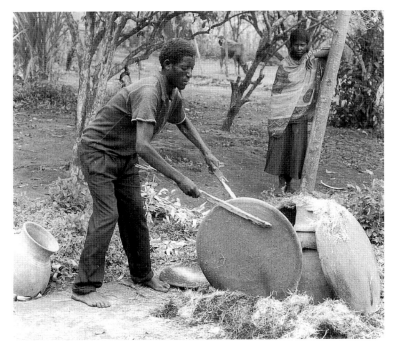

Fig. 11.10 Wagete's husband removes a *mit'ad* from the fire.

Because it is performed in the open air, firing pottery is a precarious endeavor; if it fails, all of the pots may be ruined. When there is a light rain, Tabita covers the pots with banana or *enset* leaves and continues the process. Too much rain can extinguish the fire and destroy the work of several weeks. When people are careless, houses catch fire. Indeed, during the period when villagization was in effect, this possibility was the formal explanation used by the dominant group, the farmers, to segregate the potters into separate villages.[27] Historically, this possibility has also been a source of insult to the potters (Tsehai Berhane-Selassie 1991b). Tabita, who takes great pride in the attention she gives to this phase of pottery production, has never allowed a house to catch fire as a result of negligence.

Removing the pottery from the fire is often men's work but women also become involved.[28] The men use sticks to remove the pots, first the *mit'ad* on the outside, then the smaller pieces (fig. 11.10). Potters become very annoyed if they find cracks in the pots. Tabita told us that

this rarely occurs with her firing. If small cracks appear, the gluelike sap from the *enset* plant is applied to fill the cracks. If a large crack occurs, the piece is discarded and its sherds later used as grog in future pots. It is always a bit nerve-wracking waiting to see the outcome of the firing of pots.

As soon as the firing is finished, the sap from the *enset* plant is applied to the surface. In the old days, sap from acacia trees was also used for this purpose. The sap gives the pottery a shine without changing its color and, where cracks appear, helps to fix some dust on top of them. For drinking vessels, contrasting-color decoration is added on this wet sap, often by old men. Unlike potters in the central highlands, Wolayta potters, and indeed many in the south, do not smoke or smudge their pottery for decoration (see Cassièrs 1988: 161; Hecht 1969: 9).

Since the villagers returned to their old homes after the fall of the Derg, Tabita has been working in back of her house. Most women, including Tabita, prefer to "create" while others are not watching so that their skills remain their own. While the creation is in progress, co-wives may chat with one another, and neighbors from the farming community may come to visit. Such socializing is tolerated because observing a potter at work in this manner is thought to help very little in learning this competitive skill.

Tabita involves her whole family in her work. Her six boys have learned all aspects of pottery making except the mixing of clay with water and shaping it. The boys even cook and get their own meals if she asks them to, although this is not typical of any group of men in Ethiopia.

Potters are supposed to engage in production continuously, although they can take holidays occasionally. Generally, people refrain from work for a whole month during periods of mourning; however, potters were still supposed to produce a small amount of pottery because it was believed that otherwise they would die. Tabita takes regular breaks every Sunday, when she goes to church. When we asked her about other times when she does not work, she said flatly: "We stop work when somebody dies out of respect for our neighbors." As for the belief that potters work continuously because otherwise they would die, Tabita said, "That was in the days when people were silly!" Perhaps this reflects a new outlook that she has acquired as a Protestant; other potter women

still hold to that belief. The fact that Tabita does not maintain this view has not reduced her commitment to her creative lifestyle—she continues to be a prolific potter.

Normally (i.e., when she is free from debts), Tabita collects clay twice a week, fetches water twice a day, and has some pottery ready for firing at least once a week. Firing is done at about 2 p.m. on Thursdays, just before the market gets into full swing. In her village of Shento everybody fires their pottery on Thursday afternoon, which is the market day. If the women have been particularly productive, they also fire pottery for the Saturday market in Sodo and for the Friday market in Boditti.

"I know exactly how much to produce for each market day," said Tabita. Leaving unfired pottery lying about in the house immediately exposes it to dampness and the need for firing or seasoning it immediately, which makes the product secondhand and less valuable. Storing until the next market day is not done at all in Wolayta.

After the Pot Leaves Its Maker's Hands

Both Tabita and Busho go to the market, but more often than not Busho carries Tabita's pots there because the pots she makes are the heavy brewing pots and other big pieces which she cannot carry on her own (fig. 11.11).[29] His involvement in firing the pottery and marketing it forces Busho to abandon his functions for the Ministry of Agriculture, but he gets his compensation. "He brings back all the money he makes from selling it, and I give him some for his needs. I also spend whatever I want from that." This attitude is common among the potters in Wolayta and elsewhere.[30]

Potters like Tabita make sure that their pottery sounds dry (i.e., produces a ringing tone when knocked with the knuckles). Such a level of dryness is achieved by the drying and firing processes; but this is only the initial consideration. Potters need to develop their reputation with customers, which is determined by the survival rate of their pots during the seasoning process performed by customers to make the pots leakproof (see also Hecht 1969: 9). Every piece, except water and grain containers, is seasoned by applying special ingredients that each potter recommends. The standard method is to heat the product and rub it with burning cakes of oil seeds such as castor, cotton, or cabbage. Most

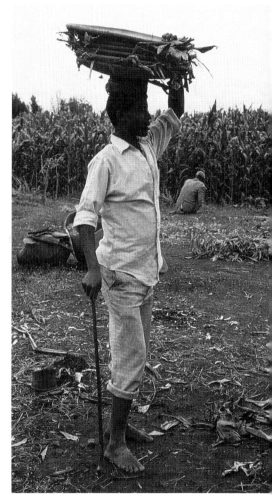

Fig. 11.11 Wagete's husband with freshly fired mit'ad on his head, about to set off for the market at Boditti.

pots are heated with these seeds inside and out. Cooking pots are easier to season because they are burned and rubbed with the hot oil seeds only on the inside. The coffee pot is even easier; all it requires is boiling coffee fast and letting it boil over. More difficult to season are the large pots, such as the *gan,* because women have to bend inside them in order to reach the bottom with burning oil seeds, fat, and beeswax on a pad of rough cloth. The *mit'ad* requires heating at a high temperature while being rubbed with the oil seeds. Water containers are smoked with large amounts of twigs and leaves of oily wood such as sycamore. All seasoning involves subjecting the pottery to another round of high heat—hence the emphasis on the initial ringing tone, which indicates that the pottery has been dried out completely and properly. The hot oil treatment from the melting seeds, fat, and beeswax or the fumigation with the leaves and twigs blocks the pores of the coarse-textured earthenware. It also makes the pottery shiny and durable. The best-made pots may last for many years, often breaking only when subjected to an excessive shock.[31]

Potters recommend that their customers use specific oil seeds in seasoning their products. Some, like Tabita, take pride in informing customers that the utensil will "come out" all right when seasoned with any of the oil seeds in any fashion. Women always buy from potters whose work they know will survive the seasoning process—price is determined by such reputations. In some cases, such as with the brewing pot, the size of the pot and the rarity of the skill needed to make it are additional factors. In 1993 when Tabita was raising money to cover her debts, she was producing very good large pots that she sold for 50 birr apiece, equivalent to about U.S.$10.00. A *mit'ad* costs about 15 birr; smaller items may sell for no more than 5 birr. Potters get very little return for their work, and nowadays they are having to compete with imported plastic goods, which many urbanites prefer.

Conclusion

Tabita, a strict follower of tradition with regard to her creativity, is nonetheless a woman of her time. She has been influenced by a new religion and has lived through the years of the revolution maintaining the self-sufficiency she acquired in her youth. She deals with the vicis-

situdes of life without assistance. Like other rural women, the government development schemes have hardly touched her lifestyle and quality of life. When these schemes did affect her, they invariably reinforced the gendered access to the "modern" sector, and in Tabita's particular case, her husband's involvement with them has been depriving her of his help to some degree.

Tabita loves to produce pottery, and when a piece cracks during firing she says: "This too has its uses. It strengthens my future creation!" The functionality of the pottery produced by Tabita and other potters does not stop customers from appreciating the utensils' artistry and beauty. Indeed, customers add to the beauty and functionality through the seasoning process. For Tabita, her ancestors, and her customers, pottery is a traditional craft that will continue, representing a whole lifestyle, with beauty and functionality emanating from it.

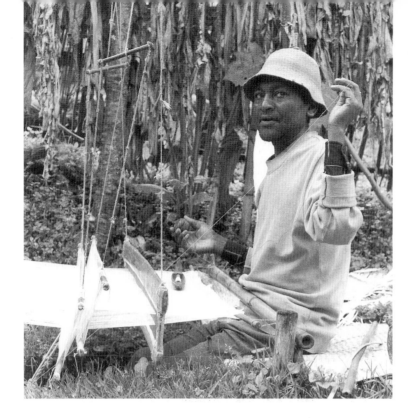

Fig. 12.1 Ilto Indalay weaving at his loom.

Fig. 12.2 Arba Desta (right) and his youngest son, Malako, weaving.

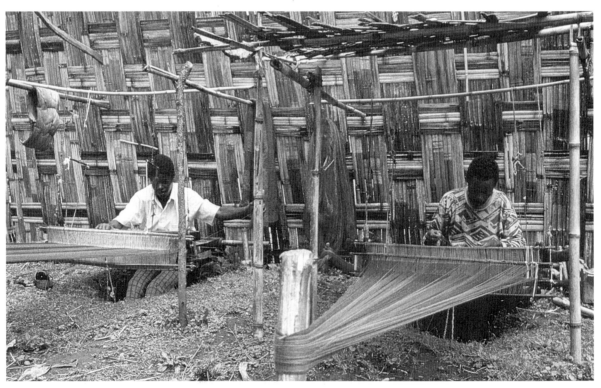

Ilto and Arba—Two Doko Weavers 12

Mary Ann Zelinsky-Cartledge and Daniel M. Cartledge

HIGH IN THE GAMO HIGHLANDS OF SOUTH-CENTRAL ETHIOPIA
is a green, precipitous land of terraced mountain slopes and cold, tumbling streams (fig. 12.3). This is the land of Doko, a home to rugged highlanders and a province of gifted handweavers. It was here that we came to settle among the society of the Doko Gamo and it was here that we came to meet several of the weavers whose products are well known throughout Ethiopia. In this essay, we will spotlight the lives and works of two weavers, Ilto Indalay and Arba Desta (figs. 12.1–12.2), both of whom live in Losha, a neighborhood of Doko.

Doko is situated in the central Gamo highlands, 2,600–3,300 meters above sea level. By road, it is 500 kilometers south-southwest of Addis Ababa, Ethiopia's capital. Doko is surrounded on three sides by the steep and barren Sura Mountain Ridge. Marching from north to south are the peaks of Moota, Soola, Olay Obota, Sura, Mar, and Mazay. From the mountaintop above Arba's and Ilto's homes, one can get a good overview of the quilt-work pattern of farms, cropland, pastureland, small woodlots, bamboo groves, wetlands, and forest tracts that constitute the land of Doko.

Doko weavers such as Ilto and Arba do not work solely on their craft but are also full-time farmers. Their main crops are wheat, potatoes, barley, peas, onions, cabbage, and enset (Ensete ventricosum). Enset is a banana-

Research for this essay was supported by a Fulbright Research Fellowship and a grant from the Florida Tropical Weavers Guild. We would like to thank Gezahegn Alemayehu, Arba Desta, and Ilto Indalay for helping us better understand the weaving traditions of Doko Losha.

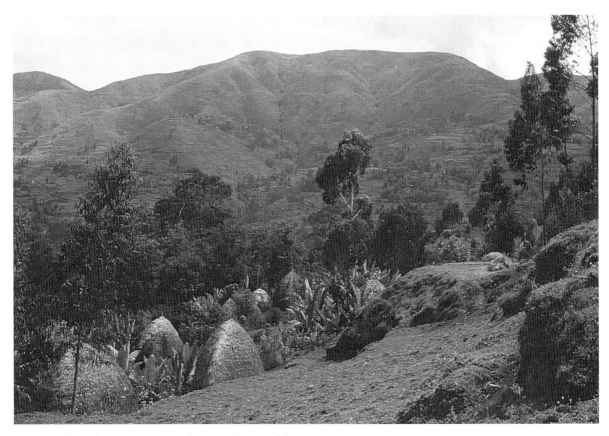

Fig. 12.3 The Doko Gamo countryside near Arba Desta's home.

like crop found only in the southern highlands of Ethiopia. Unlike banana, however, it produces no edible fruit. Rather, a variety of foods are prepared from the starchy pulp of the plant. It also yields a high-quality fiber that has many diverse uses in Doko society. It is, for example, the primary material used for lashing together the component parts of the weaver's loom.

Doko is one of approximately forty semiautonomous societies, locally known as *derays*, in the greater Gamo culture area. It is a society with regularly elected leaders (elders or chiefs) and hereditary ritual specialists. These specialists are responsible for carrying out traditional religious ceremonies and maintaining or enforcing the local system of rules and taboos. Doko is divided into two districts: Doko Gambella and

242

Doko Mesho. Both of these districts have a central market site and are divided into seven neighborhoods. The former regional administrative center of Chencha adjoins Doko Gambella to the north. Doko Losha, the home of Arba and Ilto, is one of the seven neighborhoods of Doko Gambella.

Doko society is almost totally agrarian. Most crops are produced for local consumption only; and essentially all farms include cattle, sheep, and perhaps a horse or mule. Weavers form a distinct socioeconomic component within this society. They belong to the *mala* social class—the commoners, or average citizens, of Doko. As such, they are eligible to be selected as *halakas* (the elected leaders of Doko society). This quite clearly distinguishes weavers from other Doko artisans because other artisan groups (including blacksmiths, butcher-tanners, and potters) are relegated to distinct lower-caste status in Doko society.

Following an intricate set of traditional rules, members of these caste groups must live apart from the rest of Doko society and are ineligible to hold office as *mala halakas*. Weavers are quite clearly a special occupational group rather than a social caste. Being a weaver carries no stigma, unlike that suffered by other Doko artisans, who must follow certain distinct behavioral rules. For example, a blacksmith is not allowed to use the front entrance to a commoner's (*mala*'s) house. Or, if a family of higher status serves food to a butcher-tanner, he is usually given a special plate or cup to use rather than being allowed to eat from a communal plate with the family. Products made by weavers are usually much more expensive than those of the artisan groups. This is true even though these other products (such as pottery) are just as necessary to Doko society as woven materials. Weavers such as Arba and Ilto tend to do more trading at a variety of markets and have more family network ties in Addis Ababa than do the caste groups' artisans.

Even though there are many differences between weavers and the lower-caste artisans, there are several similarities. For example, once a weaver is known or established within his area, many people will go to the weaver to get an article made rather than buying it in the market. This is also true for blacksmiths. Neighbors will frequently visit a specific blacksmith to have their knives sharpened or to have new tool handles made.

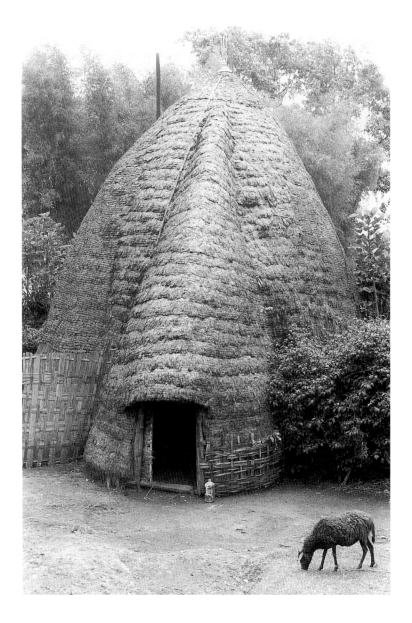

Fig. 12.4 A typical Doko house.

Weavers and butcher-tanners also both play important roles in the life of the *halaka*. The weaver has the honored task of making the shorts (*dunguza*) and tunic (*asara*) for a newly elected *halaka*. Similarly, butcher-tanners make an animal-skin cape (*zeeto*) for the new *halaka* to wear. Each of these social groups is distinct but all play an important role in Doko

society and have underlying connections with one another. The products of Doko's weavers are but the end result of a complex interplay of various sociocultural influences.

We began our search for a better understanding of these influences near our home base in Doko Losha. Fortunately, we didn't have far to go. Only two kilometers from our house we came across Ilto Indalay. At the time he was forty-five years old and had been weaving for twenty years. When we first approached him, he was busily weaving in his compound with the assistance of one of his sons. He wore a locally woven hat and near his loom he had a beehive and his trusty waterpipe (*gaya*).

He lives in a typical Doko Gamo house (fig. 12.4). Woven of split bamboo covered with wheat straw, this steeply domed structure looks like a large brown haystack perched on the mountainside.[1] His house is located down a long, narrow path and one has to bend over to enter through the small doorway of the two-meter-high bamboo fence that surrounds his compound. Ilto was friendly and did not seem to mind having some foreigners visit him while he was working. We briefly explained, through our field assistant, Gezahegn Alemayehu, that we were interested in learning more about the weavers in Doko and the various textiles that they produce.

Ilto took pride in showing us his weaving techniques and in explaining the process of producing a finished piece of cloth. He also took pride in telling us about his family. Ilto and his wife, Sinkay Seenay, have six children, five boys and one girl. When we would visit Ilto, we would frequently see one of his sons or a friend assisting him by winding the thread on a handmade bobbin winder (*diwura mekina*) (fig. 12.5). For most sons of weavers, the winding of the thread, which is later made into woven cloth, is usually the first step in learning to become a weaver, a tradition passed down from generation to generation. Just as Ilto's sons have a part to play in the weaving process, so do Ilto's wife and daughter. As we were told, and frequently witnessed, generally only men and boys actually weave. However, in complementary manner, female family members are responsible for the spinning of the cotton used for the weft (*shalo*) threads. These are the threads which run the width of the loom. This spun cotton (*kotsa*) is used in making a variety of Doko textiles.

Most of the cotton that the weavers use for the warp (*kacheena*), the

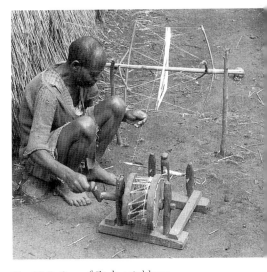

Fig. 12.5 One of Ilto's neighbors winding thread on a bobbin using a *diwura mekina*.

threads running the length of the loom, is factory-made. However, the cotton that is used for the weft (*shalo*) is grown in the Rift Valley lowlands. Women make regular trips down into the valley and return via steep mountain footpaths. They carry huge loads of goods into the valley and return with bundles of freshly picked cotton on their backs. These same women often sell this cotton at the three Doko area markets and at those in neighboring *deray* areas such as Dorze and Zozo (fig. 12.6). They sell the cotton in various forms, including cotton with seed (*foot aeefay*), cotton without the seed (*footo*), and handspun cotton (*kotsa*). Throughout our stay in Doko, it was a common sight to see females of all ages spinning cotton using a drop spindle (*inzert*) (fig. 12.7).

Most weavers, like Arba and Ilto, have their looms set up outside in their compound near their main house (figs. 12.1–12.2). The Doko pit-style loom is supported by four vertical posts (*ayko sota meetsa*). The posts are made from local timber, often eucalyptus or *k'orch* (*Erythrinia brucei*). Two horizontal pieces of wood (*geedo sota meetsa*) help connect the vertical posts of the loom. There are two harnesses (*meeyana*). These are also made from local woods or bamboo. On each harness are many string heddles. Attached to the bottom of the harnesses is a long piece of rope, made from *enset*. This forms the treadles of the loom. In front of the harness is the reed. The reed rests inside the wooden frame of the beater (*memcha*). The reed is composed of vertical bamboo pieces with a space between each. The reed can hold up to 600 threads. At the very front of the loom is a beam (*wonderashay*), around which the finished cloth is wound.

The loom frame is usually built into a hillside. The weaver uses the embankment of the hill as a natural bench. Below the bench is a small hole (*data holla*). The weaver places his feet in this hole to operate the treadles. These raise and lower the harnesses. The frame of the loom stays permanently in the ground. The reed and harnesses, however, can be removed. Sometimes Ilto removes these at the end of a day's work and takes them into his house. Some weavers have a separate building that they use as a weaving house. Most weavers build the frame of the loom themselves but purchase the front beam, reed, and harnesses at one of the local markets from men who specialize in making these items (fig. 12.8).

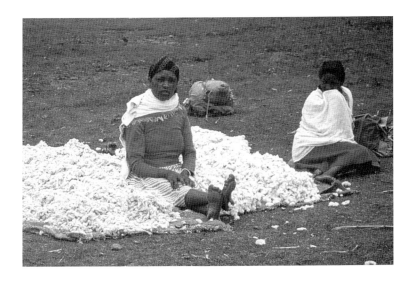

Fig. 12.6 Raw cotton for sale at Doko Mesho market.

Fig. 12.7 Ilto's daughter spinning cotton using the *inzert*, a drop spindle.

Fig. 12.8 Loom parts for sale at the Doko Mesho market.

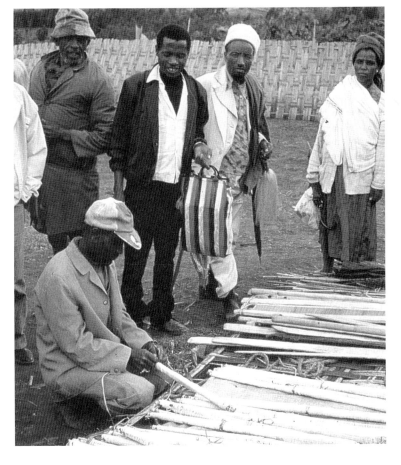

The first part of the weaving process, referred to as warping (*denso*), generally takes two to three hours to complete and is done outside in a large grassy area. To begin the warping for a *net'ala*, a fine gauzelike cotton cloth, a weaver needs approximately 1.5 skeins (*tubba*) of *asmara* (thin cotton thread). This factory-made thread is obtained in the local markets. A *tubba* is divided into ten separate loops of thread. Thus a weaver begins with fifteen long threads. These are carefully placed on a hand-held warping reel (*wagoombo mazewur*). The free ends of these fifteen threads are tied together onto the first warping post. This is one of the eight wooden posts set in the ground in two parallel rows. The weaver then unrolls the threads around each warping post in a zigzag pattern. When the weaver comes to the last two posts, the thread is crossed and an X is formed. This is to prevent the threads from tangling and aids in the dressing of the loom. The weaver retraces his steps, repeating the zigzag pattern around all the posts at least twenty times.

The two rows of posts are set approximately six to seven meters apart. This will be the length of the finished *net'ala* cloth. A weaver may use between 300 and 500 threads to make one *net'ala*. If the *net'ala* is to be sold at the market, it is not uncommon for a weaver to use fewer threads than if his work is being commissioned. Frequently the weaver may have someone assist him throughout the warping process because the *asmara* thread is so fine it frequently breaks. The assistant helps by twisting on additional pieces of thread to the broken section. Once the warping is completed, the threads are carefully removed from the posts.

Now the weaver is ready to put the warping threads on the loom (*harpa*)—a process called dressing the loom. The weaver takes one end of the warp threads and ties this to a post (*yechay meetsa*) located at the front of the loom near the weaver's seat. The warp threads are then brought around a second post (*seeno meetsa*), which is 2.5 meters beyond the back end of the loom. Next the weaver takes the warp threads and pulls them through the harnesses (*meeyana*). When this is finished, half of the warp threads will be on each of the two harnesses. Then each warp thread is pulled through a small space in the reed (*achay*). Finally the warp threads are tied onto the beam (*wonderashay*) at the front of the loom.

After Ilto dresses the loom, he puts the weft threads on a set of bobbins (small hollow pieces of bamboo). He winds the weft threads on the bobbin using a bobbin winder (*diwura mekina*) (as in fig. 12.5). This is a small wooden apparatus which enables the weft threads to be quickly wound. It has a rectangular base with a small wooden wheel that rests on top. A string or piece of leather goes around the wheel and attaches to the front of the machine, where the bobbin is held. Ilto places an empty bobbin on the winder and attaches a small piece of weft thread. He then begins to turn the handle, which causes the wheel and bobbin to rotate simultaneously, rapidly winding the weft thread onto the bobbin.

Once enough bobbins have been wound with thread, one is placed in the shuttle. The bobbin is held in the shuttle by a thin stick (*intarsa*). The shuttle (*mokay*) is similar in shape to a small dugout canoe. It is usually made of eucalyptus wood. The shuttle is the tool that carries the weft threads across the warp.

To begin weaving, Ilto presses down with his right foot on the treadle to open up the shed (the space between the threads). Next he takes the shuttle and, with a flip of the wrist, throws the shuttle through the shed with one hand. The shuttle glides across the warp threads. Ilto catches it with his other hand. He beats the cloth with the beater by pulling it toward him and then pushing it back. Then he presses his left foot down to once again open the shed and throw the shuttle across the warp threads (this time left to right). These steps are continuously repeated. Ilto frequently sings traditional Doko songs as he maintains a steady methodical rhythm on the loom. Here is one example:

> Oh, never problems, never problems inside the
> bottomlands.
> I solve the problems because I live in the land of Losha.
> I am like good *farso*. I have free lands in Endo.
>
> I am the great grandson of Data Benela and people
> call me Ilto, Ilto.
> I am a black king, black king. I look like cotton.
>
> One day I can stop one big horse. People say I am powerful.
> I am called Ilto, Ilto; people call my name Ilto, Ilto.

Oh, I am a strong leopard, a strong leopard. I can
 overcome any hardship.
I am clear and honest. A strong fighter for truth.

I was born in war and I am a participant in the Gamo
 war places.
I want people to know about the war and the battle place.

I am the great-grandson of Weyzero Konayfay and my name is
 Ilto.
People call me Ilto, Ilto. I look like a running horse.
My name is Ilto, Ilto.

Ilto first learned to weave the *net'ala* from his father. This cloth is worn
by most women in the Gamo region. It is usually about 160×260 cen-
timeters in size. The cloth is white with a colorful 3- to 6-centimeter
border at each end. There are two types of borders: one is a plain-weave
design called *loomoot* using only one color; and the other, the *t'ibeb*, is an
inlay design using one or more colors and various patterns (pl. 21).

Ilto knows how to weave other cloths as well but prefers to weave
net'ala because these are quickly made and easily sold in the markets (fig.
12.9). The *net'ala* is woven in one panel (*zengee*) at a time. When Ilto begins
to make a *net'ala*, he will first weave one panel, starting with the border.
He then completes the main body of the cloth. To make the appropri-
ate length of one panel Ilto places a small piece of mud (*oorqa*) on the
warp threads. He will then leave a gap and begin to weave the second
panel. This is the common Doko method of making cloth sections. Ilto
can complete a *net'ala* in one day, and so, he is frequently seen at the
local markets, loaded down with an assortment of these delicate white
cloths.

Joining Ilto at the market are other Doko weavers, who sell a bright,
multicolored, plaid cloth referred to as a *fota* (pl. 22). Through some
local contacts we were able to meet a small active group of *fota* weavers
residing in a scenic meadow area of Doko Losha. One was the eighty-
year-old weaver Arba Desta. Arba's compound is somewhat larger than
Ilto's. It contains four woven bamboo houses and a large grassy lawn

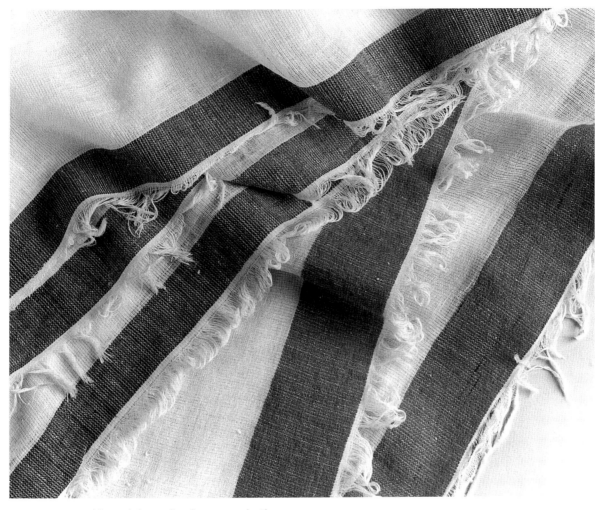

Fig. 12.9 Two *net'alas* with *loomoot* borders woven by Ilto.

on which Arba's six sheep graze. In one corner of his compound, built next to one another, are two pit-style looms. When we visited, the looms were dressed with very bright red and blue thread.

During our conversations with Arba we found out that he has been weaving nearly half of his lifetime. He and his first wife, Kaotay Kasa, have eight children, six sons and two daughters. Arba also has a second wife, Woletay Ika, who resides in Addis Ababa along with their five sons. In the Doko culture it is not uncommon for a man to have up to four

Ilto and Arba—Two Doko Weavers

wives. But, as many farmers told us, it is difficult to support more than one wife. Arba's family is very active in weaving. Five of his sons are also weavers. Four reside in Addis Ababa, and one son, Malako, still lives in Doko Losha and weaves on the loom alongside his father (fig. 12.2). Due to his family ties in Addis, Arba speaks both Amharic and the local Doko Gamo dialect. This is in contrast to Ilto, who speaks only Doko Gamo.

Originally, one of Arba's neighbors taught him how to weave. Like Ilto, he first began weaving the *net'ala*. Now, however, he prefers weaving the *fota* (pl. 22). The thread used for the *fota* is stronger and does not break as easily as the thread commonly used for the *net'ala*. The *fota* is a rather new type of cloth. It is said to have originated in the central Gamo highlands only about twenty years ago, but it is now the most popular textile in Doko. The *fota* has similar dimensions to the *net'ala*. It is approximately 146×266 centimeters, but the entire body of the cloth is woven with brightly colored thread. There are numerous plaid designs. The most common pattern is one with blue and red thread alternating in the warp and weft. By alternating the two threads, the pattern develops into a checkerboard of 13×13 centimeter squares throughout the cloth. The *fota* differs from the *net'ala* in that it is much more colorful, it does not have a border, and it is a medium-weight textile, whereas the *net'ala* is a lightweight, gauzelike cloth.

The *fota* and *net'ala* not only differ in design but also in the ways they are worn. In Doko society, there are four basic ways to wear a *net'ala*. For general wear, the *net'ala* covers the back and shoulders but the border is worn folded up over the right shoulder. For church activities, the two layers of the *net'ala* are opened up all the way, and the border edge is placed over both shoulders. When the border is worn up around the face or shoulders, it is a sign of mourning or bereavement. For recreation or resting, the border edge of the *net'ala* is worn over the left shoulder.

There are not as many variations in the way that a *fota* may be worn. Generally it is simply wrapped around the shoulders or over the head as a shawl. Some women wear it toga-style like a dress. It is also often seen being used as a baby carrier. A woman places her baby on her back and ties the *fota* securely around her waist to support the child. Unlike the *net'ala*, the *fota* is also used as a sleeping blanket.

Arba's youngest son, Malako, who is fifteen years old, has recently been learning to weave the *fota*. He has been weaving since he was ten years old. In addition to the *fota*, he also knows how to weave the *net'ala* and *dancho*. Like most young boys in Doko society, Malako first began weaving by learning to make a cloth called a *dancho* (pl. 22). This is a very long cotton sash with some edgework added for color. This sash is usually worn only by married women. There are two types of *dancho*. One type is narrow and long (10.5 × 615 cm) and is usually worn by the *mala* (commoners). The cloth is tightly beaten and a hand-spun thread is used for the weft. The other type of *dancho* is a lightweight cotton sash that is loosely beaten and is much wider and longer than the first type. It is generally about 33 × 800 centimeters. The wider *dancho* is usually worn by the wives of *halakas*. Men sometimes also wear this kind of *dancho* to hold the large Gamo dagger. The *dancho* is worn by simply wrapping it around the abdominal area and tucking in the loose ends.

Malako usually finds time to weave between going to school and helping his father with the farmwork. He would very much like to join his older brothers in Addis Ababa and become a full-time weaver. For the time being, Malako is helping his family by selling his finished woven products at the local markets.

Doko weavers attend the local open-air markets both to procure necessary supplies and to sell their finished products. Different markets are held on various days of the week. There are three market sites in Doko: Mesho, Indota, and Chencha. The Mesho market operates on Sundays (fig. 12.10). A small market is held every Friday at Indota. And on Tuesdays and Saturdays, a big market is held in the town of Chencha. Sometimes Doko weavers also go to the neighboring *derays* of Dorze, Ezo, Zozo, and Deeta to transact business. There is no set time for a market to begin. People start arriving at the marketplace early in the morning but the busiest time is generally between 10:00 a.m. and 3:00 p.m.

Market days are the most colorful days of the week. One sees a wide variety of people wearing many different types of colorful clothing. Some people wear Western-style clothes but many also don a traditional cloth as well. Most Doko residents wear the brightly colored *fota*. It is used by women, for example, to cover bundles of goods carried on their backs. Both men and women use it as an outer garment on cool, cloudy days.

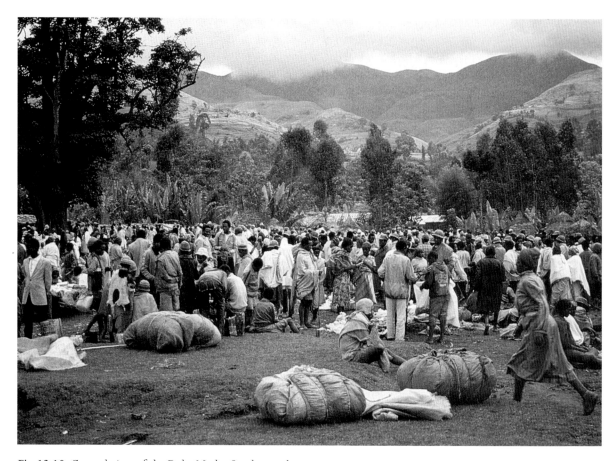

Fig. 12.10 General view of the Doko Mesho Sunday market.

Most goods are transported to market by the females of a household. According to Doko tradition, females should carry items on their backs. Men and boys, on the other hand, must carry things only on their heads or shoulders, never on their backs. Horses and mules provide another, less-common means of transporting goods to and from the local markets.

Each market site is customarily divided into specific sections where various items are bought and sold. There are designated areas for the sale of various foods, for livestock, for imported goods, and for textiles and weaving supplies. Weavers and/or their wives will often have specific spots where they regularly display their products for sale.

Since most weavers also produce much of the food needed to sustain their families, on market days they often purchase only a few special items such as salt or farm implements, in addition to needed weaving supplies. Local weavers, such as Ilto and Arba, usually market their products themselves, though occasionally a wife or child may handle the sale of finished textiles. There are no set prices for various items; lively bargaining is the rule.

Ilto can sell his *loomoot*-bordered *net'alas* for about 20 birr (U.S.$4.00) each. This is the average market price. Arba's blue and red *fota* (which he claims are better made than most) can fetch between 40 and 60 birr. When one purchases a *net'ala*, the panels are usually not sewn together, so the buyer must go to a tailor and have the panels assembled. Most often, however, the *fota* is fully assembled before being sold. Weavers themselves admit that the quality of the handwoven cloth sold at most markets varies considerably. This is because some weavers are more production oriented than others. A well-made piece of cloth will consist of more warp threads, and in producing the cloth, the weaver will pull the reed or beater more forcefully to produce a tighter weave. Arba not only weaves to sell at the market but also produces commissioned work for friends and neighbors.

The marketplace is not just a place for buying and selling; it also provides a context for socializing. Much of the socializing takes place at the *t'ej* (honey-wine), *t'alla* (beer), or *shay* (tea) *bets* (houses) that surround every market site. The local *t'ej* is a popular drink among both Doko and Amhara people. It is served in a glass beaker that looks something like a chemist's flask. *T'alla* is locally produced beer made from barley and/or wheat. It is usually drunk from decorated gourds. Tea, on the other hand, is served in a small glass with two to three teaspoons of sugar. The unique thing about the tea is that each teahouse uses its own blend of different spices (including clove, fennel, and oregano).

Market day is also a time when rural residents such as Ilto and Arba can eat some of the Amhara foods served in marketplace restaurants, primarily *injera* with *wet'*. *Injera* is a thin, flat, spongy bread that is served cold and is usually made from *t'ef* (a grain grown at elevations lower than Doko). *Wet'* is a spicy meat or vegetable stew. A popular side dish is raw beef. After such a meal, men often smoke tobacco using the *gaya*,

the local Gamo waterpipe. This is usually accompanied by lively singing and conversation that echo up and down Doko's deep valleys and mountain slopes.

Weavers constitute a distinct occupational group within Doko society. In contrast to the lower-caste status of other artisans, weavers, by virtue of their special talents and lucrative business dealings, enjoy a relatively high status position in this still very traditional culture. The production of textiles often involves the participation of many members of the weaver's family. Sons often apprentice under their father's watchful eye, while wives and daughters assist in procuring weaving supplies and in spinning the thread that will eventually become useful and attractive cloth. In Doko society, weaving remains a family tradition; it is handed down from father to son, from generation to generation.

The unique Doko pit loom is often built by the weaver himself, and all its component parts are made from locally grown bamboo and the wood of various indigenous tree species. Common highland Ethiopian textiles such as the *net'ala* are produced in abundance by Doko weavers. Additionally, colorful handwoven items such as the *fota* and *dancho* are found here also. The products of the Doko weaving tradition are in distinct contrast to those found in other parts of Ethiopia and sub-Saharan Africa in general. Uniquely adapted to the cold and wet climate of the Gamo highlands, they are both functional and pleasing to the eye. The proud mountain farmers striding energetically up and down Doko's rugged mountain tracks garbed in colorful, flowing traditional garments owe much to the industriousness and creativity of weavers such as Arba and Ilto.

NOTES

Chapter 1. Introduction

1. The various types of crosses (processional, hand, and neck) associated with the Ethiopian Orthodox Church also have received some attention, but to a lesser extent.

2. Sidney Kasfir (1992: 44) has recently considered this "condition" of anonymity. In her commentary she refers to the earlier work of other scholars who have examined this issue.

3. The collectors also often failed to document who owned the objects, how the objects were used, how they were made, etc. In short, there is very little information about these objects. In many instances, the only information that remains with the "anonymous" object is the name of the person who collected it!

4. Only since the 1950s have museums, commercial galleries, national cultural centers, and hotels in Ethiopia been exhibiting "art."

5. A good deal of scholarly writing has dealt with the challenge of interpreting art and aesthetics in other cultures. An excellent set of essays that consider various dimensions of this complex subject is found in *Anthropology, Art, and Aesthetics,* a volume edited by Jeremy Coote and Anthony Shelton (1992).

6. Neal Sobania and I recently considered this situation in a published conference paper: "Ethiopian Traditions of Creativity: 'Art' or 'Handicraft'?" (Silverman and Sobania n.d.-a).

7. An excellent consideration of various aspects of this subject may be found in Vogel 1988.

8. There are exceptions, a number of which are referred to in the essays presented in this volume.

9. The research undertaken for the exhibition involved collecting examples of the objects made by the artists with whom we worked. Most of the field-collected materials were commissioned by the researchers from the artists. However, a few noncommissioned pieces were also collected. The researchers were well aware of the cultural and personal importance of these older objects (such as Banja's stool, two baskets that Amina had made for herself prior to her marriage, and Jembere's portrait of Haile Selassie I) and spoke to each of their makers/owners about this and the reasons why we were interested in collecting such objects. In every case, the object makers and/or owners willingly agreed to sell these objects because they understood the cultural and historical importance of preserving these objects and using them to teach people about the traditions with which they are associated.

10. The issue of authenticity has been one of the foci of debate among scholars and collectors of African art for some time. Kasfir (1992) offers a thought-provoking critique of some of the key topics relating to the subject.

11. The magic scroll is a magico-religious device worn to ward off ill fortune and combat disease. It is made by covering one side of a narrow strip of parchment with written incantations and graphic imagery. The strip is then rolled up and inserted into a tube that is

attached to a cord so it can be worn by the supplicant. The tradition is an important manifestation of popular religion as practiced in the highlands of central and northern Ethiopia. Zerihun's "bamboo-strip" paintings utilize strips of parchment that are glued to a "bamboo" armature (actually the part of a weaver's loom known as the reed); this in turn serves as the painting surface. Many of the images that he incorporates in his compositions are derived from the graphic designs used in the magic scrolls.

Chapter 3. Harari Basketry through the Eyes of Amina Ismael Sherif

1. My own research has revealed that Hecht may be overstating this quality of exclusivity; this issue is discussed at greater length below.

2. The symbolic value of this cone-shaped basket has been forgotten and its utilitarian purpose is unknown. We can suggest a couple of possibilities. It may represent a pre-Islamic phallic symbol, like the wooden *kelecha* (a symbol of authority) of the Oromo. Or perhaps, in an Islamic context, it could represent the minaret of a mosque.

3. Dire Dawa, a large city with close historical ties to Harer, is located 55 kilometers northwest of Harer.

4. Daughters, until marriage (i.e., until they acquire their own land), work on their mother's land.

5. In 1993 a birr was equivalent to U.S.$.20.

6. Most girls used to attend Qur'anic schools until they reached the age of puberty. Today this traditional mode of education has been replaced by state-sponsored schools that include Islamic education through the eighth grade.

7. Hecht 1992 provides color illustrations of some of these patterns.

8. E.g., *mashala* (praise to God), *nafatahana* (we have opened up to you).

9. See the detailed diagram of a Harari *gidiir gaar* that is reproduced in Hecht 1992: 21, fig. 3. I originally drew this diagram for Hecht. It accurately identifies the key features of the living room, with the exception of the various sitting areas. Information about these areas is given in the present essay.

Chapter 4. Every Woman an Artist

1. The Borana divide time into periods of eight years, each named after the *abbaa gadaa* (father of the *gadaa*) who led the community during that eight-year period. *Gadaa* is the term for a generation age grade as well as for a calendrical period of eight years.

2. In Borana culture and society a great value is attributed to sons, especially the firstborn.

3. She finally agreed to sell the *ciicoo* she had made for her daughter to our research team but only after we agreed that delivery would occur in secret. Elema told us she would make her daughter another one.

4. Male sterility is not considered a problem, because Borana married women are institutionally allowed to have lovers.

5. All scientific names presented in this essay are derived from Wilding 1985.

6. Elema Boru showed us one *gorfa* that could stand by itself. It was very old and the bottom had been repaired with a flat base.

7. The most common varieties of wood used for fumigation are *dhaddacha* (*Acacia tortilis*), *baddana okolee, ejersa* (*Olea africana*), and *madheera* (*Cordia gharaf*).

Chapter 5. Zerihun Yetmgeta and Ethiopian World Art

1. The chapter on Zerihun Yetmgeta in Biasio 1989: 87−122 contains twenty photographic reproductions of his work. Zerihun is mentioned in the following publications as well: Kifle Beseat 1970: 29−30; Caputo 1983: 624; Benzing 1988a: 13; Ministry of Culture and Sports Affairs et al. 1990: 34−35; Ministry of Culture and Sports Affairs et al. 1991: 16, 30; Kennedy 1992: 131−32; Taye Tadesse 1991: 226−27.

2. His first show is discussed in Murray 1970.

3. I am very grateful to Ms. Sokoloff for allowing me

to study and photograph Zerihun's work at her home.

4. For a discussion of this attitude see Bender 1989: 185–86.

5. Inv. no. 21003, Völkerkundemuseum der Universität Zürich.

6. See Mercier 1979 and Musée National des Arts d'Afrique et d'Océanie 1992 for a description of this tradition.

7. The human remains were named Lucy after the Beatles song "Lucy in the Sky with Diamonds." In Amharic they are referred to as *dinqnesh*, meaning "you are wonderful."

8. For example, images of cattle are found in rock art produced roughly four thousand years ago at sites near Dire Dawa (eastern Ethiopia).

9. The similarity of Zerihun's works with "wax and gold" has been pointed out by Chojnacki (1973c: 89).

10. See, e.g., the reproduction in Kennedy 1992: 132.

11. See Vogel 1991: 17–20 for various examples of this attitude.

12. Kennedy (1992: 128–38) offers insight into Skunder's works and those of his disciples in the United States.

13. The latter painting is published in Ministry of Culture and Sports Affairs et al. 1991: 30.

14. See the artist biographies in Taye Tadesse 1991.

Chapter 6. Menjiye Tabeta–Artist and Actor

1. Shack notes in passing that the Gurage "specifically distinguish artisans according to their craft activity; woodworkers are known as *Fuga*, blacksmiths as *Näfwrä* and tanners as *Gezhä*" (1964: 50).

2. They hunt with dogs after the end of the rainy season when the rivers have subsided. Leslau (1950: 62) recorded an account in which Fuga are described going with their dogs in groups of ten or twenty with spears and bows to hunt gazelle and rhinoceros. Shack (1964: 50) noted that for the "Eastern" Gurage "hunting hippopotami and gazelle is still economically important."

3. Shack suggests that "according to tenable theories" the Fuga are "remnants of earlier inhabitants of the Horn" generally known as Watta (1966: 8). He suggests that the Fuga "were first subdued several centuries ago by the Sidamo peoples who once occupied present-day Gurageland; the coming of the Gurage merely replaced the Sidamo as conquerors" (Shack 1964: 50).

4. In a note Shack explains that the term "language" is incorrect, adding "most probably *Fedwet* is an argot composed partly of Gurage words inverted in meaning and perhaps partly of survivals of a Fuga dialect. The latter is admittedly purely conjecture since *a study of Fuga 'language,' if it exists at all*, is yet to be carried out, and this is so for *Fedwet* as well" (1966: 133 n. 43; our emphasis).

5. This argot has been analyzed by Leslau, who suggests that it is "composed of partly Guragigna words inverted in meaning and perhaps partly of several of Fuga dialect" (1964: 42). It is spoken only by women and by Fuga ritual experts and is kept carefully guarded from Gurage men and strangers (Shack 1966: 9, 133).

6. These included words for "male gazelle," "female gazelle," "antelope," "wild pig," "leopard," and "lion." The Fuga also have a term for "let's go hunting" (*attamuwe*) and collective terms for a big wild animal (*antar*) and hunting implements (*chadiras*), which include bows and spears. There were also terms for "blood," "honey," and specific hunting implements.

7. There were a few basic verbs, such as "he comes," "goes," "eats," "drinks," and some commands, such as "give me food" and "give me drink."

8. Menjiye was emphatic that the Fuga "language" was different from the *fedwet* ritual "language." Seven terms we collected coincided in meaning with words in Leslau's *fedwet* list but were different words.

9. Leslau notes that among the Gurage it is believed that the Fuga are "pagans" and that they "have no special festivals of their own" (1950: 62). Gebru suggests that Fuga "celebrate the Gurage deities, but alone" (1973: 47).

10. In the past Fuga used to walk, but now they use public transport.

11. Menjiye explained: "We do not accuse one another of wrongdoing in the court, in police stations, or in the Yejoka [Gurage council of elders]. We bring our problems with one another only to Waliso." Since this essay was written, Ambaye Degefa has shown that on the day of a festival arbitration takes place (1997: 39–40).

12. Today ordinary Zhera (noncaste) Gurage also perform circumcision, though it is unclear whether this was the case in the past.

13. The chief *mweyet* and the initiated girls "throw" each girl on the roof (Leslau 1964: 53).

14. As Shack notes: "A woman may call upon the chief *mweyet* for special sacrifices when spiritual uplift is needed" (1966: 134).

15. The male leader of the Demwamwit cult in Chaha is called *yewey demam* and is addressed as Abetena. According to Leslau's (1964: 52) informant, he is either a Fuga or a member of a special group that arrived in the region recently, and therefore he does not belong to an established descent group. However, we found no evidence to support the assertion that the leader was ever a Fuga. He is a hereditary leader chosen from the Yamaqesab clan by the fertility goddess Demwamwit. Under him are several assistants, called *samamwa* or *yegama mweyet* (i.e., "male *mweyet*"). Some of the latter are Fuga. The *yewey demam* sets up several cult leaders in every region. However, recent evidence has shown that in an area that the Fuga migrated to near Waliso in Oromoland, the leader of the Demwamwit cult is a Fuga (Ambaye 1997: 38–39).

16. The exact relationship between these Fuga and the cult leaders remains a mystery. Shack (1964: 51) speaks of a Fuga "Chief" of the *mweyet* and a Fuga "Chieftainess" who rank above their respective male and female Fuga assistants. These chiefs receive only part of the fees collected for ritual duties performed by their assistants, "the largest part of the fees passing to the Gurage religious dignitaries who represent the deities and guard the shrines" (Shack 1964: 52). We found no evidence of any Fuga "chief" or "chieftainess" in Chaha. The Fuga involved in the cult are the male *mweyet*, who play an important but subsidiary role.

17. Shack notes that he was told that craft specialists cannot perform rituals, for these are organized and controlled by the Gurage dignitaries representing the deities. However, he adds that "a Fuga can fall in disfavor and be debarred from performing rituals, though it is unknown whether he is permitted to take up craft work" (1964: 52).

18. Shack notes: "In some cases a husband and wife team up as ritual experts, but this does not seem to be the rule for every married Fuga couple. Fuga women often do craft work" (1964: 52).

19. In fact, some of these women did not obtain hides from tanners.

20. In fact, there are exogamous clans among the Fuga.

21. The text on Gurage culture that Leslau recorded states: "the Fugas have no land for themselves, they live by doing the work of other people" (1950: 61).

22. Leslau's text notes: "A Fuga does not raise cows nor does he cultivate the land on which he lives. Some of them, however, ask for a loan of a cow, cultivate the land on which they live and plant the äsät plant" (1950: 61). However, Gebru's survey (1973) suggests that some Fuga did own livestock, although none owned land.

23. This was called *yefuga wedir* and consisted of the lower part of the back and the feet of the animal (Leslau 1950: 61–62), which they were supposed to eat alone and apart from the homesteads (Shack 1966: 10).

24. "The Gurage hold strongly to the belief that Fuga can destroy the fertility of the soil, injure the breeding capabilities of the cattle, and change their milk into blood or urine. For these reasons Fuga are never permitted to assist in ensete cultivation or to tend to cattle" (Shack 1966: 10).

25. Lewis (1965: 53) notes that the Fuga in Jimma were "handy men."

26. The text recorded by Leslau notes: "If a man has much land he brings in a Fuga into the back of his house, and the Fuga builds a house and lives there. Inasmuch as the Fuga lives on the land without paying for it, the proprietor of the land, when he needs something, can tell him: 'Take care of this for me.' The Fuga will then leave all the work he has to do, however important it is, and goes to do the work of his master" (1950: 61).

27. He recalled: "In the past the Fuga used to be rebellious. When a Fuga became hungry, he set fire to his master's house in the night so that he could eat the burnt animals."

28. This is reminiscent of Hallpike's (1968: 268) description of the caricature of Konso craftspeople as mean and stingy, a characteristic which he attributes in part to their needing to drive a hard bargain and to the wish of the dominant group to assert their own moral rectitude in opposition to the behavior of the artisans.

29. Shack notes that the central pole "is the focus from which the social, ritual, and economic role of the homestead radiates" (1966: 10), and the occasion of its erection requires the slaughtering of an ox (1966: 42).

30. Shack noted: "At the annual festival to *Waq*, Fuga present as tribute a number of wooden constructions called *wuqab*, which resemble the Christian cross minus the vertical extension above the crossbar. On the *wuqab* the crossbar is attached to the long staff by diagonal members at each end. At the close of the festival, the *wuqab* are stationed at various places throughout Gurageland, symbolically designating the site as a sacred area, similar to a wayside shrine, where petitions can be offered to *Waq*" (1974: 112).

Chapter 7. Qes Adamu Tesfaw–A Priest Who Paints

1. I had met Ato Wendemu during my first visit to Ethiopia. He is a *debtera* (a cleric who functions as a scribe, cantor, healer, etc.) in the Orthodox Church, a competent painter, and a gregarious businessman, who has been selling his work to visitors to Addis Ababa for a least forty years. A photograph, preserved in the Frobenius Institut (Frankfurt), of Wendemu taken by the anthropologist Eike Haberland between 1950 and 1952 indicates that the artist has been interacting with foreigners for well over forty years. Unlike Adamu, who primarily paints religious themes, Wendemu interprets genre and historical subjects. Adamu is considerably younger than Wendemu, but both were born and grew up in Bich'ena, Gojjam Province, and moved to Addis Ababa as young men.

2. The Ge'ez alphabet is a syllabary containing 231 characters. See Haile Gabriel Dagne 1970: 84–88 for a description of the curriculum of the *nibab bet*.

3. Haile Gabriel explains that a "*Qidasse* teacher normally teaches only hymns which a deacon or a priest has to use in the liturgy of the Church. The rest, including teaching the traditions and service of the Church, is learned through daily experience in the parish itself. Usually a candidate for this training is attached to a priest or monk to whom he gives certain services, accompanying him on visits to families, festivals, and ceremonies in and outside the parish. Through observation or day-to-day practice and instruction by his priest-master, the boy learns the Church activities and functions of a deacon and of a priest. . . . activities of the priest, therefore, are limited to the rituals, which do not usually demand the understanding of the Scriptures. Thus relatively little education is expected from a young man to be ordained an altar priest" (1970: 88).

4. It is perhaps significant that many of the capital's twentieth-century "traditional" artists are from Bich'ena, including the well-known painters Yohannes Tessema (Pankhurst 1966: 45); Yitabarek Haile Maryam; the latter's younger brother, Alemu Haile Maryam (Girma Kidane 1989: 73, 75); and Belatchew Yimer.

5. The Empress Menen Handicrafts School was

established to train artists and craftsmen and was supported by the Ethiopian government.

6. A number of his paintings have been published in various magazines and books; for instance, a set of agricultural scenes was published in the *Ethiopia Observer* in 1964. It is interesting that these and other published works by Yohannes show little stylistic affinity with Adamu's recent paintings.

7. For an introduction to the Ethiopian Orthodox Church see Wondmagegnehu Aymro and Joachim Motovu 1970; Ephraim 1968.

8. Even today, religious paintings serve this important function. At a church school in the town of Gonder, for instance, Heyer (1971: 56) observed a priest-teacher, Mamher Kefle Maryam, using a mural depicting various religious subjects to teach his students.

9. Lepage asserts that based on existing evidence it appears that early painting in Ethiopia was "exclusivement religieuse et chrétienne" (1977: 60). He adds that there is no evidence for "profane" paintings, for instance in the interior of palaces, during the early periods.

10. Examining these schemas is outside the purview of this essay. Seyoum Wolde (1989) has critiqued some of them, as has Chojnacki (1983a: 22–28). There are problems with all of them. As Chojnacki (1983a:27) points out, scholars have been preoccupied with assigning newly discovered paintings to specific periods; he questions whether there is enough data to do this. Leroy (1967, 1970) presents the standard schema that most scholars continue to use. He delineates two major periods: a medieval period and the Gonderine period (beginning ca. 1635). The Gonderine period is often divided into two eras: the First Gonderine and the Second Gonderine (starting at the end of the seventeenth century). Heldman (1993) has presented periodization that delineates three periods: Zagwe (1137–1270), Early Solomonic (1270–1527), and Late Solomonic (1540–1769).

11. The term "Habesha" describes the Christian peoples, specifically the Amhara and Tigray, living in the central and northern highlands of Ethiopia. The term "Abyssinia" is derived from "Habesha."

One could cite many sources that reveal the tendency to ascribe all change in Ethiopian church painting to outside influences. A good example is Claude Lepage's (1977) essay "Equisse d'une histoire de l'ancienne peinture éthiopienne du Xe au XVe siècle," in which he delineates five phases for the church painting of the tenth through fifteenth centuries. All of the significant events that drove the evolution of painting during this 500-year period he sees as coming from outside Ethiopia.

12. The town of Aksum, located in northern Ethiopia, is still a very important religious center. It is traditionally held that in the year 333 King Ezana converted to Christianity.

13. Heldman, for instance, writes that it was during the sixth century that a "specifically Christian style and iconography was introduced to Ethiopia" (1993: 118).

14. Lalibela was a Zagwe king whose tomb, located at Roha, became an important pilgrimage site. The most accessible study of the churches in this area and their painting is Gerster 1970.

15. For reproductions of some of the paintings found in Beta Mariam see Gerster 1970: 95–98, pls. 66–75. Heldman (1993: 134) suggests that some of the Beta Mariam paintings, such as the frieze of animals, follow the Late Antique iconography introduced to Ethiopia during the Aksumite period (i.e., second to seventh centuries). But this in itself is not evidence that the paintings were produced during the Zagwe period, for, as Heldman (1993: 119) herself points out, many of the iconographic and stylistic features associated with Late Antiquity continued to be used until the sixteenth century.

16. See Heldman 1993: 129–30 for a discussion of this manuscript.

17. Later, however, the convention was established of depicting wicked or evil people in profile.

18. Heldman (1993: 119) observes that the evidence offered in fourteenth- and fifteenth-century Ethiopian Gospel manuscripts suggests that, until the sixteenth century, the formal and iconographic characteristics of Ethiopian manuscript illumination conformed closely to the Byzantine book traditions of Late Antiquity.

19. See Heldman 1993: 144–45, 176–77, for examples of the illuminations and for information about the manuscript, which is maintained today in the National Library, Addis Ababa.

20. Heldman points out that "much remains to be learned of artisans, patrons, and centers of artistic training and production. The distinctive styles of manuscript illumination await localization, and information concerning workshop practices and the training of artists is virtually nonexistent" (1993: 141).

21. Heldman relates that "monasteries served as centers of training in chant, singing, and painting, and it seems that most artisans were monks, although it was possible to enter a monastery without taking monastic vows in order to obtain training as a scribe or painter" (1993: 142).

22. Heldman (1989; 1993: 142) mentions two monasteries in particular; Ewostatewos and Estifanos.

23. Other painters for whom we have scant information are Iyasu Mo'a and Abuna Maba'a S'eyon. Also, Mérab (1929: 3.303) mentions the names of three early painters: Meraf, who lived in the time of Amda S'eyon I (r. 1314–44); Sige Dengel, during the reign of Yeshaq I (r. 1414–29); and Aleqa Hailu, who was active in the time of Iyasu I (r. 1682–1706). Mérab describes Aleqa Hailu as the "Raphael of Ethiopia." It is not clear where he obtained these names. Mérab also offers the names of a few painters who lived during the second half of the nineteenth century.

24. Examples of Fre S'eyon's or his workshop's icons (and paintings that were influenced by this work) are reproduced and discussed in Heldman 1993: 77–81, 94, 160–62, 182–83; 1994: 23–69.

25. See Heldman 1994: 149–51 and Chojnacki 1983a: 378–98 for a discussion of Brancaleon's residence in Ethiopia. European documents from the era contain references to a number of other European artists who visited Ethiopia. Two of the more celebrated figures are the Venetian Gregorio Bicini and the Portuguese Lazaro de Andrade. See Chojnacki 1983a: 398–407 for information on their presence and impact on Ethiopian painting.

26. For information on this painting and its influence in Ethiopia see Chojnacki 1983a: 217–89; Heldman 1994: 153. For a reproduction of this famous work see Heldman 1994: fig. 81.

27. For information on the *Evangelium arabicum* see Heldman 1993: 241; for a reproduction of a single page see Heldman 1993: cat. 98.

28. For information on the *Kwerata Re'esu* see Pankhurst 1979; Chojnacki 1983a: 405–7; Heldman 1993: 248. For a reproduction of the painting see Chojnacki 1983a: fig. 190.

29. The best-known example is the Four Gospels of Emperor Yohannis, which contains illuminations influenced by the aforementioned *Evangelium arabicum*. See Heldman 1993: cat. 97 for reproductions and a discussion of the manuscript.

30. See, for example, the page from Collection of Prayers to Our Lady Mary depicting the Assumption of Mary that is reproduced in Heldman 1993 (cat. 117). It was painted sometime after 1730 and displays distinct Deccani features. See Heldman 1993: 251 for a discussion of the multiple sources for this image. The Portuguese served as a conduit between India and Ethiopia. The Portuguese were actively engaged at the court of various Ethiopian emperors and they maintained diplomatic and commercial ties with India. In addition to painting, there is evidence in royal architecture suggesting that Goan architects or artisans may have come to Gonder to assist in building palaces and churches during the seventeenth century.

31. Objects that are covered (i.e., "overlapped") may be read as residing farther back in space than objects in

front. Using vertical positioning, more distant objects are placed higher in the picture plane.

32. See Heldman 1994: 80–90 for a general discussion of the relationship between art, artists, and patrons.

33. Adamu signs his work "Painter-Priest Adamu Tesfaw."

34. It has been suggested that church paintings are generally anonymous because of the deep religious significance attached to producing holy images in Ethiopia (Chojnacki 1983a: 21). Elisabeth Biasio (1989: 63), in a conversation with Kasala Marcos, a contemporary artist who works as a restorer of paintings at the Museum of the Institute of Ethiopian Studies, learned that in a religious context, the inclusion of one's signature in a painting would be considered an act of immodesty, for it is God's recognition that is most important.

35. Heldman (1993: 143) suggests that it may have been European craftsmen employed by the ruling elite in the fifteenth century who introduced the idea of signing works of art.

36. See Heldman 1993: 142 for a brief discussion of this topic.

37. This tradition is recorded in the *Actes de Iyasus Mo'a, abbé du couvent de St-Étienne de Hayq*, translated and edited by S. Kur (CSCO 259/260, script. aeth. 49/50; Louvain, 2965) and cited in Heldman 1994: 80–81. Other evidence of the elevated status afforded artists in the church may be seen in traditions associated with Abbot Maba'a S'eyon and Fre S'eyon. It seems that monks could learn to work certain metals. The greatest stigma is attached to working iron. The only reference to monks engaged in ironworking that I have been able to find is the nineteenth-century account of Charles Johnston (1844: 2.320–22), in which he describes seeing monks at Myolones in Shewa who worked as blacksmiths. It is possible that status distinctions may have been made based on the type of metal worked. With so little evidence it is difficult to judge. The variable status of different types of metal specialists is discussed to a limited extent in chapter 9.

38. This is unlikely since Iyasu Mo'a was already in his sixties at this time and probably would have assigned the task to talented scribes in the scriptorium of the monastery of Debre Hayq Estifanos, where he was abbot. Sergew Hable Selassie (1992: 244–45) discusses the monk's skills as a scribe and the issue of who produced the Four Gospels of Abbot Iyasu Mo'a. See also Heldman 1993: 176 for a discussion of this important manuscript.

39. Indeed, Heldman indicates that "documentation of Ethiopian workshop practices is nonexistent" (1994: 80). Molesworth (1957: 360–61) offers a general overview of the training of a church painter.

40. Before the advent of schools, like the School of Fine Arts or the Empress Menen Handicrafts School in Addis Ababa, learning to paint was part of one's church education.

41. See Girma Fisseha and Silverman 1994: 372 and chapter 8 in this volume for a description of how Jembere Hailu was supported by the provincial ruler of Begemdir.

42. There is a third painting depicting this theme that Adamu painted at roughly the same time. It is also hung in Mutti Qiddus Giyorgis, on a wall opposite the painting illustrated here. Though the composition is basically the same, there is a good deal of variation in detail.

43. When used for painting, the *net'ela* is saturated with a gesso-like sizing that creates a viable surface for applying pigments. For information on the weaving of *net'ela* see chapter 12.

44. Adamu and Belaynesh's introduction to their discussion of painting in the Ethiopian Church is a good example of this orientation: "The hall-mark of a sophisticated artistic expression of any country can be tested by its capacity to assimilate many elements from foreign sources and indigenise these foreign influences. Ethiopian representational art is no exception to this

rule. In fact Ethiopian art has syncretized both Oriental and Byzantine artistic traits" (1970: 79).

45. Over thirty years ago Chojnacki made the same observation: "the paintings of the Ethiopians were an extraordinary blend of imported models, transformed according to the psychology and artistic canons of the people. Of the paramount questions, which were the models and how were the models transformed, only the first has been dealt with fairly extensively . . . the second is awaiting sensible art historians who can be art critics at the same time" (1964: 1).

46. There are a few notable exceptions. Marilyn Heldman (1993: 92–94, 142–43, 182–85; 1994: 23–69), in writing about the fifteenth-century monk-painter Fre S'eyon suggests that he (and members of his monastic circle) was responsible for creating a new iconographic and stylistic program for devotional images used in the veneration of Saint Mary and, in doing so, gave material form to the new religious doctrines formulated by the then emperor, Zara Ya'eqob. Elisabeth Biasio (1994) has begun to consider the changes that occurred in the paintings of the eighteenth and nineteenth centuries as a reflection of the political and social climate of highland Ethiopia at that time.

47. The issue of creativity is an important one that, in the present context, we may only briefly touch upon. Donald Levine (1965: 238–86) offers a fascinating discussion of "individualism" in Amhara society. Chojnacki suggests that artists "in general did not make direct transpositions from a text into the image they were painting, but frequently followed a stereotyped version common in Christian art, though with the occasional addition of their own interpretation of details of the subject depicted" (1973b: 81). This view is echoed by Biasio (1989: 63), who asserts that the traditional painter did not consider himself an artist—at least not in the modern sense of the word—who had to create a unique work; he was more concerned with

reproducing a specific subject "correctly," that is, in accordance with the iconographic and stylistic rules of the period in which he lived and worked. In such an environment there was not much room for creativity.

48. Molesworth offers a nice comment on the issue of originality in Ethiopian painting: "there seems to be a real nervousness of, even distaste for, 'original' work. Where the image of the illustration is firmly fixed in his mind, the artist goes ahead happily though he may introduce slight variation of size and very minor details in different paintings of the same subject. Far from finding the iconographic traditions irksome, the artist seems to find that their solid foundation brings a security, and enables him to concentrate on the aesthetic qualities of the picture in hand according to his feelings at the moment" (1957: 364).

49. Walter Raunig, writing about twentieth-century "folk art painting" in Ethiopia, is of the same opinion: "Ethiopian folk art painting is a young variant of the older Ethiopian tradition of painting—emerging from it and remaining in close connection with it. Folk art, on the basis of its origin, choice of theme, and intention, must be considered to form a special branch within the long and distinguished tradition of Ethiopian painting" (1989: 71).

50. Biasio (1994) offers a brief, but important, foray into this document-rich arena.

51. This is especially true in the rural areas, where the majority of Ethiopia's people live.

52. Girma Kidane (1989) has offered brief biographies of four church-trained artists: Wendemu Wende, Qengeta Jembere Hailu, Alemu Haile Maryam, and Berhanu Yimenu. More extensive documentation of their lives is required. Of course, the lives of many other painters living in Addis Ababa as well as in other parts of Ethiopia need to be documented. One in particular, Aleqa Yohannis Teklu, was the most prominent painter in Aksum. A number of his paintings can be seen in the Church of Mary of Zion in Aksum. He recently passed away but his life could easily be documented through

discussions with his family and other members of the Aksum community. Another is Aleqa Gebre Selassie, who lived and worked in Meqele (Tigray). Little has been written about him, but a number of scholars (namely, Dan Bauer, Marilyn Heldman, and Neal Sobania) met with him and collected some of his paintings in the 1970s. The only example of the sort of study I am proposing is Jacques Mercier's (1988) biography of the *debtera* (healer) Asres.

53. Chojnacki tells us that in "virtually all Church decoration from the 17th century onwards St. George occupies a prominent position; his portrayal is often found on the left side of the western wall of the Holy of Holies, a place of special distinction" (1973a: 57). He also indicates that in the sixteenth and seventeenth centuries Saint George was often depicted in icons, usually placed on the lower half of the left wing of a triptych or on the left panel of a diptych (Chojnacki 1973b: 74).

54. In the stratified society of highland Christian Ethiopia, where only the nobility learned the arts of horsemanship and war, the victorious equestrian saint has had a special appeal. In a broader context, the equestrian saint has been a popular talismanic image, having its roots in the world of Late Antiquity and early Byzantium, where the holy rider was used as an apotropaic image (Heldman 1993: 244).

55. For a description of these attributes see Chojnacki 1973b: 82–92.

56. For more information about the Ethiopian attire of the equestrian saints see Chojnacki 1983b.

57. The identification of the maiden in Ethiopian paintings as Birutawit (i.e., the maiden born in Beirut)—in Adamu's painting she is identified in an inscription located to the right of the maiden's head—suggests that Ethiopians were familiar with the medieval tradition of a small town close to Beirut claiming to be the spot where Saint George fought the dragon and saved the maiden, said to be a daughter of the king of Beirut (Chojnacki 1973b: 57). Chojnacki (1973b: 58) suggests that it may

have been Nicolò Brancaleon who introduced these two innovations.

58. Chojnacki (1973b: 54, 87) cites a number of specific examples in mural paintings found in churches in or near Bich'ena (Gojjam).

59. These servants, according to the Encomium of Saint George and the Description of His Twelve Miracles, assisted Saqrates in burying the saint and later transported the body back to Saint George's native city, Lydda.

60. For the dating of the church and its murals see Gerster 1970: 116. There is also an image of Saint Mercurius in the chapel of Abba Dane'el located on Mount Qorqor, which, according to Chojnacki (1975: 43) may date to as early as the turn of the fourteenth century. However, Heldman (1994: 173) has recently dated the murals in the chapel to the second half of the fifteenth century.

61. For additional information on Mercurius see Esbroeck 1991.

62. See, e.g., the account in the Ethiopian Synaxary translated by Budge 1928: 1.125–26, 228–29, 278–82.

63. See Budge 1928: 3.755–72 for one of the saint's hagiographies. For an overview of his life, especially how it is depicted in Ethiopian paintings, see Chojnacki 1971: 85–87; 1978b: no. 10.

64. Such practices were popular in Ethiopian monasticism.

65. See Belaynesh Michael, Chojnacki, and Pankhurst 1975: 179–80 and Getachew Haile 1991: 1047 for brief biographies of Yared's life.

66. Both objects are carried by members of the Ethiopian clergy. The sistrum is a rattle-like musical instrument used in Ethiopian Orthodox churches to maintain the cadence of liturgical chant.

67. This particular version of the tradition is published in Budge 1928: 3.876.

68. For information about the appearance of sword-bearing angels in Ethiopian representations of Saint Mary see Chojnacki 1983a: 187–91, 233, and Heldman 1994: 136–37, 151–52.

Chapter 8. Jembere and His Son Marcos

1. His works can be found in the Museum of the Institute of Ethiopian Studies (Addis Ababa University), Staatlisches Museum für Völkerkunde München, Bayerisches Nationalmuseum München, Völkerkundemuseum der Universität Zürich, Musée National des Arts d'Afrique et d'Océanie (Paris), and Michigan State University Museum (East Lansing, Michigan). Jembere's paintings have been collected by expatriates for some time. His painting *The Birth of Christ* (pl. 14), which dates from around 1960 and is today maintained in the Bayerisches Nationalmuseum in Munich, was reproduced as a UNICEF Christmas card in the 1980s. Rolf Italiaander reproduced Jembere's *Story of Ahmed ibn Ibrahim al-Ghazi*, which dates from around the same period, in an issue of *Scala International* (1965). Jembere's paintings have appeared in a number of recent exhibitions. For example, see Girma Fisseha and Raunig 1985: 67, 80, 102, 106–7, 109, 119; Musée National des Arts d'Afrique et d'Océanie 1992: 97; Girma Fisseha and Silverman 1994.

2. Much of the biographical information presented here is drawn from the authors' earlier essay "Two Generations of Traditional Painters: A Biographical Sketch of Qangeta Jembere Hailu and Marqos Jembere" (1994), which was based on data collected in interviews with Jembere and Marcos in April and May of 1993. Additional material was gleaned from the short biography of Jembere published by Girma Kidane in 1989 and from a brief autobiographical statement prepared by Jembere for Girma Fisseha in 1986. See Girma Fisseha and Silverman 1994: 369 for information about the autobiography and a discussion of the problem of dealing with the discrepancies that occur among the three accounts.

3. This is traditionally the date on which a boy begins his formal church education. For an overview of a traditional Ethiopian Orthodox Church education see Alaka Imbakom Kalewold 1970 and Teshome Wagaw 1979: 10–21.

4. Calligraphy is learned because, in addition to producing the painting itself, the traditionally trained church painter must also be able to "label" the various figures depicted in the painting. This is the last reference made to any formal aspects of Jembere's church education. It seems that he did not "finish his formal course of study" since it takes thirty years or more to receive a complete church education.

5. A thorough study of these tenets or canons has yet to be undertaken.

6. Artists attached to the imperial court were often well rewarded for their work. An often cited example is Nicolò Brancaleon, a Venetian artist who worked at the court of Emperor Lebna Dengel in the late fifteenth and early sixteenth century (Chojnacki 1983a: 379). See also Haile Gabriel Dagne 1988: 215.

7. A *dawilla* is equivalent to 100 kilograms, and one *gwendo* is equal to 20 kilograms.

8. This account is presented in his autobiographical statement; see n. 2 above.

9. Jembere did not explain why he became involved in the independence movement.

10. According to Girma Kidane (1989: 75), he was given 6,000 birr.

11. For a brief biography of Balatchew Yimer's life see Taye Tadesse 1991: 6. Hailu Weldeyesus's work is discussed below.

12. There is evidence that Jembere was painting in the 1980s. Both Elisabeth Biasio and Jacques Mercier collected paintings by the artist in the mid-1980s.

13. Eight paintings produced between 1991 and 1993 were purchased for the collection of Michigan State University Museum.

14. In two separate articles Pankhurst explores the interpretation of these two battles in Ethiopian painting. See Pankhurst 1989a: 98–101; 1994: 286–88.

15. See Silverman's essay on Qes Adamu Tesfaw in this volume for a brief discussion of individuality and an overview of the evolution of Ethiopian traditional painting. Interestingly, in the eyes of many students of

Ethiopian traditional art, it is this receptivity to change and interest in innovation, creativity, and individuality that have brought about the demise of Ethiopian traditional painting.

16. See, e.g., his paintings *The Battle of Mattema and the Death of Emperor Yohannes IV* (inv. 20031) and *The Judgment of Tewodros and the Battle of Maqdela* (inv. 20032) that he completed in the mid-1980s and that are today maintained in the Völkerkundemuseum der Universität Zürich.

17. Though very few sketchbooks have been documented, it appears there is a tradition of maintaining a collection of basic patterns or templates. Ruth Plant (1973), for instance, documented a pattern book produced by an artist in Meqele (Tigray) at the beginning of the century. Silverman also had the opportunity to examine the sketchbook of the contemporary traditional painter Qes Leggese Mengistu in 1993.

18. One wonders how common this attitude is among traditional painters in Ethiopia. Silverman, during his work with the priest Adamu Tesfaw, encountered this same creative approach. See Silverman's essay on Qes Adamu in this volume.

19. We commissioned a number of paintings from Marcos that deal with a range of themes. These include *Mesqel Celebration; Market—Rural Life Scenes; Hunting, Fishing, Marketing, Church; The Countryside; Saint Mercurius; The Judgment of Emperor Tewodros and the Battle of Maqdela; The Battle of Adwa; Ethiopian Saints and Historical Places; Hunters; T'imqet Celebration; Tewodros and the Feast of Kings; The Birth of Jesus; Yohannis IV's March to Mattema and the Mahdist Invasion of Gonder; Last Judgment; Ahmed Gragn's Invasion.*

20. The nation became known as Ethiopia only after World War II.

21. For an overview of this period see Bahru Zewde 1991: 60–114 and Marcus 1994: 91–103.

22. An exception to this rule are the artists (e.g., the fifteenth- to sixteenth-century Venetian artist Nicolò Brancaleon) who came to Ethiopia and worked for various rulers.

23. Arab Faqih, who chronicled the life of Ahmad ibn Ibrihim al-Ghazi, reported that the palace of Emperor Lebna Dengel (r. 1508–40) located at Andotnoh in Shewa, was decorated with "pictures, of lions, men and birds painted in red, yellow, green and other colours" (R. Basset, *Histoire de la conquête de l'Abyssinie (XVI siècle) par Chihab el-Din Ahmed ben Abd el-Quader surnome Arab-Faqih* [Paris, 1879], p. 215; cited in Pankhurst 1966: 9). The chronicler of the life of Emperor Bekaffa, who ruled in Gonder from 1721 to 1730, indicates that the emperor's palace was adorned with pictures (I. Guidi, *Annales Iohannis I. Iyasu I et Bakaffa* [Paris, 1955], p. 316; cited in Pankhurst 1966: 9). Henry Salt, who visited northern Ethiopia in the early nineteenth century, observed, "All classes of people in Abyssinia . . . are fond of pictures; the inner walls of their churches being filled with them, and every chief considering himself fortunate, if he can get one painted on the wall of his principal room" (1967: 394). A French scientific mission that visited Ethiopia in the 1840s, for instance, reported that paintings "were never intended other than for the churches" but adds that "one nevertheless finds some in the palace of the king" (T. Lefebvre et al., *Voyage en Abyssinie executé pendant les années 1839, 1840, 1841, 1842, 1843 par une Commission Scientifique composée de Théophile Lefebvre, A. Petit, Quartin-Dillon, Vignaud*, 9 vols. [Paris, 1845–48], vol. 1, p. lxxi; cited in Pankhurst 1971: 94).

24. Chojnacki points out that "lay subjects occasionally appeared. For example, the decoration of the royal palace with paintings was recorded by the chronicler of Emperor Bekaffa, 1721–1730; this, however, was quite unusual" (1978a: 72).

25. E.g., see Wylde's (1888: 300–301) and Powell-Cotton's (1902: 393–94) descriptions of the paintings in the Church of the Holy Trinity in Adwa; Wylde's (1901: 171) description of the paintings in the Church of the Savior of the World, also in Adwa; and Bent's (1893: 42) comments on the paintings in the old stone church at Asmara.

26. The Zemene Mesafint, or Era of the Princes, was a particularly unstable period during which local rulers

were constantly engaged in conflicts as they maneuvered for control of the central and northern highlands of Ethiopia. See Biasio 1994: 551.

27. Biasio (1993: 9) cites two examples, one involving a painting given by Emperor Yohannis IV (r. 1872–89) to the German diplomat Gerhard Rohlfs, and the other a painting given to a Swiss mission in the 1930s by Emperor Haile Selassie. There also is evidence that painters used to give their work to noblemen and dignitaries as New Year's gifts and that rulers exchanged paintings as gifts (Biasio 1993: 8–9).

28. A line drawing of the painting is reproduced by Salt (1967: following p. 394). It depicts two "Abyssinian horsemen engaged in battle with the Galla." Salt indicates that it took the painter six days to complete the painting and offers the following description of the process: "He first suspended the paper against the wall; then, made an exact outline of his design with charcoal; and afterwards went carefully over it again with a coarse sort of Indian ink; subsequently to which he introduced the colours" (1967: 394).

29. Though it is not explicitly stated, we may assume that he commissioned the paintings. His collection is now maintained in the Institute of Ethnology of the Academy of Sciences in St. Petersburg (Pankhurst 1966: 32–36). Pankhurst (1966: 29) also mentions a series of paintings by the artist Mikael Ingida Work that were collected by the French traveler Hugh Le Roux. Another important collection of paintings, by Behailu Gebre Maryam, an artist from Tigray, was made by the Swiss engineer M. E. W. Molly in the 1920s. These were deposited in the Musée d'Ethnographie in Geneva (Pittard 1928).

30. Zervos (1936: 467) offers a brief biography of this well-known merchant. Also see Natsoulas 1977: 130–32.

31. The artists originally came from various provinces: Shewa, Tigray, Begemdir (Gonder), Gojjam, Wello, and Wellega. Pankhurst (1966: 18–19), drawing primarily from the writings of Mérab and Zervos, lists

and offers a limited amount of information on twenty-one artists who lived and worked in Addis Ababa in the late nineteenth and early twentieth centuries.

32. Djougashvilli was known as the Algawrash, or "Prince."

33. They included Yohannes Tessema, Shimeles Hapte, Tasso Hapte Welde, Belatchew Yimer, Itbarek Haile Maryam, Alemu Haile Maryam, Haile Selassie Mekonnen, Wendem Agegnew, Berhanu Yimenu, and Gebre Hiot (Pankhurst 1966: 39).

34. All of these "pioneers" have passed away. Limited biographical information about some of them has been collected but for the most part we know very little about their lives and work. The most useful compilation of information is Richard Pankhurst's 1966 article "Some Notes for a History of Ethiopian Secular Art." In this article he presents data gleaned from primary documentation and his own interviews with various artists. Other scholars offer additional information on artists. See, e.g., Girma Kidane 1989; Taye Tadesse 1991; Girma Fisseha and Raunig 1985.

35. The school was closed during the Italian Occupation, and in 1978 it changed its name to the Handicrafts and Small-Scale Industries Development Agency (HASIDA) of the government of Ethiopia. It was finally closed in 1991 (Biasio 1993: 16). Molesworth (1957: 366) offers a brief discussion of the support of government schools and workshops in Addis Ababa.

36. The ETTC was founded in the early 1970s. Its name was changed in December 1992 to Ethiopian Tourist Trading Enterprises (ETTE).

37. Ricci (1989: 120–52) reproduces a representative collection of skin paintings that may have been produced about fifty years ago. Since the paintings bear no signatures, it is impossible to know whether they were made in a workshop or by independent artists.

38. Biasio (1993: 22) also recorded that the well-known traditional painter Berhanu Yimenu painted the Church of Peter and Paul in the Kolfe district of Addis Ababa.

39. There are, of course, various idiosyncratic themes that do not fit in any of these previous groups. Benzing (1988b: 116) offers a similar set of nine categories: hagiography; legend of the Queen of Sheba; nobility, politics, and diplomacy, court festivities; fights and battles; tribunal and legal sanctions; hunting; games and sports; everyday life, including festivities; animal society.

40. For more information on this popular theme see Perczel 1978 and Pankhurst and Pankhurst 1957.

41. These compositions are pictorial representations of Abyssinian folk stories that function in a manner very similar to Aesop's fables. To the best of our knowledge this particular genre has no precedent in earlier eras. It would be interesting to discover the creator of the genre, which is firmly rooted in oral tradition. An analysis of one of these paintings can be found in Scholler and Girma Fisseha 1985: 164–66.

42. Donald Crummey (1994: 6–10) recently considered the "place of violence in historic Ethiopian political culture" in his analysis of the life and times of Emperor Tewodros.

43. To date, no one has attempted a critical analysis of the range and frequency of subjects in Ethiopian painting. No doubt such a study would yield significant insight into the cultural dialogue between Ethiopians and visitors to Ethiopia reflected in these paintings. A number of studies explore this phenomenon; perhaps the most relevant to the Ethiopian situation is Bennetta Jules-Rosette's *Messages of Tourist Art: An African Semiotic System in Comparative Perspective* (1984).

44. One of the earliest extant manuscripts, the Four Gospels of Abbot Iyasus Mo'a, dating from 1280–81, includes a portrait of the monk who commissioned the manuscript, Iyasus Mo'a. See Heldman 1993: 176 for a discussion of the manuscript and its illustrations.

45. Portraits of historical figures like the legendary fourth-century kings of Aksum (Abreha and Atsbeha), Emperor Yekuno Amlaq (r. 1270–85), Emperor Susneyos (r. 1607–32), Emperor Yohannis I (r. 1667–82), Emperor Iyasu I (r. 1682–1706), and Emperor Bekaffa

(r. 1721–30) appear in manuscripts dating from the seventeenth and eighteenth centuries. A number of these are illustrated in Jäger 1960.

46. Earnestine Jenkins (1995) has recently examined one of these manuscripts, maintained in the Church of Tekle Haimanot at Ankober. It dates from 1817 and its illustrations include scenes of Sahle Selassie overseeing a banquet, playing chess, having his hair braided, killing "heathens," hunting an elephant, etc.

47. The Church of Debre Tsehai in Gonder is said to have had a portrait of Emperor Iyasu II (r. 1730–55) beneath a representation of the Crucifixion and a portrait of the emperor's mother, Menteweb, beneath an image of the Holy Virgin (I. Guidi, *Annales Iyasu II et Iyoas* [Paris, 1910], p. 106; cited in Pankhurst 1966: 9). It is likely that these portraits indicated that the emperor and his mother had commissioned the religious paintings for the church; such sponsorship was quite common during the Gonderine period.

48. Pankhurst (1966: 16–18) cites numerous examples of portraits of Emperor Menilek II, as well as other members of the Abyssinian aristocracy, in churches throughout the empire.

49. The genre of portraiture has not yet been studied. Pankhurst's "Some Notes for a History of Ethiopian Secular Art" (1966) offers a compilation of references to portraiture as one of the themes of Ethiopian "secular" painting and is still the most complete treatment of the subject. Girma Fisseha and Raunig (1985: 26–27) briefly consider the topic, drawing on Pankhurst's earlier work and the descriptions of Zervos and Mérab. Ricci (1989: 11) includes a painting of a "Moslem notable" who, from the inscription on the top right of the painting, is named Ahmad Abduh (?). Ricci attributes the painting to Eritrea (Asmara) at the turn of the present century. The man is rendered as a "type," following the Second Gonderine style of Ethiopian traditional painting. But because it is undoubtedly a portrait, Ricci suggests that it may be one of the earliest examples of this genre.

50. Pankhurst (1966: 19–20) offers a brief discussion of the influence of photography. Adrien Zervos, who lived in Ethiopia from 1905 to 1935, was one of the first to document the production of portraits. He was particularly impressed with the work of Itbarek Haile Maryam, who produced a particularly fine portrait of Emperor Haile Selassie. He relates that other favorite subjects of portrait painters were Ras Mekonnen, Lij Iyasu, Emperor Menilek II, Empress Menen, and the imperial children (Zervos 1936: 244).

51. One will find portraits of Chancellor Adolf Hitler, King Leopold III, King Fouad I of Egypt, President Franklin D. Roosevelt, President Albert Lebrun, King Victor Emmanuel III, Emperor Hirohito, King Gustave V, President Gazi Mustafa Kemal Ataturk, and King Imam Yehya.

52. Other traditional-style paintings by Hailu are reproduced on the facing page, and more portraits of Ethiopian and European dignitaries are scattered throughout Zervos's book. One can observe the close affinity between photograph and painting by comparing Hailu's portrait of Ras Mekonnen and the photograph (reproduced on p. 62 in Zervos 1936) from which it is derived.

53. Zervos (1936: 246) lists some of the foreign artists who worked in Ethiopia during the first three decades of the twentieth century.

54. For a discussion of the influence of painters who came to Ethiopia in the fifteenth and early sixteenth centuries, see Chojnacki 1983a: 375–432.

Chapter 9. Silverwork in the Highlands

1. One of the richest sources of information for beginning to reconstruct the history of this tradition are the travel accounts of European visitors to Ethiopia. A thorough survey of the travel literature, however, is well beyond the scope of this essay, but examples of the sort of information these accounts contain are used throughout to illustrate the long history of gold- and silversmithing in Ethiopia and to begin the process of placing these traditions in a broader context. For a detailed discussion of the light that these sources shed on the tradition, see Silverman and Sobania n.d.-b.

2. Even studies of ironworking and the role of blacksmiths in society are limited, though there are a few good sources, e.g., Amborn 1990 and Todd 1985.

3. For a discussion of this stratification see Hoben 1970.

4. A variety of terms are found in the scholarly literature to refer to these special groups found in many Ethiopian societies: "submerged classes," "outcast groups," "pariah groups," "occupationals," "despised groups," and "caste groups." The literature is full of debate addressing the validity of using any and all of these terms.

5. For descriptions of some of these finds see Munro-Hay 1989: 210–21, 228–33; 1991: 180–95; 1993. There has been a limited amount of work reconstructing the history of gold- and silverworking in Ethiopia. The best-studied objects made from gold and silver (as well as copper and its alloys) are associated with the Ethiopian Orthodox Church and include items such as processional crosses, hand crosses, neck crosses, sistrums (s'enas'il), the finials of prayer sticks (maqwamiya), chalices, and crowns. See Moore 1973, 1989; Perczel 1981; Brus 1975.

6. Bureau mentions the jewelers associated with the region of Aksum: "Les Tigré, et plus spécialement les Shiré de la région d'Axum, sont d'excellents orfèvres dont la réputation est assez forte pour qu'aujourd'hui ils détiennent la presque totalité du marché des bijoux de la capitale" (1975: 39).

7. Tossi is not an Ethiopian name. Gezahegn told us that his father's father was in fact Italian but that his father had never met him and knew nothing about the man. Apparently, Tossi left Aksum before Gezahegn's father was born.

8. The design of the waqari is very similar to pendant necklaces produced by Bedouin smiths in Arabia and by the jewelers of Yemen and Oman.

9. Artificial aging is a response to market demands. The tourists from Europe and America who visit Ethiopia prefer things that are old, and a variety of aging processes are employed by the artists and artisans who fabricate goods for the tourist trade.

10. Though not as abundant as the Maria Theresa thalers, other silver coins, from Saudi Arabia and Italy, for instance, as well as coins minted during the reigns of Emperors Menilek II (r. 1989–1913) and Haile Selassie (r. 1930–74), are in circulation. Though they are not accepted as legal tender, they still are valued for their silver content.

11. For these practices in West Africa see Garrard 1989.

12. At times the finished product does not weigh as much as the metal originally given to the silversmith; in such situations the silversmith will return the difference to his customer with the finished product.

13. The Pankhursts conducted a limited survey of European and North American museums for a study of Ethiopian earpicks (Pankhurst and Pankhurst 1979: 102–3). Silverman documented many examples of Ethiopian gold- and silverwork in his survey of European and North American museums (Silverman and Sobania n.d.-b, n. 2).

14. See, e.g., Pankhurst's (1989b: 46; 1991: 59; 1992: 55) survey of manuscript illuminations. This, in fact, is a method that Eine Moore (1973, 1989) used in her study of processional crosses.

Chapter 10. Sorghum Surprise

1. Ethiopia has one of the fastest-growing populations in Africa. At the current fertility rate of 7.0 children per woman, this country of 58 million will double its population in twenty-three years (13 percent of the population is urban and 87 percent rural) (Menzel 1995: 31; Asefa Hailemariam and Kloos 1993: 58).

2. One quintal is equal to a hundredweight, or 100 kilograms (220.46 pounds).

3. The name Yehudgebaya simply translates "Sun-day market." The village apparently is or was the site of a weekly market held on Sundays.

4. By some estimates the speakers of afan-Oromo make up more than 40 percent of Ethiopia's population. They live throughout much of the west, south, and east of the country as peasant agriculturalists and pastoralists and may be Christians, Muslims, or traditionalists.

5. Like Yehudgebaya, the name Hamusgebaya is a reference to the town serving as the site of a weekly market, this one meeting on Thursdays.

6. During the later years of the reign of Haile Selassie I, the monetary unit was a dollar of one hundred cents, with one Ethiopian dollar equal to twenty U.S. cents.

7. In June 1993, the official rate of exchange was 5 birr to U.S.$1.

8. Tolera planned to return to school and the tenth grade in the fall of 1993 and hoped to finish the twelfth grade in 1996.

Chapter 11. Tabita Hatuti

1. Wolayttatto is classified by linguists as belonging to the Omotic group of the Sidama cluster.

2. This classification is discussed in Tsehai Berhane-Selassie 1994a: 20; 1991b: 15–18.

3. This figure is derived from unpublished notes from fieldwork carried out from September 1989 to July 1993. The estimate is based on an intensive house-to-house baseline survey among the potters' community.

4. The issue of potters as a "caste" group in Ethiopia has been discussed by David Todd (1978), among others. Donald Levine, in his *Greater Ethiopia* (1974: 170, 195–97), seems to use the term "caste" synonymously with "ethnic groups." Since "caste" is loaded with religious meaning, it is best avoided in the case of Ethiopia. My objection to the term is also based on the fact that most artisans in Ethiopia can move in and out of their occupations. See Hakemulder 1980: 9–10. For more on my argument, see Tsehai Berhane-Selassie 1991b:

21–22; 1994c: 350–52. Although they do not make the point explicitly, Steven Kaplan (1992) and Jon Abbink (1987) provide further evidence on the difficulties of using the term "caste" with regard to Ethiopia. In many linguistic groups in Ethiopia, "immigration" rather than "caste" is the concept applied to distance the potters. See also Cassièrs 1988: 162–63.

5. This is a widespread system of symbolic history and classification in Ethiopia. See Lange 1982: 70, 75–78, 98 n. 7, 105 passim.

6. The men of the potters' community in Wolayta are the ritual experts for the dominant group, the farmers. They perform rites and sing and dance at funerals and weddings. See Tsehai Berhane-Selassie 1991b: 21; 1994c.

7. Occasionally, children in Wolayta also make clay figurines, depicting pregnant women, new hairstyles, male and female bodies, etc. These are strictly toys, and adults discourage their production.

8. Landlords owned and controlled access to forests (and therefore fuelwood), grazing grounds, and certain sources of water such as springs. Such control over the use of the physical environment was particularly limiting to potters. See Tsehai Berhane-Selassie 1994a.

9. Occupational endogamy is practiced in different ways. In many areas, only weavers and potters intermarry, excluding blacksmiths, tanners, and slaves (Cassièrs 1988: 166, 169, 189).

10. This type of mutilation involves removal of the labia majora. See Tsehai Berhane-Selassie 1991a: 220–83; 1994c: 355.

11. Although I have interviewed many potters, no one has ever explained their move away from a virilocal residence using this reasoning; nevertheless, it appears to be an acceptable reason for asserting one's independence, and many practice it.

12. These were grassroots political structures created to support the Marxist-Leninist Party. The peasants' associations formed the local level of government, and the farmers' service cooperatives functioned as the base for the circulation of basic goods and services to the rural community. See Clapham 1988: 171–79.

13. Many other women that I interviewed in Wolayta said the same thing. It was their way of rejecting a program that was forced on them.

14. Villagization was a controversial program, supposedly designed to aggregate scattered hamlets to provide better delivery of basic services such as schools, water, and health care. In reality, it is said, it was for easier control of the rural people by the Marxist-Leninist Party, which ruled the country until 1991. See Clapham 1988: 174–79.

15. The separation in Shento was partly due to the historical accident that a large number of potters lived in that particular area. Elsewhere in Wolayta potters were deliberately segregated as a result of the traditional prejudice against them. See Tsehai Berhane-Selassie 1991a: 239–40, 268.

16. This program was based on a study made by the Handicrafts and Small-Scale Industries Unit (HSIU), a joint International Labour Office/Economic Commission for Africa project sponsored by the African Training and Research Center for Women (ATRCW). See the Introduction in Hakemulder 1980.

17. Development agents and home agents argue in a matter-of-fact manner that women should be left out of technology-training schemes because they are illiterate. "Literacy" included having mathematics skills, and by 1984 no potter woman was deemed literate enough. Even if they could read and write, they lacked the power and didn't feel the need to enforce gender equality and reverse the local government's decision to exclude them.

18. Gender plays a role in pottery production in much of Africa. Asante women potters, for instance, are forbidden to make anthropomorphic and zoomorphic decoration, which is supposed to threaten their fertility (Fagg and Picton 1970: 10). In Ethiopia it is generally a man's job to construct houses and provide drinks, and thus in the south men are generally restricted to

making only roof tops and to helping women in the firing and selling processes.

19. Forming potters' associations was a problem elsewhere in Ethiopia. See, e.g., Hakemulder 1980: 25.

20. Hakemulder (1980: 26, 63) reports on similar failures, albeit with surprise, elsewhere in Ethiopia. See also Tsehai Berhane-Selassie 1991a for a report on Band Aid–sponsored research to evaluate its own impact on rural women.

21. Hakemulder (1980: 17–18) describes a motley collection of more or less similar items for other areas in central Ethiopia.

22. Men dig clay in Wolayta only when women are threatened or are actually trapped by the holes caving in. Elsewhere, men can dig clay. See Hakemulder 1980: 51, 55. Potters always follow a set pattern in their work, until age requires modifications. See Hakemulder 1980: 13.

23. See Hakemulder 1980: 18–21 for comparison. The type of modeling described by Hakemulder (1980: 20, 56) does not seem to be practiced by potters in Wolayta, although she reports that the potters she saw in Menagasha, near Addis Ababa, had come from Wolayta.

24. For decorating practices elsewhere in Ethiopia and further detailed descriptions of pottery decoration in Wolayta, see Hecht 1969: 9, 93–99.

25. No bellows are used for firing pottery in Wolayta. Hakemulder (1980: 21) describes how firing was done indoors in the kitchen in Addis Ababa. In another village, where there has been no government intervention, the potters fire their wares outside (Hakemulder 1980: 44).

26. Elsewhere in the country women are actually forbidden to fire the pottery they make; firing is a man's task. See Hakemulder 1980: 46.

27. The amount of smoke generated by open-air firing has been cited as a reason for placing potters on the outskirts of populated areas in Latin America (Rice 1987: 156).

28. Cassièrs (1988: 161) confirms this.

29. Hakemulder (1980: 60) reports that in Menagasha the men take care of the marketing as a rule.

30. Hakemulder (1980: 48) also reports that couples in potter families share their income.

31. Despite Cassièrs's (1988: 166 n. 18) amazement, I am personally aware of at least one *gan* that has been in use for the last four decades.

Chapter 12. Ilto and Arba–Two Doko Weavers

1. Formerly, these structures were thatched with k'ata, the stem sheath of the bamboo plant. But today most houses are thatched using wheat straw.

GLOSSARY

Edited by Grover Hudson

THIS GLOSSARY INCLUDES ALL THE WORDS OF ETHIOPIAN languages that appear in the book, except for names of persons and places. The words are listed here alphabetically according to their English-alphabet spellings as used in the book, followed by their pronunciations and meanings. Oromo words are presented in the current established Oromo orthography.

The English-alphabet spellings, without the use of special characters, are a simplification which is helpful for most readers, who are uninterested in the phonetic details of the languages that special characters would express, for example, the high-tone vowels of Me'en shown with accents [á, é, í, ó, ú], the voiced glottalized implosive stops of Me'en and Oromo [ɓ] and [ɗ], and the central vowels of Amharic and Gurage-Chaha [ə] and [ɨ]. For those who are interested in such details, however, this glossary includes pronunciations as International Phonetic Alphabet representations. Consonants followed by apostrophes are voiceless glottalized ejectives.

The pronunciation of some words in this glossary, especially those of the little-studied languages Gamo (Gamu), Me'en, and Wolayta, has been based entirely on information provided by the authors of the essays. The pronunciation of most words of the better-known languages Amharic, Gurage-Chaha, Harari, and Oromo, however, has been verified in the available dictionaries: Thomas Kane, *Amharic-English Dictionary*, 2 vols. (Wiesbaden: Otto Harrassowitz Verlag, 1990); Wolf Leslau, *Etymological Dictionary of Gurage*, 3 vols. (Wiesbaden: Otto Harrassowitz Verlag, 1979); Wolf Leslau, *Etymological Dictionary of Harari* (Berkeley and Los Angeles: University of California Press, 1963); Gene Gragg, *Oromo Dictionary* (East Lansing: African Studies Center, Michigan State University, 1982); and Hamid Muudee, *Oromo Dictionary*, vol. 1, *English-Oromo* (Atlanta: Sagalee Oromoo Publishing Co., 1995).

A = Amharic
G = Gurage-Chaha
Ga = Gamo
H = Harari
M = Me'en
O = Oromo
W = Wolayta

a'a (M) [aʔa] goods, stuff, belongings

aadaa (O) [aːdaː] norm, custom, tradition

abbaa gadaa (O) [abːaː gadaː] leader in *gadaa* system, lit. "father of *gadaa*" (see *gadaa*)

achay (Ga) [ačaj] small space in the reed of a loom

adurru iin (H) [adurːuiːn] basket pattern: "cat's eye"

aflala uffa (H) [aflala ufːa] conical basketry lid

afoocha (H) [afoːča] community association

afutu (H) [afutu] flat basketry sieve

agergera (H) [agərgəra] type of straw used like thread for weaving baskets

aleqa (A) [alək'a] head of a church, learned priest

amir nedeba (H) [amiːr nədəba] seat situated to the right of the entrance in the *gidiir gaar* and reserved for the owner of the house or for the learned; lit. "seat of king or sovereign"

angafa (O) [aŋgafa] firstborn male, senior

aqwaqwam (A) [ak'wak'wam] choir performance

areqe (A) [arək'e] traditional distilled liquor

ari (H) [ari] the reverse, "bad" side of the basket

asara (Ga) [asara] tunic worn by a *halaka*

asmara (Ga) [asmara] factory-produced thread made in Asmara

aw moot (H) [aw moːt] basket produced for a bridegroom to be carried with him when visiting relatives; lit. "basket of father"

ayele (W) [ajele] slave

ayko sota meetsa (Ga) [ajko sota mitsa] vertical posts that support the loom

ba'aa (O) [baʔaː] load, bundle, bundle of dried sorghum stalks

baballoo (O) [babalːoː] basketry weaving technique

baddana okolee (O) [badːana okoleː] type of aromatic wood

balambaras (A) [balambaras] honorific title

banga (M) [baŋga] machete

bans'alach (M) [bans'alač] type of plant (*Periploca linearifolie* A. Rich)

berch'uma (G) [bərč'umːa] three-legged stool (A. [bərč'umaː])

bet (A) [bet] house

bete kristyan (A) [betə kr̀istjan] church; lit. "house of Christians"

bhech (M) [ɓeč] iron ax

bhogol (M) [ɓogól] type of gourd container

birr (A) [birː] basic monetary unit; in 1993 one birr was equivalent to U.S.$.20

bisaat' (H) [bisaːt'] basket pattern: "rug"

bissha mudaay (H) [bišːa mudaːj] chewing gum container

bitirya (W) [bitirya] small pot for drinking

bitt'i bitt'i (H) [bitː'i bitː'i] small flat basket

bula (W) [bula] gray

bulla (W) [bulːa] food made from *enset*

buqqee (O) [buk'ːeː] milk container made from a gourd

busetti (H) [busətːi] careless or lazy woman

buttee (O) [butːeː] wood and basketry container for water

buttee okollee (O) [butːeː okolːeː] basketry container for water

buuda (O) [buːda] horn container for aromatic butter

buudunuu dhadhaa (O) [buːdunuː ɗaɗaː] wooden container for butter (*dhadhaa*, "butter")

cancala (O) [č'anč'ala] a frame made of leather and wood used for holding containers

ch'at (H) [č'at] type of plant cultivated in Harer region, the leaves of which contain a mild narcotic (*Catha edulis*)

chakam (M) [čákam] small wooden stool used by adult males

chate (O) [čate] sorghum, a cereal grass (A. *mashilla*)

chaych (M) [čajč] buffalo-leather sandals worn by males

chena (W) [čena] pot used for collecting and storing water

chifat (G) [čìfat] coffeepot stand

chinasha (W) [činaša] potter, artisan (used pejoratively)

ch'iqa (A) [čʼɨkʼa] mud, clay

ciicoo (O) [čʼiːčʼoː] type of basketry milk container

daafa (M) [daːfa] beaded belt worn by women around the hips

damo (G) [damo] traditional Gurage civil title

dancho (Ga) [dančo] long cotton sash worn by women and sometimes men

data holla (Ga) [data holːa] small hole where the weaver places his feet to operate the treadles

dawilla (A) [dawɨlla] unit of measure, ca. 100 kg

dawit (A) [dawit] Psalms of David

debtera (A) [dəbtəra] a "lay-cleric" in the Ethiopian Orthodox Church who functions as a scribe, cantor, healer, etc.

dejazmach (A) [dəǰazmač] politico-military title below ras

demwamwit (G) [dəmwamwit] Gurage fertility goddess, the cult of the goddess

denso (Ga) [denso] the warping process in weaving

deray (Ga) [deraj] local ethnic region/group

derg (A) [dərg] the Marxist military regime in Ethiopia (1974–91)

destiya (W) [destija] pot used for serving wet'

dhaddacha (O) [ɗadːačʼa] aromatic wood

dhibaayyuu (O) [ɗibaːjːuː] type of rite

dibbee (O) [dibːeː] wooden container for butter (lit. "drum")

dinqnesh (A) [dɨnkʼnəš] popular name given to female hominid remains found near Hadar, Wello Province (lit. "you are wonderful")

diski (M) [dískī] medium-sized clay pot

diwura mekina (Ga) [diwura mekina] bobbin winder

dokhon lanka (H) [doxon laŋka] basket pattern: "the trunk of an elephant"

dole (M) [dolé] small clay pot

doola (O) [doːla] leather container for butter

doro (A) [doro] hen

dunguza (Ga) [duŋguza] pair of colorful shorts worn by the halaka

echba (G) [əčba] central pole of a Gurage house

ejersa (O) [eǰersa] type of aromatic wood

elellaani (O) [elelːaːni] cowrie shells

enset (A) [ɨnsət] edible "false banana" plant, the stem and root of which provide a staple food among many groups in southern highland Ethiopia (Ensete ventricosum)

ergamsa (O) [ergamsa] fiber derived from the roots of the ergamsa plant and used to weave containers

farso (Ga) [farso] a drink similar to beer, made from fermented honey, water, and wheat

fedwet (G) [fedwət] ritual language of the mweyet girls' age-group

ferenji (A) [fərənǰi] foreigner

fershi mahallaq (H) [fərsi mahalːakʼ] basket pattern: "coin"

finch'iq (H) [fɨnčʼɨkʼ] basket pattern: "splash"

finjaan gaar (H) [finǰaːn gaːr] small lidded container

fitawrari (A) [fitawrari] politico-military title below dejazmach

foora (O) [foːra] mobile cattle camps

foot aeefay (Ga) [fut aifaj] cotton with the seed

footo (Ga) [futo] cotton without the seed

fota (Ga) [fota] bright, multicolored plaid cloth

fuga (G, A) [fuga] special class of craftspersons (woodworkers, bamboo-workers, and potters)

gabate (W) [gabate] footed shallow pottery bowl

gabi (Ga, A) [gabi] heavy woven textile, blanket

gadaa (O) [gadaː] period of eight years, name of generation grade, person who occupies the grade

gadaammoojjii (O) [gadaːmːoːǰːiː] name of a ceremony, name of a generation of elders, person who occupies the grade

galata (O) [galata] gift given as a sign of gratitude or praise

galma (O) [galma] ceremonial hut, hearth

games (G) [gaməs] self-designation of the Fuga

gan (W, A) [gan] large beer-brewing pot

garju (M) [garǰu] food basket

gaya (Ga) [gaja] waterpipe for smoking tobacco (A. [gaja])

gebete (G) [gəbəte] large wood bowl used for serving food, especially on ceremonial occasions

gebre merfi (H) [gəbrə mərfi] basket pattern: "slave needle"

gebtiher nedeba (H) [gəbtihər nədəba] seat in the *gidiir gaar* where "ordinary" people sit

geedo sota meetsa (Ga) [gido sota mitsa] two horizontal pieces of wood attached to the vertical posts of a loom

gelach (H) [gelač] society of young women of similar age who live in the same neighborhood

gerengi (H) [gerengi] term describing the colors used in traditional Harari baskets (as opposed to those used for tourist baskets)

gesho (G, A) [gešo] hops-like plant used in fermentation of traditional beer (*Rhamnus prinoides*)

gidiir gaar (H) [gidiːr gaːr] traditional living room in a Harari home; lit. "big room"

gidiir nedeba (H) [gidiːr nədəba] seat in the *gidiir gaar* reserved for the elderly

gizhe (G) [gižə] a caste group of tanners; a tanner

golondii (O) [golondiː] leather and wood container for liquids

gombuwa (W) [gombuwa] pot used for transporting *t'ej* or *t'alla*

gongul (M) [goŋgul] wooden bowl

goqa (W) [gok'a] farmer

gorara (G) [gorara] deity of the Fuga

gorfa (O) [gorfa] type of basketry milk container

gubbisa (O) [gubːisa] name-giving ceremony for firstborn male

gufta mudaay (H) [gufta mudaːj] hairnet container

gwendo (A) [gwəndo] unit of measure, ca. 20 kg

gyimme (G) [gʲimːə] wooden headrest

habesha (A) [habəša] Semitic Christian peoples, specifically the Amhara and Tigray, living in the central and northern Ethiopian highlands

hala mehal (H) [hala məhal] important lessons associated with social etiquette

halaka (Ga) [halaka] elected leader (A. [aləkʼa])

hamaat moot (H) [hamaːt moːt] basket that a new bride makes for her mother-in-law

hareg (A) [harəg] a vine or tendril of a climbing plant; the decorative designs used to frame the pages of manuscripts

harpa (Ga) [harpa] pit-style loom

hilansha (W) [hilanša] polite term for a potter or artisan; lit. "people who make things"

holotaa (O) [holotaː] fiber derived from roots of a small tree and used to weave containers

hurdi (H) [hurdi] yellow

hurdi inchi (H) [hurdi inčʼi] type of yellow spice; lit. "yellow wood"

injera (A) [inǰəra] thin, flat, spongy, fermented bread made from *t'ef*, a millet-like cereal grown in the highlands of Ethiopia

intala fuudhuu (O) [intala fuːɗuː] marriage; lit. "take the girl away"

intarsa (Ga) [intarsa] narrow stick that holds the bobbin in the shuttle

inzert (Ga) [inzert] drop spindle used for spinning cotton (A. [inzɨrt])

iqub (G) [ikʼub] rotating credit association (A. [ikːʼub])

irbaa (O) [irbaː] stick for mixing curdled milk

it'aan mudaay (H) [itʼaːn mudaːj] incense container

itege (A) [ɨtege] empress

itittuu (O) [itɨtːuː] curdled milk

jabana (W) [ǰabana] coffeepot (A. [ǰəbəna])

jakach (M) [ǰakáč] type of tree (*Maytenus senegalensis* (Lam) Exell.)

ju (M) [ǰú] large clay cooking or storage pot

kacheena (Ga) [kačina] threads running the length of the loom, referred to as the warp

kachekerya (W) [kačekerja] pot used for serving food

kashe (W) [kaše] porous, (burned) black, brittle

k'ata (Ga) [kʼata] stem sheath of the bamboo plant, formerly used to thatch Doko houses

kene (G) [kənə] skilled person, master house builder

kere (W) [kere] pottery saucepan

ket-te-koroy (M) [ketːekoroj] type of bush (*Rhamnus prinoides* L'Herit.)

kitfo (G, A) [kɨtfo] minced meat, a Gurage speciality

kobe (G) [kobe] wooden-soled shoes

koddaa (O) [kodːaː] small water and milk container with a lid

komorut (M) [komorút] hereditary ritual leader

k'orch (Ga) [k'orč] eucalyptus

koso (A) [koso] type of tree used in making wood objects and also as tapeworm purgative (*Hagenia abyssinica*)

kotsa (Ga) [kotsa] spun cotton

laba (O) [laba] horizontal band on the *gorfa* milk container

laba qadaadaa (O) [laba k'adaːdaː] horizontal band on lid of the *gorfa* milk container

labagaadi (O) [labagaːdi] part of the *gorfa* below the laba band (*gadi* "down," "under")

laka (M) [laká] leather bracelets

lange (M) [laŋge] ritual friendship bond

le'ay mooreja (H) [ləʔaj moːrəja] basketry plate used as cover for another basket

leba (A) [leba] thief

lemat (H) [lemat] large flat basket

loomoot (Ga) [lumut] plain-weave border design on the *net'ala*

madaala (O) [madaːla] word used to designate the *gorfa* milk container when used during ceremonies, always full of milk or curdled milk

madheera (O) [maɗeːra] aromatic wood

makorkurya (W) [makorkurja] pitcher-shaped ceramic vessel

mala (Ga) [mala] commoners

mammite (A) [mamːite] servant who takes care of the children or who cooks

mant'iret (G) [mant'ɨret] bamboo sieve

maqwamiya (A) [mak'wamija] prayer stick carried by priests

marxa (O) [mart'a] giraffe tail hair, decoration made with same

mashala (H) [mašala] "Praise to God," an example of an inscription that may be woven into a basket

meeyana (Ga) [mijana] loom harness

mekina (A) [məkina] automobile

memcha (Ga) [memča] the beater of a loom

meqet'qet' (G) [mək'ət'k'ət'] mortar (of mortar and pestle, for grinding)

meqnati (H) [mək'nati] basket pattern: "belt"

merigeta (A) [mərigeta] a church title for the leader of the *debtera*

mesob (A) [məsob] table-basket

mesqel (A) [məsk'əl] feast of the finding of the "True Cross" celebrated on 27 September

metarika mahallaq (H) [mətarika mahalːak'] tradition of "receiving coins" from visitors to the *mooy gaar*

mewasit (A) [məwasit] hymns sung at funerals and memorial services

micciirroo (O) [mičʼːiːrːoː] basketry weaving technique; lit. "twisting"

mido (G, A) [mido] comb

migir (H) [migir] type of sturdy grass used for the core of the coil of a basket

mit'ad (W) [mit'ad] round baking pan made from pottery (A. [mɨt'ad])

miyyu (O) [mijːu] word used to designate the *ciicoo* milk container when used during ceremonies, always full of milk or curdled milk

mokay (Ga) [mokaj] shuttle, the tool that carries the weft threads across the warp

mooy gaar (H) [moːj gaːr] group of young women who regularly come together to weave baskets (*mooy* "passing the day"; *gaar* "house"; Ahmed's gloss of the term is "house of work")

morma (O) [morma] upper section of the *gorfa* milk container; lit. "neck"

mooyyee qayyaa (O) [moːjːeː k'ajːaː] type of small container for aromatic butter

muda (M) [mudá] small iron pick

muqe (G) [muk'ə] bamboo (A. [mək'a] "reed") and objects made from bamboo

mutaa (O) [muta:] awl

mutaa midaa (O) [muta: mida:] awl with a notch cut into its point; lit. "the awl to make"

mutaa waraansaa (O) [muta: wara:nsa:] sharp awl; lit. "the awl of the hole"

mweyet (G) [mwəjət] initiated Gurage girls' age-group and male ritual experts of the cult

nafatahana (H) [nafatahana] "We have opened up to you," an example of an inscription that may be woven into a basket

nefwre (G) [nəfwrə] a caste group of blacksmiths; a blacksmith

net'ala (Ga) [nət'ala] fine, thin, gauzelike cloth (worn as clothing) (A. [nət'əla])

net'ela (A) [nət'əla] locally woven textile that is some-times used as a painting surface (Ga. [nət'ala])

nibab bet (A) [nɨbab bet] first level of church edu-cation; lit. "houseof reading"

nug (A) [nug] plant cultivated for its seeds, from which oil is extracted (Guizotia abyssinica)

oobrisa (O) [o:brisa] decorative cross-stitching on basketry

oobrisa looni (O) [o:brisa lo:ni] cross-stitching pat-tern: "obriis of the cattle"

oobrisa qeenc'a tarri (O) [o:brisa k'e:nč'a tar:i] cross-stitching pattern: "obriis of the dik-dik hoof"

okollee (O) [okol:e:] fiber derived from the root of a small tree and used to weave basketry containers

okolee (O) [okole:] milk and water container made from giraffe skin

okolee qadaadaa (O) [okole: k'ada:da:] okolee with a wooden lid and leather-strap holder; lit. "lid of okolee"

oor (H) [o:r] the "good" side of the basket

oorqa (Ga) [urk'a] mud

ottuwa (W) [ot:uwa] pot used for boiling food

qada (M) [k'áda] type of gourd container

qadaada (O) [k'ada:da] lid

qadaada ciicoo (O) [k'ada:da č'i:č'o:] lid of the ciicoo milk container

qadaada gorfa (O) [k'ada:da gorfa] lid of the gorfa milk container

qajach (M) [k'aǰáč] fresh, unused gourd

qana (G) [k'ana] builders of traditional houses

qanta (W) [k'anta] brown

qararrii (O) [k'arar:i:] type of tree (Sterculia africana)

qaraych (M) [k'arajč] type of tree (Lippia grandifolia Hochst.)

qebele (A) [k'əbəle] local administrative unit, precinct

qeeh (H) [k'e:h] red

qeeha t'ey (H) [k'e:ha t'əj] "red and black," a term used for dyed grass

qengeta (A) [k'əngeta] individual responsible for the priests who stand on the right side of the altar during mass

qenyazmach (A) [k'əɲazmač] traditional minor title in the imperial army and bureaucracy; lit. "comman-der of the right"

qerch'at (G) [k'ərč'at] large bamboo basket (A. [k'ɨr-č'at])

qerma (H) [k'ərma] barley stalks used for wrapping the coil of a basket

qes (A) [k'es] priest in the Ethiopian Orthodox Church

qes gebez (A) [k'es gəbəz] priest responsible for arranging the church service

qiddase bet (A) [k'ɨdase bet] second level of church education; lit. "house of mass"

qiddus (A) [k'ɨd:us] saint

qine (A) [k'ɨne] liturgical poetry

qocho (A) [k'očo] staple food made from enset

qolo (G) [k'olo] roasted barley

qoraasuma (O) [k'ora:suma] hot charcoal of aromatic woods

qoraasuu (O) [k'ora:su:] the process of cleaning containers

qurur (G) [k'urur] small bamboo basket

qut'ur fetah (H) [k'ut'ur fətah] basket pattern: "tie and release"

qwanta (G) [k'wanta] two-legged benchlike seat

ras (A) [ras] politico-military title second only to *negus*, "king"

retech (M) [reteč] large clay roasting plate

riftoo (O) [rifto:] horizontal band on the *gorfa* milk container

sadi (A) [sadi] type of earring consisting of three silver "bulbs"

samamwa (G) [samamwa] male assistant to the leader of the Gurage *demwamwit* fertility cult

satya (W) [satja] small pottery serving bowl

sebat-bet (G, A) [səbat bet] traditional confederation of Gurage groups; lit. "seven houses"

sebisa (G) [səbisa] implement for scraping *enset*

seeno meetsa (Ga) [sino mitsa] post located at the back end of the loom

seephani (O) [se:p'ani] leather straps used to suspend containers

seera (O) [se:ra] law

sef (G) [səf] basket container for serving *qolo*

sehna segaari (H) [səhna səga:ri] small plate

s'enas'il (A) [s'ənas'il] sistrum

sera (G) [sera] burial association; lit. "law, custom"

set birr (A) [set bir:] Ethiopian name for the Maria Theresa thaler; lit. "woman silver"

shalo (Ga) [šalo] threads running the width of the loom (weft)

shat (G) [šat] bamboo granary

shay (Ga) [šaj] tea (A. [šaj])

shektin (M) [šèktin] beauty, aptness

shifta (A) [šifta] renegade or outlaw

shola (A) [šola] sycamore tree (*Ficus sycomorus*)

shuhum (H) [šuhum] boiled grain

soodduu (O) [so:d:u:] Borana ritual commemorating a death

soroora (O) [soro:ra] wooden container for liquids

sugud (H) [sugud] plain, undecorated basket for measuring grain

sunbelt (W) [sunbelt] savanna grass

sutri nedeba (H) [sutri nədəba] seat situated to the left of the entrance in the *gidiir gaar* that functions as

the sleeping area for the owner of the house

suxaa (O) [sut'a:] fiber derived from *qararrii* tree (*Sterculia africana*) and used to weave containers

tabot (A) [tabot] representation of the Ark of the Covenant, which is considered necessary to render a church holy in Ethiopian Orthodox Christianity

t'alla (A) [t'əl:a] beer

tebir (G) [təbir] woven bamboo mat, sometimes used as a door

t'ef (A) [t'ef] indigenous highland cereal grain (*Eragrostis tef*) used to make *injera*

t'ej (A) [t'əĭ] honey-wine

t'ej bet (A) [t'əĭ bet] drinking house, place where *t'ej* is served

t'eqesha (G) [t'ək'əša] legless, round sitting board

t'equye (G) [t'ək'ujə] round container basket made from bamboo

t'ey (H) [t'əj] black

t'ibeb (Ga) [t'ibeb] inlay border design on the *net'ala* (A. [t'ɨbəb])

t'ibs (A) [t'ɨbs] roasted meat

t'ihin (H) [t'ihin] refined weaving

t'imqet (A) [t'ɨmk'ət] baptism; the Ethiopian Orthodox festival day (19 January) celebrating the baptism of Jesus Christ

t'it nedeba (H) [t'i:t nədəba] seat in the *gidiir gaar* where "ordinary" people sit; lit. "small seat"

toh toh (H) [toh toh] unrefined weaving, used mainly for tourist baskets

tubba (Ga) [tub:a] 1.5 skeins of cotton thread

tumtuu (O) [tumtu:] blacksmith

ukhaat moot (H) [uxa:t mo:t] basket used for holding bread

urit (M) [urit] ironworker, blacksmith

uuf harda (H) [u:f harda] basket pattern: "footprint of a bird"

waata (O) [wa:ta] ritual assistant belonging to the hunter-gatherer caste

wagoombo mazewur (Ga) [wago:mbo mazewur] hand-held warping reel

wanza (A, G) [wanza] type of hardwood (*Cordia africana*)

waq (G) [wak'] the sky god

waqari (H) [wak'əri] type of pendant necklace produced in Harer; lit. "beehive" (its shape is reminiscent of a beehive)

waqema (G) [wak'ema] washing bowl

wariiq (H) [wariːk'] green

wasfi (H) [wasfi] awl used for weaving baskets

waskembaay (H) [waskəmbaːj] conical basketry lid

watar (G) [watar] boardlike implement for scraping *enset*

weka (G) [wəka] supporting beams for the central pole of a house

weleba (G) [wələba] ordinary Gurage not of caste group

wenet (G) [wənət] two-pronged digging stick

weskembya (G) [wəskəmbja] low table

wet' (A) [wət'] stew, sauce with hot pepper

wezgeb (G) [wəzgəb] bamboo door

wirer (G) [wɨrər] type of wood (*Clausena anisata*)

wiyiyyit (A) [wɨjɨjːit] pickup truck with a cab mounted on the back and used as a taxi in Addis Ababa and its environs

wonderashay (Ga) [wonderašaj] beam of loom around which the finished woven cloth is wound

woshi (M) [wóši] basketry plate

wuqab (G) [wuk'ab] wooden symbol of a sacred area

yachinya (G) [jačɨnjə] single-pronged, iron-tipped digging stick

yebeser ich'e (G) [jəbəsər ič'ə] wooden bowl with subdivision, used in the preparation of minced meat (*besir* "meat")

yechay meetsa (Ga) [ječaj meːtsa] post located near the weaver's seat

yechochepwa ich'e (G) [jəčočəpwa ič'ə] end piece used in chopping *enset*

yeew mager (G) [jəew magər] salt-lick trough for animals

yegama mweyet [jəgama mwəjət] male *mweyet*

yegibir yiwerepwe (G) [jəgɨbɨr jɨwərəpwə] small cupboard (*gibir*, "object," "tool")

yegir waqema (G) [jəgɨr wak'ema] foot-washing bowl

yejoka (G) [jəǰoka] traditional Gurage council of elders with a judiciary and parliamentary role

yekuraz yiwerepwe (G) [jəkuraz jɨwərəpwə] oil lamp stand (*kuraz*, "oil lamp")

yesin ich'e (G) [jəsin ič'ə] coffee cup tray (*sin*, "cup")

yesin yiwerepwe (G) [jəsin jɨwərəpwə] coffee cup stand (*sin*, "cup")

yewey demam (G) [jəwəj dəmam] male leader of the Gurage *demwamwit* fertility cult

yezenbore senda (G) [jəzənborə sənda] knife used to chop *enset*

zarzarach (M) [zarzarač] basketry beer sieve

zebangiba (G) [zəbangiba] implement for scraping *enset*

zebennya (A) [zəbəɲːa] guard, guardian, watchman, keeper

zeeto (Ga) [zeːto] animal-skin cape worn by a *halaka*

zema (A) [zema] religious music

zembora (G) [zəmbora] wooden platform for chopping *qocho*, a staple food made from *enset*

zengee (Ga) [zeŋeː] panel of woven cloth

zhera (G) [ʒəra] ordinary Gurage not of caste group

zigba (A, G) [zɨgba] type of hardwood from a cedar-like tree (*Podocarpus gracilior*)

zimmare (A) [zɨmːare] hymns sung at the end of the Mass

REFERENCES

Abbink, J.

1987 "A Socio-cultural Analysis of the Beta Israel as an 'Infamous Group' in Traditional Ethiopia." *Sociologus* 37 (2):140–54.

1990 "Tribal Formation on the Ethiopian Fringe: Toward a History of the 'Tishana.'" *Northeast African Studies* 12 (1):21–42.

1992a "An Ethno-historical Perspective of Me'en Territorial Organisation (Southwest Ethiopia)." *Anthropos* 86 (4–6):351–64.

1992b *The Me'en of Southwestern Kafa: Material Culture of an Ethiopian Shifting-Cultivator People.* Addis Ababa: Institute of Ethiopian Studies.

Adamu Amare and Belaynesh Mikael

1970 "The Role of the Church in Literature and Art." In *The Church of Ethiopia: A Panorama of History and Spiritual Life*, edited by Sergew Hable Selassie, pp. 73–80. Addis Ababa: Ethiopian Orthodox Church.

Alaka Imbakom Kalewold

1970 *Traditional Ethiopian Church Education.* Translated by Menghestu Lemma. New York: Teachers College Press.

Aleme Eshete

1982 *The Cultural Situation in Socialist Ethiopia.* Studies and Documents on Cultural Policies. Paris.

Alliance Ethio-Française

1993 *Programme.* May–June. Addis Ababa: n.p.

Almeida, Manoel de

1954 *Some Records of Ethiopia 1593–1646 Being Extracts from The History of High Ethiopia or Abassia by Manoel de Almeida together with Bahrey's History of the Galla.* Translated and edited by C. F. Beckingham and G. W. B. Huntingford. London: Hakluyt Society.

Alvares, Francisco

1961 *The Prester John of the Indies: A True Relation of the Lands of the Prester John Being the Narrative of the Portuguese Embassy to Ethiopia in 1520 Written by Father Francisco Alvares.* Translation of Lord Stanley of Alderley (1881), revised and edited with additional material by C. F. Beckingham and G. W. B. Huntingford. 2 vols. London: Hakluyt Society.

Amarech Agedew

1983 "The Status and Role of Women in Wolaita Socio-cultural System." Senior essay, Addis Ababa University.

Ambaye Degefa

1997 "Social Organization and Status of Occupational Groups: The Case of Woodworkers in Megnako and Gambela Villages, Woliso District, South-Western Shewa." Master's thesis, Addis Ababa University.

Amborn, H.

1990 *Differenzierung und Integration: Vergleichende Unter-*

suchungen zu Spezialisten und Handwerkern in südäthiopischen Agrargesellschaften. Munich: Trickster Verlag.

Anonymous

1957 "Empress Menen Handicraft School." *Ethiopia Observer* 1 (3):80–84.

Anselmi, Ines

1993 "DAK'ART: Erste Internationale Biennale für zeitgenössische Kunst in Senegal—Ein Anfang mit Mühen." *WochenZeitung* (Zurich), no. 3 (22 Jan.):19.

Asefa Hailemariam and Helmut Kloos

1993 "Population." In *The Ecology of Health and Disease in Ethiopia*, edited by H. Kloos and Z. A. Zein. Boulder, Colo.: Westview.

Asmarom Legesse

1973 *Gada: Three Approaches to the Study of African Society.* New York: Free Press.

Bahrey

1954 "History of the Galla," in Almeida 1954: 111–29.

Bahru Zewde

1991 *A History of Modern Ethiopia, 1855–1974.* London: James Currey.

Barbour, J., and Wandibba Simiyu, eds.

1989 *Kenyan Pots and Potters.* Nairobi: Oxford University Press in association with the Kenya Museum.

Beaux Arts Magazine

1992 *Dakar 1992—Biennale Internationale des Arts* (Special edition of *Beaux Arts*, Paris).

Belaynesh Michael, S. Chojnacki, and Richard Pankhurst, eds.

1975 *The Dictionary of Ethiopian Biography.* Vol. 1, *From Early Times to the End of the Zagwé Dynasty, c. 1270 A.D.* Addis Ababa: Institute of Ethiopian Studies Museum.

Bender, Wolfgang

1982 *Populäre Malerei und politische Plakate aus Äthiopien.*

Bayreuth: IWALEWA-Haus, Universität Bayreuth.

1989 "Moderne Kunst in die Völkerkundemuseen!" In *Die verborgene Wirklichkeit: Drei äthiopische Maler der Gegenwart*, edited by E. Biasio, pp. 182–96. Zurich: Völkerkundemuseum der Universität Zürich.

Bent, J. Theodore

1893 *The Sacred City of the Ethiopians.* London: Longmans, Green, and Co.

Benzing, Brigitta

1988a "Auseinandersetzung mit der Wirklichkeit—Moderne äthiopische Malerei im Kulturzentrum der Universität von Addis Abeba." *Äthiopien Magazin, Presseabteilung der Botschaft der Volksdemokratischen Republik Äthiopien* (Bonn), Nov., pp. 13–14.

1988b "Popular Paintings." In *Visitors' Manual* (Institute of Ethiopian Studies Museum), edited by E.-D. Hecht and B. Benzing, pp. 113–22. Addis Ababa: Institute of Ethiopian Studies.

1994 "Investigations into Contemporary Ethiopian Art, with Special Reference to Painting." In *Proceedings of the Eleventh International Conference of Ethiopian Studies*, edited by B. Zewde, R. Pankhurst, and T. Beyene, vol. 2, pp. 29–39. Addis Ababa: Institute of Ethiopian Studies, Addis Ababa University.

Berhanu Abbaba

1961 "La peinture éthiopien, point de vue d'un éthiopien." *Cahiers d'Études Africaines* 2 (1):160–65.

Biasio, Elisabeth

1989 *Die verborgene Wirklichkeit: Drei äthiopische Maler der Gegenwart.* Zurich: Völkerkundemuseum der Universität Zürich.

1991 "Bilder aus Äthiopien—Zu einer Ausstellung in Addis Ababa." *Basler Magazin, Politisch-kulturelle Wochenend-Beilage der Basler Zeitung* 262 (45):12–13.

1993 "Twentieth-Century Ethiopian Paintings in Traditional Style: 'Traditional,' 'Folk,' or 'Popular' Art?" Paper presented at the Third International Conference on the History of Ethiopian Art, Addis Ababa, 9–11 Nov.

1994 "Art, Culture, and Society—Considerations on Ethiopian Church Painting Focussing on the 19th Century." In *Proceedings of the Eleventh International Conference of Ethiopian Studies*, edited by B. Zewde, R. Pankhurst, and T. Beyene, vol. 2, pp. 541–62. Addis Ababa: Institute of Ethiopian Studies, Addis Ababa University.

Bourg de Bozas, P. M. R. du

1906 *De la mer Rouge à l'Atlantique à travers l'Afrique tropicale (Octobre 1900–Mai 1903)*. Paris: F. R. de Rudeval.

Brus, René

1975 "Ethiopian Crowns." *African Arts* 8 (4):8–13, 84.

Buchholzer, J.

1955 *The Land of the Burnt Faces*. Translated by M. Michael. London: Arthur Barker.

Budge, E. A. Wallis

1928 *The Book of the Saints of the Ethiopian Church: A Translation of the Ethiopic Synaxarium . . . made from the Manuscripts Oriental 660 and 661 in the British Museum*. 4 vols. Cambridge: Cambridge University Press.

Bureau, Jacques

1975 "Le statut des artisans en Éthiopie." In *Éthiopie d'aujourd'hui: La terre et les hommes*, pp. 38–44. Paris: Musée de l'Homme.

Caputo, Robert

1983 "Ethiopia: Revolution in an Ancient Empire." *National Geographic* 163 (5):615–45.

Cassièrs, Anne

1988 "Mercha: An Ethiopian Woman Speaks of Her Life." In *Life Histories of African Women*, edited by Patricia W. Romero, pp. 159–93. London: Ashfield Press.

Chauvy, Laurence

1993 "Biennale de Dakar—L'art à l'ombre des baobabs." *Journal de Genève*, 9 Jan., p. 23.

Chojnacki, Stanislaw

1964 "Short Introduction to Ethiopian Painting." *Journal of Ethiopian Studies* 2 (2):1–11.

1971 "Notes on Art in Ethiopia in the 16th Century: An Enquiry into the Unknown." *Journal of Ethiopian Studies* 9 (2):21–97.

1973a "The Iconography of Saint George in Ethiopia." Part 1. *Journal of Ethiopian Studies* 11 (1):57–73.

1973b "The Iconography of Saint George in Ethiopia." Part 2. *Journal of Ethiopian Studies* 11 (2):51–93.

1973c "A Survey of Modern Ethiopian Art." *Zeitschrift für Kulturaustausch* (Sonderausgabe äthiopien, Institut für Auslandsbeziehungen, Stuttgart), pp. 84–94.

1974 "The Iconography of Saint George in Ethiopia." Part 3, "St. George the Martyr." *Journal of Ethiopian Studies* 12 (1):71–132.

1975 "Note on the Early Iconography of St. George and Related Equestrian Saints." *Journal of Ethiopian Studies* 13 (2):39–55.

1978a "Notes on the Ethiopian Traditional Art: The Last Phase." *Ethnologische Zeitschrift Zürich* 2:65–81.

1978b *The Rayfield Collection of Ethiopian Art*. Toronto: Art Gallery of York University.

1983a *Major Themes in Ethiopian Painting: Indigenous Developments, The Influence of Foreign Models, and Their Adaptation from the 13th to the 19th Century*. Wiesbaden: Franz Steiner Verlag.

1983b "A Note on the Costumes in 15th- and Early 16th-Century Paintings: Portraits of the Nobles and Their Relation to the Images of Saints on Horseback." In *Ethiopian Studies—*

Dedicated to Wolf Leslau, edited by S. Segert and A. J. E. Bodrogligeti, pp. 521–53. Wiesbaden: Otto Harrassowitz.

Clapham, C.

1988 *Transformation and Continuity in Revolutionary Ethiopia.* Cambridge: Cambridge University Press.

Coon, Carleton S.

1935 *Measuring Ethiopia and Flight into Arabia.* Boston: Little, Brown, and Co.

Coote, Jeremy, and Anthony Shelton, eds.

1992 *Anthropology, Art, and Aesthetics.* Oxford: Clarendon Press.

Crummey, Donald

1994 "Personality and Political Culture in Ethiopian History: The Case of Emperor Téwodros." Paper presented at the 12th International Conference of Ethiopian Studies, East Lansing, Mich., 5–10 Sept.

Dahl, Gudrun

1990 "Mats and Milk Pots: The Domain of Borana Women." In *The Creative Communion: African Folk Models of Fertility and the Regeneration of Life*, edited by A. Jacobson-Widding and E. W. van Beek, pp. 129–36. Uppsala: Acta Universitatis Upsaliensis.

DeCarbo, E. A.

1977 "Artistry among Kasem-Speaking Peoples of Northern Ghana." Ph.D. dissertation, Indiana University, Bloomington.

Diop, Cheikh Anta

1974 *The African Origin of Civilization—Myth or Reality.* Translated by Mercer Cook. New York: L. Hill.

Duri Mohammed

1955 "The Mugads of Harar." *Bulletin of the Ethnological Society* 4:15–19.

Ephraim Isaac

1968 *The Ethiopian Church.* Boston: Henry N. Sawyer.

Esbroeck, Michel van

1991 "Saint Mercurius of Caesarea." In *The Coptic Encyclopedia*, edited by A. S. Atiya, vol. 5, pp. 1592–94. New York: Macmillan.

Esseye Gebre Medhin

1991 "El Artista Zerihun Yetmgeta." In *Cuarta Bienal de la Habana, 1991*, pp. 184–85. Habana: Centro Wifredo Lam.

Fagg, William Buller, and Picton, John

1970 *The Potters in Africa.* London: British Museum Publications.

wa Gacheru, Margaretta

1993 "Work of Two Worlds Wins the Top Spot." *Daily Nation* (Nairobi), 26 Nov., p. 10.

Garrard, Timothy

1989 *Gold of Africa: Jewellery and Ornaments from Ghana, Côte d'Ivoire, Mali, and Senegal in the Collection of the Barbier-Mueller Museum.* Munich: Prestel-Verlag.

Gebru Wolde

1973 "A Study of the Attitude of the Gurage towards Fuga (Low Caste Occupational Groups)." Senior essay, School of Social Work, Addis Ababa University.

Gell, A.

1992 "The Technology of Enchantment and the Enchantment of Technology." In Coote and Shelton, 1992: 40–63.

Gerster, Georg

1970 *Churches in Rock: Early Christian Art in Ethiopia.* London: Phaidon.

Getachew Haile

1991 "Ethiopian Saints." In *The Coptic Encyclopedia*, edited by A. S. Atiya, vol. 4, pp. 1044–56. New York: Macmillan.

Girma Fisseha and Walter Raunig

1985 *Mensch und Geschichte in äthiopiens Volksmalerei.* Innsbruck: Pinguin-Verlag; Frankfurt am Main: Umschau-Verlag.

Girma Fisseha and Raymond A. Silverman

1994 "Two Generations of Traditional Painters: A Biographical Sketch of Qangeta Jembere Hailu and Marqos Jembere." In *New Trends in Ethiopian Studies: Papers of the 12th International Conference of Ethiopian Studies*, edited by H. G. Marcus, pp. 369–79. Lawrence, N.J.: Red Sea Press.

Girma Kidane

1989 "Four Traditional Ethiopian Painters and Their Life Histories." In *Proceedings of the First International Conference on the History of Ethiopian Art*, edited by R. Pankhurst, pp. 72–77. London: Pindar Press.

Gonzáles Mora, Magda J.

1992 "Afrikas Kunst lebt: Nicht nur im Museum." *Partnerschaft* (Schweizer Gesellschaft für Entwicklung und Zusammenarbeit) 129 (Sept.): 6–8.

Graburn, Nelson H. H.

1976 "Introduction: Arts of the Fourth World." In *Ethnic and Tourist Arts: Cultural Expressions from the Fourth World*, edited by N. H. H. Graburn, pp. 1–37. Berkeley and Los Angeles: University of California Press.

Haile Gabriel Dagne

1970 "The Ethiopian Orthodox Church School System." In *The Church of Ethiopia: A Panorama of History and Spiritual Life*, edited by Sergew Hable Selassie, pp. 81–97. Addis Ababa: Ethiopian Orthodox Church.

1988 "The Scriptorium at the Imperial Palace and the Manuscripts of Addis Ababa Churches." In *Proceedings of the Eighth International Conference of Ethiopian Studies, University of Addis Ababa, November 1985*, edited by T. Beyene, vol. 2, pp. 215–23. Addis Ababa: Institute of Ethiopian Studies, Addis Ababa University.

Hakemulder, Roel

1980 *Potters: A Study of Two Villages in Ethiopia*. Addis Ababa: ECA/ILO/SIDA Handicrafts and Small-Scale Industries Unit, African Training and Research Centre for Women, United Nations Economic Commission for Africa.

Hallpike, Christopher

1968 "The Status of Craftsmen among the Konso of Southwest Ethiopia." *Africa* 38 (3):258–69.

Harris, W. Cornwallis

1844 *Highlands of Ethiopia*. New York: J. Winchester New World Press.

Head, Sidney W.

1969 "A Conversation with Gebre Kristos Desta." *African Arts/Arts d'Afrique* 2 (3):20–25.

Hecht, Elisabeth-Dorothea

1969 *The Pottery Collection*. Addis Ababa: Haile Selassie I University, Institute of Ethiopian Studies Museum.

1992 "Basketwork of Harar." *African Study Monographs*, Supplement no. 18:1–39.

Heldman, Marilyn

1989 "An Ewostathian Style and the Gunda Gunde Style in Fifteenth-Century Ethiopian Manuscript Illumination." In *Proceedings of the First International Conference on the History of Ethiopian Art*, edited by R. Pankhurst, pp. 5–14. London: Pindar Press.

1994 *The Marian Icons of the Painter Fre Seyon: A Study in Fifteenth-Century Ethiopian Art, Patronage, and Spirituality*. Wiesbaden: Harrassowitz Verlag.

Heldman, Marilyn, with Stuart C. Munro-Hay

1993 *African Zion: The Sacred Art of Ethiopia*. New Haven: Yale University Press.

Heyer, Friedrich

1971 *Die Kirche äthiopiens*. Berlin: Walter de Gruyter.

Hoben, Allan

1970 "Social Stratification in Traditional Amhara Society." In *Social Stratification in Africa*, edited

by Arthur Tuden and Leonard Plotnicov, pp. 187–224. New York: Free Press.

Italiaander, Rolf

1965 "Hunters, Heroes, Saints." *Scala International*, no. 12:2–7.

Jäger, Otto

1960 "Ethiopian Manuscript Paintings." *Ethiopia Observer* 4 (9):353–91.

Jenkins, Earnestine

1995 "Visual Authority: Charismatic Leadership in a 19th-Century Ethiopian Court." Paper presented at the Tenth Triennial Symposium on African Art, New York, 20–23 Apr.

Johnston, Charles

1844 *Travels in Southern Abyssinia through the Country of Adal to the Kingdom of Shoa.* 2 vols. London: J. Madden.

Jules-Rosette, Bennetta

1984 *Messages of Tourist Art: An African Semiotic System in Comparative Perspective.* New York: Plenum Press.

Kaplan, Steven

1992 *The Beta Israel (Falasha) in Ethiopia: From Earliest Times to the Twentieth Century.* New York: New York University Press.

Kasfir, Sidney

1992 "African Art and Authenticity: A Text with a Shadow." *African Arts* 25 (2):40–53, 96–97.

Keller, C.

1904 "Über Maler und Malerei in Abessinien." *Jahresbericht der Geographisch-Ethnographischen Gesellschaft in Zürich*, pp. 21–38.

Kennedy, Jean

1992 *New Currents, Ancient Rivers: Contemporary African Artists in a Generation of Change.* Washington: Smithsonian Institution Press.

Kifle Beseat

1970 *An Introduction to Abstract Painting in Ethiopia.* Addis Ababa.

Lange, Werner J.

1982 *History of the Southern Gonga.* Wiesbaden: Franz Steiner Verlag.

Lepage, Claude

1977 "Esquisse d'une histoire de l'ancienne peinture éthiopienne du Xᵉ au XVᵉ siècle." *Abbay*, no. 8:59–94.

Leroy, Jules

1967 *Ethiopian Painting in the Late Middle Ages and during the Gondar Dynasty.* New York: Praeger.

1970 "Ethiopian Painting in the Middle Ages." In Gerster 1970: 61–68.

Leslau, Wolf

1950 *Ethiopic Documents: Gurage.* Viking Fund Publications in Anthropology, no. 14. New York.

1964 "An Ethiopian Argot of a Gurage Secret Society." *Journal of African Languages* 3 (1):52–65.

Leus, T.

1988 "Borana-English." Unpublished dictionary, Catholic Church, Dadim (Yavello).

Levine, Donald N.

1965 *Wax and Gold: Tradition and Innovation in Ethiopian Culture.* Chicago: University of Chicago Press.

1974 *Greater Ethiopia: The Evolution of a Multiethnic Society.* Chicago: University of Chicago Press.

Lewis, Herbert S.

1965 *A Galla Monarchy: Jimma Abba Jifar, Ethiopia, 1830–1932.* Madison: University of Wisconsin Press.

Maquet, Jacques

1979 *Introduction to Aesthetic Anthropology.* Malibu: Undena Publications.

Marcus, Harold

1994 *A History of Ethiopia.* Berkeley and Los Angeles: University of California Press.

Menzel, Peter

1995 *Material World, a Global Family Portrait.* San Francisco: Sierra Club Books.

Mérab, Docteur [Etienne]

1921–29 Impressions d'Éthiopie: L'Abyssinie sous Ménélik II. 3
 vols. Paris: H. Libert and Ernest Leroux.

Mercier, Jacques

1979 Zauberrollen aus Äthiopien—Kultbilder magischer
 Riten. Munich: Prestel-Verlag.

1988 Asrès, le magicien éthiopien: Souvenirs, 1895–1985.
 Paris: Éditions Jean-Claude Lattès.

Ministry of Culture and Sports Affairs et al.

1990 Art Exhibition of 55 Contemporary Ethiopian
 Artists. (Exhibition catalog in Amharic.)
 Addis Ababa.

1991 Ethiopia in Fine Arts. (Exhibition catalog.)
 Addis Ababa.

Molesworth, H. D.

1957 "Painting in Ethiopia: A Reflection of
 Medieval Practice." In Fritz Saxl, 1890–1948:
 A Volume of Memorial Essays from His Friends in
 England, edited by D. J. Gordon, pp. 359–69.
 London: T. Nelson.

Moore, Eine

1973 "Ethiopian Crosses." In Religiöse Kunst Äthi-
 opiens, pp. 66–90. Stuttgart: Institut für
 Auslandsbeziehungen.

1989 "Ethiopian Crosses from the 12th to the
 16th Century." In Proceedings of the First Inter-
 national Conference on the History of Ethiopian Art,
 edited by R. Pankhurst, pp. 110–14. Lon-
 don: Pindar Press.

Munro-Hay, Stuart C.

1989 Excavations at Aksum: An Account of Research at the
 Ancient Ethiopian Capital Directed in 1972–74
 by the Late Dr. Neville Chittick. London: British
 Institute in Eastern Africa.

1991 Aksum: An African Civilisation of Late Antiquity.
 Edinburgh: Edinburgh University Press.

1993 "Aksumite Coinage." In Heldman 1993:
 101–16.

Murray, Edmund P.

1970 "Art Calls Art." Ethiopia Mirror 8 (4):46.

Musée National des Arts d'Afrique et d'Océanie

1992 Le roi Salomon et les maîtres du regard: Art et médecine
 en Éthiopie. Paris: Éditions de la Réunion des
 Musées Nationaux.

Natsoulas, Theodore

1977 "The Hellenic Presence in Ethiopia: A Study
 of a European Minority in Africa (1740–
 1936)." Abba Salama 8:5–230.

Norden, Hermann

1930 Africa's Last Empire: Through Abyssinia to Lake Tana
 and the Country of the Falasha. London: H. F. &
 G. Witherby.

Pankhurst, Richard

1961 "Status, Division of Labour, and Employ-
 ment in Nineteenth-Century and Early
 Twentieth-Century Ethiopia." Bulletin of the
 Ethnological Society 2 (1): 7–57.

1966 "Some Notes for a History of Ethiopian
 Secular Art." Ethiopia Observer 10 (1): 5–80.

1971 "The Beginnings of Ethiopian Secular Art."
 In Colloquium on Negro Art, pp. 85–98. Dakar:
 Society of African Culture.

1979 "The Kwer'ata Resu: The History of an
 Ethiopian Icon." Abba Salama 10: 169–87.

1989a "The Battle of Adwa (1896) as Depicted
 by Traditional Ethiopian Artists." In Proceed-
 ings of the First International Conference on the His-
 tory of Ethiopian Art, edited by R. Pankhurst,
 pp. 78–103. London: Pindar Press.

1989b "Secular Themes in Ethiopian Ecclesiastical
 Manuscripts: A Catalogue of Illustrations
 of Historical and Ethnographic Interest in
 the British Library." Journal of Ethiopian Studies
 22: 3–64.

1991 "Secular Themes in Ethiopian Ecclesiastical
 Manuscripts." Part 2. "Catalogue of Illustra-
 tions of Historical and Ethnographic Inter-
 est. . . ." Journal of Ethiopian Studies 24: 47–69.

1992 "Secular Themes in Ethiopian Ecclesiastical
 Manuscripts." Part 3. "A Catalogue of Man-

uscript Illustrations of Historical and Ethnographic Interest in the Library of the Institute of Ethiopian Studies." *Journal of Ethiopian Studies* 25: 49–72.

1993 "Wanted! A Museum of Modern Ethiopian Art!" *Addis Tribune*, no. 29 (13 May): 15.

1994 "Emperor Tewodros II and the Battle of Mäqdäla (1868) as Depicted in Ethiopian Popular Art." In *Études éthiopiennes: Actes de la X^e Conférence internationale des études éthiopiennes*, edited by C. Lepage, vol. 1, pp. 280–93. Paris: Société Française pour les Études Éthiopiennes.

Pankhurst, Richard, and Rita J. Pankhurst

1979 "Ethiopian Ear-Picks." *Abbay*, no. 10: 101–10.

Pankhurst, Sylvia, and Richard K. P. Pankhurst

1957 *Ethiopia Observer* 1 (6). (Special issue on the Queen of Sheba.)

Parkyns, Mansfield

1966 *Life in Abyssinia, Being Notes Collected during Three Years Residence and Travels in That Country.* 2d ed. 1868. Reprint, London: Frank Cass.

Pearce, Nathaniel

1820 "A Small but True Account of the Ways and Manners of the Abyssinians." *Transactions of the Literary Society of Bombay* 2: 15–60.

Perczel, Csilla Fabo

1978 "The Queen of Sheba Legend in Ethiopian Art." *Art International* 22 (5/6): 6–11.

1981 "Ethiopian Crosses at the Portland Art Museum." *African Arts* 14 (3): 52–55, 90.

Pittard, Eugène

1928 "Les arts populaires de l'afrique: Quelques peintures d'Abyssinie." *Archives suisses d'anthropologie générale* 5 (1): 87–103.

Plant, Ruth

1973 "Painter's Pattern Book, Makelle, Tigre Province, Ethiopia." *Ethiopia Observer* 16 (3): 133–40.

Pofliet, Leo

1978 *Traditional Zairian Pottery.* Munich: Galerie F. Jahn.

Powell-Cotton, P. H. G.

1902 *A Sporting Trip through Abyssinia.* London: Rowland Ward.

Prussin, Labelle

1987 "Gabra Containers." *African Arts* 20 (2): 36–45, 81–82.

Raunig, Walter

1989 "Ethiopian Folk Art Painting." In *Proceedings of the First International Conference on the History of Ethiopian Art*, edited by R. Pankhurst, pp. 69–71. London: Pindar Press.

Ravenhill, P. L.

1991 *The Art of the Personal Object.* Washington: National Museum of African Art, Smithsonian Institution.

Rey, Charles F.

1923 *Unconquered Abyssinia As It Is To-Day.* London: Seeley, Service & Co.

Ricci, Lanfranco

1986 "In margine a una mostra di dipinti etiopici tradizionali." *Annali dell'Istituto Universitario Orientale (Napoli)* 46 (2): 277–90.

1989 *Pittura etiopica tradizionale.* Rome: Istituto Italo-Africano.

Rice, Prudence

1987 *Pottery Analysis.* Chicago: University of Chicago Press.

Sahlström, Berit

1990 "Political Posters in Ethiopia and Mozambique—Visual Imagery in a Revolutionary Context." *Acta Universitatis Upsaliensis, Figura*, n.s., 24. Uppsala.

Salt, Henry

1967 *A Voyage to Abyssinia, and Travels into the Interior of that Country, Executed under the British Government in the Years 1809 and 1810.* 1814. Reprint, London: Frank Cass.

Scholler, Heinrich, and Girma Fisseha
1985 "Ethiopian Open Air Courts in Popular
 Paintings." *Afrika und Übersee* 68 (2): 161–85.

Sebhat G. Egziabher
1983 "Man behind the Brush." *Quarterly Yekatit*
 (Addis Ababa) 6 (3): 18–20.

Sergew Hable Selassie
1972 *Ancient and Medieval Ethiopian History to 1270.*
 Addis Ababa: United Printers.
1992 "The Monastic Library of Däbrä Hayq." In
 Orbis Aethiopicus, edited by P. O. Scholz, vol.
 1, pp. 243–58. Albstadt: Karl Schuler Pub-
 lishing.

Seyoum Wolde
1989 "The Profile of Writings on Ethiopian
 Mediaeval Christian Art." In *Proceedings of the
 Eighth International Conference of Ethiopian Studies,
 Addis Ababa University, 1984*, edited by T. Bey-
 ene, vol. 2, pp. 165–71. Huntington: Elm.

Shack, William
1964 "Notes on Occupational Castes among the
 Gurage of South-West Ethiopia." *Man* 64
 (54): 50–52.
1966 *The Gurage: A People of the Ensete Culture.* London:
 Oxford University Press.
1974 *The Central Ethiopians: Amhara, Tigrina, and Related
 Peoples.* London: International Africa Institute.

Silverman, Raymond, and Neal Sobania
n.d.-a "Ethiopian Traditions of Creativity. 'Art' or
 'Handicraft'?" *Proceedings of the Third Interna-
 tional Conference on the History of Ethiopian Art*,
 edited by R. Pankhurst. Forthcoming.
n.d.-b "Mining a Mother-Lode: Information Con-
 cerning Silver- and Goldworking in the
 Traveler Accounts of Highland Ethiopia." In
 Festschrift in Honor of Richard Pankhurst, edited by
 R. Grierson. Forthcoming.

Simoons, Frederick J.
1960 *Northwest Ethiopia: Peoples and Economy.* Madison:
 University of Wisconsin Press.

Taye Tadesse
1991 *Short Biographies of Some Ethiopian Artists.* Addis
 Ababa: Kuraz Publishing Agency.

Teshome G. Wagaw
1979 *Education in Ethiopia: Prospect and Retrospect.* Ann
 Arbor: University of Michigan Press.

Todd, David
1978 "The Origins of Outcastes in Ethiopia:
 Reflections on an Evolutionary Theory."
 Abbay, no. 9: 145–58.

Todd, J.
1985 "Iron Production among the Dimi of Ethi-
 opia." In *African Iron-Working, Ancient and Tradi-
 tional*, edited by R. Haaland Press and P. L.
 Shinnie, pp. 88–101. Bergen and Oslo:
 Norwegian University.

Tsehai Berhane-Selassie
1991a "Ethiopia: Country Annex and Case Stud-
 ies." In *Reducing People's Vulnerability to Famine: An
 Evaluation of Band Aid and Live Aid Financed Projects
 in Africa*, edited by Luther Banga. Douala,
 Cameroon: PAID/GS.
1991b "Gender and Occupational Potters in
 Wolayta: Imposed Femininity and 'Mysteri-
 ous Survival' in Ethiopia." In *Gender Issues in
 Ethiopia*, edited by Tsehai Berhane-Selassie,
 pp. 15–30. Addis Ababa: Institute of Ethi-
 opian Studies, Addis Ababa University.
1994a *Social Survey of the Soil Conservation Areas Dizi,
 Anjeni, and Gununo (Ethiopia).* Soil Conservation
 Research Project, Research Report 24. Uni-
 versity of Berne in association with the
 Ministry of Natural Resources Development
 and Environment Protection, Ethiopia, and
 the United Nations University.
1994b *Early Marriage in Ethiopia.* Geneva and Addis
 Ababa: Inter-Africa Committee on Tradi-
 tional Practices Affecting the Health of
 Women and Children.
1994c "The Wolayta Conception of Inequality, or

Is It Inclusiveness and Exclusiveness?" In *Proceedings of the Eleventh International Conference of Ethiopian Studies*, edited by B. Zewde, R. Pankhurst, and T. Beyene, vol. 2, pp. 341–58. Addis Ababa: Institute of Ethiopian Studies, Addis Ababa University.

Vogel, Susan

1988 *Art / Artifact: African Art in Anthropology Collections.* New York: Center for African Art.

1991 *Africa Explores—20th Century African Art.* New York: Center for African Art.

Von Gagern, A., et al.

1974 *Ostafrika—Figur und Ornament.* Hamburg: Museum für Völkerkunde.

Wilding, R.

1985 "A Check-List of Plants Used in the Borana Economy." International Livestock Centre for Africa, Addis Ababa. Mimeo.

Wondmagegnehu Aymro and Joachim Motovu

1970 *The Ethiopian Orthodox Church.* Addis Ababa: Ethiopian Orthodox Mission.

Wylde, A. B.

1888 *'83 to '87 in the Soudan.* 2 vols. London: Remington.

1901 *Modern Abyssinia.* London: Methuen.

Yohannes Tessema

1964 "Agricultural Scenes." *Ethiopia Observer* 7 (3): 202–7.

Zervos, Adrien

1936 *L'empire d'Éthiopie: Le miroir de l'Éthiopie moderne, 1906–1935.* Alexandria, Egypt: Imprimerie de l'École Professionnelle des Frères.

CONTRIBUTORS

Jon Abbink

Abbink studied anthropology and history at the Universities of Nijmegen and Leiden (the Netherlands). His dissertation research was on the Ethiopian immigrants in Israel. In 1989–92, he was a postdoctoral research fellow of the Royal Netherlands Academy of Science and engaged in an extensive field study of southern Ethiopian ethnic groups in the Kefa region. His interests are, apart from Ethiopian studies, in the history and theory of anthropology, interpretive approaches, and applied anthropology. He has taught at the University of Amsterdam and at the University of Nijmegen and is now senior researcher at the African Studies Centre in Leiden.

Jon Abbink with a Me'en elder.

Ahmed Zekaria

Ahmed received his bachelor's degree in history at Addis Ababa University (1979) and his master's degree in ethnology and museum ethnography at Oxford University (1989). He has curated a number of exhibitions and written several articles dealing with various aspects of Ethiopian culture and history. He is particularly interested in the history and historical preservation of the ancient city of Harer. Ahmed was a lecturer in history before he transferred to the Institute of Ethiopian Studies, Addis Ababa University, and is currently acting head of the museum at the Institute.

Ahmed Zekaria discussing the meaning of the patterns in one of Amina's baskets.

Marco Bassi

Marco Bassi is a social anthropologist specializing in African studies and pastoralism. He carried out field research among the Borana of Kenya in 1983 and 1986 and among the Borana of Ethiopia in 1989 and 1990. In 1992 he received his Ph.D. from the Istituto Universitario Orientale in Naples. He has been working as an applied anthropologist in Ethiopia and is currently teaching in the master's program in social anthropology at Addis Ababa University.

Elisabeth Biasio

Biasio studied ethnology, psychology, and history of religion at the University of Zurich from 1972 to 1978. From 1974 to 1979 she served as assistant curator and since 1979 as curator for Northeast and North Africa and the Near East at the Völkerkundemuseum der Universität Zürich. She is particularly interested in Ethiopian art, especially paintings of the eighteenth to twentieth centuries. Biasio has been conducting research in Ethiopia since 1982 and has curated a number of exhibitions in Zurich and written articles, essays, and catalogs dealing with various aspects of Ethiopian art.

Daniel M. Cartledge

Cartledge, a sociocultural anthropologist and human ecologist, completed his doctorate at the University of Florida in 1995. In 1992 and 1993, he conducted field research to examine issues of land use and agricultural sustainability in the Gamo highlands of Ethiopia with funding from the National Science Foundation and the U.S. Fulbright Program. Currently, Cartledge is a visiting professor of anthropology at Universidade Federal de Sergipe, Brazil. He conducts research on rural development and traditional artisans in the northeast region of Brazil.

Marco Bassi (left) and his assistant, Halake Elema, interviewing Elema.

Fig. 13.4
Elisabeth Biasio and her associate, Peter Gerber, talking with Zerihun in his studio.

Girma Fisseha

Born in Ethiopia, but living in Munich, Germany, since 1974, Girma has long been interested in the art and material cultural of Ethiopia. During the 1960s and early 1970s, he served as a research assistant to Stanislaw Chojnacki, as the latter built the collection of the Museum of the Institute of Ethiopian Studies at Addis Ababa University. Since 1974 he has been the curator for Ethiopia at the Staatliches Museum für Völkerkunde in Munich, where he has organized and prepared catalogs for a number of exhibitions dealing with Ethiopian art and culture.

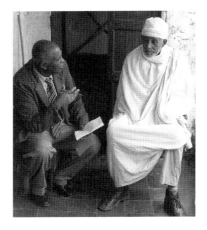

Girma Fisseha talking with Jembere.

Alula Pankhurst

Pankhurst received his B.A. in oriental languages (Arabic and Ge'ez) at Oxford University (1984) and his M.A. (1986) and Ph.D. (1989) in social anthropology at Manchester University. His research and writing have focused on issues of famine and resettlement in Ethiopia. Pankhurst has been teaching in the Department of Sociology, Anthropology, and Social Administration at Addis Ababa University since 1990, where he also served as chair of the department from 1992 to 1994. He is editor of the *Sociology Ethnology Bulletin* (Addis Ababa University).

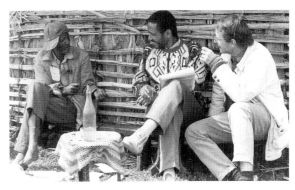

Alula Pankhurst (right) and Worku Nida (center) talking with Menjiye.

Raymond A. Silverman

Silverman is an art historian specializing in the arts of Africa. He received his B.A. in art history at the University of California, Los Angeles (1975), and his M.A. (1977) and Ph.D. (1983) in art history from the University of Washington. He has conducted research and written on the arts of the Akan peoples of Ghana and Côte d'Ivoire. In 1989 he began organizing the exhibition "Ethiopia: Traditions of Creativity," of which this volume is a product. Silverman is currently engaged in an ethnohistorical study of metalworking in the Tigray region of northern Ethiopia. He is associate professor of art history and adjunct curator of African visual culture at Michigan State University.

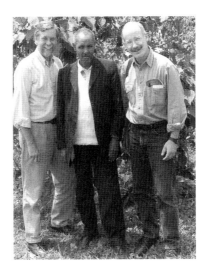

Raymond Silverman (right) with Adamu and Neal Sobania.

Contributors

Neal W. Sobania

Sobania is professor of history and director of International Education at Hope College in Holland, Michigan. His involvement with Ethiopia extends over more than twenty-five years and includes research, writing, and teaching. He teaches courses in African history and culture and has published widely on the history, ecology, and socioeconomic relations of pastoral production systems in Kenya and Ethiopia.

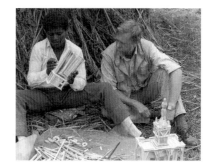

Neal Sobania talking with Tolera as he works on one of his sorghum-stalk models.

Tsehai Berhane-Selassie

Tsehai received her B.A. in history at Haile Selassie I University (1969) and M.A. (1976) and Ph.D. (1981) in social anthropology at Oxford University. Her primary research and writing interests lie in the areas of women's studies and development, and she has spent many years working with the women of Wolayta (south-central Ethiopia). Tsehai was on the faculty of the Department of Sociology, Anthropology, and Social Administration at Addis Ababa University and is currently a research fellow at the Center for Advanced Studies at Princeton University.

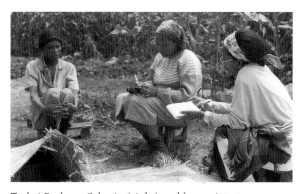

Tsehai Berhane-Selassie (right) and her assistant, Werqnesh Weltamo, interviewing Tabita (left).

Mary Ann Zelinsky-Cartledge

Zelinsky-Cartledge (B.A., Lake Erie College, 1982) conducted research on handweaving and other traditional crafts in the Doko Gamo area of southwest Ethiopia in 1992 and 1993. An experienced weaver herself, she has studied textiles and handweaving at the University of Florida, University of Tennessee, and Cape Breton School of Crafts, Nova Scotia. She currently resides in Hendersonville, North Carolina.

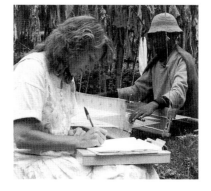

Mary Ann Zelinsky-Cartledge interviewing Ilto as he sits at his loom and weaves.

Worku Nida

Worku received his B.A. in history (1984) and his M.A. in social anthropology (1995) from Addis Ababa University. He has conducted research in the Gurage region of Ethiopia and is particularly interested in the impact of urban migration on village life. He has published articles concerning Gurage religion and culture, as well as a book on Gurage history. Worku is currently leading a policy-making team at the Ethiopian Ministry of Culture and Information that deals with the study and conservation of Ethiopian cultural heritage.

PHOTO CREDITS AND MUSEUM ACCESSION NUMBERS

(msum = Michigan State University Museum)

Figs. 2.1–2.4 Photos by J. Abbink, 1993.

Fig. 2.5 Photo by J. Abbink, 1993.

Fig. 2.6 (Left to right) msum 7557.180, msum 7557.164. Photo by K. Kauffman, 1996.

Fig. 2.7 (Left to right) msum 7557.170, msum 7557.160. Photo by K. Kauffman, 1996.

Fig. 2.8 (Left to right) msum 7557.167, msum 7557.175, msum 7557.166. Photo by K. Kauffman, 1996.

Figs. 3.1–3.2 Photos by R. Silverman, 1993.

Fig. 3.3 Photo by R. Silverman, 1992.

Figs. 3.4–3.7 Photos by R. Silverman, 1993.

Figs. 4.1–4.2 Photos by N. Sobania, 1993.

Fig. 4.3 (Left to right) msum 7557.307, msum 7557.283, msum 7557.306. Photo by K. Kauffman, 1995.

Fig. 4.4 Photo by N. Sobania, 1993.

Fig. 4.5 (Left to right) msum 7557.299, msum 7557.300. Photo by K. Kauffman, 1995.

Fig. 4.6 (Left to right) msum 7557.304,

msum 7557.348, msum 7557.286, msum 7557.303. Photo by K. Kauffman, 1995.

Fig. 4.7 msum 7557.282. Photo by K. Kauffman, 1995.

Figs. 4.8–4.12 Photos by N. Sobania, 1993.

Fig. 5.1 Photo by R. Silverman, 1991.

Fig. 5.2 Photo by R. Silverman, 1993.

Fig. 5.3 Photo by R. Silverman, 1991.

Fig. 5.4 Photo by R. Silverman, 1993.

Fig. 5.5 Collection of the artist (Zerihun Yetmgeta). Photo by R. Silverman, 1994.

Fig. 5.6 Church of Qiddus Giyorgis, Addis Ababa. Photo by Ania Biasio, 1989.

Fig. 5.7 Private collection, deposited in the Staatliches Museum für Völkerkunde, Munich.

Fig. 5.8 Collection of the National Museum of African Art, Smithsonian Institution, no. 91-18-2. Photo by Franko Khoury.

Fig. 5.9 Collection of the Völkerkunde-

museum der Universität Zürich, no. 21382. Photo by Erich Frei.

Fig. 5.10 Collection of the Völkerkundemuseum der Universität Zürich, no. 21388. Photo by Erich Frei.

Figs. 6.1–6.3 Photos by R. Silverman, 1993.

Fig. 6.4 Photo by N. Sobania, 1993.

Figs. 6.5–6.7 Photos by R. Silverman, 1993.

Fig. 6.8 (a) msum 7557.219.4, (b) msum 7557.215, (c) msum 7557.217.2, (d) msum 7557.211, (e) msum 7557.221.1. Photo by K. Kauffman, 1996.

Fig. 6.9 Photo by N. Sobania, 1993.

Figs. 7.1–7.3 Photos by R. Silverman, 1993.

Fig. 7.4 Church of Debre Berhan Selassie, Gonder Province. Photo by R. Silverman, 1991.

Fig. 7.5 Church of Mutti Qiddus Giyorgis, Addis Ababa. Photo by R. Silverman, 1993.

Figs. 7.6–7.7 Photos by R. Silverman, 1993.

Fig. 7.8 msum 7557.36. Photo by K. Kauffman, 1995.

Fig. 7.9 msum 7557.39. Photo by K. Kauffman, 1995.

Fig. 8.1 Photo by R. Silverman, 1993.

Fig. 8.2 msum 7557.1. Photo by K. Kauffman, 1996.

Fig. 8.3 Church of Qeranno Medhane Alem, Addis Ababa. Photo by Doro Röthlisberger, 1986.

Fig. 8.4 msum 7557.13. Photo by K. Kauffman, 1996.

Figs. 8.5–8.7 Photos by R. Silverman, 1993.

Fig. 8.8 msum 7557.15. Photo by K. Kauffman, 1996.

Fig. 8.9 msum 7557.6. Photo by K. Kauffman, 1996.

Fig. 8.10 msum 7557.20. Photo by K. Kauffman, 1996.

Figs. 9.1–9.5 Photos by R. Silverman, 1993.

Fig. 9.6 (Left to right) msum 7557.264, msum 7557.260. Photo by K. Kauffman, 1996.

Figs. 9.7–9.11 Photos by R. Silverman, 1993.

Fig. 10.1 Photo by N. Sobania, 1993.

Fig. 10.2 Photo by R. Silverman, 1993.

Fig. 10.3 msum 7557.58. Photo by K. Kauffman, 1996.

Fig. 10.4 msum 7557.52. Photo by K. Kauffman, 1996.

Fig. 10.5 (Left to right) msum 7557.64, msum 7557.67, msum 7557.65, msum 7557.66. Photo by K. Kauffman, 1996.

Fig. 10.6 Photo by R. Silverman, 1993.

Fig. 10.7 Photo by K. Kauffman, 1996.

Fig. 10.8 Photo by R. Silverman, 1993.

Fig. 10.9 Photo by N. Sobania, 1993.

Figs. 11.1–11.7 Photos by R. Silverman, 1993.

Fig. 11.8 msum 7557.354. Photo by K. Kauffman, 1996.

Figs. 11.9–11.11 Photos by R. Silverman, 1993.

Figs. 12.1–12.8 Photos by R. Silverman, 1993.

Fig. 12.9 (Left to right) msum 7557.351, msum 7557.350. Photo by K. Kauffman, 1996.

Fig. 12.10 Photo by R. Silverman, 1993.

Pl. 1 (Front row, left to right) msum 7557.163, msum 7557.176; (back row, left to right) msum 7557.174, msum 7557.173. Photo by K. Kauffman, 1996.

Pl. 2 (a) msum 7557.274.1&2, (b) msum 7557.272.1&2, (c) msum 7557.275&276, (d) msum 7557.273.1&2, (e) msum 7557.271.1&2. Photo by K. Kauffman, 1996.

Pl. 3 Photo by R. Silverman, 1993.

Pl. 4 (a) msum 7557.291, (b) msum 7557.299, (c) msum 7557.348, (d) msum 7557.304, (e) msum 7557.294, (f) msum 7557.286, (g) msum 7557.281, (h) msum 7557.300, (i) msum 7557.283, (j) msum 7557.298, (k) msum 7557.290, (l) msum 7557.287, (m) msum 7557.303, (n) msum 7557.292, (o) msum 7557.279. Photo by K. Kauffman, 1995.

Pl. 5 (Left to right) msum 7557.298, msum 7557.283, msum 7557.290. Photo by K. Kauffman, 1995.

Pl. 6 Collection of Dr. Carl Robson, Cleveland, Ohio. Photo by K. Kauffman, 1995.

Pl. 7 Collection of the artist (Zerihun Yetmgeta). Photo by K. Kauffman, 1995.

Pl. 8 Collection of the MacAuley Family, East Lansing, Michigan. Photo by K. Kauffman, 1995.

Pl. 9 (a) msum 7557.243, (b) msum 7557.257.3, (c) msum 7557.257.1, (d) msum 7557.242, (e) msum 7557.241, (f) msum 7557.237. Photo by K. Kauffman, 1996.

Pl. 10 (a) msum 7557.232, (b) msum 7557.227, (c) msum 7557.277, (d) msum 7557.235, (e) msum 7557.278. Photo by K. Kauffman, 1996.

Pl. 11 (a) msum 7557.228, (b) msum 7557.231, (c) msum 7557.84, (d) msum 7557.212, (e) msum 7557.229, (f) msum 7557.230, (g) msum 7557.85, (h) msum 7557.213. Photo by K. Kauffman, 1996.

Pl. 12 msum 7557.35. Photo by K. Kauffman, 1995.

Pl. 13 msum 7557.34. Photo by K. Kauffman, 1995.

Pl. 14 Collection of the Bayerisches Nationalmuseum, Munich, ETH480.

Pl. 15 msum 7557.2. Photo by K. Kauffman, 1996.

Pl. 16 msum 7557.14. Photo by K. Kauffman, 1996.

Pl. 17 (a) msum 7557.113, (b) msum
7557.112, (c) msum 7557.111,
(d) msum 7557.114, (e) msum
7557.110, (f) msum 7557.107,
(g) msum 7557.108, (h) msum
7557.109, (i) msum 7557.105,
(j) msum 7557.96, (k) msum
7557.95, (l) msum 7557.97,
(m) msum 7557.99, (n) msum
7557.101, (o) msum 7557.100,
(p) msum 7557.102, (q) msum
7557.103, (r) msum 7557.106,
(s) msum 7557.104, (t) msum
7557.98. Photo by K. Kauffman,
1996.

Pl. 18 (a) msum 7557.130, (b) msum
7557.126, (c) msum 7557.125,
(d) msum 7557.123, (e) msum
7557.129, (f) msum 7557.128,
(g) msum 7557.124. Photo by
K. Kauffman, 1996.

Pl. 19 (Left to right) msum 7557.46,
msum 7557.53, msum 7557.63,
msum 7557.54, msum 7557.45.
Photo by K. Kauffman, 1996.

Pl. 20 (a) msum 7557.204.1, (b) msum
7557.187.3, (c) msum 7557.205,
(d) msum 7557.199, (e) msum
7557.196, (f) msum 7557.189.3,
(g) msum 7557.203.1, (h) msum
7557.202.1, (i) msum
7557.200.1, (j) msum
7557.194.1, (k) msum
7557.195.1, (l) msum
7557.188.2. Photo by
K. Kauffman, 1996.

Pl. 21 Photo by R. Silverman, 1993.

Pl. 22 msum 7557.324, msum
7557.359, msum 7557.355, msum
7557.358. Photo by K. Kauffman,
1996.

Index